John Constable
1776-1837

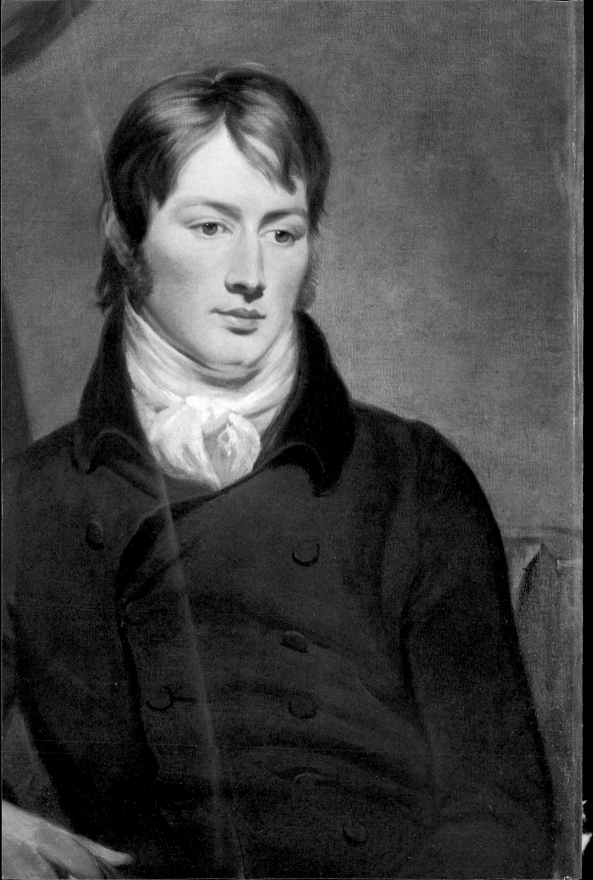

John Lloyd Fraser

John Constable
1776-1837
The man and his mistress

Landscape is my mistress – 'tis to her
I look for fame.

JOHN CONSTABLE
September 1812

Hutchinson of London

Hutchinson & Co (Publishers) Ltd
3 Fitzroy Square, London W1

London Melbourne Sydney Auckland
Wellington Johannesburg and agencies
throughout the world

First published 1976
© John Lloyd Fraser 1976

Set in Monotype Baskerville

Printed in Great Britain by The Anchor Press Ltd
and bound by Wm Brendon & Son Ltd
both of Tiptree, Essex

ISBN 0 09 125540 6

To Rosie
for
Nancy, Hatty, Alice and Patrick

Contents

Illustrations

(All paintings and sketches are by Constable, unless otherwise indicated)

Frontispiece: John Constable aged 23, by R. R. Reinagle

Acknowledgements

Anyone writing about John Constable must be in some measure in debt to the late R. B. Beckett. His edition and annotation of *John Constable's Correspondence* is an invaluable source. I am grateful to the Suffolk Records Society for allowing me to print quotations from the *Correspondence*. My thanks are also due to the late Lieutenant-Colonel J. H. Constable and Mrs Eileen Constable, Lord Plymouth, Ian Fleming-Williams and other holders of the copyright in the letters.

The staffs of the following museums, libraries, and galleries were invariably helpful in responding to my queries: British Museum; Castle Museum, Norwich; Christchurch Mansion, Ipswich; Fitzwilliam Museum, Cambridge; National Gallery, London; National Portrait Gallery; Royal Academy; London Library; Cambridge University Library; Courtauld Institute of Art; Swiss Cottage Library; Ipswich Central Library; Norwich Central Library; Guildhall Library, London; University of East Anglia Library; Victoria and Albert Museum. Leslie Parris of the Tate Gallery was particularly helpful in arranging for me to consult material in the Gallery's care.

I would also like to express my thanks to all those with whom I corresponded and to others who gave of their time to discuss with me various aspects of Constable's life and work.

For access to documents and pictures owned by the Constable family I am especially grateful to the late Lieutenant-Colonel J. H. Constable and Mrs Eileen Constable of Kettleburgh, Suffolk, whose hospitality I enjoyed on several occasions.

I have benefited greatly from the advice of Norman Scarfe –
General Editor of the *Correspondence* – who kindly read and com-
mented upon the typescript.

 John Lloyd Fraser

Norwich

John Constable
1776-1837

1

1776-1798

The scenes of my
boyish days

Tuesday the eleventh of June 1776 was a day of anticipated tragedy in the Constable home in East Bergholt. The fourth child and second son of Ann and Golding Constable was not expected to survive his birthday. The crisis continued into the evening and by darkness was considered serious enough for the Reverend Walter Wren Driffield to be summoned to perform the ceremony of baptism.* The nature of the weakness and its duration are unknown, but the infant subsequently became a strong and healthy child.

John Constable was the son of a countryman and a Londoner and it is curious how his life reflected the duality of his origins. Golding Constable came from a family with well-entrenched connections in East Anglia. In the seventeenth century the patronymic was not uncommon on both sides of the River Stour where for

*The ceremony did not take place in the family home. In September 1812 Constable wrote: 'He [the Rev. Mr Driffield] always remembers me as he had to go in the night over the Heath to make a Christian of me at a cottage where I was dying, when I was an infant.' (JCC II, p. 85.) In July 1814 Constable wrote: 'He [the Rev. Mr Driffield] is a very old friend of my father's and once lived in the parish [East Bergholt] — he has remembered me for a very long time as he says he christened me one night in great haste about eleven o'clock.' (JCC II, p. 127.)

generations Constables had been farmers and landowners. Such a
man was John Constable's grandfather, also named John, of Bures
St Mary in Suffolk whose son, Golding, was born in 1739. Golding,
named after his grandmother's family, was a fortunate man. The
favourite nephew of his uncle Abram, a prosperous cornfactor, he
was left at the age of twenty-six most of his business which included
over £3000 in cash, shipping, and a water-mill at Flatford on the
Stour.

Flatford Mill was a thriving concern conveniently situated on an
arm of the Stour navigable by barges. Grain destined for London
was hauled downstream from Flatford and off-loaded at Golding's
yards on the quay at Mistley before continuing its journey in the
Telegraph. Golding Constable's first years in business were not with-
out difficulties: the valley was regularly flooded and corn prices
fluctuated capriciously. Those early years were anxious ones, but
Golding placed his trust in the twin virtues of faith and hard work.
In time he became prosperous enough to be able to purchase a
larger corn mill at Dedham and a windmill and other buildings
nearby.

Constable's two portraits of his father show a friendly-looking
man with strong features. He commanded extraordinary loyalty
from his servants. His steward lived and died in his service; his
huntsman boasted of thrashing for him for seventy years. And when
one of his bargemen refused to move from his cottage to another,
claiming that he would no longer be able to shave, Golding patiently
sought the reason for his reluctance. When he was told that the
bargeman had used the top step of the stairs of his cottage to sharpen
his razor Golding offered to allow the man to remove the step, even
the whole staircase.[1]

As a cornfactor Golding Constable was from time to time obliged
to do business in the Corn Market in London. It was probably as
a result of his visits to the capital that he came to marry a Londoner.

Ann Watts was the daughter of a London cooper; she was one of
eleven children of whom six survived. She spent her girlhood at
83, Upper Thames Street where her father had begun trading in
1743 shortly after his marriage. Both of Ann's sisters, Mary and
Jane, married prudently as she did herself in 1767, a few days short
of her nineteenth birthday.

Golding and Ann Constable set up home at Flatford Mill where
their first three children were born. With the birth of Golding in
1774, after Ann and Martha (nearly always known as Patty), their

father deemed that larger quarters were required. On a site not far from the Church, Golding Constable built East Bergholt House, 'a Capital Brick Mansion' with twelve rooms arranged on three floors standing in some thirty-seven acres of pasture and arable land.[2] It was a house that a middling-rich country merchant might be expected to build. It was Constable's home until he was twenty-four years old.

In the fifteenth century East Bergholt had been a thriving community almost entirely dependent on the cloth trade. By the end of the following century the weavers had departed. At the time of Constable's birth East Bergholt was a village of about one thousand people most of whom relied on the land for their livelihood. It was, then, a village that had seen better days. Most of the houses were situated at the Church end to the west while others were to the north of the road which connected Church Street, the main street, with Burnt Oak Street at the eastern end of the village.

East Bergholt House and the Rectory, where the Reverend Doctor Durand Rhudde lived, both possessed semi-circular approaches; these two houses together with Old Hall, the seat of the squire, Peter Godfrey, and the widow Roberts' home at West Lodge* gave East Bergholt an appearance 'far superior to that of most villages'.[3] The Church was unlike most Suffolk village churches in that it did not possess a tower. It was built between 1350 and 1550. A tower was begun in 1525 but was not completed due to lack of funds. The lack of a tower led to the construction of a bell-cage which is still in use and now lies to the west of the Church; the bells are rung not by ropes or levers, but by the bell-ringer grasping the bell and swinging it; an agreeable change and the safety of the ringer depends upon an accurate sense of timing.

It is tantalizing that of Constable's early years we know little more than the nostalgic memories he recalled as an adult. These show that his childhood was happy and contented. He was a member of a loving, close-knit, and pious family, living in the midst of country that even during his lifetime would bear his name.†

With the birth of Mary in 1781 and of Abram in 1783, the

*West Lodge was renamed 'Stour' by the late Randolph Churchill who lived there until his death in 1968.

† Constable wrote to the engraver, David Lucas, in November 1832: 'In the coach yesterday coming from Suffolk, were two gentlemen and myself all strangers to each other. In passing through the valley about Dedham, one of them remarked to me — on my saying it was beautifull — "Yes Sir — this is *Constable's* country!" I then told him who I was lest he should spoil it.' (JCC IV, p. 387.)

B

Constable family was complete. By about this time it must have become evident that Golding, the eldest son, who suffered from occasional attacks of what seem to have been fits, would be incapable of succeeding to his father's business. But there was an admirable substitute who was only two years younger. So John became the heir apparent. It was a reasonable solution to a family problem, but for John it was to become more significant as he passed from boyhood to youth into early manhood.

Constable's idyllic days of boyhood were interrupted at the age of about seven when he was sent to a boarding school some fifteen miles from East Bergholt. His first brush with formal education did not last long and he was soon removed to another school at Lavenham. It seems that the proprietor, Mr Blower, was in love. He therefore left the school in the charge of an usher who flogged the boys unmercifully. The young Constable resolved to repay the tyrant in kind were they ever to meet as men. Fortunately for the flogger their paths never crossed again, but 'he remained to the end of the same mind with regard to that individual'.[4]

For a boy to have been unable to settle down at two schools suggests that he was a difficult pupil, an unteachable prospect, but there are no grounds for suspecting that Golding and Ann Constable removed John from Mr Blower's establishment and placed him in his third school, Dedham Grammar School, in any spirit of make or break.* They would not have been deaf to the pleas of a boy who quite probably expressed his unhappiness at being away from his home and family, a trait which remained with him throughout his life. If Dedham Grammar School did not bring out any latent academic ability in John Constable, it did, through the personality of the headmaster, Dr Thomas Lechmere Grimwood, provide an atmosphere in which he could develop instinctively, unhindered by a rigid regime.

According to one's view of the purpose of education, Dr Grimwood was either grossly indulgent or a man as gifted intuitively as he was intellectually. Himself a Wrangler and coming from an academic family, headed by his father who had founded the school, Dr Grimwood might have been expected to have had little patience or sympathy with a dreamy youth whose interests were clearly incompatible with his own. 'Dr Grimwood had penetration enough to discover that he was a boy of genius, although he was not remark-

* Oral tradition in Dedham has it that Constable was a 'parlour boarder'. He lived at home but took his meals, including breakfast, at the school.

able for his proficiency in his studies, the only thing he excelled in being penmanship.' Dr Grimwood's classical teaching did however keep John supplied with Latin tags for the remainder of his life. A tutor engaged subsequently to teach Constable French enjoyed less success. He was aware of the competing interest and would interrupt the pauses which frequently punctuated his lessons. 'Go on', he would say, 'I am not asleep: Oh! now I see you are in your painting-room.'[5]

From the Constable home at East Bergholt to Dedham was a walk of about two miles and an energetic boy would no doubt have found a short cut across the fields. So in his adolescent years Constable would have tramped the paths and lanes between the two villages, unselfconsciously immersing himself in the landscape he was to depict with intimate understanding:

But I should paint my own places best—Painting is but another word for feeling. I associate my 'careless boyhood' to all that lies on the banks of the *Stour*. They made me a painter (& I am gratefull) that is I had often thought of pictures of them before I had ever touched a pencil. . . .[6]

By the age of about fifteen or sixteen Constable had become the close friend of a plumber and glazier who lived in a cottage near the gates of East Bergholt House. His name was John Dunthorne. Mrs Constable regarded Dunthorne as an impecunious adventurer who had exploited a Bergholt widow, Hannah Bird, whom he had married in 1793. When Constable later criticized 'Dunthorne's *old woman*'s conduct' towards his friend, Mrs Constable leapt to Hannah's defence. 'To take in a man, from an advertizement, without a change of raiment or a shilling to his pocket & marry him—put him in possession of her house, furniture, trade, & and what property she had—surely he ought to be grateful at least.'[7] Typically, Mrs Constable did nothing to discourage a friendship which clearly gave her son much pleasure.

Dunthorne seems to have been quite remarkably talented in painting and drawing and in music. He was skilled on the flute, and he made musical instruments, including a violincello for his young friend. He spent much of his time sketching in the Stour Valley.[8]

There can be little doubt that Dunthorne provided the first encouragement to John Constable to represent on paper aspects of the country around him. It is not difficult to imagine the young Constable tramping the woods and the fields in the Vale of Dedham under those dramatic Suffolk skies in the company of Dunthorne.

There could have been no greater contentment for a boy than to have had as a friend a mature sympathetic man whose interests coincided with his own.

Dunthorne and Constable were methodical. They would take their easels into the fields and paint one view only for a certain time each day. When the shadows from the objects changed, their work was postponed until the same hour on the following day. And when they returned to the village, there would be Golding to twit them: 'Here comes Don Quixote and his man Friday'. This was probably Golding's friendly way of expressing his annoyance that his son, whom he regarded as his heir, should show more interest in sketching windmills in the company of Dunthorne than in learning from him the intricacies of their operation.[9]

Dunthorne probably had a certain facility which would have impressed a tyro who, although he might have thought about pictures, was still learning how to transfer them to paper. It would not be many years, however, before Dunthorne would be writing to Constable: 'How often I wish for your good and instructive company to set aright the many vague ideas of my mind which often like the false lights of a Bad Picture throw the whole into confusion.' But at the start of their association Dunthorne was the teacher, Constable the pupil. It must surely have been through observing the effects that Dunthorne could conjure up with his pencil that Constable first resolved that he could spend his life in no other way than by becoming a painter. His resolution was confirmed in 1795 by an event brought about by his mother who gained for her son an introduction to Sir George Beaumont.

In 1795, Sir George was a rich man of forty-two, a Member of Parliament, and one of the leading art-collectors of the day. He was also an amateur artist of talent. Sir George often travelled to Dedham to visit his mother and it was during one of these visits that the young man from East Bergholt was presented to him. It was not Sir George who impressed the young visitor so much as his possessions, namely, some water-colours by Girtin and Cozens and, the pride of his collection, a painting by Claude known as *Hagar and the Angel*. But John Constable had some of his own works to show Sir George. In addition to the sketches he had been doing in company with Dunthorne he had been making large pen and ink copies of Dorigny's engravings from the Raphael cartoons, *The Death of Ananias* and *Elymas the Sorcerer Struck with Blindness*. Sir George pronounced himself impressed. This meeting gave Constable his first

encouragement at a time when the portents did not advertise a glittering future for him as a painter; gratitude cannot more easily be earned.

In about 1798 Constable met another man who was also to be a source of great encouragement to him. Dr John Fisher was nominally the Rector of Langham, a village on the Essex side of the vale of Dedham. The Rector rarely deigned to appear amongst his flock who were left in the care of his curate, the Rev. Brooke Hurlock, who was a friend of Constable's. It was the Rev. Mr Hurlock, who by introducing Constable to the Rector, laid the foundation of an enduring friendship. In 1824, Constable reminded Dr Fisher that he had been his 'kind monitor for twenty-five years'. The reason why Dr Fisher appeared so infrequently in the village of which he was Rector was that the appointment ranked least in importance among the several posts he held at that time. Dr Fisher had taken the royal road to preferment. He had been tutor to Queen Victoria's father and had swiftly received appointments as Royal Chaplain and Canon of Windsor; he also had the care of parishes in Hampshire and Somerset at a time when plurality of livings and its concomitant of non-residence went largely unremarked except by Cobbett and other social reformers. Dr Fisher became Bishop of Exeter in 1803 and was soon afterwards charged by George III with the education of the Princess Charlotte. Perhaps to encourage him in this onerous task the monarch translated Fisher to the see of Salisbury in 1807, a year in which he was also elected Chaplain to the Royal Academy. Constable's fortunate meeting with this considerable man was to lead to an even more valuable friendship with his nephew.[10]

Constable continued to paint and sketch, often in the company of Dunthorne, but he was also acquiring a number of other artistic cronies. One was Elizabeth Cobbold of Ipswich. She was nine years older than Constable and was married to John Cobbold, an Ipswich brewer. Although Mrs Cobbold was better known for her poetry she was also an amateur artist. She and her husband were patrons of the painter Daniel Gardner who made a tempera portrait of Constable in 1796. Possibly through Mrs Cobbold, Constable met another Ipswich painter and drawing-master named George Frost with whom he occasionally went on sketching jaunts.

The profession of painter would not have been seriously considered when the time came to decide where the boy was to be placed in the world. As an alternative to following his father, the Church

was considered and rejected because of Constable's disinclination to study. When he was about sixteen, Constable donned a white hat and coat and reluctantly began to learn the mundane practice of milling. He was a dutiful son and resigned himself without rancour to his duties which he performed 'carefully and well'. The financial side of the business was understandably of less interest to him than the practice of milling with its dependence upon the natural elements. The period he spent familiarizing himself with wind and water-mills was not wasted. 'When I look at a mill painted by John', Abram Constable later remarked, 'I see that it will *go round*, which is not always the case with those by other artists.'*

Once the decision had been taken and implemented Constable must have lived the ordered and predictable life that was the lot of the miller. Like many a youth on the threshold of manhood he must have been beset with wishful thinking. Here he was patiently and obediently labouring in the service of his father – not a particularly disagreeable life – when he would have been aching to be in the fields with a sketchbook on his knees. But his painting and sketching were now probably confined to the long summer evenings, for a pious family would surely not have permitted the Sabbath to be defiled by the pursuit of so inconsequential an activity as sketching from nature.

As a young man about the village of East Bergholt Constable was far from being the doleful artist. His ambition, tentative as it was, was probably known only to his family; the village no doubt found it commendable but unremarkable that the Constable boy was doing his filial duty. The miller was to be congratulated on having such a fine son with whom to share his load. His well-built figure, the dark eyes in a sensitive face set off by his mid-brown hair led him to be dubbed 'the handsome miller'.

In 1796 Constable was sent to London, probably to gain direct experience of the City end of his father's business. He had a number of relatives in London, notably Mrs Whalley, as his sister Patty had become. She lived with her husband, Nathaniel, at Temple House, East Ham. In August 1796, however, he stayed with his

*Constable's accuracy was also later commended by Samuel Strowger, head porter (and model in the Life Academy) at the Royal Academy. A Suffolk man, Strowger once advised the arranging committee that Constable's representation of reaping correctly placed one man, known as the *lord*, ahead of his companions. 'Our gentlemen are all great artists, sir', Strowger told Constable, 'but they none of them know anything about the *lord*.' (Leslie, pp. 18–19.)

uncle Thomas Allen at Edmonton, then a village on the outskirts
of the capital. Uncle Thomas had a deep interest in antiquities and
numbered among his friends a professional artist called John Thomas
Smith. 'Antiquity' Smith was ten years older than Constable.
Smith's father was for a time chief assistant to Joseph Nollekens,
R.A., in whose studio John Thomas himself worked from the age of
twelve until he was fifteen; it was a period which yielded valuable
impressions for his celebrated biography of the sculptor. Subse-
quently he learnt mezzotint engraving and etching and by 1788
had become a drawing master at Edmonton. Here he completed
much of the work for which he is best remembered, his *Antiquities
of London and its Environs* from which he took one of his nicknames.

It soon became apparent to Golding that the intended purpose
of the visit to London was not being advanced; the opportunity of
taking a 'dish of tea extraordinary' with Smith and his friends
to talk about 'the art' was of far greater attraction to John than
spending long, sweaty days in the Corn Market. The Allens, report-
ing to East Bergholt on the great enjoyment the young man was
obviously deriving from the artists' company, aroused Golding's
suspicions. The paternal rebuke brought a carefully composed
exculpatory letter from a 'dutiful and affectionate son':

I must own upon first reading your letter I was rather confused but
upon recollecting myself I soon found that I deserved all the reproof
you was so good to give me; and moreover I should not think you was
my friend if you did not give it when you see it as necessary as it certainly
then was; I laboured under two disadvantages, in the first place I have
a very bad pen and no knife to mend it, and in the next place it was almost
dark. But if there was any part of it which tended towards disrespect I
am very sorry for it, as it certainly was not my intention, which I hope
you will not be tardy in believing.

I find you mistake the matter if you think it was my own intention or
wish to get a situation in town, (any more than this) that if I could have
somewhere for a year or two, to have got some knowledge of a business
which had some affinity to your own, it might have been of service to
you now and to myself hereafter.[11]

Golding seems to have suggested that his son should seek out his
brother-in-law Christopher Atkinson, the husband of his sister
Elizabeth, a man with a colourful history of rank dishonesty. Even
at the age of twenty, Constable had an instinctive distaste, which
remained with him, for anyone who bore the faintest whiff of
mendacity. He declined to call on his uncle by marriage although

he assured his father, 'If it is your real wish that I should apply to Mr. Atkinson I certainly will do it, but he is not a man I should apply to by choice'.

That summer visit to Middlesex in 1796 also began Constable's acquaintanceship with John Cranch, a friend of Smith's who also lived at Edmonton under the patronage of Sir James Winter Lake. Remembered now, if at all, for the *Death of Chatterton*, Cranch, as much as Smith a professional artist, was an enviable being to the young painter from Suffolk. He should however be remembered, perhaps revered, for a lengthy note he wrote to Constable on 30 September 1796. In his 'Painter's Reading, and a hint or two respecting study' he recommends the standard works: Da Vinci's and De Pile's treatises on painting, Hogarth's *Analysis of Beauty* and *Du Fresnoy de arte graphica* in Dryden's translation. 'If you like it better in *rhyme*, Mason's version is spirited and elegant, and has the advantage of some notes by Sir Joshua Reynolds.' He goes on to commend Webb's essay on the beauties of painting, and works by Algarotti, Abbé du Bos, the Richardsons, Chevalier Mengs, and Gerard Lairesse. Cranch urged Constable to observe 'Nature herself' and in qualifying his recommendation of Reynolds' *Discourses* he issued a warning that we know Constable heeded:

But be cautious it does not bias you against *familiar* nature, life and manners, which constitute as proper and as genuine a department of imitative art as the *sublime* or the *beautifull* . . . The 'Discourses' are a work of unquestionable genius, and of the highest order of literature; but they go, if I may so express it, to establish an *aristocracy in painting*. They betray, and I believe have betrayed, many students into a contempt of everything but grandeur and *Michael Angelo*. The force, and the splendid eloquence, with which the precepts are inculcated, makes us forget that the truth of Teniers and the wit and moral purposes of Hogarth, have been, and will forever be, at least *as* usefull, and diffuse at least as much pleasure, as the mere *sublimities* of Julio and Raphael: In truth, while these Discourses pretend to greater expanse and comprehension, I know of none that would *hamper and confine* the faculties (I was going to say the blessings) of our art, into a narrower or more inaccessible province.[12]

It was John Cranch who set Constable along the road towards his iconoclastic view of landscape art: respect the achievements of the Old Masters, says Cranch, but do not feel that they are standing over you, even wielding your brush or doctoring your palette. The unaffected common sense of Cranch is conveyed in his advice to study not only great paintings, but also the works of bad painters.

From the Masters young painters learn 'by what courses of *thought*, and by what combinations and *contrivances*, those works were produced'. In studying bad pictures 'truths and falsehoods may be ascertained by *comparison* with good pictures and with Nature'. In short, Cranch was laying the foundation for Constable's subsequent conclusion that 'there was room enough for a natural painture'.[13]

It was as a result of meeting Smith that Constable obtained what may be regarded as his first commission. Smith was preparing a treatise entitled *Remarks on Rural Scenery with Twenty Etchings of Cottages from Nature*, and he encouraged Constable to send him some of his sketches. Constable was enthusiastic about the project and with the ingenuousness of youth regarded himself as Smith's collaborator; a discreet attribution was all that he needed to be drunk with joy. Returning to Bergholt in the autumn he persuaded several family connections to subscribe to the volume. Soon he was diffidently reporting to Smith that 'I have in my walks pick'd up several cottages and peradventure I may have been fortunate enough to hit upon one, or two, that might please. If you think it is likely that I have, let me know and I'll send you my sketchbook and make a drawing of any you like if there should not be enough to work from.'

The sketches which Constable is known to have done after meeting Smith show unmistakably that he was trying to emulate him. It was Cranch, however, whom he followed when he came to begin his first known landscape in oils. 'I have lately painted a small moonlight in the manner or style of Cranch', he told Smith in November 1796. This picture, known as *The River Brett by Moonlight*, is the earliest known landscape in oils by Constable. It is a conventional rendering of a river scene at night with the spire of Hadleigh Church visible on the skyline.[14] In the following year he doffed his hat again in the direction of Cranch with *The Chymist* and *The Alchymist* 'for which I am chiefly indebted to our immortal Bard. You remember Romeo's ludicrous account of the Apothecary's shop'.

It was fortunate for the impressionable young man that Constable seems to have been, that Smith offered him notions about painting which, though they were unfashionable, were not impractical. 'Do not', Smith advised, 'set about inventing figures for a landscape taken from nature; for you cannot remain an hour in any spot, however solitary, without the appearance of some living thing that will in all probability accord better with the scene and time of day

than will any invention of your own.'[15] Smith said that the colours of scenery should be carefully matched and drew attention to Nature's most important colour. The colour green, Smith claimed, demanded close study since most landscapes contained a higher proportion of this colour than any other; because of this there must necessarily be a trace of green in most of the elements of a landscape, irrespective of the strength of the dominant colour. To write, as Smith did, that 'the shades or degrees of this colour as it is distributed in nature are unnumerable' may now seem a truism, but at that time conventional landscape painters – it was regarded as very much an inferior branch of art – would not have been criticized, for example, for representing spring grass in colours ranging from brown to ochre; indeed, they would have commended themselves to prospective purchasers for more nearly approaching the appearance of an Old Master. When an eighteenth-century connoisseur looked out of the windows of his country house he saw that the grass was green; if he commissioned a picture of that same scene it would have been a rash painter who simply painted what he saw. Illusion was attractive; truth was vulgar.

By the early spring of 1797 Constable must have felt that he and Smith were well enough acquainted for him to seek Smith's opinion on his prospects as a professional artist. Smith, who must have envied Constable's settled background, counselled caution. He foresaw that a man of business could in time become a man of leisure, free of the punishing necessity, with which he was familiar, of measuring income against artistic production, of the almost intolerable pressures exerted upon an artist not of the front rank. Constable accepted his friend's advice with resignation. Inspired more perhaps by filial loyalty than self-pity he wrote: 'And now I certainly see it will be my lot to walk through life in a path contrary to that in which my inclination would lead me.' He continued to work alongside a father who, though sympathetic to his aspirations, could not countenance his son becoming a professional artist. Golding would have based his objections on practical grounds. No longer a young man, he was shouldering alone the considerable responsibilities of the family business. Of his three sons only two could be considered as suitable heirs; but Abram, at the age of fifteen, was still too young. John was the only candidate. The reluctant young miller would also have had to accept the unpalatable truth that so far there was little indication that his artistic inclinations were matched by other than mediocre ability.

However, the traffic with 'friend Smith' in prints, books and information continued. From time to time Constable sent Smith, who was now living in Frith Street, Soho, a 'parcel of cottages' but none found their way into Smith's book. Smith was still writing the text of the book in May 1797 when he asked Constable for information about Gainsborough. John Thomas Smith's *Remarks on Rural Scenery* was published in July. The result of Constable's energetic 'puffing' of the book can be seen in the number of his relatives and friends who subscribed to it.

Constable met Smith again in London later that year and, perhaps in gratitude for his help with launching the book, Smith wrote to Mrs Constable. He had no reason to write to Constable's mother and the most likely explanation is that Constable put him up to it. There is a suggestion in Mrs Constable's reply that she also suspected a conspiracy; it indicates clearly the strait-jacket that she expected her son to wear:

Your discernment makes me hope your praises are not the effect of flattery but approbation – his future conduct I trust will ever merit the favor of your friendship which I well know he greatly values; let me assure you that was you personally & intimately acquainted with his Father, you would not wonder he had so worthy a Son. We are anticipating the satisfaction of seeing John at home in the course of a week or ten days, to which I look forward with hope that he will attend to business – by which means he will please his Father, and ensure his own respectability, comfort and accommodation.[16]

The status quo continued into the next year, but in the autumn of 1798 Constable was host to Smith at Bergholt and arranged for him to meet some of the subscribers to his book. It seems likely that during his visit Smith persuaded Golding and Ann Constable that his earlier praise had been sincere. He could have pointed out that during the two years of their association their son had made considerable progress. Without some such assurance coming from a professional artist who was known to be taking a close interest in the development of their son's artistic ability it seems unlikely that Golding would have agreed to release John at a time when he must have become valuable to him as a right-hand man. But Golding and Ann could hardly have failed to notice the enthusiasm he brought to what they regarded as his hobby, in contrast to his indifference to the family business. They must have realized at last that any attempt to change his inclinations would end in failure. They gave way.

2

1799-1809

The patient pupil
of nature

Once the decision had been taken to release him from his obligation
to succeed his father, both Constable's parents did what they could
to help him enter what must have seemed to a country miller and
his wife the curious world of art and artists. Golding gave him a
generous allowance of £100 a year. His mother, ever solicitous of
his health, saw to it that he was well-prepared for the rigours of
a bachelor's life in London; later, her concern was such that she
even offered to send him a bag of coal, but decided that money
would be more convenient so that he could buy it 'in the retail way'.
Of more immediate help was the letter of introduction, possibly
engineered by his friend Elizabeth Cobbold, which Mrs Priscilla
Wakefield,* the Quaker philanthropist, wrote to Joseph Farington,
arguably the most powerful figure in the Royal Academy. In effect,
it represented Constable's passport into the Royal Academy Schools
at Somerset House.

Joseph Farington had reached an age when generous men
conclude that they must help rather than hinder those who are

*Priscilla Wakefield, 1751–1832. Children's writer, also wrote on natural
history, science, and travel; one of the earliest promoters of savings bonds –
'frugality banks'. Sister of Mrs Gurney; her niece was Elizabeth Fry. (DNB)

about to replace them. Farington, remembered more as a diarist than as an artist, was a landscape painter who had been a pupil of Richard Wilson. A wealthy bachelor, aged fifty-two, he had applied himself successfully to achieving a position of power and influence within the Royal Academy; significantly, he had more than once rescued the Academy from financial difficulties. At the turn of the century few matters affecting Somerset House could be decided without the knowledge and approval of the 'Dictator of the Academy' as he was known.

February 25th 1799 Mr J. Constable of Ipswich called with a letter from Mrs W— devoted to art though not necessary to profess it – knows Sir G[eorge] B[eaumont] – thinks first pictures of Gainsborough his best, latter so wide of nature.[1]

From this time on Farington showed an affectionate interest in Constable's affairs and advised and championed him whenever he could. He received him again on the following day.

Constable called & brot. his sketches of landscapes in neighbourhood of Dedham – Father a merct. who has now consented that C— shall devote his time to the study of art – wishes to be in Academy. I told him he must prepare a figure.[2]

Constable's drawing of a torso from the antique satisfied Farington who recommended him to Joseph Wilton, the Keeper of the Academy, as 'fit to be a probationer'. The 'Director' having given his fiat, Constable's entry was assured. So, at the age of twenty-three, Constable entered the Royal Academy; it was an association that was to afford him much bitterness and frustration for the remainder of his life.

The Royal Academy had moved from its original premises in Pall Mall, where it was founded in 1768, and was now at Somerset House in the Strand. Built by Sir William Chambers, it also housed the Society of Antiquaries and several government departments including the Navy. The part occupied by the Royal Academy was reached by a punishing staircase. Dr Johnson said, to indicate his recovery from an illness, that he could run up the whole of it if necessary. As a probationer, Constable would have spent much of his time on the principal floor which housed the assembly or lecture rooms and the library. In the latter room he would have seen works by Reynolds, Cipriani and the then President of the Royal Academy, Benjamin West. The young student was surrounded by improving

homilies: in the library there was Reynolds' *Theory* – a female figure seated on a cloud holding a scroll bearing the words 'Theory is the knowledge of what is truly nature'. The Greek inscription over the door of the Great Room read, 'Let no stranger to the Muses enter'.

When Constable joined the Academy aspirants were required to spend three months on probation in one of the schools, usually the Antique Academy, before acceptance as a student; the training period was seven years, but in 1800 it was increased to ten years. The founding instrument of the Royal Academy laid down the system of education that was to be followed in the Schools; it was largely unchanged when Constable set out on his career. The tuition, provided free, was in the hands of several professors, all elected from among the Academicians. They were responsible for the various aspects of art: Anatomy, Architecture, Painting, Perspective and Geometry. Their duties consisted, in the main, of giving six lectures a year on their respective subjects. The Professor of Painting was required 'to instruct the Students in the principles of composition, to form their taste of design and colouring, to strengthen their judgement, to point out to them the beauties and imperfections of celebrated works of Art, and the particular excellences or defects of great masters; and, finally, to lead them into the readiest and most efficacious paths of study. . . .' The Professor of Perspective and Geometry was to concern himself with 'the principle of Lineal and Aerial Perspective, and also the projection of shadows, reflections and refractions shall be clearly and fully illustrated; he shall particularly confine himself to the quickest, easiest, and most exact methods of operation'.[3]

One of Constable's professors in his second year in London was Henry Fuseli, R.A. He was an ordained Swiss priest who had turned to art; after some years in Italy he had settled in London in 1779. He had a well-deserved reputation for irascibility; he claimed to be able to swear in nine languages, an ability he did not forego in the Schools. During one session, after repeated interruptions, Fuseli yelled 'You are a pack of wild beasts.' From among the students a wag rejoined, 'Yes, sir, and you are our keeper.'[4]

Discipline was particularly lax in the Schools during the last decade of the eighteenth century. Farington records in 1795 that Joseph Wilton, the Keeper, had complained that students had 'a practise of throwing the bread, allowed them by the Academy for rubbing out, at each other, so as to waste so much that the Bill

for bread sometimes amounts to sixteen shillings a week'. The missiles were withdrawn.

Among Constable's contemporaries as students were many men whose names and work are forgotten, but there were a handful who became students between 1794 and 1806 who did subsequently make their mark on the artistic life of the nineteenth century. But of these only (Sir) David Wilkie, the Chalon brothers, and John Jackson retained Constable's respect and affection throughout his life.

Constable's friendship with Ramsay Richard Reinagle began soon after he came to London. At first he was probably flattered at having acquired the friendship of so accomplished a figure as Reinagle appeared to be. By contrast with the serenity of his own early life, Reinagle could lay claim to a background of dash and colour. Born in 1775, he was the son of an Academician, Philip Reinagle. The younger Reinagle had exhibited his first painting at the Royal Academy at the age of thirteen; even Turner did not achieve that honour until he was fifteen. The few years before his meeting with Constable, Reinagle had spent studying in Rome and in Holland. By Christmas 1799, which Reinagle spent with Constable at East Bergholt, they were good enough friends to decide to take up rooms together in the new year at 52, Upper Norton Street, off Portland Place. Constable's first lodgings had been conveniently near Somerset House – at 23, Cecil Street, off the Strand.

Within a few months of moving to Upper Norton Street, Constable became disillusioned with Reinagle; their ideas on painting, on the very nature of art, were totally opposed. The relationship did not end suddenly on a note of acrimony; it petered out. The sorry end to Reinagle's career – in 1848 he was required to resign from the Royal Academy for passing off another painter's work as his own – indicates that Constable's intuitive assessment of his character was accurate.

I do not like men who force their tongue to speak a language whose source is not in the heart. It is difficult to find a man in London possessing even common honesty; and it is a melancholy reflection, to know we are living in a Christian country and we *Christians* are devoted to mercilessly preying upon one another. Mr. R— wanted me to dine with him to-day but I declined it, this would be reviving an intimacy which I am determined never shall exist again, if I have any self command. I know the man and I know him to be no inward man.[5]

Thus dismissed, Reinagle took himself off to be married to a Miss Bullfinch, who had been governess to his sisters. Relations between the two men remained amicable enough, but time did not mellow Constable's opinion of Ramsay Richard Reinagle.

Constable began the new century no longer a probationer, but an admitted student of the Royal Academy Schools. Apart from the tasks he was required to perform at Somerset House, he was also working hard in his own time. He maintained his association with Farington and with Sir George Beaumont both of whom loaned him pictures to copy. Constable could count himself fortunate in having access to a wealthy man's pictures. Most private collections could not be seen without letters of introduction; to some not even scholars were always admitted. Student painters resorted to the salerooms and galleries on the rare occasions when an Old Master was on view. Constable somehow gained free admission to Michael Bryan's 'picture room where are some fine works, particularly some landscapes by Gaspar [Poussin]—I visit this once a week at least'. Farington urged his protégé (for that is how he regarded him) in the direction of his own master, Richard Wilson. Constable was put to copying *Adrian's Villa* and *The Ruins of Maecena's Villa*. Sir George, whose London home was in Grosvenor Square, also offered encouragement and the loan of his small Claude, the *Hagar*; this was a signal favour since Sir George claimed the picture to be his favourite and one that accompanied him whenever he travelled. Constable was also copying a Ruisdael which he and Reinagle had bought together for £70. 'Indeed, I find it necessary to fag at copying, some time yet, to acquire execution', he told Dunthorne. 'The more facility of practice I get, the more pleasure I shall find in my art; without the power of execution I should be continually embarrassed, and it would be a burthen to me.'[6]

His first essay into friendship with a man of his own age having failed, Constable was wary about launching into further intimacies. He was disappointed, too, that London had not come up to his expectations. He had expected to be surrounded at Somerset House by men of ideas and enthusiasm as he was himself. Instead, he was learning that his fellow students were mostly an uninspiring group who 'looked only to the surface not to the mind. The mechanics of painting is their delight. Execution is their chief aim.'

But he had access to an antidote for his depression. A dose of Suffolk air and a sight of Suffolk fields was stronger than any medicine. His determination to 'remain in town the chief of this summer' only

deepened his sense of separation from the country in which his am-
bition had been nurtured. 'This fine weather almost makes me
melancholy,' he wrote to Dunthorne, 'it recalls so forcibly every
scene we have visited and drawn together. I even love every stile
and stump, and every lane in the village, so deep rooted are early
impressions. . . .' Late July found him in Suffolk but not at East
Bergholt. The village plumber must have despaired of ever again
tramping the fields in his young friend's company when Constable
took up what was probably an open invitation to visit Helmingham
Hall, the seat of the Earl of Dysart, near Ipswich.

Here I am quite alone amongst the oaks and solitude of Helmingham
Park. I have quite taken possession of the parsonage finding it quite
empty. A woman comes from the farm house (where I eat) and makes
the bed, and I am left at liberty to wander where I please during the day.
There are abundance of fine trees of all sorts; though the place upon the
whole affords good objects rather than fine scenery; but I can hardly
judge yet what I may have to show you. I have made one or two drawings
that may be usefull.[7]

By the beginning of 1801 Constable was established in 'three
rooms in a very comfortable house, No. 50, Rathbone Place. My
large room has three windows in front. I shall make that my shop,
having the light from the upper part of the middle window, and
by that means I shall get my easel in a good situation.'[8] Constable
had been in London now for two years and the increasing rigour
of his self-discipline suggests that he felt that only by developing
himself could he make up the time that he had lost. His fellow-
students were mostly several years younger than himself and had not
suffered the false start that had delayed his own entry into the
Schools. 'I hope to be able to keep more to myself than I did in
former times, in London. I have been among my old acquaintances
in the art, and am enough disgusted (between ourselves) with their
cold trumpery stuff. The more canvas they cover, the more they
discover their ignorance and total want of feeling. . . .' The monastic
theme continued in Constable's next letter to Dunthorne:

I seldom go out as I am so much confined to work at present. I paint
by all the daylight we have, and that is little enough, less perhaps than
you have by much, I sometimes however see the sky, but imagine to
yourself how a purl must look through a burnt glass.[9]

He was appalled by the levity in the Life Academy:

C

I am so much more interested in the study than I expected, and feel my mind so generally enlarged by it, that I congratulate myself on being so fortunate as to have attended these lectures. Excepting astronomy, and that I know little of, I beleive no study is really so sublime, or goes more to carry the mind to the Divine Architect. Indeed the whole machine which it has pleased God to form for the accommodation of the real man, the mind, during its probation in this vale of tears, is as wonderfull as the contemplation of it is affecting. I see, however, many instances of the truth, and a melancholy truth it is, that a knowledge of the things created does not always lead to a veneration of the Creator. Many of the young men in this theatre are reprobates.[10]

The puritan did not shun social life altogether. If he could find few among his contemporaries in the Schools with whom to spend his free time, his sister Patty Whalley at her home in East Ham provided a haven to which he often escaped. Patty's house, conveniently near the coach route from Suffolk, provided Constable with a link with the life of the family and the country which he had in a sense abandoned. 'I never hear of an arrival from E. Bergholt but I forthwith take my hat & stick and trudge off for the news.'

Constable trudged east on several occasions during 1801 to spend the evening, or a Sunday, with his Whalley relatives. He also frequently visited Patty's father-in-law, Daniel Whalley, at his home in America Square, Minories. He was popular enough with old Mr Whalley to be invited to take a holiday at his family home near Newcastle-under-Lyme in Staffordshire in July. The visit enabled Constable to make a tour of the Peak District without which at that time no artistic education could be considered complete. Daniel Whalley's diary for Friday 31 July reads: 'About nine this morning son Daniel and Mr. John Constable, set out on a Tour to the Peake in Derby-shire.'[11]

Constable spent three weeks in the Peak District, but the grandeur of the scenery left him unmoved as did that of the Lake District a few years later. He produced a dozen or so sketches of or near the places he visited: Matlock, Mam Tor, Dovedale, Chatsworth, Haddon Hall, and Edensor. Farington remarked that these sketches, now in the Victoria and Albert Museum, are 'so like Sir George Beaumont's that they might be taken for his'. The two young men returned to Dovedale on 19 August when who should they run into but the 'Dictator' himself; he was on his way to Scotland in the company of his wine-merchant. Farington duly recorded the meeting: 'At nine o'clock we entered *Dovedale, I made a sketch of the first appear-*

ance of the entrance, and while I was so employed *Mr. Constable* came up to me, He having come a 2d time to make studies here.'

On the following day Constable and his companion returned to Staffordshire. Constable could hardly have found the Midland countryside congenial, yet he remained in the Whalley home for a further three months. Daniel Whalley's diary throws little light on his reasons for staying so long. He made the visit to 'Mr. Spode's manufactory' which a visitor might be expected to make. He joined in the social life of his host, he observed the Sabbath and he often went out riding with Daniel Whalley, his son or his daughters. 'John Constable and daughters took an airing. . . .' So begin two entries in October. It was not until Tuesday, 17 November 1801 that Daniel Whalley wrote: 'At six this morning Mr. John Constable left us, went for London. He came to us 23rd July last.

Apart from the time he had already spent in London, this was the longest period Constable had been away from either his home or his bachelor lodgings. He reported to Dunthorne:

My visit to the Whalleys has done me a world of good—the regularity and good example in all things which I had the opportunity of seeing *practiced* (not talked of only) during my stay in that dear family, will I trust be of service to me as long as I live.

I find my mind much more decided and firm—and since I have been this time in town I have enjoyed a serenity of soul which nothing in this earth could purchase, and I have acquired considerably, what I have so long and ardently desired—patience in the pursuit of my profession.[12]

Throughout his life Constable reacted similarly towards those who provided him with hospitality and sympathetic company. He could never regard staying in friends' homes casually; a family going about its daily life was to him almost a sacred act.

In the spring of 1802 Constable's two mentors, Dr Fisher and Sir George Beaumont, took it into their heads that their young friend needed what has been anathema to painters down the ages – a regular job. Dr Fisher learned that a drawing-master was required at the junior department of the Royal Military College and arranged for Constable to stay at Windsor before his interview with the Commandant, General Harcourt. He was offered the post. Constable returned to London with a few drawings of Windsor Castle and Eton College, beset with misgivings about the decision he had to make. He went to see Farington who said that no artist should work for money unless he had to; to teach drawing to boy soldiers

would harm his development as a painter. Sir George Beaumont, however, no doubt recalling that even J. M. W. Turner had been a drawing-master, urged him to accept. Still uncertain, and grappling now with conflicting advice from men he respected, Constable asked Benjamin West what he should do. The P.R.A.'s advice made certain that General Harcourt's young men would not have the benefit of tuition by John Constable. Turn it down, said West, or give up all hope of future distinction. The President also generously offered to smooth things over with Dr Fisher. Paraphrasing West, Constable wrote to Dunthorne on 29 May: 'Had I accepted the situation offered it would have been a death-blow to all my prospects of perfection in the Art I love.'

It was Benjamin West who gave Constable what he regarded as the best practical lesson on chiaroscuro that he had ever had. After one of his pictures was rejected by the Academy Constable called on the President with another of his paintings. 'Don't be disheartened young man,' said West, 'we shall hear of you again; you must have loved nature very much before you could have painted this.'

He then took a piece of chalk, and showed Constable how he might improve the chiaroscuro by some additional touches of light between the stems and branches of the trees, saying 'Always remember, Sir, that light and shadow *never stand still* . . . Whatever object you are painting, keep in mind its prevailing character rather than its accidental appearance (unless in the subject there is some peculiar reason for the latter), and never be content until you have transferred that to canvas. In your skies, for instance, always aim at *brightness*, although there are states of the atmosphere in which the sky itself is not bright. I do not mean that you are not to paint solemn or lowering skies, but even in the darkest effects there should be brightness. Your darks should look like the darks of silver, not of lead or of slate.'[13]

By 1802 Constable would have had few fears that he would be unable to earn his living by his art. He had good reason for buoyant confidence in himself for on the walls of the Royal Academy Exhibition at Somerset House hung, for the first time, a picture by John Constable. It was entitled *Landscape* but has not been identified. 'I have received considerable benefit from exhibiting—it shows me where I am, and in fact tells me what nobody else could.' He made a sober confession to Dunthorne.

For these few weeks past I beleive I have thought more seriously on my profession than at any other time of my life – that is, which is the

shurest way to real excellence. And this morning I am the more inclined
to mention the subject having just returned from a visit to Sir G. Beau-
mont's pictures.—I am returned with a deep conviction of the truth of
Sir Joshua Reynold's observation that 'there is no *easy* way of becoming a
good painter.' It can only be obtained by long contemplation and
incessant labour in the executive part.

And however one's mind may be elevated, and kept up to what is
excellent, by the works of the Great Masters – still Nature is the fountain's
head, the source from whence all originally must spring – and should an
artist continue his practice without referring to nature he must soon form
a *manner*, & be reduced to the same deplorable situation as the French
painter mentioned by Sir J. Reynolds, who told him that he had long
ceased to look at nature for she only put him out.

For these two years past I have been running after pictures and seeking
the truth at second-hand. I have not endeavoured to represent nature
with the same elevation of mind – but have neither endeavoured to make
my performance look as if really *executed* by other men.

I am come to a determination to make no idle visits this summer or
to give up my time to common place people. I shall shortly return to
Bergholt where I shall make some laborious studies from nature – and I
shall endeavour to get a pure and unaffected representation of the scenes
that may employ me with respect to colour particularly any thing else—
drawing I am pretty well master of.

There is little or nothing in the exhibition worth looking up to—there
is room enough for a natural painture. The great vice of the present day
is *bravura*, an attempt at something beyond truth. In endeavouring to do
something better than well they do what in reality is good for nothing.
Fashion always had, & will have its day—but *Truth* (in all things) only
will last & can have just claims on posterity.[14]

A few days later Constable took the coach to Suffolk, intent on
putting into practice the resolution that he had so ingenuously
presented to Dunthorne. In that summer of 1802 he produced the
first pictures which are recognizably 'Constables'. There is nothing
'second-hand' about the upright *Dedham Vale* in the Victoria and
Albert Museum, except perhaps its similarity in design to Sir George's
Hagar. This *Dedham Vale* must have been one of those pictures that
Constable had thought about 'before I had ever touched a pencil'.
It is one of the earliest illustrations of his attempt 'to get a pure and
unaffected representation' of nature.

The following year Constable experimented with marine painting.
The opportunity to do so arose through Captain Robert Torin, a
friend of his father's, who offered him a passage from London to
Deal in the East Indiaman *Coutts* which he commanded. Constable

joined the ship, which was bound for China, in April and sailed down the Thames to Gravesend; from there he visited Chatham and Rochester.

> Rochester Castle is one of the most romantic I ever saw. At Chatham I hired a boat to see the men of war, which are there in great numbers. I sketched the 'Victory' in three views. She was the flower of the flock, a three-decker of (some say) 112 guns. She looked very beautifull, fresh out of Dock and newly painted. When I saw her they were bending the sails – which circumstance, added to a very fine evening, made a charming effect. On my return to Rochester, I made a drawing of the Cathedral, which is in some parts very picturesque, and is of Saxon Architecture.[15]

After nearly a month he was put off at Deal in some confusion following stormy weather and left his drawings on board. His sketches – there were about one hundred and thirty – were eventually recovered. Constable subsequently regarded marine subjects as 'hackneyed', and his next sea pictures did not come until over twenty years later.

Constable was 'near a month on board' the *Coutts* and that month occupied most of April. As Constable's career advanced, early spring became the busiest period of his year as he rushed to finish his work for Somerset House. As there is no mention in his letters of frantic activity during the early months of 1803, he presumably sent his four exhibits to Somerset House before he departed on his voyage. Pictures had to be submitted by the first week of April, but varnishing – which with some painters amounted to repainting – could take place after a picture had been given the chalk mark of approval. Constable returned to London anxious to find out how well his pictures had been hung.

Although many years were to pass before a visitor to Somerset House would buy one of Constable's pictures, he himself, at the age of nearly twenty-seven, was in no doubt that he held within him the seeds of a considerable achievement. But there is not mere arrogance in his assertion to Dunthorne that 'I feel now, more than ever, a decided conviction that I shall some time or other make some good pictures. Pictures that shall be valuable to posterity, if I not reap the benefit of them. This hope, added to the great delight I find in the art, buoys me up, and makes me pursue it with ardour.' It is simply a characteristically fervent statement of intent in which he was to indulge only with those few friends to whom he could unburden himself without reserve. He never retreated from this deep-

seated belief in himself. Although his confidence was constantly undermined, we know, but he did not, that his belief in posterity was not misplaced.

Constable's belief in his own powers was unfortunately not shared by his father who remarked that he was 'pursuing a shadow'. Despite his misgivings Golding continued to give John his cautious support; it was probably his father who helped him to secure the small studio in Church Street, East Bergholt, which he began using in 1802. Golding seems never to have lost hope that John would return, if not to the mill, to the village. He found it difficult to believe that landscape art would ever provide a competence for his son. But portrait painting was almost as respectable a profession as those that he had shied from – the Church and his business. So Constable dutifully but reluctantly did the rounds of the ample citizens of Suffolk and North Essex: lifesize portraits – three guineas with hands, two guineas without. His situation was not unknown around East Bergholt and sitters offered themselves believing that not only were they helping the young painter, but at the same time they were making a courteous gesture towards his parents. At least he was earning and at the same time teaching himself to depict likenesses with accuracy, but as in his landscapes, he was happiest and most successful painting those he knew well or loved.

Among his early portrait work can be counted an altar-piece for Brantham Church near Manningtree, a commission which he began in 1805. *Christ Blessing the Children*, the first of his three essays in religious painting, is a composition of eight figures painted on mahogany in the style of Benjamin West, whose painting of the same subject hung in the Royal Academy. Mrs Constable was impressed by the picture; her well-to-do brother, David Pike Watts, was not. Constable had invited his uncle's comments on the altar-piece when it was still on his easel. As an orthodox churchman David Pike Watts was perturbed that the work was alien to his conception of religious painting:

The *mind* of the Picture has fled. It may be a more finished work of Art, but the Spirit, the Devotion the *Effect* is gone, at least the *Effect* on my eyes, like a portrait in its *free* state perfectly resembling the original and afterwards the Likeness partly lost by *finishing* . . . The soul of that Picture and which attached it to me was *Devotional Sentiment*. I see little of that Sentiment now in the Picture.[16]

David Pike Watts had become wealthy as the result of events

which many a nineteenth century novelist could have turned to account. Following his father into the trade of cooper, he became acquainted with Benjamin Kenton, a London wine-merchant with premises in the Minories. Pike Watts fell in love with his only daughter, but Kenton opposed the match. Miss Kenton died, so it was believed, because of this disappointment. After this tragedy the relationship between the rough-mannered Kenton and Pike Watts – once described by his sister, Mrs Constable, as a 'milk sop' – grew closer; during the last decade of the eighteenth century Pike Watts acted as manager for Ben Kenton's business. On his death in 1800 the wine-merchant left Pike Watts the bulk of his fortune which amounted to about £200 000.

At the age of forty-six David Pike Watts undertook the difficult task of establishing himself in a way of life which he felt his unexpected wealth now demanded. After obtaining a grant of arms in 1801 he tried the life of a country gentleman, establishing his seat at Storrs Hall, a large mansion overlooking Lake Windermere. Five years' residence during which he devoted himself to charitable works convinced him, a Londoner born and bred, that the role of squire was not one that he could play for the remainder of his life. He retreated to London and established himself in Portland Place in 1806.[17]

One of his acts of private charity was to urge his nephew to make an extended visit at his expense to his former home in the Lake District in 1806. Probably with no great enthusiasm. Constable took the north-bound coach towards the end of August.

At Storrs Hall he lived in a cottage in the grounds which was occupied by a Mr Worgan who had been employed by his uncle to distribute funds to the poor of the district. Among the wealthier residents of the area were the Hardens of Brathay Hall who had known and liked Constable's uncle. John Harden, a wealthy, jovial Irishman – to Constable he was 'composed of whip syllabub, and spruce beer' – with a talent for drawing, had married Jessy Allan, the daughter of an Edinburgh banker. She was also an artist, having been a pupil of Alexander Nasmyth and a friend of Sir Henry Raeburn.

The Hardens were far from being country bumpkins, for their chief pleasure was entertaining any artists who happened to be in the Lake District. And from what we know of the popularity of the Lakes amongst the romantic artists, Brathay Hall during the Hardens' occupancy could scarcely have known a time when it was

not harbouring a painter or a poet. Soon after she and her husband
had settled at Brathay in 1803, Jessy Harden began a diary which
she would send as an occasional newsletter to her sister in India.
Apart from recording the trivia of daily life in a wealthy artistic
household in the first decade of the nineteenth century, Jessy
Harden also reported on her numerous guests.

Constable makes his first appearance in Jessy's diary on 9 September when he accompanied her husband and a friend named Richard
Shannon on a day's sketching:

Mr. Constable who came with Richard from Worgan's went out with
John and him to sketch. He is the keenest at that employment I ever saw
& makes a very good hand of it. He is a nephew of Mr. Watts the late
proprietor of Storrs, but chose the profession of an Artist against the
inclination of his friends, at least so he says, & I don't doubt him. He is
a genteel handsome youth. On Tuesday Worgan came to us & has
remained ever since, so that we have had a pretty full house.

Constable seems to have moved to Brathay as a guest of the
Hardens during September, but sketching trips about the Lakes
were curbed by the weather. His hostess saw to it that he did not
remain unemployed:

Yesterday rained all day, so Mr. Constable got some oil colors &
painted a portrait of me which he executed wonderfully well considering
he was only 5 hours about it. He is a clever young man but I think
paints rather too much for effect.

The sitter was not enthusiastic about the finished work:

On Monday Constable finished my picture which is generally thought
like & tolerably well painted particularly on considering he was only 9
hours about it. Mrs. Hunter arrived in good time for dinner & also
Mr Gardner, a friend of Constable's. . . . We spent a very pleasant day,
Mr Gardner entertained us in the evening by singing to a guitar which
he accompanied himself with.[18]

Music was an important activity in a house which saw many
visitors. Gardner and his guitar would have been unusual musical
entertainment; Mr Worgan at the piano was the common fare.

At some time during his visit to the Lakes, Constable met Coleridge, Southey, and Wordsworth, but there is no evidence that
the encounters developed into friendship. At first, Constable was
unimpressed by Wordsworth, as Farington later noted:

Constable remarked upon the high opinion Wordsworth entertains of himself. He told Constable that while he was going to Hawkshead school, his mind was often so impressed with images so lost in extraordinary conceptions, that he was held by a wall not knowing but he was part of it.—He also desired a lady, Mrs Lloyd, near Windermere when Constable was present to notice the singular formation of his skull.—Coleridge remarked that this was the effect of intense thinking.—I observed to Constable if so, he must have thought in his mother's womb.[19]

Farington's waspishness was due to his belief that altogether too much fuss was being made of Wordsworth and Coleridge by Lady Beaumont among others. Constable, however, did not allow this first unfavourable impression to colour his subsequent judgement, and there is ample evidence that he developed a warm admiration for the work of both Coleridge and Wordsworth.

George Gardner, the son of Daniel Gardner by whom Constable had been painted in 1796, accompanied him when he set out to see more of the Lakes in mid-September. The tour lasted about three weeks in which Constable produced the bulk of the Lake District pictures which have survived. They show that, among other places, he saw Leathes Water, Keswick, the Vale of Newlands, Rosthwaite, Derwentwater, and Borrowdale. He applied himself with considerable energy and produced over thirty drawings in three weeks. It was more than enough for his companion who 'left his friend Constable in Borrowdale drawing away at no allowance . . .'

For all his application, the grandeur of the Lake District left Constable unmoved. He said later that the solitude of the landscape 'oppressed his spirits'. It was not that he was unimpressed by the magnificence of what he saw – he endorsed a drawing of Esk Hawse 'the finest scenery that ever was' – but that 'his mind was formed for the enjoyment of a different class of landscape'.

It was during his visit to the Lake District that Constable began annotating his sketches with the prevailing weather conditions. One of his drawings in Borrowdale, dated 25 September 1806, bears the inscription: 'Fine cloudy day, tone very mellow, like the mildest of Gaspar Poussin and Sir G. B. & on the whole deeper toned than this drawing.' Briefer and more typical inscriptions read: 'Evening after a fine day'; 'Evening after a shower'; 'Twylight after a very fine day.'

The leading London exhibitions of the next two years contained one or more of Constable's Lake District pictures and gained for him his first notice in the Press. Having seen *Bow Fell, Cumberland*

in the 1807 Academy Exhibition, the *St James's Chronicle* was moved to comment that 'this artist seems to pay great attention to nature and in this picture has produced a bold effect'. But the critic was 'not quite so well pleased with the colouring of No. 98, *Keswick Lake*, in which the mountains are described with too hard an outline'.[20]

In the following year, no doubt partly encouraged by the *St James's Chronicle*, Constable sent the *View in Westmorland* to the newly-formed British Institution. And in the spring the Somerset House Exhibition included *Windermere Lake, Borrowdale*, and *A Scene in Cumberland*.

In 1807 Lord Dysart, who knew of Constable even if he had not met him, gave him an onerous commission. Lord Dysart wanted several family paintings copied. This was the first act of a patronage which was to continue throughout Constable's life. The Earl of Dysart was not without ability as an artist himself, and he was a discerning collector who owned pictures by Gainsborough and Wilson. The commission required Constable to work at the Earl's London home at the Hyde Park end of Piccadilly from about the middle of August until well into November. He did not enjoy the close confinement or the 'fag of copying' because it precluded his usual summer visit to Suffolk and also adversely affected his health. It was probably as a result of working for Lord Dysart – the copies may have been for the Dowager Countess – that Constable met Lord Dysart's sister Lady Louisa Manners and a brother of the Dowager Countess, Henry Greswolde Lewis of Malvern Hall in Warwickshire, both of whom commissioned copies and original work from him during the next few years.

Commissions from the aristocracy signalled success both financial and professional to Golding Constable who now expressed himself reconciled to his son's vocation. He would also have been encouraged by reports from his brother-in-law that his son was 'Industrious in his profession, Temperate in Diet, plain in Dress, frugal in Expenses, sedulous in pursuit of science and in the progress of his Art, and in his professional character has great Merit.' Further evidence that his son was following his profession with a measure of prudence came later that year when Constable attended a dinner party arranged by David Pike Watts at which several distinguished members of the Royal Academy were present. His uncle was pursuing his aesthetic education by buying himself with bread and wine into intellectual and artistic London society. It is of course easy to mock

'D.P.W.' with his 'habitual reverence for rank and title', his belief that '*descent* is what money cannot purchase', and the pretensions of his social behaviour, but in including his nephew in this and other social occasions he combined self-interest with generosity to one whom he thought he and his fortune could benefit. The Constable family certainly regarded him as a benefactor whom it would be foolish to offend.

At half past three therefore on Saturday, 12 December 1807 there gathered at No. 33, Portland Place, the President of the Royal Academy, Mr Benjamin West, James Northcote, R.A., Thomas Daniell, R.A., Thomas Stothard, R.A., Anthony Carlisle, the surgeon, whose chief interest says Farington (also a guest) lay in himself, and Dr William Crotch, the 'celebrated Performer on the Organ and Piano Forte'. Also present was the host's elder son David, said to be a dissolute Army officer, who was to die of yellow fever only a few months later in Jamaica. The occasion began with a hefty meal in the late afternoon, followed by tea at nine o'clock, noyau and cake at ten, the guests dispersing an hour later.

The conversation covered a number of diverse topics: the P.R.A. spoke of a steam passenger boat that had been invented in his home country; Dr Crotch said that the last chorus of the *Messiah* was the noblest of all musical compositions. The host delivered to his guests the belief that men who had to do with money and accounts tended to succumb to mental deficiency.

Constable spoke of his contemporaries at the Academy, particularly David Wilkie, and the poets he had met in the Lake District. Farington and his fellow-guests pronounced themselves 'much pleased with the kind attention of Mr. Watts who was solicitous to oblige us. He expressed to me his knowledge of the notice I had taken of his nephew, Mr. Constable, and how sensible Constable was of my goodness'.[21]

Constable was not a clubbable man. Among his contemporaries, his friends were few. To Constable friendship was a serious relationship, not to be entered into casually. The few painters who could be properly described as friends are men, such as David Wilkie or John Jackson, whom he respected for their work and for themselves. For succour and encouragement he went principally to Farington and Sir George Beaumont, perhaps feeling that his confidences would be safer with older men who could not in any way be regarded as competitors. Dr Fisher continued to take a kindly but distant interest in his progress; and within the Academy,

he could count on the advice and encouragement of two senior Academicians, James Northcote and Thomas Stothard.

One of Constable's most attractive traits was his generosity towards others who achieved success and honours long before he did. Within a year or so of his arrival in London from Scotland in 1805, at the age of twenty, David Wilkie was producing accomplished works which were the talk of the artistic community and were soon in public demand. Wilkie became a Royal Academician at the early age of twenty-five to Constable's enthusiastic approval.

Constable would probably have liked John Jackson for his straightforward character, not unlike his own. Jackson was a Yorkshireman who was plucked from being a tailor's apprentice by Lord Mulgrave, on whose estate he lived, and sent to study the paintings at Castle Howard. Jackson came to the notice of Sir George Beaumont and he, Lord Mulgrave and others supported him when he came to London in 1804. Jackson generously introduced Wilkie to Sir George who before long commissioned Wilkie to paint *The Blind Fiddlers*. Beaumont had a reputation for sudden enthusiasms which could fade as quickly as they arose. Northcote remarked on hearing that Wilkie had joined Sir George's current clutch of favourites 'So, he is to have a ride in the Flying Coach this year.'[22]

Another of Sir George Beaumont's enthusiasms during the first decade of the nineteenth century was Benjamin Robert Haydon, a man of vastly different temperament from Wilkie, Jackson or Constable. During 1807 and 1808 Wilkie and Jackson spent much time with Haydon and were impressed by his ability and judgement. Constable, who was on the fringe of this trio, was alarmed that Haydon with his bombastic and authoritative manner was 'having a great influence over the mind of *Wilkie*, that the latter after every day's work is desirous to have Haydon's opinion of his proceeding & is affected by it accordingly as it is approval or the reverse'. Constable observed to Wilkie that 'if he continued to do so he would at last come to paint from Haydon's mind rather than from his own'. That Constable as a young man was possessed of a marked sense of self-esteem is illustrated in an exchange he had with Haydon in May 1808: 'Haydon asked him "Why he was so anxious about what he was doing in art."—"Think," said he [Constable], "what I am doing," meaning how much greater the object & the effort.'[23]

By 1809 Haydon was in the 'Flying Coach' and Constable somewhat petulantly reported to Farington that 'Haydon is now Sir George's *Hero*, who is with him every day.' Constable, who could

claim the longest acquaintance with the common patron, had to be satisfied with Sir George's hospitality, his well-intended reactionary criticism, and the run of his London house to copy his pictures.*

During the next few years Haydon managed to alienate most of his friends and patrons. Constable, perhaps no more than an acquaintance of Haydon, fell first. Haydon, furious that his vast canvas *Dentatus* had not been hung in the principal room at Somerset House in the 1809 exhibition, was even more ready than usual to take offence at the slightest provocation. Farington recorded the substance of Haydon's complaint: 'Constable shewed me a letter from Haydon dated April 9th, 1809 accusing him of having said to Northcote, that he, Haydon, had been warned by him [Constable] not to ridicule the *ladder* by which *he had ascended*, meaning Jackson. —The letter concluded, "That he was *mad* at having allowed Constable to have wound himself into his acquaintance".'24

Soon afterwards Haydon accused Wilkie of disloyalty 'for not having spoken more warmly of his picture now in the Exhibition.— Lord Mulgrave has recommended to Wilkie to advise Haydon to leave off his habit of swearing; and Sir G. Beaumont has done the same & also wished him not to put himself forward in such a manner as to give offence to artists his seniors'.25 Later that year Haydon suffered a nervous breakdown, but was nevertheless helped to recovery by Wilkie and Beaumont who both provided him with recuperative holidays. Although Haydon's letter effectively ended their acquaintance, Constable, no doubt in common with many others, continued to monitor his erratic behaviour which provided Somerset House with a source of gossip for the next thirty years.

By 1809 Constable had been in London for ten years. He was thirty-three. It had been a period of unremitting work; he must have felt that nothing must be allowed to delay his attainment of the technical knowledge that his fellow-painters appeared to possess. Although his formal training had ended a few years earlier, he continued a self-imposed education. A less resolute man might have begun to question the wisdom of continuing with a career that demanded so much and appeared to promise so little. But Constable retained his confidence in himself, despite his frequent anxieties, as he saw his contemporaries – and his juniors – achieve the professional and financial success that was being denied him. He had yet to sell a picture to 'a stranger'. As time went on, the unsolicited

*They included Rubens' *Le Château de Steen* which Sir George had acquired in 1803.

approach from anyone interested in owning his work – there were not many – took on an almost mystic significance.

Constable's single-minded concentration on achieving 'execution' did not prohibit him seeking recognition from the Academic body. But he had seen or would soon see Augustus Wall Callcott, A. E. Chalon, Thomas Daniell, George Dawe, William Owen, Thomas Phillips, Robert Smirke, Henry Thomson, James Ward and David Wilkie all achieve Associate status long before he did. His first attempt, made on Farington's recommendation in 1809, was not successful. By contrast, Turner, a year younger than Constable, was made A.R.A. in 1799 at the age of twenty-four, the youngest permitted age, and became an Academician only three years later.

The probable reason for Constable's lack of Academic recognition was that he had become a diffident but determined rebel. Life for rebels, even quiet ones, is always uncomfortable; only uncommon men become and remain rebels. The life of a well-to-do country merchant, who painted pictures of his mills and the surrounding country when the fancy took him, could have been his without the exertion of any appreciable effort. But he had decided to become an original when landscape painting was considered inferior to history pictures or even portraits. Only those works, purporting to be landscape, which contained a classical nude or an historical figure, often placed woodenly amongst the drabness of the vegetation, were taken seriously; it was a compromise that allowed critics, connoisseurs, and Academicians to believe that they were not bestowing their interest or approval upon frivolous work. It was unthinkable that Constable should tailor his approach to the prevailing fashion. 'Whatever may be thought of my art', he wrote later, 'it is my own. And I would rather possess a freehold though but a cottage than live in a castle belonging to another.'[26]

3

1809-1812

Dear Miss
Bicknell

Constable's first ten years in London were characterized by an almost desperate application to what he regarded as his vocation. They were lonely years not because Constable was an unattractive person – there is much evidence to the contrary – but because his self-disciplined dedication to his calling would have repelled intimacy with all but the most determined. No one had been brave enough to take on this cautious, hard-working and rather private East Anglian who probably made no secret of his distaste for 'common-place people'. And, search as we may, there is no evidence that he sought comfort or encouragement from the opposite sex outside his own family; it is quite probable that in Constable's eyes his mother with her strong, sensible character, her sympathetic encouragement – despite her frequent chivvying – stood head and shoulders above any woman he had met. Soon, however, two people were to enter Constable's rather self-contained life. One became his wife, the other his closest friend.

Maria Elizabeth Bicknell was the grand-daughter of the Rector of East Bergholt, the Reverend Doctor Durand Rhudde. Constable had known of her existence for some years. In 1800, when Maria was twelve years old, he had met her for the first time, probably

during the Christmas holiday which she was spending at the Rectory. For the next few years they would have met only on the rare occasions that their visits to East Bergholt happened to coincide. No evidence exists to suggest that Constable marked out Maria as a possible mate at the age of twelve and then patiently waited for her to attain womanhood or that the adolescent Maria dreamed of one day marrying the miller's son.

In 1809, the year in which Maria attained her majority, Constable was thirty-three. For a man who had not until this time formed any serious female attachment it was a memorable year. It was, as he wrote later, at East Bergholt in 1809 that he first avowed his love for Maria. 'It is gratifying to me to think that the scenes of my boyish days should have witnessed by far the most affecting event of my life.'[1] And it is infinitely poignant to learn that the letter in which he writes with the urgency and passion of a man half his age that 'never will I marry in this world if I marry not you' is dated 27 February 1816, a few months before his fortieth birthday.

Maria came from a family of lawyers. Her father, Charles Bicknell, after an education at Charterhouse School, subsequently became Solicitor to the Admiralty and Navy, to the Prince Regent, and to his youngest sister, the Princess Amelia. He seems to have had a talent for getting himself appointed to what seem to have been undemanding posts: during the incapacity of George III he was one of a committee of three charged with administering the Royal parks and forests; he was also variously Commissioner of Bankrupts, Deputy Bailiff of the City and Liberty of Westminster, and treasurer of the Society for the Propagation of the Gospel in Foreign Parts.

By his first marriage Charles Bicknell had three children, the second of whom, as Mrs Skey, was much admired by Constable who met her in 1811. His second marriage to Maria Elizabeth Rhudde produced, firstly, Maria Elizabeth on 15 January 1788, followed by two sons, Durand and Samuel, and two daughters, Louisa and Catherine.

In that summer of 1809, John Constable began his courtly wooing of the Rector's grand-daughter, no doubt under the curious eyes of villagers eager to see the outcome of his suit: Trade tangling with the Church was always worth watching. Their meetings had necessarily to take place openly, for any hint of the clandestine would have brought down the considerable wrath of Doctor Rhudde rather sooner than it did in fact descend. For them there could be no dancing the 'light fantastic toe' in the houses of friends and

D

relatives. John and Maria had to be satisfied with the occasional walk together; on Sundays they no doubt exchanged restrained pleasantries after Dr Rhudde's ministrations. It was a decorous beginning. And so it was to continue. Three years later Constable reminded Maria that 'from the window where I am writing I see all those sweet feilds where we have passed so many happy hours together.'

Mrs Constable attempted to stage-manage the developing relationship from East Bergholt. She invited Maria and her sisters to tea, and she passed on any intelligence that might contribute to the success of her son's courtship. She recognized that he drew much strength from his family and particularly from her, but she was unselfishly anxious that his filial attachment should eventually be diverted to a love of his own choice, preferably one of which she could approve. Mrs Constable approved wholeheartedly of Maria Bicknell. She did not doubt that Maria would make him a good wife: she was young, but appeared to be sensible beyond her years, and she came from a family of the highest respectability. For John Constable, descended from merchants on both sides of his family, to marry the Rector's grand-daughter was an alliance which would enable the painter's family to make a considerable social advance. But caution and energy must ever be his watchwords: 'You must exert yourself if you feel a desire to be independent – and you must also be wary how you engage in uniting yourself with a house mate, as well in more serious and irrevocable yokes.'[2]

Early in 1810, Constable decided that the time had come for him to show that his interest in Maria was both serious and honourable by calling upon her parents at their house in Spring Garden Terrace, a street behind the Admiralty in Whitehall. The house, the inside of which Constable was to come to know during the next few years rather less well than the outside, had been the Bicknells' London home since 1802. His early visits appear to have been agreeable occasions because from the first he was accepted; he was far from being a 'coming man' – quite the opposite – but he was personable; and, most important of all in the eyes of Mr Bicknell, no objections had been raised by his father-in-law Dr Rhudde, a man whom he was careful not to cross. Later, Constable recalled that 'there was a time when your father would not have passed my door but was calling on me with you on his hand, and inviting me to his house when he knew of our mutual attachment'.[3]

In March 1810 Constable was living in rooms in Percy Street, but in April he moved to 49, Frith Street. One of the works in progress that would have been moved to the new rooms was an unfinished altar-piece he was painting for Nayland Church. It had been commissioned by his Aunt Patty Smith who promised to pay him in her will.* Urged on to complete the painting by his mother, naturally anxious that no son of hers claiming to be a painter should be seen to be unable to fulfil a commission, Constable nevertheless did not find the strength, or more probably the inclination, to work on the painting seriously until the end of May. Mrs Constable was enough aware of her son's character to keep up the pressure: the hope expressed in April that he would 'soon have leisure and desire' for the Nayland work was succeeded in May by the hope that he would find 'time and inclination' for it. By 2 June she was able to write: 'I rejoice to hear you have begun your Altar piece and have no doubt it will give satisfaction *to all parties*.'

Constable at first wanted to depict the *Agony on the Mount of Olives*, but was persuaded by his mother and David Pike Watts, to portray 'Christ Blessing the Bread and Wine' on the grounds that 'adoration was more becoming our Saviour than humiliation'. Mrs Constable urged her son

to make it a Capital Picture, one that I hope will fix your fame. Whenever you begin a work with zeal, you have always succeeded.

Energy and good temper gives a grand finale to *your* pictures. When you fag at your work, it never pleases either the performer or the beholders. Finish therefore well & as soon as you can—& then come to Bergholt, & let us injoy friendly converse without offence either given or taken where none is intended.[4]

At its installation at Nayland in 1810 the work came under the critical eye of 'D.P.W.' who, from his passing acquaintance with leading painters of the day, felt qualified to give his nephew the benefit of his considered comments. He stood in the church on a cold November day and contemplated the painting for 'above an hour' and was enough exercised by it to write immediately from his sister's house in East Bergholt to the painter in London.

He found twenty-five points on which to offer the 'poor opinions' of a 'mere Observer'. First, he was uncertain whether the figure

*Constable's aunt kept her word and left her nephew £400. The work is still in Nayland Church, Suffolk.

was standing or sitting. He would have liked to have seen a 'Ray of Celestial Light shining from the upper line of the Picture to which the Eyes of the Saviour are directed'. Next, the physical characteristics of the figure, which he alleged was a portrait of Constable's elder brother, Golding: the Head was 'too *round*; a more Oval form is usually impressive of the historic character of the Divine original'. The face was too small and too flat, the eyes were too large, the beard was poorly drawn, the lips were too pale, the neck was disproportionate to the head, the shoulders were too sloping. The clothing could do with some improvement: the 'Outer Garment' did not correspond to the natural formation of the arm and elbow; a trifling amendment to the Scarlet Mantle, which was 'admirably folded and painted', would 'have prevented the appearance of the cloth being "cut from the piece" '. David Pike Watts could not perhaps conceive of an Almighty who did not have the good taste to employ a competent tailor. Hygiene was also his concern for the 'Bread appears at first sight *Half a Loaf* and looks manifestly as if the cut side was downwards and is objectionable on that account'. However, 'D.P.W.' acknowledged that he had 'boldly and frankly (too bold and too frank) given my simple and unskill'd observations. I repeat my first declaration that with all these minute and captious exceptions, as a *whole* it is a fine Work, correspondent to the Subject and to the Place, and is justly entitled to commendation – as it confers considerable Credit on the Artist.'[5]

Pike Watts' view that the picture was unfinished was shared by his sister. But Mrs Constable was to admit a year or so later, after seeing West's *Christ Healing the Sick*, that 'your Brantham Altar piece is much more delightful in my eyes — and my thoughts on the subject.' And having learned that West had been paid a considerable sum for his work Mrs Constable could 'perceive no cause or just impediment that you should not in due time with diligence and attention, be the performer of a Picture worth £3000'.[6]

Constable spent Easter with the Gubbins family at Epsom. They were a prosperous Surrey family headed by James Gubbins who had married Mrs Constable's sister Mary. A surveyor in London at a time when the capital was expanding, James Gubbins after several successful building ventures had retired to Epsom at a comparatively early age. He and his wife had surmounted the horrifying experience of seeing not one of their first six children survive infancy. Of their four subsequent children only three were to complete a normal life span; their eldest son James, whose ruffled

shirts were copied by Mrs Constable to keep John in the latest fashion, fell at Waterloo. The Gubbinses who were more in touch with metropolitan life than was possible for the Constables down in Suffolk, took a close interest in the career of their relative. And perhaps suspecting that a modest man might be keeping his parents in ignorance of his successes they diligently monitored the journals:

I find from your Aunt Gubbins there are more encomiums on *our* artist in the Magazine for last month, called the *Repository of Arts, Literature, &c, &c*.[7]

This journal, reviewing the Royal Academy exhibition of that year (1810), found Constable's *Landscape* 'a fresh and spirited view of an enclosed fishpond – a very masterly performance'. One of Constable's two contributions to the Exhibition was bought by Lord Dysart. The identity of the purchaser suggests that he bought the picture commended by the critic which was almost certainly one of Constable's first versions of *Helmingham Dell*. Constable, although pleased to have made a sale, must at the same time have been disappointed that his work had yet to find favour with a stranger; there could have been no sweeter accolade than that someone quite unknown to him should have chosen to buy one of his pictures from amongst the many that hung on the walls of the Academy. For that distinction he would have to wait two more years. Constable confided in Farington that his father doubted the wisdom of giving his best years to art. With a hurtfulness surely unintentional in such a kindly-disposed man as Golding Constable, he observed that what little employment he had obtained he owed to the kindness of friends. Constable's father was particularly gloomy about his prospects as he had recently learned that his son was in debt; it seems that a few bills were 'too long unpaid'.

In the early years of his career Constable normally spent from late spring until late autumn sketching in Suffolk and the rest of the year preparing his Academy work. Despite prods from his mother that nothing should delay her son's 'studys from nature's beauty abroad', he did not begin his open air sketching until summer was almost over. But 1810 was not a normal year, for Miss Bicknell became a factor to be considered as well as the seasons.

If Miss Bicknell had to be considered so did her grandfather, the formidable Dr Rhudde. To the parishioners of East Bergholt, Great Wenham and Brantham, the Rector was a man of unassailable power, invested as he was with the authority of the Established

Church. He was also rich and he was unafraid of displaying it. He headed a generous table in a rectory tended by numerous servants; he travelled in some comfort conveyed in his own coach drawn by his own horses; he spent his summers by the sea in Norfolk and he maintained a London house in Stratton Street. The Doctor's wealth was however acquired as a result of orthodox devolution and not through the chicanery of which churchmen at that time were generally believed to be capable.

Durand Rhudde was the son of John Rhudde of Dorset, a man 'of a very singular and eccentric turn of mind'. Born into a Baptist family John Rhudde defected to the Unitarians, eventually becoming a priest of the Established Church. For a short period he was a ship's chaplain in the West Indies and then a Rector in Jamaica. In 1733 he married a Mary Silly in London by whom he had three children, Durand, Anthony and Deborah.

After an education at Merchant Taylor's School and King's College, Cambridge, where he was a poor scholar, Durand Rhudde, like his father, opted for the Church. Unlike him he suffered no confusion about the direction of his worship. Livings in Kent and London preceded those he acquired in Suffolk in 1782. After being awarded his Doctorate of Divinity in 1789 Dr Rhudde was appointed a chaplain in ordinary to King George III. Of Dr Rhudde's wife Mary almost nothing is known other than that she was four years younger than her husband by whom she had two children, Maria (Mrs Bicknell) and Harriet; in 1795 Harriet married a wealthy Leicestershire landowner, Edward Farnham.

The three livings at East Bergholt, Brantham and Great Wenham would have yielded about £1300 a year in addition to a free house and perquisites. This was a considerable income and would have enabled Dr Rhudde and his family to live comfortably. It was his sister Deborah's husband whom the Rector could thank for the inheritance he seemed determined to protect.

In 1775 Deborah Rhudde had married William Maurice Bogdani who owned properties in Hertfordshire and Suffolk. He died in 1790 and left his Suffolk land and property for life to his brother-in-law Durand Rhudde; Deborah had died four years earlier. On his death the properties were to go first to the Rector's daughters in turn for life; first, Mrs Bicknell, then Harriet Farnham. On the latter's death the 'heirs of the body' of Mrs Bicknell were to succeed. It was therefore possible that Dr Rhudde's grand-daughter Maria might succeed to the properties on which he relied for his consider-

able affluence. Dr Rhudde must have felt that he had a right to approve or disapprove Maria's future husband.*

He knew Constable as a God-fearing member of a family of some piety. He had seen him grow up to become a 'fine handsome man'; no one disputed that, not even the Doctor. Indeed, Dr Rhudde later conceded that he had no objection to Constable 'as a man', but he certainly was not much of a prospect. For a man in his mid-thirties he had achieved neither riches nor advancement; his chosen profession was not that of a gentleman; he owned no property; his income was paltry; his expectations were not encouraging. Inexplicably, he seemed reluctant to augment his funds by painting portraits. Altogether, to a superficial or uninformed observer, John Constable seemed to be heading for ignominious failure. For his grand-daughter to bind herself to such a man was not an alliance of which he could approve.

Largely because Mrs Constable was a diplomat, seeing no weakness in appeasement if it might lead to the eventual happiness of her son, relations with the Reverend Doctor, though always formal, never broke down. 'Do not think I am an advocate for servility, believe me not', Mrs Constable wrote. 'It is civility *only* I plead you.' Although Golding Constable and Dr Rhudde had fallen out over some trifle during 1809 the breach seemed to be healed by the following year. Mrs Constable had an opportunity to test the Doctor's attitude in July 1810 when after a visit to Patty Whalley in London she was given a lift home to Suffolk in the Rector's 'chariot':

The Doctor was all that courtesy or kindness could urge him to – and on our parting, he said, 'he usually slept the chief of the journey, but now had not so much as once shut his eyes, so agreeably & pleasantly had the time passed, & truly happy he was to have accommodated me.' How far preferable this to animosity—thank God, that seems to have ceased—never more to return—for I earnestly for the remnant of my life wish to be in peace with all.[8]

The Rector even carried Mrs Constable's letters to London, thereby saving postal charges, at that time paid by the recipient. But only eighteen months later Mrs Constable was writing that 'altho he smiles and bows to us, yet something still *rankles* at his

*For this information I am indebted to 'The Rhudde Family' by Leslie Dow, Appendix D *John Constable's Discourses*, Suffolk Records Society, 1970.

heart, which I trust will never burst out whilst I live; — I will at least be cautious to avoid it.'[9]

At the beginning of 1811 Mrs Constable decided that simply insisting that all members of the family should be punctilious towards Dr Rhudde was not in any way softening the Rector's attitude towards John. She therefore asked him to copy one of his drawings of East Bergholt church 'as a present from you to Dr. Rhudde — it is what he so much wishes for'. He fell in with his mother's plan and towards the end of February the drawing was presented to the old Rector. It was inscribed by John Dunthorne – although his contribution was probably not advertised to the Rector:

A South East view of East Bergholt Church, a drawing by John Constable & presented in testimony of respect to Durand Rhudde D.D., the Rector.
Feb. 26, 1811.[10]

Mrs Constable was overjoyed at the reception of her gift. Dr Rhudde declared that he was proud to own such a beautiful drawing. ' "How can I possibly make you (some return) Mrs. Constable; – I cannot imagine." I told him the (amends) was in his very gracious reception.'[11] But the Rector, learning that the gift came from Mrs Constable's son, wrote him a formal letter of thanks in which he enclosed a banknote suggesting that it be used to buy 'some little article by which you may be reminded of me, when I am no more'.[12]

It was unfortunate for Constable that a number of factors were combining to upset the ordered life of the Rectory. Dr Rhudde was beginning to complain of rheumatism while it was apparent that his wife, who had been an invalid for some time, would not see out the year. Mrs Constable was as usual well supplied with intelligence of affairs at the Rectory. Her source, indeed that for the entire village, was an indiscreet servant of Dr Rhudde, one Thomas. It was Mr Travis, the village 'surgeon', who was first favoured with Thomas's information. Travis edited and embellished it and almost certainly erred on the side of drama in relaying it. Thus, Mrs Constable for one knew that Mrs Rhudde was 'lamentably weak' and that her mind was giving way to such an extent that once she refused all food for two or three days in the belief that the 'Bicknells were below *poisoning* everything she should eat'.

In March 1811 Mrs Rhudde died at a time when her eldest grandson Durand Bicknell was lying ill in London, suffering from an ailment 'beyond the power of medicine'. It seems to have been

tuberculosis to which the young man, not yet twenty, succumbed in the following month. The loss of a grandmother and brother within the month would not have left Maria unmoved, and to help her overcome her grief, perhaps also to separate her from her admirer, it was decided that she should spend some time with her step-sister Mrs Skey at Spring Grove, her house at Bewdley in Worcestershire.

After a brief visit to the Gubbinses at Epsom, Constable returned to a London that held few attractions for him. He set about finishing his pictures for that year's Academy exhibition. Constable exhibited *Twilight* and *Dedham Vale: Morning* at the Academy in 1811. *Dedham Vale* is a calm evocation of country life. This serene picture furnishes not one scrap of evidence that the mind of the man who painted it was in turmoil, grappling as it was with the almost continuous lack of progress in both his professional and his private life. Constable's unhappiness was apparent to David Pike Watts who, on his nephew's thirty-fifth birthday, was inspired to send him a homily.

I am sorry to see too visible Traits in your whole person, of an inward anxiety, which irritates your nervous system and in its effects doubtless deranges the digestion & secretions, vitiates the Blood, and undermines the Health.

But Health alone, that valuable possession, is not the *sole* thing impair'd; the *mental* powers are liable to participate in the depressions of the animal system; – it is not in the human faculty of even your nearest Friend, to see into the secret cause of the operations of the Mind, but a tolerable opinion may be formed of what passes within the Thoughts of another Person by certain *external* Traits.

The conclusion to be drawn from this remark is that your Indisposition arises from more than *one* cause, though *one* has of late been predominant; and has become the *Major Trouble* which absorbs the minor one's; and resolves all the subordinate cares into *one* overwhelming Solicitude—and *this* is a deep Concern of the Heart and Affections.[13]

The cure for his nephew's ailment lay in prayer. 'D.P.W.' seems genuinely to have wanted to help Constable overcome his private and his professional difficulties rightly believing the two to be connected. And he probably recalled vividly and painfully his own love for Ben Kenton's daughter and its tragic severance. He would also at this time have been recovering from the loss of his younger son Michael, an Ensign in the Coldstream Guards, who had been killed in battle at Barrosa in March. And his daughter Mary was soon to be married to Jesse Russell, the son of a wealthy soap maker;

her new home would be far from London, at Ilam Hall in Stafford-
shire. The diagnosis of Constable's troubles although frank was
also substantially correct, but another letter from the same hand
on the following day was probably more galling:

I sometimes wish you had copied more; and that at an early age you
had put yourself under a great master.

That dread of being a mannerist, and that desire of being an original,
has not, in my imperfect judgement, produced to you the full advantage
you promised yourself from it. As far as my unqualified, and simply
native taste extends (which I acknowledge to be very inadequate to form
a correct judgement), I had rather see some of the manner of those
highly extolled works, which have commanded the applause of the public
at large, from the perfect connoisseur down to the simple spectator.

I have before taken the freedom to offer my sentiments to you; you
have before paid me the compliment to ask and receive them. I have no
motive in my observations but your good, or what I conceive to be so,
joined to a regard to truth, and an aversion to flattery. My opinion is,
that cheerfulness is wanted in your landscapes; they are tinctured with
a sombre darkness. If I may say so, the trees are not green, but black;
the water is not lucid, but overshadowed; an air of melancholy is cast
over the scene, instead of hilarity. . . .[14]

His Academy offerings for that year having met with the indiffer-
ence to which he was accustomed, Constable retreated for a few
weeks to Suffolk. He produced a sketch in oils of the fair that was
held in the village every July, but he was soon back in London
nursing the hope that Maria might have returned from the Midlands.
But he was disappointed and returned to Suffolk and continued
working in and around the village.

In the autumn Constable travelled west to fulfil a longstanding
invitation from the Bishop of Salisbury, as Dr Fisher had now become,
to stay with him in the Cathedral Close. Mrs Fisher was fond of
Constable and had remarked to Farington that he resembled one
of the young figures in the works of Raphael and that his appearance
was that 'of one guileless'. The visit gave birth to the most important
friendship of Constable's life. In Archdeacon John Fisher, the
Bishop's nephew, Constable acquired as loyal a friend as any man
could wish for. John Fisher was twelve years younger than Constable.
Their backgrounds were very different. Fisher, the eldest child of
the Bishop's brother, Dr Philip Fisher, came of stock that regarded
the ancient universities and the high offices of the Established Church
as its natural habitat. The son of a former Oxford don, the nephew

of a former Cambridge don, Fisher was educated at Charterhouse, where his father was Master, and Christ's College, Cambridge. In 1810 he was ordained by his uncle who appointed him to the Cathedral Deaconry. Fisher was not destined to have such a glittering intellectual or professional career as either his father or his uncle, but as Constable's most intimate friend his contribution to the development of his art is incalculable.

Constable and the Archdeacon, who was also an amateur painter, passed their time in walking and talking about 'the art'. There were visits to local families with artistic interests, including Stourhead, the home of the banker Sir Richard Colt Hoare; like Turner, and many other artists before and after him, Constable sketched the Italianate gardens which Sir Richard had laid out in the style of a Claude landscape. The vacation did not altogether allay the dejection that he had brought with him from London. 'I did not however do so much as I might when there. I was not in the humour, to avail myself of the many interesting plans which the Bishop and Mrs. Fisher proposed to me.'[15] He did, however, make a number of pencil and chalk sketches of the Cathedral which would later be used as the basis of the larger Salisbury pictures. Constable's distaste for portrait painting was either unknown or overlooked by the Bishop who commissioned his friend to paint him. It was not long before Constable learned that 'D.P.W.', who was acquainted with the Bishop, did 'not only look for mere likeness in the Portrait of a Prelate, but the combined traits of Religion, Learning, Manner and especially in the Bishop of Salisbury, Goodness so congenial to his Nature'.[16]

At the beginning of October 1811 Constable took leave of the Close and returned once again to an empty London. Wrongly believing Maria to have returned from Worcestershire he called at Spring Garden Terrace, but he knocked upon an unyielding front door. After twice receiving no reply he returned to his rooms in Frith Street, angry at the unfairness of a world which continued to deny him so much. Opening his letter 'Dear Miss Bicknell', the only form that would have been acceptable, he plunged straight in:

Am I asking for that which is impossible when I request a few lines from you? – I have called twice at your house since the return of your family from Worcestershire, without being so fortunate as to see any body. I much wish to see Suffolk again before the season is quite gone & I should leave London with far less anxiety could I hear from yourself that you are well. I can hardly call again in Spring Gardens.[17]

Three days later, on 26 October, Miss Bicknell sent her considered reply from Spring Grove:

Accept my grateful thanks, dear Sir, for your enquiries after me. I cannot with truth say I am Hygeia herself, but I am far better than when I last had the pleasure of seeing you. I am delighted to think you have spent your time so agreeably in Salisbury, kindness will win its way to the heart, the excursion to Stourhead must have greatly added to your enjoyment, I have always heard it named as the most beautiful spot.

After an absence of some months I felt particularly happy in the company of dear Mamma, who was here six weeks. You are fully aware of the constant uneasiness I have caused her, but you know not the grief I feel when I distress her, let me beg and entreat you to think of me no more but as one who will ever esteem you as a friend. I am confident it will hurt your feelings as much as it has done mine, but the sooner we accustom ourselves to what is inevitable the better, I am blessed with the kindest the most affectionate of Parents, can I wilfully make them unhappy?[18]

From this sober letter Constable could deduce that Maria too had been suffering from the enforced separation of the past few months, but it gave him no encouragement that she would ever rebel against the parental yoke. On 29 October he took up his pen again. 'Dear Miss Bicknell' in faraway Worcestershire must have trembled to read such a robust commitment:

Much indeed must I congratulate myself on having loved you, when I see you exerting those high principles of duty on the behalf of your excellent parents—and with these sentiments it is impossible for me to think for a moment of relinquishing every hope of our future union, however unfavourable any prospects may be at present. . . .

Do therefore soon let me hear from you again—and tell me that your own sentiments are not altered.[19]

On the last day of October Constable called again at Spring Garden Terrace and was admitted. He left the house having made a significant advance. It seems probable that he sought Mr Bicknell's formal permission to marry Maria, but he, loathing haste in his lawyer-like way, would have refused it without first ascertaining Maria's views and reflecting on his own. But to indicate that the approach was far from rejected outright he gave his permission for their letters to continue. Down in East Bergholt, Mrs Constable was full of conjecture:

Now my dear Son—what can this mean! and what may be augured

from this! I pray it may be favourable for you & all—they are too good and too honorable to trifle with you, or your feelings—therefore I am inclined to hope for the best, and that all will end well, and to the mutual comfort of all. Perhaps I am too buoyant—what ought I to think or do—indeed I am in a great straight. My maternal anxiety is almost overpowering me.[20]

Encouraged by this relaxation of what was assumed to be Mr Bicknell's implacable opposition to any consideration of their marriage the couple, enjoying at a distance a euphoric few days, took to their writing tables:

I am very impatient as you may imagine to hear from Papa on a subject so fraught with interest to us both. . . . I hope you will not find that your kind partiality to me made you view what passed in Spring Gardens too favourably, you know my sentiments, I shall be guided by my Father in every respect.
Should he acquiesce in my wishes I shall be happier than I can express, if not, I shall have the consolation of reflecting that I am doing my duty, a charm that will stifle every regret and in the end give the greatest satisfaction to my mind.[21]

Constable, for his part, was certain that he had not read too much into his reception at Spring Garden Terrace, but his optimism courted disappointment. Maria, very much her father's daughter, conveyed his judgement to a disappointed suitor in London:

I have received my Father's letter, it is precisely such a one as I expected, reasonable and kind. His only objection would be on the score of that necessary article, Cash, what can we do? To live without it is impossible, it would be involving ourselves in misery instead of felicity, could we but find this golden treasure we might yet be happy, you say it is not impossible.
I wish I had it, but wishes are vain – we must be wise, and leave off a correspondence that is not calculated to make us think less of each other, we have many painful trials required of us in this life, and we must learn to bear them with resignation.
You will still be my friend, and I will be yours, then as such let me advise you to go into Suffolk, you cannot fail of being better there. I have written to Papa, though I do not in conscience think he can retract anything he has said. If so, I had better not write to you any more, at least *till I can coin*, we should both of us be bad subjects for poverty, should we not? Even Painting would go on badly, it could not survive in domestic worry.[22]

By the end of the year Constable had moved to 'excellent rooms,

above an upholsterer's shop at 63, Charlotte Street' – nearly opposite Farington – and from there he wrote to Maria in December:

I am endeavouring to settle myself as much as possible to my profession, as I am convinced that nothing so much as employment will keep the mind from preying upon itself – especially an employment which takes up the attention so much as painting does, as it is our duty to make every manly exertion.

I trust that I may expect the greatest good to be the result of this – advancement in the art I love, and more deserving of you. To one who is so much alone as I am I know the struggle will be great, but I look with confidence to the happiness of your correspondence to support me in it – which, next to your society, can alone afford me consolation. I again mention it to you – I know of no obstacle to an unreserved correspondence between us.[23]

Maria, still in Worcestershire, replied with a dismal recital of filial loyalty:

You grieve and surprize me by continuing so sanguine on a subject altogether hopeless. I cannot endure that you should harbour an idea that must terminate in disappointment. I never can consent to act in opposition to the wishes of my Father, how then can I continue a correspondence wholly disapproved by him? He tells me too that I am consulting your happiness, as well as my own, by putting an end to it.

Then let me beg and intreat that you will cease to think of me, forget that you have ever known me, and I will willingly resign even all pretensions to your regard, or even acquaintance, to facilitate the tranquility and peace of mind which is so essential to your advancing success in a profession, which will ever in itself be a source of continued delight. You must be certain that you cannot write without increasing feelings that must be entirely suppressed. You will therefore I am sure see the impropriety of sending me any more letters.[24]

To be told by Mr Bicknell not to write to his daughter might have been difficult to disregard. But this was not Mr Bicknell suggesting an end to their association, but Maria herself. Out of the window went the careful manoeuvrings, the wary treading amongst the thistles of polite society. A few days before Christmas Constable boarded the mail coach to Worcester. From there he made his way to Bewdley and presented himself at Spring Grove. Fortunately, the mistress of Spring Grove was Sarah Skey, Charles Bicknell's second child by his first wife. She, apart from showing great affection for her younger step-sister, was to strengthen Maria's

resolve to obey the dictates of her heart. Maria forgave him for his impetuosity and the couple spent a rainy weekend together.

I may now say that some of the happiest hours of my life were passed at Spring-Grove—mixed as they were with moments of utterable sadness. Nor could it be otherwise when I reflected that you who might, & who deserved to have been entirely happy, I had taken pains to render not so—and had implanted in your excellent mind a source of sorrow to your worthy parents.

But I congratulate you on being with Mrs Skey—it was in the highest degree gratifying to me to see you enjoying that calm, which her domestic circle and more especially her friendship and society seemed so much calculated to impart. I was happy to see you possessing many sources of amusement, for I too well know the effect that hours of desponding have upon the health not to see the necessity of making every exertion for the present—'till it shall please providence to bring us together—which must be sooner or later, for I shall think that I am leaving this world when I think for a moment to the contrary.[25]

This chivalrous and uncharacteristic gesture brought home to Maria, if she had not known it before, that her correspondent was no mere lover-by-letter; a journey of over a day made simply to see her, to hear her voice, was more than enough to convince her that John Constable was a man who would not be baulked.

Believing that he could not endure yet another winter alone, certain that both his health and his work would suffer, Constable decided to ask his sister Mary to live with him. His old friend Thomas Stothard commended the idea saying that by being too much alone Constable 'thought impertinently'. Brother Abram was 'uncommonly glad she came to you, knowing her company would dispell many of those gloomy hours of thinking you must have when quite alone'.

Her goodness of heart shewed itself conspicuously to me, in her determination to come, contrary to her own inclination, for from remaining a very long time at home arose an idea in her mind, that no pleasure was to be found out of her parent's house, but this time she feels the happiness of contributing to a Brother's comfort &, I doubt not but you will find a benefit of female converse sufficient to enable you to close application to a Suit in which you must succeed, but not without. I long to come and see you both together, it is the way a family should divide & separate, when marriage does not take place early.[26]

And on the last day of 1811 advice came from a usually muted quarter – his father.

If my opinion was requested it would not be to give up your female acquaintance in toto; but by all means to defer all thoughts of a connection until some removals have taken place, & your expectations more certainly known.

My further advice recommends a close application to your profession & to such parts as pay best. At present you must not choose your subject or waste your time by invitations not likely to produce further advantages. When once you have fixed on a subject, finish it in the best manner you are able, & not through despair put it aside & so fill your room with lumbar.

I fear your too great anxiety to excell may have carried you too far above yourself; & that you make too serious a matter of the business & thereby render yourself less capable; it has impaired your health & spirits. Think less & finish as you go (perhaps that may do). Be of good cheer John; as in me you will find a parent & a sincere friend.[27]

Although Constable was still permitted to meet Maria at the Bicknells' house, such chaperoned encounters were far from satisfactory. Theirs was no longer simply a formal friendship; it now needed intimacy in which to develop and mature. But how to achieve it? They resorted to the miserable expedient of 'accidental' meetings in St James's Park. On some occasions, when they had been unable to arrange a meeting Constable took to wandering for hours in the Park, from time to time advancing as far as the entrance to Spring Garden Terrace in the hope that Maria might emerge. To have handed her into a carriage would have provided his tormented soul with solace enough. Maria, however, was no romantic.

Think my dear Sir of the number of wasted hours spent in the Park, think what an unsettled being I am rendered. I should not love you if you did not feel my absence, but feel it as a Man, rejoice that I shall be acquiring health and that you will be getting on with a profession upon which so much depends.[28]

Maria was again despatched to her step-sister in Worcestershire to Mrs Constable's satisfaction – 'for my own part I think it much more desirable to have our much esteemed Miss Bicknell with her, than to be in the continuous way of molestation'. But she, like Maria, was concerned that her son's emotional concerns would undermine his professional advance. She urged him to 'paint with energy and spirit — do not be *supine* . . . do my dear John come to a compleat finish . . . do secure your fame, — which will bring oil to your flame. You see my maternal energy — but I must not urge

you *too much*.' Maria was given an account of his endeavour at the end of March:

You are now too well acquainted with the pleasures and pains of my profession not to be aware of this anxious time. I am sure you will not only pardon me when I tell you my time and almost my thoughts have been so much occupied with the pictures which I intend for the Exhibition, that untill I had in some degree conquered them I could not write to you with so much satisfaction. I cannot help pleasing myself with thoughts that could you see them you would like them better than any others that I have ever done before – and that I may have the happiness of enjoying and profiting by your real criticisms of some of my future pictures for other Exhibitions.[29]

For the Academy Exhibition of 1812, Constable was working on his *View of Salisbury*, the first-born child of his love for the Close. It was begun on the advice of Thomas Stothard who had admired his drawings of Salisbury and recommended him to work up a 'general view of Sarum' from Harnham Hill into a painting 'of a respectable size'. He was also preparing a *Flatford Mill* and two smaller landscapes.

I met Mr. West in the street the other day—he stopped to speak to me, and told me had been much gratified with a picture (the Mill, &c) which passed the Council at the Academy. He said it had given him much pleasure and that he was glad to find I was the painter of it. I wished to know if he considered that mode of study as laying the foundation of real excellance. 'Sir' (said he) 'I consider that you have attained it.'[30]

When the exhibition opened Constable was relieved to discover that his own work had been given 'excellent situations'. Hanging was very much a lottery for a non-Academician, particularly one who had yet to attain the status even of Associate. But what was competing for the attention of an indifferent public on the walls of the Academy in the year 1812? Benjamin West had included his 'heroic landscape' *Saul before Samuel and the Prophets*. Lawrence was showing a portrait of the actor Charles Kemble in a classical pose. Turner's *Hannibal Crossing the Alps* was 'so ambiguous as to be scarcely intelligible in many parts (and those the principal), yet as a whole it is novel and affecting'. Constable's friend and neighbour offered 'some beautifull landscapes but they are heavy and crude'. But, fairly, Constable returned to see Farington's work 'by twylight when they looked much better'. His own work evinced scant interest.

E

Callcott told him that they looked very well, but rather dark and heavy. Certainly no visitor to the Academy Exhibition of that year was enough taken with the works of J. Constable to pay for the privilege of owning one of them. He showed his sisters Patty and Mary around the Exhibition, but 'they were however rather bent on shopping than pictures and left me'.

In his professional life as in his private existence all appeared bleak and immutable. One source of solace was the pleasant intercourse he continued to enjoy with the Bishop of Salisbury and his family at their London house in Seymour Street. He would occasionally receive a brief note – a summons rather than an invitation – calling him to dinner; and knowing of the friendship that had sprung up between his nephew and the painter, the Bishop invariably sent a note to Charlotte Street so that they could meet during John Fisher's rare visits to the capital.

From the start of their friendship Constable and Fisher avoided the wariness, the testing of the ground, that so often bedevils the growth of real friendship between man and man; they both seemed to realize that they had embarked on a deep-rooted and significant association. From the beginning Fisher had a mature, informed understanding of what Constable was about. His letter thanking him for a small landscape is typical of his affectionate candour:

It is most pleasing when you are directed to look at it—but you must be *taken* to it. It does not *sollicit attention*—And this I think true of all your pictures & the real cause of your want of popularity. I have heard it remarked of Rubens that one of his Pictures *illuminates* a room. It gives a cheerfulness to everything about it. It pleases before you examine it or even know the subject. How he obtained this, or how it is to be obtained—hic labor, hoc opus est. Don't laugh at my feeble criticisms Constable I *mean* your service & all men are allowed to talk *goodnatured* nonsense.—[31]

Fisher combined a genuine admiration for Constable's work with a sympathetic appreciation of his private and professional aims. His letters reflect the intrinsic good nature of the man: they are without exception generous, uninhibited, modest, and brimming over with robust good humour. Writing in May 1812 to warn Constable of his imminent arrival in London to be ordained priest, Fisher urged Constable to accompany him on his return to Salisbury:

You know I take no refusals. All obstacles be they of whatsoever nature they may be must be overcome by my impetuosity.—

But as some kind of animals lead better than they drive & as perhaps you belong to that class, I will try and coax you here by an account of the life we will lead. We will rise with the sun, breakfast & then out for the rest of the day—if we tire of drawing we can read or bathe & then home at nightfall to a *short* dinner—we'll drink tea at the Benson's or walk the great aisle of the Cathedral—or if the maggot so bites puzzle out a passage or two in Horace together—I think this life of Arcadian or Utopian felicity will tempt you, so come and try it. I would have painted in more glowing colours, but I eat a great lump of cheese just now & it has got into my head and muddied it.[32]

But Constable was anxious 'to get into Suffolk'. He told Maria that he was at the same time reluctant to leave London because 'I cannot go to Bergholt without being at least sixty miles farther from you and seeing a thousand objects to remind me of those happy hours when we *could* meet.'

I am still looking towards Suffolk where I hope to pass the greater part of the summer, as much for the sake of pursueing my favorite study as for any other account. You know I have succeeded most with my native scenes. They have always charmed me & I hope they always will— I wish not to forget early impressions. I have now very distinctly marked out a path for myself, and I am desirous of pursuing it uninterruptedly.[33]

During his first fortnight at home Constable called at the Rectory twice in the company of his mother; their reception was 'unusually courteous'. Mrs Constable, however, was much put out by 'the sway' that the widow Everard was enjoying at the Rectory. Mrs Everard – or 'Miss Durable', as Mrs Constable had dubbed her – had evidently, since Mrs Rhudde's death, assumed control of the Rector's social life. Mrs Constable, typically, extracted what humour she could from the relationship. Dr Rhudde's gardener had put down 'two beds of moulds for flowers – just before the Rector's study window — & what shapes should his fancy have fixt on, but *two large hearts*'. Mrs Everard was not amused:

'Truly ridiculous', as Mrs. E. says. 'If he must make these places for flowers, why not ovals or squares – but two *monstrous hearts*.' I should not wonder if they were thought, synonymous *things*, and termed by the commonality, the Doctor's & Mrs. E.'s. Methinks I have no objection to the Doctor's being touched by Cupid – as it may cause him to have a fellow feeling for *others* in the same situation.[34]

Constable determined to make the most of his time in Suffolk

for he intended remaining there until Maria returned to London which he hoped would be in July. Apart from a few social calls he 'lived a hermit-like life though always with my pencil in my hand'.

How much real delight I have had with the study of Landscape this summer. Either I am myself improved in 'the art of seeing Nature' (which Sir Joshua Reynolds calls painting) or Nature has unveiled her beauties to me with a less fastidious hand—perhaps there may be something of both, so we will divide these fine compliments between us—but I am writing this nonsense to you with a really sad heart, when I think of what would be my happiness could I have this enjoyment with you. Then indeed would my mind be calm to contemplate the endless beauties of this happy country.[35]

Having exercised the dogs at East Bergholt House – 'his three little mates' – and resisted the temptation to romp through the day with his two visiting Whalley cousins (Daniel, aged six, and four-year-old Alicia) Constable painted and sketched around Flatford Mill and the village. Even he was struck by the oddity of continually depicting the same scene: 'I am sure you will laugh when I tell you I have found another very promising subject at *Flatford Mill.*'

Constable's hope that he would soon be reunited with Maria was not fulfilled. Mrs Skey's eldest son Samuel died in July at the age of ten and Maria remained to comfort her step-sister. Constable faced this new disappointment with serenity:

In your society I am freed from the natural reserve of my mind – 'tis to you alone that I can impart every sensation of my heart – but I am now too apt to dwell on this melancholy side. Should I not rather think on the thousand blessings which I possess? I am hourly receiving every kindness from the best of parents – have I not health and time to pursue my darling study? – and above all I have your great love and esteem. I feel that what I desire would be joy too great for me – that I am really unworthy, and my constant prayers are to be deserving of you – and that I may bear this trial, the only one which I have had in the world, with resignation and patience.[36]

The couple managed a brief meeting in London during August before Maria departed for Bognor where her parents were established for the summer. The meeting was unsettling and Constable admitted on his return to Suffolk that he found it difficult to resume his landscape studies – 'I have not found myself equal to the vivid pencil that that class of painting requires.'

Golding Constable, now aged over seventy, fit enough to be astride his horse at six o'clock in the morning, was 'pursuing his plans with all the ardour of a young man'. He had been perturbed, however, by a newspaper report that his son's work 'wanted more carefulness in finishing'. His interpretation was that John was not following his profession with as much energy and application as he considered necessary; he ascribed his slow advancement to his 'unhappy situation'. Constable's disclosure that 'my father still thinks it will be the ruin of me' brought a pained response from Spring Grove: 'It distresses me more that I can say . . . only tell me if it is in my power to avert any *ruin* from you, and I will do it.' Stubbornly Golding pressed his view that his son's future lay in portraits. 'He has a pretty little house at Dedham, which he has offered me, if I would quit London. But that was not possible — I will never leave the feild while I have a leg to stand on.' Constable allowed that his father's offer was kindly intended: 'but you know Landscape is my mistress — 'tis to her I look for fame and all that the warmth of imagination renders dear to man.'

Commissions 'in the face way' continued to be given to the reluctant portraitist who completed them more because of loyalty than for the few guineas they brought in. Peter Godfrey of Old Hall asked him to paint his son William, a naval officer who was shortly to depart for the West Indies. The Godfreys, who had themselves been painted by Constable earlier in the year, were pleased with his work. 'I wish all they tell me about it could make me vain of my portraits.' Mrs Constable commended his portrait of Captain Thomas Western, another family friend, for giving him 'what we never saw before – a smile upon his face . . . a sensation I hope you will give to us all'. Dr Rhudde revealed himself by remarking that 'if he can paint such portraits as these he may yet get money'. His success with the Godfreys led to a commission to paint the seven-year-old daughter of General Sir Francis Slater Rebow of Wivenhoe Park in Essex.* Certain that Maria would think him 'the greatest egotist in the world', but no doubt anxious to convey to her his good standing with a distinguished member of the East Anglian gentry Constable wrote that he had learned from the Reverend Walter Wren Driffield that 'much as I had gratified him as an artist' the General 'was much pleased with me as a gentleman and a man'. He reminded her that she had urged him to write

*Wivenhoe Park is now the site of the University of Essex.

'without reserve', but on the subject of his work Constable apologized for his reticence: 'but it is a subject on which I cannot write to you with any pleasure. It seems to be our greatest enemy but nevertheless I love it more and more dayly.'

East Bergholt must have been like a school without a headmaster when Dr Rhudde was away on his holiday in Norfolk. But when he returned in September one family in the village was left in no doubt that term had started yet again. Constable's father had been impressed by his son's recent application to his portrait work and during the customary call at the Rectory he 'mentioned my success at General Rebow's but the Doctor would not hear my name. I fear I must have committed some new sin, or revived some old one, but I shall call on him soon myself, as I am determined to omit no opportunity of shewing him respect.'[37]

Mr Godfrey put himself in the way of rectorial obloquy by having the 'temerity to visit Mr. Eyre' who kept a pet bear. The Rector of East Bergholt with Brantham seems to have sentenced the luckless beast to death, an event which left Mr Eyre inconsolable for 'he loved it dearly though he has the marks of its teeth in many parts of his body'. The portents for a quiet winter were not good.

During September Constable descended to new depths of indignity. The spectacle of a man of thirty-seven running 'till I was out of breath' the half-mile between the Constable home and the Rectory merely because Abram had reported that the Rector was 'in the highest possible good humour' can hardly have commended him to the young woman taking her ease beside the sea at Bognor. The ingenuousness of his admission is appealing; a lesser man would have remained silent about the circumstances, preferring to plant in the mind of his loved one a picture of a dignified progress, graced with manliness and determination. The Doctor's man, Thomas, would have been on hand to receive the panting runner and possibly to dust him down before announcing him to his master. Thomas was still Mercury to East Bergholt and little time would have passed before Constable's latest essay in gaining favour at the Rectory would have been all around the village.

As Maria's stay in Sussex extended into the autumn – although the 'boisterous weather is driving the company away very fast' – Constable announced in a matter-of-fact way towards the end of October that he soon intended leaving Bergholt and that 'I shall probably find you at Bognor'.

Now how shall I reply to what my heart would give so ready an assent to, were we differently situated, but as it is, had you not far better, not, 'find me at Bognor', I do not think my sister would like it, and as we shall meet so soon in Town prudence whispers you had better not come, unless indeed you could produce the certificate of a physician that sea bathing was recommended to you, but I am far happier in finding you are perfectly well.[38]

So there was not to be another gallant dash if Maria Elizabeth Bicknell had anything to do with it. And that was not the only suggestion for the future conduct of their relationship that Maria had to make:

I recollect a short time ago our agreeing the reverse was the better plan, so that I rather doubt the proposition I am now going to make, but however my dear John we must try it, and that is, the not meeting often in London. You perfectly well know, what terrible havoc it makes with your time, indeed it will not be such a season for walking so that the temptation will not be so great![39]

Constable made it clear that he could not accept proximity without intimacy:

You know the high opinion I have of your understanding and prudence, and the entire reliance I have on your attachment, which always makes me endeavour to submit to your wishes in every thing—indeed when I look about me, what other way have I it in my power of showing my affection for you? My sacrifice of my own feelings I know I ought to make to you who have borne so much for me—but how can I bear your being in London and not seeing you?—or but seldom? . . .

Time however my dearest Love must help us, and this excessive-contumely must have an end—because I trust I am not myself wholly unworthy nor any one that belongs to me. Remember, my dear Child, that our business is with ourselves, and that while you love me I shall consider every circumstance attending this unpropitious scene but as the dust on my shoes.[40]

As if Constable had not enough to contend with, a fire broke out at 63, Charlotte Street during the early hours of 10 November. As the most able-bodied occupant of the house Constable took charge of fire-fighting in the hour that elapsed before the arrival of a solitary fire-engine.

It now appeared that nothing could save the house itself, and it was very difficult to pass up and down stairs, as the heat was so great at the windows and the fire have very seriously injured the stairs themselves—

but we persevered as long as we could, and while we were getting Lady Heathcote's large picture down, I had a shower of broken glass about me from the large window on the staircase. I ran with it over the way to Mr. Farington's and on my return for something else, I found the poor woman servant . . . in great distress, as all her fortune was in her garret—she particularly lamented her pockets which were under her pillows—there was no time to be lost, and I ran upstairs—and she was overjoyed to see me return with them through the smoke, for by this time we were almost all of us choaked with it, quite safe.[41]

Uncle David, generous as ever, offered his nephew a room at Portland Place for as long as he needed it. A neighbour in Charlotte Street – a dentist named John Henderson – provided him with a studio and Farington stored some of his work while repairs were carried out at No. 63 opposite. Both neighbours were rewarded by a grateful mother with gifts of game.

Maria left a blustery Sussex to return to London towards the end of November. When Constable presented himself at Spring Garden Terrace on 1 December he was admitted to the house but was not allowed to see Maria who was confined to her room with a cold. Apart from the brief meeting in August it was ten months since they had last seen each other. Miss Bicknell thought it was all to the good:

It is I am well convinced for our mutual benefit that we should not often see each other, it is this alone makes me support the privation with tolerable *good humour*, but your time is infinitely valuable to me, I cannot have it lost, the *genius of painting* will surely one day or other rise up against me for *too often* keeping one of her *favourite* pupils from a study that demands his exclusive attention.[42]

4

1813-1816

A most particular gentleman

The New Year of 1813 was celebrated in East Bergholt with 'balls and routs'. Constable was invited to celebrations given by one of Dr Rhudde's curates: 'but as I do not join in these things I cannot tell many particulars about them'. He was however able to inform Maria that at the Godfreys' his sister Mary 'had the honor of having your brother for her partner'. Young Samuel Bicknell, now sixteen, had not made himself popular in the Constable household during the Christmas holiday. Mrs Constable was 'really vexed to know that a Brother of hers should have resided 5 weeks in this village without entering our doors, tho' we have met tis true & that most friendly. But as his Grandfather never sent him, I was obliged to suffer that violence to the real courtesy of my nature, and not ask him, for fear of a refusal — as that would have hurt me still more.'[1]

Conditions at the front were no better. Mr Bicknell's opposition to Maria's association with Constable had now hardened and he forbade him to enter his house at Spring Garden Terrace. Mrs Constable was saddened that Mr Bicknell had taken against her son to such a degree 'as not to obtain for you the admittance of a Gentleman to her Father's house, never having been guilty of

anything to forfeit that character . . .'. Mrs Constable's anger was so great that she felt that she could not 'express my sentiments, to Mrs. B. or indeed any of the family for fear of involving myself in fresh troubles & making bad worse – but till you have admittance as before, I never can be happy'. Hurt though she may have been, Mrs Constable was advising her son in February that he should 'call upon the Rector during his stay in Stratton Street in March . . . you must not kick against the pricks'.

Within days of returning to London the only remaining line of communication between them – clandestine meetings apart – was cut by Mr Bicknell. Learning that Maria had been ill, Constable directed a number of letters inquiring about her health to Spring Garden Terrace. Mr Bicknell – 'a Father who even in anger is mild' – was furious at having to convey to his daughter letters from a man whom he had barred from his home. The correspondence was to cease. And so it did until 13 May when Constable sent Maria a formal report of a dinner he had attended in celebration of an exhibition commemorating Reynolds at the British Institution: 'Will you my dear Miss Bicknell receive any excuse for this letter?' Constable began, 'a thing so contrary to your express commands . . .'. The Prince Regent headed 'perhaps two hundred of the highest characters in the country' who attended the dinner including Lord Byron, Mrs Siddons and Constable's friends, Sir George Beaumont and the Bishop of Salisbury.

Lest his nephew lose sight of the rewards of pleasing a contemporary public, David Pike Watts, who had arranged for him to attend the celebration, sent him Northcote's life of Reynolds. 'It may animate you as Evidence of what *may be done* by *what has been* done; and if not to the high extent of £100000 – to the comfortable scale of fifty, or forty, or thirty, or twenty thousand pounds – but only touch the twenty thousand the rest follows as the steps of a Ladder'.[2] Reynolds' example also provided the text for a maternal sermon:

See what has been done by one bright genius & one pair of hands – who can then be satisfied with one landscape a few sketches & some unfinished portraits, for an annual employment?

Do my dear Son exert yourself, or you must pine away your prime, – and fret away the aged remnant of your Parents' lives. Your heart is so kind and so good – & your mind is well furnished, so that you have great advantages if you would but improve them.

You need never want for friends, if you will but be a friend to yourself.

Your Mother has a peculiar claim to tell you the truth & you would treat her with unkindness, not to believe her; and know her motive to be good.[3]

His mother's views were shared by Maria whose 'dislike to use the pen' never manifested itself when she considered a cautionary letter was required:

By a sedulous attention to your profession you will very much help to bestow calm to my mind, which I shall look for in vain, while I see with sorrow how unsettled you appear, and consequently unfitted to attend to a study that requires the incessant application of the heart & head. You will allow others without half your abilities to outstrip you in the race of fame, and then look back with sorrow on time neglected, & opportunities lost, and perhaps blame me as the cause of all this woe, exert yourself while it is yet in your power, the path of duty is alone the way to happiness.

Let us wait with quiet resignation 'till a merciful Providence, who alone knows what is good for his children, shall dispose of us, in the way that seemeth to him best. Believe me, I shall feel a more lasting pleasure in knowing that you are improving your time and exerting your talents for the *ensuing Exhibition*, than I should do while you were on a *stolen march* with me round the Park, merely no sooner to meet, than to part, and make Louisa act contrary to her inclinations, and her duty, but I however am *not Heroine* enough to say, wish, or mean, that we should never meet. I know that to be impossible, but then let us resolve it shall be but seldom, not as inclination but as prudence shall dictate.[4]

During the months before the 1813 Academy Exhibition Constable continued to live 'a hermit-like existence'. Benjamin West gave him the encouraging news that the Council of the Royal Academy was of the opinion that he had made a marked advance upon himself with the two landscapes he submitted this year: *Landscape: Boys Fishing* and *Landscape: Morning*. Although he claimed that 'all these fine things come too late to make any impression upon me', he was however more than a little pleased at this unexpected tribute.

I am really considered to have made a successful exertion in it this last year – and is it unreasonable to suppose that if under such untoward circumstances as I am now placed in, I have exerted some energy, might I not do much more could this load of greif and despondency be removed from me and I be once more put in possession of my own mind – would this might happen before it is too late![5]

News of Constable's success at the Exhibition that year had

reached Salisbury and Fisher wrote that he had heard 'your great picture spoken of here by no inferior judge as one of the best in the Exhibition'.

It is a great thing for *one* man to say this. It is by units that popularity is gained – I only like one better & that is a picture of pictures – the Frost of Turner. But then you need not repine at this decision of mine; you are a great man as Bounaparte & are only beat by a frost – [6]

With his summer in Suffolk about to begin Constable was in a confident mood. Before he left London he approached Mr Bicknell 'to request an interview and that he would consent to some sort of communication between us – he would consent to neither, but I do not repent of what I have done as I was happy at least to have an opportunity of approaching him in a respectfull manner'. But set against this not unexpected reverse there had been some professional advance and he was leaving London 'for the only time in my life with pockets full of money'. Largely thanks to his comparatively lucrative portrait work – fifteen guineas a head was his current charge – he was 'free from debt (not that my debts ever exceeded my usual annual bills), and I have required no assistance from my father for some time'. He was also delighted to find himself so well 'although I paint so many hours – perhaps too many – but my mind is happy when so engaged – not only by being occupied with what I love, but I feel I am performing a moral duty'.

The result of Constable's application to his 'moral duty' can perhaps be seen in the small sketchbook he used during the summer and autumn of 1813; from early July until late October he completed one hundred and thirty-two sketches, the first dated 10 July, the last 22 October. Constable would not admit the serious purpose of his sketching, but wrote disparagingly of 'how I amused my leisure walks, picking up little scraps of trees, plants, ferns, distances &c'. Several of the later larger canvases contain developments of ideas that emerged during 1813 (and 1814) which were first set down in sketchbooks. The 1813 volume is the starting point for *A Summerland, Summer Morning: Dedham From Langham, The Valley Farm* and *Flatford Mill*.

Few letters passed between Richmond, where the Bicknells were spending the summer, and Suffolk. The ban on their correspondence was being observed by a dutiful daughter who did however break silence towards the end of August to write a short letter which could have been of little comfort to Constable:

I wish I could divest myself of feeling so like a culprit when I write to you, it would be so much pleasanter for you & for me, but I know I am breaking thro' rules prescribed to me by those I love, and making you uncomfortable by my sombre reflections. I think of you equally if I write, or do not write, so recollect in future not to *expect* to hear from me, unless I have something very particular to say. . . .

What charming weather you have for sketching, I wonder which you have thought of most this summer, landscape or me (am I not a sad jealous creature?). We shall be in Town in November and then you must answer for yourself.[7]

Maria found nothing particular to say between August and November, a month which found them both returned to London where they met 'for one short morning'. Maria later conceded that she was 'a strange creature as you will one day discover'. She herself might not have been surprised to learn that Constable's cousin, Mary Russell, thought him 'an odd fish'.[8]

You say you will not see me oftener than once a month, or I should have been tempted to walk out on some of the very fine mornings last week (thinking they might be the last). Beleive me my dearest Maria I am trying in all my power to compose myself to painting (which is indeed what I ought seriously to do).[9]

The couple managed a brief meeting, possibly more than one, between the end of November and 23 December when the mis-begotten regulation of their meetings led Constable into further indignities:

I have been all this morning looking for you – and at last had the mortification of seeing [you] come up New Street and enter your door without my being able to make you or dear Catherine see me—though I was close under the iron rails directly opposite. I wasted some time hoping you might join your Mother but when I saw your Sisters without you I gave up hope of seeing you and I began to get very cold as I had been out hours without a great coat.

After such an excursion you may judge how I feel when I return to my room—I detest the sight of my wretched pictures or rather canvases, though you will forgive me when I say I ought to love them almost entirely—in short I endeavour to bear up against such feelings which are almost enough to turn a *painter's* mind.[10]

It is saddening that a man in his thirty-eighth year should have become so abject, but Constable had neither the detachment to appreciate the absurdity of his behaviour nor the confidence to shake

off his diffidence and bring his suit to completion. His lack of
confidence, stemming from the absence of measurable progress in
his profession, is perhaps not surprising; in his estimation, and that
of many of his contemporaries, he had so far achieved little to
justify his belief in himself.

The praise that he had received from men like West was encour-
aging, but it did not advance him at all. No one of any influence
in the Academy took him, or his work, at his own valuation; only
Fisher unquestioningly did that. His work still did not promise
much of a future; to Mr Bicknell and Dr Rhudde he had yet to
show his ability 'to get money'. And he must have felt that if he
failed an unthinkable compromise would be inevitable: portraits
first, landscape a poor second. He had no private income and few
expectations. If Maria decided to defy her family and marry him
it seemed certain that Charles Bicknell would allow her to lie unaided
on the bed that she had made. As Constable retreated from London
to spend the Christmas holiday with the Gubbinses at Epsom there
seemed little hope that the next year would bring any improvement
in either field. But 1814 would not be without its conquered peaks.

The year started badly. Maria was incensed by his neglect of
their correspondence. If 'it was your wish to try my patience . . . you
have completely succeeded'. She was enough disturbed by the hiatus
to suggest 'provided you like the plan' that he should 'write a little
every day and at the end of three weeks or a month it would be a
delightful journal'. The hermit did not like the plan and countered
with the suggestion that they should 'form the resolution to write
to each other once a week' only to receive the dampening reply
that such regularity of correspondence was 'totally impracticable'.

By February Constable was asking Maria for any news from
East Bergholt: 'but I have no right to complain – as I do not write
to them I cannot expect they will write to me'. To which Maria
tartly replied: 'I hear of no Bergholt news, I suppose there is none
to hear, but I am not sure that if I heard any I would tell you, for not
writing home yourself.' Constable's relations with his mother had
become strained probably due to her dissatisfaction with his lack of
progress; it was after all humiliating for a family which regarded
itself of the highest respectability that the honourable intentions
of one of its sons should be continually baulked by the prejudices
of another family. Mrs Constable must have felt that if her son
had followed his father into the family business, or even if he had
applied himself to portrait painting with more energy, she would

probably by now have been a grandmother to his children. Whatever her advice had been she felt it necessary to remark that 'it is a pity to vex me, who wish well to every one — & only give advice from affection and a desire to do what I deem right, to my maternal duty, and the experience of years'. It seemed to be symptomatic of her son's apparent lack of ambition that he should wish to engage as his assistant in London for a short time, Johnny Dunthorne, the sixteen-year-old son of his old friend. Constable merely wished to give the boy a holiday in London and hoped that it would amuse him to help him set his palette; he would also be something of a companion. 'He may be company', Mrs Constable remarked, 'but he cannot be a companion, & that is what you want to ascend, my dear John — not descend.'

It may perhaps, you think, be an advantage to him & here again we differ; he will prove like his patron; & never again regard his home & parental ties, as he did before; nor ever again be in possession of that 'bashfull forehead' (as Shakespeare terms it), that he brings with him— and besides all this, double your expenditure; which alas; now so far exceeds your income, for not a shilling do I hear of encreasing stocks—& how this can end, God knows—for I am sure I do not. You seem really anxious to avoid any, or every opportunity of earning almost your daily bread,—that to have two mouths to feed, to lodge, & wash—for an inmate, who tho' he may be company for *you*, cannot be so in point of etiquette wherever you go. These are the thoughts of your Mother, tho' no doubt uncongenial with yours.[11]

However, despite his mother's objections Constable gave young Johnny Dunthorne his holiday. It was possibly this estrangement from his mother that in February induced Constable to send Maria a sudden appeal to kick over the traces:

Is it possible for me to help contrasting that happy time with the present, when I am alienated from my own family and society, and all intercourse with the object of my affections, the only woman I ever loved in the world, as much as possible prevented, and that which is our highest virtue endeavoured to be rendered a crime. You must think with me that my punishment fully equals my offence.

The steadiness of your affection for me my dearest Maria has been my support in numberless hours of the deepest distress—for all my hopes and prospects in life are included in my attachment to you—but I am warned by my sufferings—years drag on—and no friendly hand is offered for my succour—the fates are still unrelenting.

Could you make a noble effort in my behalf, you could never regret

it—you would make the latter years of my parents happy, and save me to the Art for which I had made many sacrifices. Here is a home which you once said satisfied you—it would at least do for the present—and we could never want—for independent of what I have of my own (which shall be yours), I have many valuable friends who would patronize me, especially Mr. Watts—but they see it is of no use situated as I am—indeed Mr. Watts says so.[12]

Maria's reply can be assumed to have been unfavourable. Only a few months later she dismissed John's plans for their household economy on marriage – 'people cannot live now upon four hundred a year, it is a bad subject, therefore adieu to it'.

After a short visit to Suffolk Constable returned to London towards the end of April for the opening of the Exhibition. Hastening to Somerset House – ' 'tis natural we should look first for our own children in a crowd' – he was encouraged to discover that his *Landscape: Ploughing Scene in Suffolk* had been well received. 'I understand that many of the members consider it as genuine a piece of study as there is to be found in the whole room.' Mrs Godfrey's request that he should annotate the catalogue 'to assist their judgements' placed Constable in a dilemma: 'They probably wish me to omit the bad ones – but was I to mark a catalogue for myself, those I should fix upon first, for they are by far the most amusing to me.' Mr and Mrs Godfrey's attention would have been drawn to Turner's *Dido and Aeneas*. Constable's opinion of this work, which was attracting much attention, differed 'from that of Lawrence and many others entirely . . . but I may tell you (because you know that I am not such a vain fool) that I would rather be the author of my landscape with the ploughmen than the picture in question'.

Constable had good cause for his jaunty, almost arrogant confidence. On the last day of the British Institution exhibition in mid-April his *Landscape: a Lock on the Stour* had been sold. The purchaser was a Bond Street bookseller and publisher named James Carpenter 'who said he could not afford to pay the money he would willingly do, but he would give him twenty guineas in money, and books to a certain amount beyond that sum'. The sale came at a time when 'D.P.W.' was considering buying the *Lock*; instead he had taken to his quill again to pen his old lament: want of finish. Constable acknowledged his uncle's advice – 'as an artist I know I have great deficiencies and that I have not yet, in a single instance, realised my ideas of art' – and then told him the picture had been

sold to Mr Carpenter. 'He is a stranger, and bought it because he liked it.' The substance of the barter he kept to himself which is no doubt why Constable regarded his second sale of that year as the first act of patronage towards him by a stranger.

At the Academy exhibition *Landscape: Ploughing Scene in Suffolk* was bought by John Allnutt, a wine merchant from Clapham. Several years later Mr Allnutt decided that he 'did not quite like the effect of the sky' and he was 'foolish enough to have that obliterated, and a new one put in by another artist; which, though extremely beautiful, did not harmonize with the other parts of the picture'. Mr Allnutt, having later acquired a painting by Augustus Wall Callcott subsequently approached Constable and asked him to reduce the height of his picture 'by lowering the sky, so as to make it nearer the size of Mr Callcott's to which I wished to hang it as a companion'. Rather than amend a work that had already been meddled with Constable painted Allnutt a new picture of the size of the Callcott companion, free of charge. Allnutt, understandably puzzled by this generosity, inquired the reason. Constable told him that 'he had been the means of making a painter of him, by buying the first picture he ever sold to a stranger; which gave him so much encouragement, that he determined to pursue a profession in which his friends had great doubts of his success'.[13]

His jubilation at the Allnutt sale was over-shadowed by a tiff with Maria in the middle of May. She accused him of lack of respect for her father when he had accompanied her to Somerset House. Apparently, Constable had failed to bow. Contrite that he had caused Maria distress, however unintentionally, he replied that he had 'always considered that any notice coming first from me would be thought impertinent – this was my error – but you said it ought to have been so as I was the younger man'.

I can only repeat to you, that not the smallest disrespect or slight was intended by me in passing Mr. Bicknell – and could I have had the least idea that any notice from me could have been looked for it should not have been witheld for a moment. . . .

Perhaps your goodness will yet endeavour (though I know not what I ask) to procure me an interview with Mr. Bicknell which you know I have always been most anxious for from the moment that I was dismissed from his door.[14]

And so the melancholy courtship continued: 'Never be anxious to hear from me, for I have often told you, how almost impracticable

F

it is . . . Is it not better my dear John to send you a short letter than to fill it with the dismals.' At their next meeting, a few days later, a dispute arose over Constable's suggestion that they should meet at the house in Richmond of a friend named Mrs Ward. The excitement of an illicit meeting held no attraction for the inflexible Miss Bicknell and it does not seem that the lady ever gave the lovers shelter. 'I cannot tell for certain when I shall be in town, but it is of little consequence, and pray tell me if this letter pleases you, for you seem to be a most particular gentleman. . . .'[15]

Although Constable spent most of June in East Bergholt his working summer in Suffolk did not effectively begin until August. July was occupied completing several 'jobs'. Work, however mundane, was never 'dashed off' by Constable. He had long promised his father's friend the Rev. Walter Wren Driffield to draw his church and house at Feering. He spent a few days with the old clergyman and then accompanied him on a visit to another of his livings at Southchurch, which enabled him to see parts of Essex that were foreign to him. He 'walked upon the beach at South End. I was always delighted with the melancholy grandeur of a sea shore.' He made a drawing of Hadleigh Castle; it was to form the starting point of one of his greatest pictures which did not reach its final form until fifteen years later. The remainder of July was taken up with portrait painting in London. Constable returned to Suffolk at the end of the month to find a few more pressing 'jobs'. Firstly, Captain Thomas Western, having been promoted rear-admiral, required the appropriate amendment to be made to his portrait. 'This I was obliged to do to my great annoyance, for I grudge the fine weather exceedingly.' Another commission, but not perhaps an unwelcome one, was to paint a view of Dedham Vale, a wedding gift from Mr Thomas Fitzhugh to his bride, the Godfreys' daughter Philadelphia. The couple were married in the late autumn of that year, but Mrs Fitzhugh, like the Rev. Wren Driffield, had to wait nearly a year for the completed work.

From August until November Constable followed his practice of the previous year and made use of a small sketchbook in which he recorded the summer as he saw it. Again the subject-matter is similar: houses, distant views of country, churches, ploughs, horses and carts, harvesting and so on. But geographically he confined himself even more than in the previous year: all the identified places are within only a few miles of the village. Constable's devotion to his work meant that he saw little of his Gubbins cousins who

stayed at East Bergholt House for most of September. 'I am considered rather unsociable here — my cousins could never get me to walk with them once as I was never at home 'till night — I was wishing to make the most of the fine weather by working out of doors.' The season yielded not only sixty or so pencil sketches but also a few oil sketches. And whereas some of the summer sketches of 1813 can be seen as contributing to the process of germination, 1814 was a year in which one of the embryo sketches led directly to a finished painting in oils.

It has often been noted that in painting *Boat-building near Flatford Mill* Constable owed a debt to Claude whose works Farington had urged him to study. 'I recommended to Him to look at some of the pictures of *Claude* before He returns to His country studies, and to attend to the admirable manner in which all parts of His pictures are completed. . . . He thanked me much for the conversation we had, from which he sd. He shd. derive benefit.'[16] Constable claimed that this picture was painted 'entirely in the open air'.

In the midst of a meadow at Flatford, a barge is seen on the stocks, while just beyond it the river Stour glitters in the still sunshine of a hot summer's day. This picture is proof, that in landscape, what painters call warm colours are not necessary to produce a warm effect. It has indeed no positive colour, and there is much of grey and green in it; but such is its atmospheric truth, that the tremulous vibration of the heated air near the ground seems visible. This perfect work remained in his possession to the end of his life.[17]

It is probable that open-air painting of a largish picture in oils was an experiment, one that he had not attempted before. It may, however, have been his original intention to convert the miniature *Boat-building near Flatford Mill* he sketched on the 7 September into a finished studio work during the winter. Aware as always of the human context of his work, Constable 'was always informed of the time to leave off by the pillar of smoke ascending from a chimney in the distance that the fire was lighted for the preparation of supper on the labourer's return for the night'.

We have had a most charming season, and I hope I have endeavoured to avail myself of it. It is many years since I have pursued my studies so uninterruptedly and so calmly—or worked with so much steadiness & confidence. I hope you will see me an artist some time or another—but my ideas of excellence are of that nature that I feel myself yet at a frightfull distance from perfection.

But it is my peculiar happiness to have an object to pursue, that occupies my time and mind so much—a mind that must otherwise have falled a prey to itself. God knows my beloved Maria (when I consider the accumulation of untoward circumstances that keep us apart, and deprive me of the society of the only person I ever loved), how sincerely thankfull I am for so great a blessing—as I have always found my profession to be under all its anxieties, and I am in the last degree flattered and made happy when I know that I am to be the 'protector of your future happiness'.[18]

His solitary application continued on his return to London in November. It earned him a maternal rebuke. 'I believe it is thought', Mrs Constable remarked, 'you avoid notice too much, which damps the ardour even of the best friendship'. Maria too was perturbed by his admission that he was no longer 'on tiptoe for fame and emolument'.

It appears strange to me, that a professional man should *shun society*, surely it cannot be the way to promote his interest. Why you should have been anxious 'four or five years ago after fame & emolument' and now to have given up the idea, is what I cannot comprehend, it is certainly paying me a very ill compliment, if you like to remain single it will do very well....

I must have no more of the 'propensity to escape from notice'. I must have you known, and then to be admired will be the natural consequence. I do not know how you will like my strictures on your conduct, but I cannot help that. It is better you should know my mind now, than afterwards, it is now not too late to quarrel. It is your turn next to accuse me, and I am sure I stand convicted of numberless errors, so that I would not have you believe *I think myself perfection*.[19]

The 'recluse' was required to meet Miss Prim in St James's Square 'to make your defence, and promise to behave better in future'.

Now that the association of his daughter and the painter had lasted for over five years without any apparent weakening of their affection for each other, Charles Bicknell seems to have realized that any further attempts to undermine it would end, as earlier attempts had ended, in failure. In February 1815 he made a significant concession: 'I have obtained from Papa the sweetest permission of seeing you again under this roof to use his own words as an occasional visitor. From being perfectly wretched I am now comparatively happy.'

The stage manager down in Bergholt, pleased that John was no

longer an outcast at Spring Garden Terrace, urged that the advantage be hammered home. She reminded him that soon Dr Rhudde 'enters on this eighty-second year of his long pilgrimage thro' this world, in which he has had so much sunshine as to this world's goods. If you think it will be taken in the right — it should be — perhaps you will call and pay all due respects, to your Grandfather *in expectation* . . .'. At the same time Mrs Constable, as a parent, recognized the difficulties facing Mr Bicknell who wished at all costs to protect the benefits he and his children could expect from Dr Rhudde's will.

You must make every kind allowance for Mr. B. who is most assuredly not a free agent in this matter. He is under rigid restriction, from which, for the *sake of his family*, he must not appear to swerve. To me as circumstances stand, I esteem it a great point gained—and it certainly is more comfortable to my mind which had long been a silent sufferer, from the treatment you met, so derogatory to your respectability and honorable intentions,—for indeed I never expected this turn in the tide of your affairs, 'a l'amour.' You have now only to wait for time and opportunity, to enable you to act in conformity and with propriety, to her deserts— which will effectually prevent you from plunging her into difficulties totally uncongenial & inconsistent to her expectations.[20]

Constable, for his part, was not prepared to discard his self-respect by exhibiting undue haste in accepting Mr Bicknell's concession. Having been 'formally dismissed' from Spring Garden Terrace he demanded a formal invitation to return. Maria complied. But having gained the inside of the house on one occasion Constable was so forward as to indicate his affection for Mr Bicknell's daughter.

When Constable, on one of his visits to Spring Garden Terrace, placed himself beside Miss Bicknell, and took the hand which was soon to be given to him for life, her father said, 'Sir, if you were the most approved of lovers you could not take a greater liberty with my daughter.'—'And don't you know, sir,' he replied, 'that I am the most approved of lovers?'[21]

The news from East Bergholt was not good. Soon after Christmas Golding Constable had been taken ill with swellings in his feet. The trouble was deemed serious enough to call in a Dr Williams from Ipswich after the old man had been treated by Mr Travis with poultices. With the passing of her husband to be expected daily Mrs Constable, normally the most robust of women, seems to have lost the will to live, if it meant living the life of a widow – 'at best a forlorn woman'.

. . . The prospect of the parting pang, distresses me even in idea—for tho' I know that hand in hand we entered into the bonds of matrimony I also know, that few couples departed this life, so near, but that one was left to bewail the loss of their partner thro' life.[22]

But Golding began to recover and it was Mrs Constable herself who required the visits of Mr Travis and Dr Williams after being taken ill on 9 March. Abram, who was already acting as the effective head of the family, reported to his brother in London that their mother was 'very weak and in considerable danger'. She was partially paralysed in her left side. Mrs Constable, recognizing that her own illness was delaying her husband's full recovery, sought help from a source in whose goodness she had unquestioning faith. A few hours before evensong on Sunday, 12 March, the Reverend J. Roberson wrote in reply to his ailing parishioner that he would not fail

desiring the congregation to offer up their supplication to the Throne of Mercy in your behalf; – in which I shall most fervently join with an humble confidence that, He who has so lately manifested his saving Power in your family, & on whom you appear so implicitly to rely, will of his fatherly goodness, accept our united petitions.[23]

But by Tuesday Mrs Constable was no better; indeed, in Abram's opinion 'she is evidently weaker, & is now in a very critical state'. There was little doubt in the family that Mrs Constable would soon be 'among the Blessed'. The exact date of her death is not known, but it would seem to be during the last week of March 1815. With Mrs Constable died her hope, expressed three years earlier, that 'before I go hence & am no more seen, to add another amiable and good daughter, to those I am already blessed with'.

Constable did not attend his mother's funeral. At first his absence looked like prompting a family row. Although Abram was aware that the spring was a critical period for his brother his view was that 'there are duties, to which & before every thing gives way'. But Constable was in the midst of his usual pre-exhibition panic; the last fortnight of March was of vital importance; this was the time when sustained work might rescue a painting from mediocrity. At the 1814 Exhibition he had scored a signal success. It needed to be consolidated. He was therefore planning to swamp the Academy this year with a total of eight works, more than he had ever submitted before: five paintings and three drawings. It is an indication of the loving nature of the Constable family that his absence from

the funeral was not regarded as unforgiveable. Abram later assured him that 'it was impossible we could tell how very urgent your business was – but it is all right, no one thinks of it only as it really is, that to come was out of your power'.

In May, Maria's mother also died. 'That we should both of us have lost our nearest friends (the nearest we can ever have upon Earth) within so short time of each other is truly melancholy – and more than ever do I feel the loss of your society.'

It must have been frustrating for Constable and Maria that now that Mr Bicknell had slackened his opposition to their meetings circumstances had intervened which made them unable to make use of their new freedom. To comfort his father Constable spent from July until the end of the year in Suffolk where he passed his summer predictably: 'I live almost wholly in the feilds and see nobody but the harvest men.' Even the onset of autumn did not deter him: 'I cannot help regretting the departure of our delightful summer — but I still continue to work as much in the feilds as possible, as my mind is never so calm and comfortable as at those times.' During October he 'put rather a larger landscape on hand than ever I did before.'* It was for this and other more practical reasons that it became Constable's turn to advocate patience to Maria.

It is my intention to continue here till I feel that I have secured such a picture as I mean for the Exhibition. Here everything is calm, comfortable and good—and I am removed at a distance from you, that effectually removes the anxious desire I always feel when you are in London to meet, perhaps too often at least for each other's comfort 'till we can meet for once, and I trust for good—and do beleive me my dear Love when I tell you that I really in my heart feel no animosity towards any body that belongs to you.

However I may be pained for my family and yourself at the moment, my conscience I know to be clear, and I have never intended to wrong any one—and if there has been ill behaviour on either side, that will revert to those who gave it. My affection and determination towards you are fixed for ever, and gain strength by time.

We have certainly got the worst over—and as we have borne so much and so long, would it not be wiser yet to listen a little longer to the voice of prudence? The Doctor has given you something, and be it what it may it can help perhaps support your widowhood and comfort your

* Constable exhibited *A Wheatfield* and *A Wood: Autumn* at the Royal Academy in 1816.

children—but it is what I never will touch. That which I expect from my father, is another matter, and as it will require great accommodation one to another amongst ourselves in a future adjustment of it, I should like to have my mind at present quite at liberty on that subject.[24]

Maria petulantly expressed her disappointment that their separation, long as it had been, seemed likely to extend into 1816.

How I do dislike pictures, I cannot bear the sight of them, but I am very cross, am I not? I think you will not bear this letter, you may spare yourself telling me I am very unreasonable for I know it already, but I cannot be reconciled to your spending month after month in the country.

You say you have no idea of remaining in London for some time, at all events it is pleasant intelligence, but I feel how very often the visits here are distressing. I believe I must say you are right in remaining where you are in a comfortable home, and rendering the declining years of your Father happy. Whatever attention you can shew him, must make your hours pass the more agreeable. Whenever I wish you away, I know I do wrong. I wish we could always like what is right—henceforth I will endeavour.[25]

By the beginning of 1816 Constable had had enough. He seems to have realized – at last – that only by taking the initiative could he hope to put an end to the absurd charade in which he had been the leading player for nearly seven years. A meeting with Maria in London in January convinced him that malicious tongues had been wagging. He thought that the rumours about him which had reached Maria's ears were serious enough for him to assure her that his intentions 'were always just and honourable'. The substance of the gossip is likely to have concerned Dr Rhudde's fortune, a sizeable proportion of which, it was anticipated, would eventually devolve on Maria. Dr Rhudde and his daughter, Harriet Farnham, 'are entirely inveterate against me, but don't let this vex you – the one never saw me, and the other has had no opportunity of knowing me, and time will set all things to rights'.

I wish you had married me before now, and depend upon it we shall act most unwisely in deferring it much longer—our enemies are busy and vigilant and unprincipled—therefore we know not what we have opposed to use. We cannot be worse off—our peace is already gone & our constitutions fast following—can any money make amends for our loss? If this is to be still the case (& the late visit to the Rectory looks like it) we may as well be unhappy in each other's arms as apart, and two they say can bear trouble better than one.[26]

It also emerged that the Reverend Doctor frowned on Constable's continuing association with John Dunthorne, as did Maria, who remarked that 'a man destitute of religious principle must be, if not a dangerous, at least a most melancholy associate. It has certainly been the astonishment of many that a man so every way your inferior, should be allowed and honored with your time and company, I assure you it has been a subject of wonder to me.' Constable's loyalty to Dunthorne had protected him from earlier dismissal, but now Constable decided to act, not altogether reluctantly:

My acquaintance with Dunthorne has as you know for a long time past given me uneasiness, and it was much encreased by what you told me when I was last with you. I have made a great struggle with myself—I have given the best advice in my power for some time past—but as he was determined to continue in his perverse and evil ways, I was determined not to countenance them by being seen with him.

Accordingly I begged Mr. Travis to send for him and tell him my fixed determination, which is that he does never again come to this house without being sent for on his business & that I should never call upon him, without he chooses to alter his conduct, both at home & abroad— but he is so bent on his folly that I see no probability of any change— indeed the manner in which he received my message & Mr. Travis's advice made me regret that I should have deferred it as long as I have—but I can assure you that it was quite advisable for me to have acted in this manner for my own sake.

Surrounded as I am with enemies, every disreputable thing was struck upon that could be done, was not spared, whether unjustly or not, but I can truly say that I am not only (never) connived at any of his views, but I have all my life combated them in him, 'till at last the sight of me became a monster to him, and he wished to be rid of me. I am sure you will say here is more than enough said on a melancholy subject—yet you will be glad to hear it.[27]

To require disloyalty of a man, however, is not the best way of controlling him. Having abjured Dunthorne's friendship, Constable was in no mood to suffer further malicious behaviour from the Rector, but it was only a matter of days before he accidentally stepped upon another mine which Dr Rhudde hastened to detonate.

Miss Taylor, who ran a girls' school next to East Bergholt House, was always on the look-out for new pupils. In his neighbourly way Constable innocently suggested to Miss Taylor that her establishment might prove ideal for Maria's younger sister Catherine. A harmless enough proposal, but unfortunately Miss Taylor happened

to convey the suggestion and its origin to the prospective pupil's grandfather. That the unsatisfactory suitor for his grand-daughter should have the effrontery to propose a school for her sister was altogether too much for Dr Rhudde.

My dearest John you have now got yourself, and me in a *most terrible scrape*, the Doctor has just sent such a letter, that I tremble with having heard only a part of it read, poor dear Papa, to have such a letter written to him, he has a great share of feeling and it has sadly hurt him.

'Tho I will not acknowledge it to any one else I will to you, that I think you have done wrong, I thought you would know the Rector better, than to *suppose he would allow* you to interfere with Catherine's school, O, why did you mention it to Miss Taylor, and suffer her to go to the Rectory about it. I am so sorry I told you the subject was ever mentioned, but I like to tell all I know, and then I do not mean it to go any farther, many things are talked of without an idea of their taking place.

Had Papa wished particulars of the school, the Doctor you know would have chose to *have made the first* enquiries. It has for our mutual advantage been kept *a secret from the Doctor your visits here*. You have now unluckily my dear John dissolved that charm, and I now know not how it will end, perhaps the storm may blow over, God only knows, we must be patient yet a little while.

I am sure your heart is too good not to feel for my Father, he would wish to make us all happy if he could. Pray do not come to town just yet, I hope by the end of the month peace will again be restored.[28]

Further letters were sent to Mr Bicknell from the Rectory. Her father read Maria selected passages.

You have already so much to distress you that I hardly know if I should tell you what I fear will only do so more, it was so very likely to happen, the kind Doctor says he 'considers me no longer as his grand-daughter', from the knowledge I have of his character, I suppose I may infer he means what he says.[29]

Constable apologized, but told Maria that he was 'clearly convinced (from the anxiety there was shown to convert this nonsense into a heinous offence) of the disposition there exists to ruin us if possible'.

I now more than ever repeat it, and I assure you that nothing that can be done by any part of your family, shall ever make any alteration in me towards you. I shall not concern myself with the justice or injustice of others. That must rest with themselves alone. It is sufficient for us to

know that we have at no time done any thing that is blamable, or to deserve the ill opinion of any one.

Our business is now more than ever (if possible) with ourselves. I shall inherit a sixth part of my father's property, which we expect may be at least four thousand pounds apiece, and Mrs. Smith of Nayland will leave about two thousand pounds more amongst us – and I am entirely free from debt. I trust could I be made happy to make a good deal more than I do now of my profession.

After this my dearest Maria I have nothing more to say – but that the sooner we are married the better and from this time I shall cease ever to hear any arguments of any sort from any quarter. We have been great fools not to have married long ago by which we might perhaps have stopped the mouths of all our enemies . . . I write this for any body to see —I have no secrets—I wish your father to know what I have written if you likewise think so.[30]

By the beginning of March Constable had brought his feelings of bitterness and frustration under control. He expressed himself with crisp resolve: 'It is not my intention to wait longer than the summer – then in spite of A, B, or C let us for God's sake settle the business – then let those divide us who can.' Dr Rhudde was now simply an impediment to be out-manœuvred – perhaps defied – although Constable conceded that 'it would be foolish uselessly to irritate this old man'.

Golding Constable had gone into a slow decline after the death of his wife and he was now living the last few months of his life. At the end of March Constable went to London to see his two pictures safely into the hands of the Academy. His father's condition being unchanged he returned to London after a brief visit to Suffolk only to be told by Abram on 12 May that he thought 'it impossible he can continue many hours'.

My dear Father's end was so happy – he died whilst sitting in his chair as usual, without a sigh or a pang, and without the smallest alteration of his position or features, except a gentle inclination of his head forwards – and my sister Ann who was near had to put her face close to his to assure herself that he breathed no more. Thus it has pleased God to take (I doubt not) this good man to Himself – the rectitude of his conduct throughout life had disarmed the grave of its terrors, and it pleased God to spare him the pang of death.[31]

At the beginning of July came an event which possibly more than any other external cause strengthened Constable's resolve to make himself a married man before the year was out. John Fisher married.

How he must have envied the ease with which Fisher had managed to enter upon the married state. Fisher's wife was the daughter of Dr William Cookson, a canon of Windsor and an old friend of both the Bishop of Salisbury and Joseph Farington; Mary Cookson was also a cousin of William Wordsworth. 'My wife has the sense of a man to talk with, the mildness of a woman to live with & the beauty of an angel to look at', Fisher wrote.[32] The marriage probably took place in London on 2 July 1816. Afterwards Constable slipped across the street to talk to Farington:

Constable called and spoke of his situation with Miss Bicknell and thought it would be most proper for them to marry without further delay and to take the chance of what might eventually be the disposition of her grandfather, Dr. Rhudde.[33]

Relations between the Bicknells and Dr Rhudde were being repaired in the well-tried way: pretending that no cause for friction existed or ever had existed. Maria dined with her grandfather at Stratton Street in the middle of May, only weeks after he had intimated that he no longer regarded her as his grand-daughter. An uncomfortable occasion? Not at all, for 'the Doctor and I do not fatigue ourselves with talking'.

Constable departed for Suffolk in mid-July. Uppermost in his mind was the necessity of turning himself into a man of sufficient substance in order to avoid giving the impression that the pauper was running away with the princess.

When he gathered with his brother and sisters at East Bergholt House to discuss their father's will Constable realized that the village would never be quite the same again.

We are very happy among ourselves, and when we are all together it is really an interesting sight – I cannot however contemplate it without mixture of old associations inseparable to all sublunary affairs – so used have I been on entering these doors to be received by the affectionate shake by the hand of my father and the endearing salute of my mother, that imperceptibly I have often found myself overcome by a sadness I could hardly restrain.[34]

Golding Constable's will provided in effect that Abram would manage the business and share the profits with his brothers and sisters; the residue of the estate was to be distributed equally among them. Even before he left London Constable had been badgering his brother to see what he could do about hastening the granting of probate on their father's will. But interested parties to a will, then

as now, can do little to accelerate a legal process of which imperceptible progress towards conclusion appears to be an essential ingredient. 'I am sorry that you have been disappointed, but I believe cash is forthcoming some day or other', Abram wrote. It had been decided to sell East Bergholt House, but it would be several months before Constable would receive his share of the proceeds. Later that year he assessed his future income at about £400 a year, a figure that Maria had dismissed as insufficient to support marriage; his income until now, being so paltry, had been ignored by the tax commissioners.

In July 'D.P.W.' succumbed to a urinary infection. Constable must have had a reasonable expectation that he might benefit through his death, but his uncle, a man of extraordinary wealth gained through a chance inheritance, a man who had been generous and helpful to his nephew during his life-time, left his entire estate to his only surviving child Mary Russell; she was already the wife of a wealthy man. Village gossips got to work immediately and by the middle of August, Constable was having to seek out a go-between in the person of the Rev. Benjamin Wainwright to 'undeceive' the Rector that his uncle had 'done very handsomely with him'. Later, Dr Rhudde was 'full of indignity about poor Mr. Watts's will'. Lest the gossip reached Maria's ears, he assured her that 'the money I have ever had from Mr. Watts would amount to very little indeed – and that he always had my time, or productions for – and I never in my life would dine at his house (with a party) without an invitation, & I certainly have not dined with him four times in the last year'. Maria was unperturbed: 'I am not in the least disappointed in regard to Mr. Watts's will, for I have never thought of his death, but however, it ought to be an additional reason for the Doctor's taking care of us in this, but I do not trust to it in the least.' Constable agreed:

I think we do right about the Doctor, as we both know the man, and it will be but poor consolation to us to know that he is gone to the devil on our account – but we must make all our calculations how to live without him. I trust your good father will not forsake you but it is not in his power to do much for you. He is I believe now living at a greater expence than he ought – at least so he once told me.

The Doctor has begun his old story again about my being an infidel – poor man. I hope you will congratulate me on his having nothing else to say against me – it is now become his watchword when speaking of us – unfortunately it will serve his turn as well as any other if he is unprincipled

enough to make it. I think after this letter I never will mention this hateful subject again. We have made up our minds and that's enough – we must be happy – I am not coming to you for your money, as I beleive they all begin to think now.[35]

Constable, understandably in view of his preoccupations, does not seem to have done much 'sketching from nature' during the summer of 1816. He could not lightly take to the fields when prudence told him that he should be trying to 'get money'. His financial situation had not improved enough to make him view his intended marriage as anything more than an improvident gamble.

General Rebow of Wivenhoe Park helped by giving him two landscape commissions. Having learned from the Rev. Wren Driffield that Constable might soon be needing 'a little ready money' the General offered 'to pay me for them when I please'.

I have been here since Monday and am as happy as I can be away from you – nothing can exceed the kindness of the General and his Lady – they make me indeed *quite at home*. They often talk of you, because they know it will please me, and I am sure they will show you the same attentions they do me. I feel entirely comfortable with them, because I know them to be sincere people – and though of family and in the highest degree refined, they are not at all people of the world, in the common acceptance of the word. . . .

I am writing this in a most magnificent drawing room looking over Colchester and a beautiful evening – and hourly attended by a little dear girl whom I once painted – she has just put me down a wafer (for sealing) with 'There Mr. Constable – did you not say a black one?'[36]

Coming at this time Constable might have been excused hastiness in completing the General's pictures. But his painting of Wivenhoe Park – intended as a pictorial record of the owner's country seat – placed Constable in an artistic dilemma which he was not prepared to avoid:

The great difficulty has been to get so much in as they wanted to make them acquainted with the scene. On my left is a grotto with some elms, at the head of a peice of water – in the centre is the house over a beautifull wood and very far to the right is a deer house, which it was necessary to add, so that my view comprehended too many (distances). But to day I have got over the difficulty, and begin to like it *myself*. I think however, I shall make a larger picture from what I am now about.[37]

Back in London he busied himself with domestic details. He arranged for some of his Charlotte Street rooms to be painted and

he discussed plans for a honeymoon. John Fisher, having tasted the delights of married life, was insistent that his friend cease dithering:

I am not a great letter writer: and when I take pen in hand I generally come to the point at once. I therefore write to tell you that I shall preach at Salisbury on Sunday Sep: 22 on the occasion of an ordination: and that I intend to be in London on Tuesday Eveng. September 24 . . . And on Wednesday shall hold myself ready & happy to marry you. There you see I have used no roundabout phrases; but said the thing at once in good plain English. So do you follow my example, & get you to your lady, & instead of blundering out long sentences about the 'hymeneal altar' &c; say that on Wednesday September 25 you are ready to marry her. If she replies, like a sensible woman as I suspect she is, well, John, here is my hand I am ready, all well & good. If she says; yes: but another day will be more convenient, let her name it; & I am at her service . . .

And now my dear fellow I have another point to settle. And that I may gain it, I shall put it in the shape of a request. It is that if you find upon your marriage that your purse is strong enough, to make a bit of a detour, I shall reckon it a great pleasure if you & your bride will come & stay some time with me & my wife. That Lady joins with me in my request. The country here is wonderfully wild and sublime & well worth a painters visit. My house commands a singularly beautiful view: & you may study from my very windows. You shall [have] a plate of meat, set by the side of your easel without your sitting down to dinner: we never see company: & I have brushes paints & canvass in abundance. My wife is quiet & silent & sits & reads without disturbing a soul & Mrs. Constable may follow her example. Of an evening we will sit over an autumnal fireside read a sensible book perhaps a Sermon, & after prayers get us to bed at peace with ourselves & all the world.[38]

Maria's father remained recalcitrant: 'I have shown your, & Mr. Fisher's letters of Papa, in hopes they would make some impression upon him he merely says that without the Doctor's consent, he shall neither retard, or facilitate it, complains of poverty & so on . . .'. In September Constable made his final attempt at converting Dr Rhudde 'for the very idea of a sneak into the family is shocking'.

Although Constable conceded that in Fisher's proposals 'we have never had so respectable a plan offered to us before' he was still anxious to earn some money. Indeed he was so keen on 'getting a few pounds together' that he proposed postponing the ceremony until he had completed all his outstanding commissions. Maria was indignant at being placed second to 'the art'. After explaining his motives at length Constable pleaded for forgiveness:

I have an anxious mind, and we shall find it always a serious matter to let any thing bye – we lose not only the present sum, but the connections. Do my love think of all I am now saying only in this light. I am taking you from your friends who have so well supported you – & you are so affectionate & so kind (which I am now reaping) as to come to me not for a life of pleasure but privation – not to oppose the habits of industry of a student but to solace them.[39]

If Constable displayed a fine appreciation of what their life together might signify he was not so understanding of Maria's concern over her wedding dress. 'You talk about clothes. I wish not to interfere – I always wear black myself & think you look well in it, but I should (say) the less we cumber ourselves in that way the better.' That was on 15 September. The following day came Maria's dutiful inquiry about 'how long your family remain in mourning, you cannot think that I would wear black for any other occasion, for I dislike it very much'. But subfusc was John's choice. 19 September 1816: 'I like black best – do as you like – but I should think it advisable not to spend your money in clothes, for we have it not to waste, in plumb cake, or any nonsense whatever.'

Maria was spending her last few weeks as a spinster uncomfortably at Putney. Her sister Louisa 'is very angry both with you and with me' and 'hardly speaks'. Her only friend was her aunt, Mrs Arnold, who 'really *can enter a little into my present feelings*'. Maria was defying her father for probably the first time in her life. 'Papa is averse to everything I propose . . . I hope we are not going to do a very foolish thing . . . *Once more* and for the *last time*, it is not too late to follow Papa's advice and wait.' Any residual sympathy Constable may have felt for Maria's father had now evaporated. He told Maria that he would write to Mr Bicknell, 'but not because I think he deserves it – for I find he has quite lost himself with the Doctor who treats him with every indignity. How wretched.'*

*Since the death of Maria's mother Mr Bicknell had been besieged by the lady who had nursed his wife, Mrs Mary Christian Burminster (or Burmister). At first Mrs Burminster was regarded as a valued member of the Bicknell family circle, but it eventually became apparent that she was intent on becoming the third Mrs Charles Bicknell. Maria once referred ironically to 'the amiable Mrs Burminster'. It became a family rule that the old couple were never to be left alone together – 'without Mrs. B. is determined to *ravish Papa*, in Catherine's absence', Constable wrote to Maria. (JCC II, letter dated 9 May 1819). Mrs Burminster continued to be a reluctantly accepted appendage to the Bicknell family, and for her devotion was rewarded with a legacy from her unresponsive quarry on his death in 1828.

In East Bergholt the villagers watched every move in this rare drama of forbidden love. How Dunthorne, despite his banishment, must have cheered the victors in this pitched battle between love and religion. 'I am receiving congratulations from my neighbours on being a married man.' Even the Rector's friend Mrs Everard wished them well. The village must have delighted in this public rebuttal of the Reverend Doctor and all that he stood for.

I was in the street by the shops with old Driffield walking, when we met the old Doctor & Farnhams full [face] & I had a gracious bow from the Doctor – & Thomas was laughing on the box.[40]

Constable was being importuned, as he expressed it, to complete a portrait of an ailing clergyman in Woodbridge, 'but the smallest hint from you to come sooner will be obeyed in an instant'. He suggested that they should meet at Spring Garden Terrace on Saturday 28 September, but Maria would have none of it:

There will not be the least use in my being in town on Saturday, because I should be obliged to leave it again, soon after the time you mention, indeed I know of no other plan but of my leaving here early on Monday. Mrs. Arnold will come with me, and we will be with you in Charlotte Street, as soon as we can.

As we have much *to arrange*, it would be very unpleasant to you to come here for Papa will be here he is in town Friday. I am sorry that day does not suit you, but never mind, we shall soon finish with all these tiresome worrying plans, or they *will drive me wild*, these few days are and will be wretched.[41]

The discomfort of Maria's last days as a spinster continued until the night before the wedding when she had a row with her father. Perhaps imbued with a lately found decisiveness, she dealt with him summarily. 'Warm words passed on both sides', but there was to be no eleventh hour reconciliation.

John Constable and Maria Elizabeth Bicknell were married by Archdeacon Fisher in St Martin-in-the-Fields on Wednesday 2 October 1816. There were no fanfares to proclaim the joining of 'this man' to 'this woman'. The bleakness of the ceremony must have been painful to a courageous bride who, after all, was committing a rank disobedience on her father's doorstep. St Martin's was the family parish church: its bells could be heard and its spire could be seen by the residents of Spring Garden Terrace. Maria from her girlhood days must surely have imagined a grand occasion with St Martin's filled with friendly faces, the ceremony perhaps

G

conducted by her grandfather; rejoicings in the family home until the post-chaise arrived to take her away to a new life with a husband approved by all. So it could have been, so it would have been but for the persistence of the man she chose to marry. But there was no feast. There were no hands stretching out to grasp theirs other than those of the man who had discharged his duty and the two comparative strangers who had witnessed its performance. And when they departed, there were left to contemplate the future only a man and his wife and his friend.

5

1816-1823

My landscape and
my children

It was at the vicarage at Osmington in Dorset that John and Maria Constable spent their honeymoon. They travelled gently to Dorset staying for a few days near Southampton before journeying on to Osmington where they were welcomed by the Fishers. For six weeks in the autumn of 1816 the tiny vicarage sheltered a not particularly successful painter aged forty – a man of little education, diffident, tending to melancholy, with no interests outside his profession; his champion, aged twenty-eight, with the confidence that stems from unimpeachable lineage and a classical education; and their wives, both more of an age than their husbands, hailing from similar backgrounds and possessed of the assumptions of their class. Having endured several summers when her prospective husband found it necessary 'to get into Suffolk' Maria would not have been unduly perturbed by the frequency with which her husband and his friend sought to escape to the 'wonderfully wild and sublime' country around Osmington. The young wives seemed content to remain in the cramped vicarage to compare notes upon the conduct of marriage.

The village of Osmington is situated among the chalk hills of Dorset, a few miles east of Weymouth. The underlying chalk of the

area had been exposed in 1815 when a huge effigy of a mounted George III had been hacked out of the hill overlooking the village; a tribute from the burghers of Weymouth to a monarch whose patronage of the town had improved its status both socially and economically. Because it was Fisher's home, Constable felt an affinity with Osmington and the surrounding country; and as with Bergholt he was content to confine himself, not quite within sight of the vicarage windows, but certainly never more than a few miles away. The two men – perhaps occasionally with their wives – spent much of their time on the beaches around Osmington. Apart from sketching in oils, pencil and once in water colours, Constable began portraits of his hosts, but they, like others before and after them, had to wait several months for the pictures to be completed. Although Constable never visited the scene of his honeymoon again, Osmington joined Bergholt and Salisbury (and later Hampstead) as one of the few places that he returned to at his easel.[1]

At the beginning of December the Constables began their leisurely return to London. After spending a week with the Bishop of Salisbury they travelled to Binfield in Berkshire where they broke their journey to stay with Mary Fisher's parents, Dr and Mrs Cookson. On 9 December 1816, Mr and Mrs John Constable began their married life in the painter's rooms in Charlotte Street.

Their marriage was regarded as an accomplished fact by all but Dr Rhudde. He refused to unbend. A proposal that they should spend Christmas at East Bergholt was met with the Rector's remark that he could not avoid seeing the couple in God's house, but that he could in his own; he suggested that they should come in his absence. The triumphal return of the newly-wed couple was duly postponed. Abram and his sisters continued the diplomatic behaviour of their mother and tried to placate the Doctor whenever they could. Ann remarked that 'no good can result from War, with a stronger power'. She was sympathetic towards Mr Bicknell who is 'obliged to submit to the Doctor's tyrranical yoke'. Towards the Constable family Dr Rhudde was 'remarkably kind and friendly'; he even sent Thomas down to East Bergholt House with a turkey at Christmas. The gift brought an avuncular homily from Abram who now regarded himself as confirmed in his role as head of the Bergholt family.

We look upon it as a peace offering and pray for [good] effect; & are all of us determined to keep in with him without losing our freedom, & to avoid irritating him, as well as for his sake as for our own and those

most *dear to us*, & am I taking upon myself too much by earnestly requesting the same line of conduct from you? . . .

We must treat different disorders, in different manners, & when disorders put on great *irritability*, approaching to *insanity*, we must endeavour to *calm*, & not to *irritate*.[2]

The painter and his wife began the year in the knowledge that by the late summer room would have to be found in the Charlotte Street lodgings for a nursery. The Rector would hardly have known of his grand-daughter's pregnancy as early as January, but later having learned from Travis that Constable intended to make some form of apology to both himself and Mr Bicknell he pronounced himself 'ready to do all in his power to make you and yours happy'. The Rector was apparently enjoying a jovial and forgiving interval and assured Travis that he waited only for 'a proper apology'; he did not wish Constable to 'degrade himself'. Constable wrote to Dr Rhudde, but the letter was an unconvincing attempt at an apology made by a stubborn man, concerned to preserve his self-respect, who considered that he had no reason to make one. 'If you can see a simple apology in that letter', Dr Rhudde remarked to Travis, 'it is more than I can.' The Rector required nothing less than a genuflection if he was to unbend for he suspected that he had become a figure of fun to Constable. 'The Doctor says you laugh at him at Church, and drew caracatures.' Would that he had that we could gain a glimpse of the tantalizingly shadowy figure who for a decade loomed over Constable's life like one of his own lowering clouds. His subsequent letter seems to have been graced with the required humility. Any hope Constable might have entertained that the prospect of becoming a great-grandfather might have mellowed the Rector were abruptly ended in February when Maria miscarried. By then Dr Rhudde was 'still in a state of anger & shows no disposition to reconciliation'. At the end of March, however, he made his will which provided for any children born to the couple.

Constable meanwhile was hard at work on his pictures for Somerset House. His principal contribution in 1817, *Flatford Mill on the River Stour*, now in the Tate Gallery, was probably the largest canvas he had completed at this time. It depicts one of those scenes that had been in his mind 'before I ever touched a pencil'. The principal action is in the foreground: a boy astride the horse which, in towing a barge away from the mill, appears to be waiting for the bargeman to shout to him to move on. It is a patchwork of carefully

finished elements, but it lacks the unity of the larger canvases that were to follow. His other exhibits were *Wivenhoe Park*, one of the pictures he had done in the previous year for General Rebow, *A Cottage*, and his honeymoon portrait of John Fisher. The unenthusiastic critic of the *Literary Gazette* managed to rouse himself enough to remark on Constable's 'very improved style'.

By the beginning of May Maria was again pregnant and it became clear that the lodgings at Charlotte Street could not long remain their home. By June the prospective father had found a suitable house – No. 1, Keppel Street, not far from the British Museum – which he took for seven years at an inclusive rent of about £100 a year. Farington approved:

Constable called: had taken the house at 1 Keppel Street and had made a calculation of his probable expences which I reckoned would be £350. – Thus having himself £200 per annum and Mr. Bicknell allowing his wife £50, making altogether £250, he should have to get £100 only to meet his annual expences.[3]

Constable does not seem to have been working particularly hard at this time; he was able to visit the Academy every day and he was preoccupied with planning the decoration of the new house. He took much delight in showing his friends and relatives by marriage around their new home. He did not stint his time seeking the items that Maria wanted: a reasonably-priced Canterbury continued to elude him despite some diligent searching among the alleys of Bloomsbury.

Maria's pregnancy coming so soon after her miscarriage undermined her health. For her complete recovery Ann and Mary Constable recommended 'Bergholt Air, which we think accompanied by you, and with your care cannot fail to being beneficial'. It was to be their first visit to Suffolk as a married couple; they stayed there for about ten weeks. As usual, Constable's purpose was to gather material for the winter. His marriage did not seem to affect his application to the task: dated drawings and sketches tell us that he was out and about at Dedham, Mistley, Colchester, and Ipswich. Maria would have spent a quiet summer whiling away the time in sisterly intercourse with Ann and Mary Constable.

Constable returned to London at the end of October to a task which he loathed: preparing the ground for his long-delayed promotion to Associate of the Royal Academy at the elections to be held on 3 November. Farington had given him every reason to

believe that this year would see his election secured. He wanted professional recognition as much as any of his fellow-painters, but he was unworldly enough to believe that it could and would be given to him on the strength of his work alone. With his aversion to any activity which smacked of chicanery or 'politicking', Constable would have been the despair of Farington. An able promoter, he would have urged his man's claim only to find no doubt that the candidate knocked only reluctantly upon the doors of the powerful men of the Academy. Being human as well as powerful, they would tend to support a man with whom they had taken a pleasant dish of tea rather than one who had remained aloof.

In 1817 there were two vacancies for Associateships. Constable put up a dismal showing in the first ballot gaining only three votes which made a further ballot unnecessary and a sculptor, Edward Hodges Baily, was elected. The second vacancy was filled by Abraham Cooper who painted mostly animals and battles, but at least the matter went to a second ballot in which Constable gained eight votes compared with only five in the first. He imparted the smarting news of his defeat to Maria who, though sympathetic, would have had thoughts only for an event which could not be more than a month away.

'Ruysdael House', as Fisher had named the Constable home, saw the birth of John Charles on 4 December 1817 at about 9 o'clock in the morning. The arrival of his first-born ushered in what Constable recalled as 'the five happiest years of my life'. Told by Travis that he was now a great-grandfather Dr Rhudde 'seem'd not displeased, but said, "You must now approach me with additional respect, as I am a Patriarch".' Constable was inordinately proud at being a father for the first time. Later his response to a friend's baby was that 'it is a nice little baby — but no more to compare with our sweet duck than if it did not belong to the species . . .'. And Leslie recalled that Constable's first-born 'might be seen almost as often in his arms as in those of his nurse, or even his mother. His fondness for children exceeded, indeed, that of any man I ever knew.'

Constable's friendship with Charles Robert Leslie began in about 1817. Their friendship was well enough established when John Charles was an infant for Leslie to call on Constable at Keppel Street. Leslie was then a young man of twenty-three. Although he had been born in London he had spent most of his life in Philadelphia; his forbears were of Scottish and English origin, but his

parents came from Maryland and Leslie regarded himself as an American. As a youth he had wanted to be a painter, but it was decided that he should be apprenticed to a publisher in Philadelphia. His artistic ability was such that his employer raised a public subscription in the city to enable his apprentice to study art in Europe.

Leslie came to London in 1811 armed with introductions to Benjamin West, himself an American, and Sir William Beechey, R.A. He entered the Royal Academy Schools in the following year and was soon winning silver medals for drawing. During his early years as a professional painter Leslie relied largely on the friendship of fellow American painters then working in London – men such as Washington Allston, Samuel Morse, Charles King and Gilbert Stuart Newton; the American writer Washington Irving was also a close friend. He came to know Samuel Taylor Coleridge through a chance meeting in an inn; he also was a friend of Charles Lamb and Sydney Smith. Leslie's interest lay in depicting scenes from history or the drama and portraits; not surprisingly perhaps his friendship with Constable was slow to develop.

I had been for some time what is called *acquainted* with Constable, but it was only by degrees and in the course of years that I became really acquainted either with his worth as a man, or his true value as an artist. My taste was very faulty and long in forming; and of landscape, which I had never studied, I really knew nothing, or worse than nothing, for I admired, as poetical, styles which I now see to be mannered, conventional, or extravagant. But the more I knew of Constable, the more I regretted that I had not known him at the commencement of my studies.[4]

In January 1818 Constable sent to the British Institution exhibition the two paintings – *Flatford Mill* and *A Cottage (in a cornfield)* – which had appeared at Somerset House in the previous year; this was a common practice and gave painters with works on their hands a second opportunity of finding a buyer. It is likely that Farington was referring to these pictures when he wrote that 'Constable has sold two of his landscapes — one for 45 guineas & the other for 20 guineas. I recommended him to dispose of his pictures at moderate prices rather than keep them on his hands, as it would be for his advantage to have them distributed. — He said he had attended to my advice.'[5] Perhaps because of the demands of marriage and parenthood Constable did not, according to Farington, have 'any principal work in hand' by the end of January. But he either drew

on what must have been a small reserve of works suitable for exhibition or – and knowing Constable's later practice this is more likely – he put in many long and arduous hours in his painting room during February and March. He was represented at the 1818 Exhibition by four landscapes and two drawings, *A Gothic Porch* and *Elms*; the landscapes have not been identified.

For the first time for many years Constable was unable to spend a lengthy uninterrupted spell in Suffolk. He seems to have remained in London where he had several portraits to complete; he could no longer afford to regard his 'jobs' with quite the disdain of his bachelor days. His visits to Bergholt – in May and October – were brief and mainly concerned with family business. East Bergholt House was not finally disposed of until October. That his childhood home would no longer be in the hands of a Constable was particularly saddening; the cord attaching him to his 'native scenes' had finally been cut.

I never enter this dear village without many regrets – the affecting sentiment of this roof containing now no more those who nourished my childhood & indulged my early years in almost every wish. The thoughts of these dear memories fill my eyes with tears. . . .[6]

Although Dr Rhudde was far from reconciled to the fact that his grand-daughter was now Mrs John Constable, the Rector and his prejudices impinged on their lives now hardly at all. Constable, probably to please Maria, again attempted to make peace with the Rectory. While his letter did not ameliorate the situation the Rector's response indicated that he wanted to find a way out of his dilemma without losing face. Bypassing Travis, Abram Constable button-holed Thomas:

I ask'd him if the Doctor receiv'd your letter, he said 'Yes'. I reply'd it will do no good, his answer 'It has done no harm, if it was not for some other people, the Doctor would not be so bad.' I said it was a pity the Doctor should be so wicked, as to persist in evil at the instigation of others. I can't learn that he had mentioned the subject, or your name to any one . . .

Mary C[onstable] drank Tea at Mrs. Everard's; about eight Wainewright came in, & soon said 'how very *flat* & dull the Doctor was, he could get no conversation, so soon came away. The Doctor's *spirits* were lower than he ever saw them, could not think the reason, did Mrs. Everard know?' No, then what could it be, says Mrs. E., perhaps some letter has done it; not a word from Mary all this time.

I think the *draft* took some effect by all this—but as to any real good I am not at all sanguine. Ann & Mary call'd on the Doctor the other morning, but the subject was not touch'd upon, he was as civil as usual.[7]

When Constable went down to East Bergholt on 6 May 1819 he found that 'the bell was tolling' for the Rector who had died that morning. Now that he was dead it was of course the devolution of Dr Rhudde's considerable fortune which kept his name and his memory alive, but only for a few months.

Dr Rhudde left his personal estate to his trustees who were to transfer to each of his grandchildren (Samuel, Louisa and Catherine Bicknell, and Maria Constable) four thousand pounds' worth of stock. Catherine's inheritance was governed by the characteristic proviso that she was to marry with her father's consent:

. . . the hand of providence has been with us in the Doctor's will. You are now like your sisters & we have nothing to do with the justness or otherwise of it—that rests with *those* who made it—it is considered a very unjust will, but we have no reason to complain.[8]

Mrs Farnham – the Doctor's younger daughter Harriet and the person most likely to have influenced her father – benefited through the £5000 left to her husband under a marriage settlement. The execution of the will, insofar as it affected Maria, was slightly delayed by a proposal of the Trustees, advised by Mr Bicknell, that the £120 per annum Maria was to receive should be settled on her and the children. Constable sought Farington's advice and said that Maria herself was against it. 'He said she had expressed a dislike to settling any thing upon children as it went to render them independent of their parents.' Maria had her way and it was left to Constable to negotiate with his father-in-law for the income to be transferred to Maria and himself jointly.

At Dr Rhudde's sale during the summer, the Constable spinsters, intent on establishing separate homes, both found bargains, but Abram remarked that 'not having a commission we did not purchase any thing for you, even as a *remembrance*, well knowing you were not likely to forget him'. No eulogies of the man who had been for thirty-seven years the Rector of Brantham with Bergholt and of Great-Wenham seem to have been written for either the Suffolk or the metropolitan journals. Dr Durand Rhudde seems to have died quite unlamented by his flock; the mood of the village was captured

in Abram's terse report: 'We never hear the Doctor's name men-
tion'd in any way whatever, *clean gone.*'

Mr Bicknell decided that Constable's financial position had
improved sufficiently for him to cease paying Maria her annual
allowance of £50. 'One good picture will bring that up', wrote
Abram, 'so never mind, don't fall out if you can help it.' The
overall increase in Constable's income thus amounted to £70, but
this was of course in addition to his share of the proceeds from the
sale of East Bergholt House; the sale figure is unlikely to have been
much less than £6000. While far from turning him into a wealthy
man, this accession of capital would have done much to relieve the
anxieties of a forty-three-year-old painter who had yet to receive a
substantial figure for one of his paintings.

The early months of 1819 – and probably much of the autumn
of the previous year – found Constable at work on the largest
picture he had ever attempted: *The White Horse*. It was the first
of the 'six foot' canvases on which he believed his future reputation
would rest; and in 1819, the year of its unveiling at the Academy,
it led directly to the recognition he had been seeking.

The White Horse depicts a manoeuvre which Constable must have
known from his boyhood; indeed, he later told John Fisher, its first
owner, that it was 'one of the strongest instances' in his work of
pictures he had thought of as a child. At a point on the River Stour
between Dedham and Flatford the towpath was interrupted on one
bank because of the entry of a number of tributaries and continued
on the opposite bank. The changeover was a complicated operation
for the bargeman. He had first to persuade the towhorse – a grey
in Constable's picture – to take a ride in the barge as it was pulled
across the river. Provided the horse relinquished its brief experience
of leisure the voyage could continue. It was a sight that Constable
as a boy must have witnessed on countless occasions. It proved to
be a popular picture.

'What a grasp of everything beautiful in rural scenery', exclaimed
the *Literary Chronicle*. 'This young artist is rising fast in reputation',
the journal continued, '& we predict that he soon will be at the very
top of that line of art of which the present picture forms so beautiful
an ornament.'[*9] Fisher, who visited the Exhibition during May,
was so impressed by *The White Horse* that he wrote to Constable
inquiring the price (he referred to the work as 'Life and the pale

*Constable was 43.

horse', a reference to one of President West's mammoth works, *Death and the Pale Horse*). Constable, not realizing that Fisher himself wanted to buy the picture, replied that it was '100 Guineas exclusive of the frame'. He added that he still wished to carry out further work on it – increasingly becoming his practice with large works – before it was put on public view again at the British Institution. Fisher was not a rich man – in fact, he paid for the painting over several months – but in buying a picture for which Constable had especial regard he performed an act of generous patronage that the artist never forgot.

The ties between the rising young churchman and the painter were further strengthened in August when Constable conveyed 'our united wish' to Fisher that he should become godfather to Maria Louisa Constable who had been born on 19 July. Fisher of course acceded in his amiable way: 'I shall be delighted to be enrolled godfather on the first page of your family bible. I will endeavour to do my duty as such: and as a reward shall go down to posterity when all the relics of "John Constable" are eagerly bought up as was the arm chair of Huntington & the easil of Sir Joshua.' It is remarks such as this which indicate that Fisher was second only to Constable himself in possessing the vision to see that his ideas were ahead of their time and that he might not achieve contemporary fame. It was a view shared by Abram: 'I always think your pictures will fetch more, when there can be no more of them painted, a far distant day I trust.'

The friendship between Constable and Fisher had had little opportunity to mature. They had met for lengthy periods only at Salisbury in 1811 and during the honeymoon at Osmington; they had maintained an occasional correspondence, but their meetings occurred now only when church or family business brought Fisher to London. But theirs was a rare friendship.

If you do not come & pay me a visit this Autumn I will never forgive you. Recollect I never come to London without coming to see you, nor travel from the West End of the town to the Charterhouse without calling at the half way house. . . . Mem. I have a painting apparatus complete. Brushes clean & pallet set. Colours fresh ground every morning &c &c. . .[10]

Fisher knew how to bait the hook, and pressed his invitation in a letter which illustrates his total devotion to the cause of John Constable:

A man with an ugly face the name of Shepherd has been sketching

the Bishops Palace to illustrate B[isho]p Burnets history of his own times. I thought him but an every day man: but he spoke well of your works without knowing that I was acquainted with you—Pray come hither for a day or two if you can. I like your conversation better than any mans—and it is few people I love to talk to. Life is short let us live together while we can; before our faculties get benumbed.—[11]

But there would be no visit to Salisbury this year. Maria was slow to recover from the birth of 'Minna', as she was called; her condition and also that of John Charles, who was never to attain robust health, alarmed Constable enough for him to seek the fresher air available in the country to the north of London. For two or three months in the late summer and autumn he rented Albion Cottage on Hampstead Heath. During this period Constable divided his time between Keppel Street, from where he was conducting his desultory campaign for his A.R.A., Hampstead and Suffolk where he spent several days immediately before that year's election.

Constable would have returned to London confident that *The White Horse* indicated an advance in his work and that this would weigh with the Academicians. He confided in Farington shortly before the election that 'he had no expectation that Callcott would ever vote for him: and that Phillips had recommended to him to study Turner's "Drawing Book", to learn how to make a whole'. It was Thomas Phillips who had earlier remarked to Farington that Constable had 'produced his best picture at the last Exhibition, but he is still an artist unsettled in his practice, though what he does is his own'.[12] Farington seems to have considered supporting Samuel Lane for the vacancy and it may have been to resolve his dilemma that Lane stood down as a candidate, as he told his friend and rival some twelve years later.

At Somerset House only about a dozen Academicians gathered on 1 November to decide upon whom they would bestow the coveted distinction. There were two vacancies, one of them reserved for an engraver. Constable's principal competitor was Charles Robert Leslie. If Farington were right in his diagnosis of the Academical kidney – that 'painters of history and subjects of character would be regarded as the most eligible' – then Leslie would have been favourite. But in the first ballot the voting was almost equal: Constable six, Leslie five. The second ballot enabled Constable to sign his work, as he did for a time, 'J. Constable, A.R.A.'

There were congratulations from Suffolk, Spring Garden Terrace, and his fellow candidates on his grossly belated elevation. It was

Fisher's note on his 'honourable election' that must have pleased him most:

> Honourable it is: for the Royal Academy is in the first place an estab-lishment of the great country such as to be held in great respect: and in the second place you owe your place in it to no favour but solely to your own unsupported unpatronised merits.—I reckon it no small feather in my cap that I have had the sagacity to find them out.—[13]

While Constable was gratified by the honour, he probably gained greater satisfaction from having in some measure proved himself to Maria. There were few practical advantages: an A.R.A. could expect a few extra guineas on the price of his work; it conferred certain voting rights within the Academy and enabled him to aspire to the majestic style and title of Royal Academician. Only a seer of unimaginable gifts could have divined that posterity – those 'to whom I look for fame' – would be indifferent to the letters that he was so grudgingly permitted to append to his name.

George III died in the first month of the new year throwing the country into a constitutional crisis which served to polarize the dissent that lay beneath the surface of the comparatively docile fabric of English society. The accession of the Regent, now George IV, ushered in a period of unease and dissatisfaction. During the Regency the new king, as Prince of Wales, had not endeared himself to the people. With his extra-marital adventures and his cruel attempts to discard his wife, the Princess Caroline, he had not displayed the unimpeachable standard of moral behaviour demanded of an English monarch. Princess Caroline, who was now demanding to be regarded as Queen, was the mother of Princess Charlotte, the old pupil of the Bishop of Salisbury. She and her mother had fled to Europe in 1813. Her return to England began a popular move-ment in support of her claim to be regarded as the new Queen of England. Against her supporters were ranged those who regarded Caroline as an opportunist, the wife the new king had discarded for his own reasons seven years previously and who was now attempt-ing to exploit her anomalous position as his wife. To Constable the 'Royal Strumpet' was 'the rallying point (and a very fit one) for all evil minded persons'. It was against this backdrop of monarchy in disarray – being openly attacked and ridiculed – that Constable lived through 1820 and much of the following year; indeed, the

crisis could not have been said to have been finally contained until the death of Queen Caroline in August 1821.

But of far more importance to Constable's career was the death in March of Benjamin West, the P.R.A. While West had given Constable occasional advice and encouragement, his successor, Sir Thomas Lawrence, was to prove remote and unhelpful. On attaining the Presidency Lawrence was at the height of his powers. He had spent his life portraying powerful and fashionable contemporaries. His appointment books were filled with the names of the leading families in the land. With them the new President spent his working days and much of his recreation. It is hardly surprising therefore that his taste largely coincided with that of his patrons. Lawrence was the last of the Presidents to exercise, largely unchecked, almost kingly authority over the body artistic. When his Presidency began the power of the Academy was already on the wane. Throughout the nineteenth century it continued to decline. It was Constable's misfortune, aided to a large extent by his own reverence for the Academy as the repository of all that was good in his profession, that his development should have reached the stage it had at a time when the Academy was attempting to prop up its diminishing authority. As with any such body, fearing erosion if not extinction, it could not admit of non-conformists.

By the spring of 1820 Constable had ready for that year's Academy exhibition the second of his large Stour scenes. Entitled *Landscape* in the catalogue it is now known as *Stratford Mill*. Buoyed up by his recent elevation, recalling too the unprecedented success of *The White Horse*, Constable was confident that he could repeat, perhaps improve on, the previous year's showing. Farington, usually favoured with a preview, was given short shrift: 'Constable called & spoke of a picture he has prepared for the Exhibition' he noted on 1 April, 'but has not & does not intend to consult opinion upon it'.[14]

The painting, of the same size as *The White Horse*, depicted a scene on a bend in the Stour near Stratford Mill. The mill was used for paper-making and appears to have been in a poor state of repair; for that reason alone it would have attracted Constable. In the foreground four boys are fishing – one of them appeared 'to be undergoing the agony of a bite', in the words of Sir George Beaumont. *Stratford Mill* found favour with at least one critic. *The Examiner* remarked that 'the *Landscape* by Mr. Constable has a more exact look of nature than any picture we have ever seen by an

Englishman, and has been equalled by very few of the boasted
foreigners of former days, except in finishing'.[15]

Fisher meanwhile reported the safe arrival of 'Constable's *White
Horse*' and told him with what care it had been hung:

It is hung on a level with the eye, the lower frame resting on the ogee:
in a western side light, right for the light of the picture, opposite the
fire place. It looks magnificently. My wife says that she carries her eye
from the picture to the garden & back & observes the same sort of look
in both. I have shewn it to no one & intend to say nothing about it, but
leave the public to find it out & make their own remarks.[16]

Fisher, having been denied a visit from Constable in the previous
year, twice renewed his invitation to the Close where he now had
a house of his own: he also had two children, Osmond and Mary
Emma. Assured that 'a capital nursery' awaited his children, the
Constable family set out on the sixteen-hour journey to Salisbury
during the first week of July.

While John Fisher was not destined to possess a Bishop's mitre,
his family connections in the Church ensured that he could look
forward to an untroubled career of effortless advancement as the
placeman of his uncle, the Bishop. Vicar of Osmington, Archdeacon
of Berkshire, Fisher had been appointed a canon residentiary of
Salisbury Cathedral in 1819 at the age of thirty-two. With the
office went a spacious house in the Close named Leydenhall; its
ample garden was bordered by the River Avon. For a man of a
retiring disposition the office of canon residentiary had one serious
flaw: during his annual period of residence in the Close he was
expected to entertain and be entertained by his brother canons and
other Cathedral office-holders. After ninety days of punishing hospi-
tality, with subjects for conversation necessarily dwindling as the
period wore on, Fisher would have been glad enough for the com-
pany of his painter friend from London so that they could indulge
in long conversations about 'the art'. It was not long before Fisher
had had his fill:

And what is not a little remarkable, so belly devoted are the good
people here, that they look upon it as a sort of *duty* imposed on the Canons
in residence, to dine out or give a dinner every day as punctually as he
goes to Church.—However, I have lately resolutely closed my mouth
on meat & wine, so that these dinner attendances are only loss of time &
loss of patience, without loss of health.[17]

A house for life in the Cathedral Close was not all that had fallen

into Fisher's hands. Through a judicious shuffling of prebends by his uncle he acquired that of Fordington with Writhlington, ceded Hurstbourn, and became Vicar of Gillingham in Dorset. Such preferment of course brought with it material advantages, sufficient to finance the quarter-year's far from inexpensive gatherings on a scale appropriate to a nephew of the Bishop; Fisher estimated that it had cost him £4000 in his first year as canon residentiary.

The Constables stayed with the Fishers for about seven weeks. The pattern of their days largely followed that of the honeymoon four years earlier: for the two friends, forays for paintable subjects in the surrounding country – Old Sarum, Stonehenge, Harnham and Gillingham – while the young mothers coped with their children in the canon's grand house in the Close. The Close itself, where Constable painted in the open air, yielded several pictures, among them *The Garden at Leydenhall,* or *Salisbury Cathedral from the River.*

Constable returned with his family to London towards the end of August, and took another house in Hampstead. Fisher was concerned that he might be living beyond his income: 'Get rid of your *two* houses as soon as ever the hot weather is over & paint some portraits, you will then keep yourself independent of the world & may consult your own taste only for Landscape.' Constable would not concede that having two houses was an extravagance, least of all to a man who had three. Abram, who had a sharp eye for extravagance or financial vagueness in his elder brother, remarked: 'I make no doubt your house at Hampstead adds to your expenses & I fear cuts terribly into your precious time, there's the rub, but then health comes in.'

Constable left Hampstead in September to pay a short visit to Malvern Hall, possibly to make preliminary sketches for a commission he had received from Lady Dysart to paint two pictures of her old home; he was also engaged on some 'jobs' for her brother Henry Greswolde Lewis. It may have been the Malvern Hall commissions that delayed Constable beginning the work he was to send to the Academy exhibition in the following year, but the main reason was his own indecision. He had for several months been preparing sketches for a large picture representing the Royal opening of the new Waterloo Bridge. This event had taken place in 1817 and its colour and splendour had clearly caught his imagination. It had been his intention before leaving for Salisbury to work up his preliminary sketch into a full-size work. Fisher urged Constable to continue with the picture, but in November Farington swayed him

to abandon it; he advised him to prepare 'a subject more corresponding with his successful picture exhibited last May'. Soon afterwards Constable set up a six-foot canvas and boldly set down in greyish tones the substance of his best-known painting.

The study for *The Haywain*, now in the Victoria and Albert Museum, has a curiously modern appearance compared with the carefully finished work in the National Gallery which has over the years become 'part of the landscape of every English mind'.* The study suggests that it was painted by a man being carried along on the crest of an urgent wave of creative excitement. It has the appearance of hurried work, as indeed it must have been, for Constable did not begin work on it until November. The purpose of the study was not to see if it would stand up to exposure on a six-foot canvas; it was intended more as a final check on a design which he had been considering for some months. The painting was to be another representation, certainly on a larger scale than he had ever attempted before, of the view looking downstream from Flatford Mill; the house on the left – the home of Willy Lott who claimed never to have spent more than a night away from it in seventy years – looked over the water to the trees and meadows beyond. With the overall design firmly established, only details had to be amended. Young Johnny Dunthorne was despatched by Abram on a cold February day to make a drawing of a scrave or harvest wagon which was sent up to the hard-pressed painter in London. Constable brought the picture into sharper focus; he painted out the mounted figure, possibly his father, in the foreground. The attention to detail seems almost fussy; the impressionism of the study has gone, but then in 1821 impressionism was not art. But it was nevertheless this painting which would soon so impress the French. Three words were at the forefront of Constable's mind when he was at work on his large canal scenes: want of finish. Critics whose views he respected, even those he did not, all sang the same refrain, none more strongly than Farington. And Farington, more than any of Constable's friends, knew what an exhibition picture ought to look like. There were no half-measures about this. Academy pictures had to collar attention. 'Unfinished' works never would.

The winter of 1820–1 was spent in hectic endeavour preparing *The Haywain* for Somerset House. Neither Fisher nor Abram could fathom why Constable left himself so little time to complete his

*Fisher gave the picture its popular name. 'And how thrives the "haywain"?' he asked in his letter of 21 February 1821.

Academy work. 'Begin your picture earlier this year', Fisher urged, '& let your mind have time to work. You never allow yourself opportunity for correction & polish.' Abram, whose working life was ruled by the seasons, was frankly pessimistic when he saw *The Haywain* in February: 'I hope you will have your picture ready but from what I saw I have faint hopes of it, there appear'd everything to do.'

In the midst of his labours on *The Haywain*, Fisher again showed the depth of his belief in Constable by buying *Stratford Mill*. During the previous year Fisher had been involved in a legal wrangle, probably about tithes, which was decided in his favour. It is another indication of Fisher's generous nature that he decided to reward his lawyer, John Pern Tinney, by giving him one of his friend's pictures, a gesture which would benefit them both. The price was to be the same as for *The White Horse* – one hundred guineas.

Beleive – my very dear Fisher – I should almost faint by the way when I am standing before my large canvasses was I not cheered and encouraged by your friendship and approbation. I now fear (for my family's sake) I shall never be a popular artist – a Gentlemen and Ladies painter – but I am spared making a fool of myself – and your hand stretched forth teaches me to value my own natural dignity of mind (if I may say so) above all things.[18]

Constable's anxiety was further increased by Maria's confinement. Their third child Charles Golding, named after his two grandfathers, was born on 29 March. Two days after the birth Constable, showing a proper sense of priorities, confessed that he was now 'relieved of by far the greatest of my anxieties'.

On 10 April the window on the stairs of Ruysdael House was removed and *The Haywain* was passed out on its way to Somerset House. Constable did not consider it as 'grand' as *Stratford Mill* 'owing perhaps to the masses not being so impressive — the power of the Chiaro Oscuro is lessened — but it has rather a more novel look than I expected'. He intended to work on the painting for another three or four days at Somerset House. Constable told Fisher that he had heard that the exhibition was likely to be a 'capital' show, but composed mostly of historical and fancy pictures:

I hear little of Landscape—and why? The Londoners with all their ingenuity as artists know nothing of the feeling of a country life (the essence of Landscape) – any more than a hackney coach horse knows of pasture.[19]

Landscape: Noon, as it was described in the catalogue, received a
good press in those journals that noticed it; most did not. *The
Examiner* alone hailed it as a masterpiece: 'We challenge the Dutch
Masters to show us anything better than this.'[20] Fisher saw *The
Haywain* at Somerset House, but wanted to look at it again in the
calm surroundings of his friend's painting-room. 'For how can one
participate in a scene of fresh water & deep noon day shade in the
crowded copal atmosphere of the Exhibition: which is always to
me like a great pot of boiling varnish.' Because of the subsequent
history of *The Haywain* it is of more than passing interest that the
painting profoundly impressed a visiting Frenchman by the name
of Charles Nodier. He was travelling in England and Scotland with
the intention of writing an account of his experiences. May found
him in London and he went to Somerset House. His book, *Promenade
de Dieppe aux Montagnes d'Ecosse,* refers to only one painting in the
exhibition:

In painting, landscape and seaviews are the pieces in which the
English have the fewest rivals in Europe. Some of their pictures almost
surpass every idea that one can form to one's self of perfection in this
style of painting, but the palm of the exhibition belongs to a large land-
scape by Constable to which the ancient or modern masters have very
few masterpieces that could be put in opposition. Near, it is only broad
daubings of ill-laid colour which offend the touch as well as the sight, they
are so coarse and uneven. At the distance of a few steps it is picturesque
country, rustic dwellings, a low river where little waves foam over the
pebbles, a cart crossing a pond. It is water, air and sky: it is Ruysdael,
Wouwerman or Constable.[20]

Another visitor, probably more influential in France than Nodier,
was Théodore Géricault. His huge work, *The Raft of the Medusa,*
had been acclaimed in London in 1820. At Lawrence's invitation
he attended the 1821 Royal Academy Exhibition and on his return
to France expressed himself – to Delacroix and others – as quite
astounded at the sight of *The Haywain.* It would not be long before
the picture became the talk of French painters.

Constable's visits to East Bergholt were now necessarily infrequent.
His brothers and sisters were now settled in their new homes. Abram
had gone to live at Flatford Mill with Mary – who had 'done it
up so well' – as his companion; Ann Constable had the care of
Golding, who, she reported, had become morose and self-centred,

in a cottage not far from the mill.* Patty Whalley with her husband, Nathaniel and her children, Daniel and Alicia and her father-in-law had left London to live at Dedham in the cottage which old Golding had once offered to Constable. His sadness at being an outsider in his native village led him to express a wish to Maria that they should take a small house in the Vale of Dedham.

Although Suffolk, like much of the rest of the country, was suffering from agricultural depression, Abram continued to be the devoted and conscientious steward of his brothers' and sisters' capital, income and welfare. He took his responsibilities seriously; in his approach to his duties he seemed to combine the qualities of both his parents. He had an implicit trust in the Almighty and wished only to be able to 'pay all the demands thrown upon me (which are very heavy, & almost sink my spirits when I think of it), I shall be perfectly content . . . My father had sad times to contend with, in early life, he got through & so may I.' Abram was now thirty-eight and although still a bachelor he told his brother that as his business problems increased 'I begin to feel the want of a true friend to brighten the gloom.' But he never married. Abram seems to have been slightly in awe of his elder brother who was getting himself written about in the journals. He never lacked courage to issue his brother a friendly rebuke if he thought it necessary; he usually confined himself to money matters, but he occasionally touched on his brother's profession:

Johnny [Dunthorne] told me Bell's Weekly Messenger found fault with your great picture, want of finish I believe, I think another month would have given perfection, but what am I talking about? I don't understand I am sure & therefore I am silent.[21]

*In 1824 Golding showed that he too possessed his family's characteristic honesty. As a result of Constable's intercession Golding, who was an excellent shot despite his occasional fits, was given a job as steward or gamekeeper by Lady Dysart; his 'beat' was part of the Helmingham estate known as Bentley Woods near East Bergholt. Golding soon discovered that Lady Dysart's agent, a Mr Wenn, had been enriching himself by, among other things, selling timber from the woods which he formerly controlled. Wenn sought to oust Golding by alleging that he was incompetent. Lady Dysart, who was now nearly eighty, made only periodic visits to Suffolk and relied on Constable to bring her reports of her Helmingham affairs. Golding looked to his younger brother (John) to help him retain a job which he liked by combating Wenn's unfounded complaints. Only on Wenn's death in 1834 was the full extent of his dishonesty exposed. It was found that he was in serious debt, that to Lady Dysart alone amounting to £5000. Golding continued working on the Helmingham estate probably for the rest of his life. He died in 1838.

In June Constable accompanied Fisher on his archidiaconal visitation to Berkshire. Their progress, from Newbury to Reading, then on to Abingdon and Oxford provided a rare opportunity to have long talks about 'the art'. Their likes and prejudices were in complete accord and they took as much delight in bestowing approval as in demolishing the pretentious. From time to time Fisher recommended books to Constable most of which, because he respected Fisher's education, he obtained and read. One such book was the Rev. Gilbert White's *The Natural History of Selborne*:

The mind & feeling which produced the 'Selborne' is such an one as I have always envied. The single page alone of the life of Mr White leaves a more lasting impression on my mind than that of Charles the fifth or any other renowned hero—it only shows what a real love for nature will do—surely the serene & blameless life of Mr White, so different from the folly & quackery of the world, must have fitted him for such a clear & intimate view of nature. It proves the truth of Sir Joshua Reynolds' idea that the virtuous man alone has true taste.[22]

The Diary of an Invalid by Henry Matthews was another of Fisher's enthusiasms, but he may not have read the author's opinion of Gaspar Poussin when he suggested it to Constable:

Gaspar Poussin's green landscapes have no charms for me. The fact seems to be, that the delightful green of nature cannot be represented in a picture. Our own Glover had, perhaps made the greatest possible exertions to surmount the difficulty, and give with fidelity the real colours of nature; but I beleive the beauty of his pictures is in an inverse ratio to their fidelity; and that nature must be stripped of her green livery, and dressed in the browns of the painters, or confined to her own autumnal tints in order to be transferred to canvas.[23]

This passage provoked Constable to a typical example of his choler:

The Invalid (indeed he deserves the name if disease gives it) imagines defects in the Landscapes that he may afford an opportunity to *our own Glover* of remedying them—this is too bad and one would throw the book out of the window—but that its grossness is its own cure—and one is led on for the fun of the thing—to be amused with the novelty of shapes which Ignorance appears in—[24]

John Glover and his work were anathema to Constable. After Turner he was the most affluent landscape painter of the day. 'Our own Glover' remained a favourite butt of the two friends.

Fisher's letters abound with illustrations of his spirited promotion

of Constable's work. *The Haywain* prompted a friend of Fisher's – a lawyer named Coleridge – to remark that he thought 'some parts' of it were good:

I told him if [he] had said that *all* the parts were good, it would be no compliment, unless he had said the *whole* was good. Is it not strange how utterly ignorant the world is of the very first principles of painting? Here is a man of the first abilities, who knows almost everything, & yet is as little a judge of a picture as if he had been without eyes. There's Matthews again with 'his own Glover'.[25]

On another occasion a 'grand critical party' – probably the Bishop – objected to the sky in *Stratford Mill*. Fisher immediately went into action:

After talking in vain for some time, I brought them out of my portfolio two prints from Wouvermans and a Van der Neer, where the whole stress was laid on the sky, and that silenced them. While in every other profession the initiated only are judges, in painting, all men, except the blind, think themselves qualified to give an opinion. The comfort is, that the truth comes out when these self-made connoisseurs begin to buy and collect for themselves.[26]

Soon after returning from his jaunt with Fisher Constable took a house on Hampstead Heath – No. 2, Lower Terrace. Maria, apart from recovering from the birth of her third child, was also mourning the loss of her brother Samuel who had died of consumption in May at the age of twenty-three. But to Constable Hampstead in summer now represented happiness.

I am as much here [as] possible with my dear family. My placid & contented companion with her three infants are well. I have got a room at the glaziers down town as a workshop where is my large picture – and at this little place I have [sundry] small works going on – for which purpose I have cleared a small shed in the garden, which held sand, coals, mops & brooms & that is literally a coal hole, and have made it a workshop, & a place of refuge – when I am down from the house. I have done a good deal of work here.

I have fitted up my new drawing rooms in Keppel Street & intend keeping them in order, hanging up only decent works. My large picture looks well in them but I shall do more to it – indeed you will be surprized at the good looks of all my concerns, & still more when I tell you that I am going to pay my court to the world, if not for their sakes yet very much for my own. I have had experience enough to know that if a man decries himself he will find enough to take him at his word.[27]

By the end of the summer Constable had become familiar with Hampstead Heath. The Heath had shown itself to be good for him and for his family. While Maria and the children, particularly John Charles, regained health and strength Constable roamed the tracks and paths of the Heath in search of subjects. He found them in plenty. He worked out of doors with great energy during the late summer of 1821. He told Fisher: 'I have not been Idle and have made more particular and general study(s) than I have ever done in one summer. . . .' He was much taken with the trees on the Heath. Because Hampstead was on high ground the trees were nearly always in motion; it was probably the chiaroscuro effect that this produced when the sun was shining that would have particularly interested Constable:

I have done some studies, carried further than I have yet done any, particularly a natural (but highly elegant) group of trees, ashes, elms & oak &c—which will be of quite as much service as if I had bought the feild and hedge row, which contains them, and perhaps one time or another will fetch as much for my children. It is rather larger than a kit-cat, & upright. I have likewise made many *skies* and effects—for I wish it could be said of me as Fuselli says of Rembrandt, 'he followed nature in her calmest abodes and could pluck a flower on every hedge— yet he was born to cast a stedfast eye on the bolder phenomena of nature'. We have had noble clouds & effects of light & dark & color—as is always the case in such seasons as the present.[28]

Because of its elevated position Hampstead provided a good vantage point from which to see and record the shape and movement of clouds. Although Constable had from an early age an appreciation of clouds and their effect on the lighting of a landscape it seems likely that he would also have taken an interest in the scientific reasons for their formation. Clouds had recently been classified by Luke Howard in *The Climate of London* and it has been suggested that this work contributed to Constable's interest in clouds.[29] Whatever the reasons for his enthusiasm, Constable did a good deal of 'skying' at Hampstead in 1821 and 1822. In October he communicated to Fisher the results of his reflections on the place of clouds in a landscape.

That Landscape painter who does not make his skies a very material part of his composition – neglects to avail himself of one of his greatest aids. Sir Joshua Reynolds speaking of the 'Landscape' of Titian & Salvator & Claude – says '*Even their skies seem to sympathise with the Subject*', I have often been advised to consider my Sky – as a '*White Sheet drawn*

behind the Objects'. Certainly if the Sky is *obtrusive* – (as mine are) it is bad, but if they are *evaded* (as mine are not) it is worse, they must and always shall with me make an effectual part of the composition. It will be difficult to name a class of Landscape, in which the sky is not the *'key note'*, *the standard of 'Scale'*, and the chief *'Organ of Sentiment'*. You may conceive then what a *'white sheet'* would do for me, impressed as I am with these notions, and they cannot be Erroneous. The sky is the *'source of light'* in nature—and governs every thing. Even our common observations on the weather of every day are suggested by them, but it does not occur to us. Their difficulty in painting both as to composition and execution is very great, because with all their brilliancy and consequence, they ought not to come forward or be as hardly thought about in a picture—any more than extreme distances are.[30]

Soon after moving to Lower Terrace, Constable became embroiled in a dispute with a Hampstead neighbour, the landscape and portrait painter John Linnell. Relations between Constable and Linnell until 1821 were good. Despite his precociousness – he entered the Royal Academy Schools at the age of thirteen – Constable liked Linnell and could disapprove only of his non-Conformism.* Constable admired Linnell's work and had even allowed him to etch one of the drawings of Netley Abbey he had made on his honeymoon. The dispute – a trifling but painful episode which reflects badly on Constable – was brought about by a visit Constable received one morning from an amateur artist, David Charles Read, to whom he had been introduced by Fisher:

While sitting at breakfast the other morning we were surprized by the appearance of a singular figure with a portfolio under his arm. His waving locks on his shoulders, white hat, long great coat, large shoes with small buckles on the sides &c. surprized all my females, but it was poor Read the Salisbury artist—he is anxious to do something & I am glad to hear that the Miss Salesbures are kind to him. His studies have merit— could you show him civility? He has been shamefully treated by his friend (& *brother Baptist*) *little Linnell the artist.*[31]

*In 1824 Constable wrote to Fisher: 'Tinney mentioned a family greivance, his wife's sister having slunk off and married a nasty dirty stinking little Baptist preacher. What a calamity. . . .' (JCC VI, p. 161)

John Linnell, 1792–1882. Beckett suggests that it was Linnell who brought about the only recorded meeting between William Blake and Constable. 'The amiable but eccentric Blake, looking through one of Constable's sketch books, said of a beautiful drawing of an avenue of fir trees on Hampstead Heath, "Why this is not drawing, but *inspiration*": and he (Constable) replied, 'I never knew it before; I meant it for *drawing*." ' (JCC IV, p. 293)

Read seems to have alleged that when Linnell had stayed with him in Southampton in 1819 he had duped a clergyman named Thomas Allies by painting a portrait of his wife in return for two pictures said to be by Poussin and Everdingen. Mr Allies suspected sharp practice on Linnell's part and complained to Read who was himself angry with Linnell. During the same visit to Southampton Linnell and his wife and children had been his guests, but this did not inhibit him from charging Read fifteen guineas for a landscape which he had expected to be given. It was Linnell however who had helped Read to secure a post as a drawing-master at Salisbury.

This was juicy gossip. Constable passed it on to a number of his friends including William Redmore Bigg, R.A., who almost certainly shared it with his fellow Academicians at a time when it could cause the maximum damage to Linnell who was hoping shortly be to elected A.R.A. Linnell recruited William Collins, R.A., to help him persuade Constable to sign a retraction of the story.* Constable refused, but promised 'to contradict it wherever he recollected to have reported these statements'. Linnell never achieved Associate status and blamed Constable and his scandal-mongering for his non-election, but whether this incident alone can be wholly blamed is doubtful.

The perpetrator of the trouble – 'Read of the flowing locks' – continued to be a thorn in Constable's side from time to time over the next few years. He provided Fisher with some excellent material with which to tease Constable. Constable had hoped that his encouragement of Read would have enabled him to work as a drawing-master – 'to vegetate in teaching where he was — and never to set foot in London — but his extreme ignorance — & vanity — & inordinate selfishness — make him capable of any thing'. But Read had greater ambitions. He sent his pictures to Charlotte Street and importuned Sir Thomas Lawrence himself to go and see them. By 1823 Constable had tired of acting as agent, postman and warehouseman for the 'wretched Read and his wretched pictures'.

Poor Read I am uncomfortable about. 'Tis true I excited your neighbourly benevolence towards him for the sake of his innocent family—but that certainly would not have been the case—had I thought it would

* William Collins, R.A., 1788–1847 was, friendly with Constable for some years, but the friendship faded as Constable, who had little regard for Collins' work, came to believe that Collins and others – 'the Collins faction' – were opposing his attempts to become an Academician. (JCC IV, pp. 285–296)

have brought him one step nearer this dreadfull *feild of battle*, in which
so much worth, and innocence, are doomed to perish.

None of his pictures are received at the Gallery. No one for a moment
who saw them expected they would. Thus has he involved himself in no
small expence to get rid of his little local reputation. The feild of Waterloo
is a feild of mercy to ours. Would to God you & Mr Benson, that really
good man, would endeavour to use it to the advantage of his family &
prevail on him to quit a profession which he cannot fail to disgrace—

The truth must now be told *you*—which is that, he is ignorant of every
rudiment of art—without one grain of original feeling—without one
atom of talent—and—able only to do *something*—worse than *nothing* at
thirty years of age.[32]

Fisher chided Constable that he had made a mistake and that
Read was not the genius he had once thought he was:

You seem to have been something ruffled by poor Reads intrusion &
my recommendation. But really Constable it was your own fault. You
spoke to me of him as a man of feeling for the art & brought his sketches
for me to admire; & recommended him to my notice. I took you therefore
at your word, & thought he *was* an artist. Not knowing any better, I
had formed magnificent notions of the 'old Shepherd' & little expected
that the 'Gentlemen in Pall Mall' would reject it. Is it really bad, or are
you jealous & they ignorant?[33]

A few months later Fisher was still teasing Constable about the
Salisbury drawing-master. 'Will you get one of Reads six foot
canvasses into the Exhibition? It will be kind of you?' he wrote in a
letter in which he also asked Constable to look after 'a most beautiful
POODLE dog' he had bought in London until he could send someone
to collect it. He also provided Constable with a spirited description
of Read's latest works:

Read (I mean Raphael Read of Salisbury) seized me this morning
to shew me a six foot canvas he has just covered with paint. Imagine a
tint composed of blacking, rust of iron & cabbage water laid on with a
scrubbing brush. In the very center stares the Sun. In the distance
Southampton buries in an atmosphere of mud. . . . Another six foot
canvass contains: a black foreground, a bright yellow cornfield of the
colour & consistency of N. Wiltshire cheese: deep blue distance, dark
rusty sky, & a rainbow—that must be seen to be conceived. In the same
room is an original Titian he has just bought, & a copy of Ruben's boys
at Wilton by himself. He smelt of Ginn, shook his locks enthusiastically &
talked of future fame being preferable to present flattery. You are jealous
of this man, Constable.[34]

Reluctantly Constable agreed to accommodate Fisher's poodle 'but you are joking about another "6 foot" coming to London — does he drink?' Fisher had had his fun and in his next letter he let Constable off the hook. 'The six foot canvass & poodle dog coming to Charlotte Street is all poetry.'

Fisher thereafter tactfully kept any news of Read to himself. The last we hear of him is in October 1829. 'Your friend Read got exalted the other day at a wine-party, & said that it would be hereafter remarked, "here Read walked and there he sketched".' Fisher was wise enough to allay Constable's annoyance at being labelled Read's friend to add that 'report says in this place that you have founded "a school of painting".'

One of Constable's more agreeable neighbours at Hampstead was a comedy actor named Jack Bannister. He could certainly be included in Constable's small circle of friends who 'compensated by their fewness by their sincerity and their warmth'. Bannister who had been a student at the Royal Academy bought a view of Hampstead Heath having asked the painter for a landscape in which he could 'feel the wind blowing on his face. He says my landscape has something in it beyond freshness, its life, exhilaration &c. I was letting two chimney sweeps out of my door when he came on the steps. "What", he said, "brother brush".' Constable later passed on to Fisher another of Bannister's jokes, one of particular interest to a father whose eldest son Osmond was shortly to enter Eton: 'He said that at Eton there were three brothers — masters there — of the (name) of Heath. The boys named them, "Black Heath", "Blasted Heath", and the other (who flogged incessantly) – "Arse-cutt Heath".'

By the end of October Constable was preparing to vacate the house in Hampstead and return thankfully to Keppel Street. He had decided on another large Stour scene for the 1822 Exhibition, but he had found it impossible to work on it at Hampstead. He returned to London worried that he was 'behind hand with the Bridge' – his name for the painting which included the bridge near Flatford Mill. 'I am most anxious to get into my London painting room, for I do not consider myself at work without I am before a six foot canvas . . .'[35] But before settling down to a hard winter's work Constable decided to take up Fisher's standing invitation to visit him at Salisbury. He stayed at Leydenhall for about a fortnight in November. With Fisher he made excursions to Winchester to see the Cathedral – 'the most magnificent I ever saw, much more

impressive but not so beautiful as Salisbury' – and Longford Castle where Lord Radnor had an impressive collections of paintings, including several by Claude. Constable who did not enjoy lengthy separations from his family was homesick: 'But all my thoughts spite Claude & Ruysdael are with you and my dear infants.' Being surrounded by Fisher's domestic felicity was no help in allaying his feelings: 'I cannot at all enjoy these beautiful children because directly I begin to play with them it calls my own so much to mind I am obliged to leave them.'[36]

One of Constable's elderly advisers who would not be consulted about the new work was Joseph Farington who died at the end of December. Farington's death conferred one benefit, which, at first, had a certain poignancy:

I have been with my wife to look over Mr. Farington's house, which has left a deep impression on us both. I could scarcely believe that I was not to meet the elegant and dignified figure of our departed friend, where I had been so long used to see him, or hear again the wisdom that always attended his advice, which I do indeed miss greatly.[37]

Maria, now the mother of three children with a fourth expected towards the end of the summer, would have needed no persuading that they had outgrown the little house in Keppel Street. Farington's old house at 35, Charlotte Street, a much larger property, on three floors, offered an ideal alternative. They had lived like 'bottled wasps upon a southern wall', but the '5 happiest & most interesting years of my life were passed in Keppel St. I got my children and my fame in that house, neither of which would I exchange with any other man.' Fame in Constable's eyes was represented by his four large landscapes – *The White Horse, Stratford Mill, The Haywain,* and now *A View on the Stour near Dedham.* Negotiations for Farington's house continued through the first half of 1822 and it was not until the middle of June that the removal from Keppel Street was finally completed. With the house Constable also bought the two Wilson landscapes which he had copied on coming to London twenty years earlier.

Constable worked at *A View on the Stour near Dedham* in the know-ledge that the forthcoming elections of Royal Academicians – they were held in February – would intervene, so it was unlikely that the new picture could contribute to his advancement. But he could have

felt with some justification that his chances of elevation were better than ever this year. The election of 1822 however was typical of the jobbery which was slowly eroding the authority of the Academy. Constable was opposed for the first vacancy by a fellow-student of his year, Richard Cook. He had last exhibited at Somerset House in 1819 and never exhibited again. Having married a rich wife he was able to lavish on his supporters in the Royal Academy, hospitality of a richness Constable could not (and would not) match. Cook polled an overwhelming majority of votes for the first vacancy. The second vacancy went to William Daniell whose uncle was Thomas Daniell, R.A. Fisher was outraged at this fresh injustice:

I am very sorry the Academy has injured the value of its diploma's so much, since I had always a feeling of respect for the body. As far as the members can bring to a level merit & impotence, Wilkie & Daniels are now upon a par. I say nothing of you: because the title of R.A. will never weigh a straw in that balance in which you are ambitious to be found heavy, namely the judgement of posterity. You are painting for a name to be remembered hereafter: for the time when men shall talk of Wilson & Van der Neer & Ruisdale & Constable in the same breath. And do not let your vision be diverted from this North star, by the rubs & ragged edges of the world which will hitch in every mans garment as he hustles through life.[38]

Although Constable no doubt smarted at this latest rejection of his obvious claim to recognition he could take some comfort from the interest that *The Haywain* had excited across the Channel. *The Haywain* had gone on show at the British Institution in January; it was priced at one hundred and fifty guineas. One visitor to Boydell's Gallery, the home of the British Institution, was a picture dealer from Paris by the name of John Arrowsmith. He had learned on the artistic grapevine that an English painter, John Constable, was producing interesting things.

When he saw the picture Arrowsmith – a Frenchman despite his name – was either unimpressed with it or thought that he was dealing with a naive Anglo-Saxon. He offered £70. The offer was nevertheless tempting, coming as it did at a time of heavy expenditure connected with the new house; and it followed the Academy Elections. Even such an insular man as Constable could appreciate that the route to professional and popular recognition could be by way of Paris. Arrowsmith claimed he wanted the picture 'to show them the nature of the English art'. Constable confessed to Fisher that 'I hardly knew what to do – it may promote my fame &

produce commissions but it may not. It is property to my family – though I want the money dreadfully.' He eventually decided that if the French were to see his picture they would have to pay for the privilege.

I shall not let the French man have my picture. It is too bad to allow myself to be knocked down by a French man. In short it may fetch my family something one time or another & it (would be) disgracing my diploma to take so small a price & less by over one half than I asked.[39]

Arrowsmith returned to Paris without *The Haywain*. Although there is no recorded contact between Arrowsmith and Constable for over a year the interest shown by the French in English art continued to grow as it had been growing from the end of the Napoleonic wars. Constable was far more concerned to find out how his peers and the public would receive *A View on the Stour near Dedham*.

I am certain my reputation rises as a landscape painter – and that I am (as Farington always said I should be) fast becoming a distinct feature in that way. I am anxious about the picture. Clint [George Clint] my neighbour, who expects to be an Academician before me, called to see it – now he said not a word – but on leaving the room looked back and said he hoped *his picture* would not hang near it.[40]

His confidence was not reinforced by the critics: its reception was generally lukewarm and a point made by more than one writer was that the painter lacked originality in his choice of subjects.

Because Maria's health and that of the children still required Hampstead air, Constable again rented 2, Lower Terrace where their fourth child, Isabel, was born on 23 August. Constable seems to have spent his time very much as he had passed the previous year in making cloud studies on the Heath.

All these commitments were a serious drain on Constable's finances. The bulk of his income came from his own and Maria's capital and while this, augmented by the occasional sale of a landscape and 'jobs', would have been adequate for Maria and himself, it was far from enough for a family with four children, a large house in London and a summer cottage in the country. There was now no Farington to advise on the prudent disposition of an uncertain income. The absence of sound advice sent Constable into a panic; that he was only a step away from the workhouse was a frequent fear. On 13 April he applied to Fisher for a loan: '20 or 30£ would be of the greatest use to me at this time, as painting these large pictures have much impoverished me . . .'. Fisher, who had

financial problems of his own, could only manage a small loan and sent him 'the only disposeable 5£ I have in the world'. He need not have bothered. Constable's supposed crisis was averted by 17 April: 'As I told you I had been so long on unprofitable canvas that I was getting hard run – but I am now busy on some minor works which will bring things soon about again.' Fisher's shortage of money was only to be temporary for he had 'the prospect of a large sum of money soon of which you will be the partaker'. Possibly this money had come to him by October because he was sufficiently in funds to send a draft, but Constable did not see himself as a charity case. 'I am not aware that I (appealed) for the drafts — but they are acceptable — quite so.' To which Fisher tartly replied.: 'You certainly did not give the remotest hint for the draft. But I suppose I may pay my lawful debts how and when I please without consulting your leave.'

While it is true that the large Stour scenes had depleted his finances in the sense that the time and energy that they had demanded could more profitably have been spent in 'money getting', Constable was not short of either lucrative 'jobs' or enticing offers. Brother Abram had told him of a commission to paint an altar-piece for Manningtree Church for a fee of £200; jobs 'in the face way' were always to be had. The Bishop of Salisbury wanted a view of the cathedral. It was at about the time that Constable thought that he was facing possible financial ruin that Fisher's friend, John Tinney, made him a most generous offer:

He has desired me to paint as a *companion* to his landscape, another picture—at my leisure—& for 100Gns. (with the) stipulation that it must be exhibited (which will keep me to the collar). If however I am offered more for (it), even 100, I may take it & begin another for him. It will enable me to do another large work as a certainty—thus to keep up & add to my reputation. This is very noble—when all the nobility let my picture come back to me from the Gallery.[41]

This friendly gesture gave Constable the opportunity of adding up to two hundred guineas to his income in 1822. But it came to nothing. Constable claimed later in the year that the original commission for 'a companion to his other picture was appreciated though waived by him as there was really no room to be found for it'. On the face of it, Constable's refusal to take up Tinney's offer is perverse, but he could never paint landscapes to order. The four Stour scenes – including of course Tinney's *Stratford Mill* – were for

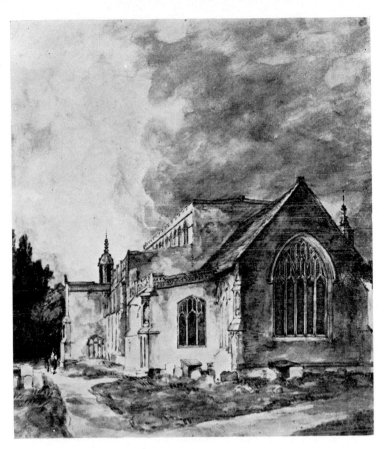

Above: East Bergholt Church. *Below*: East Bergholt Street.
Two of Constable's sketches of his native village (both
Victoria and Albert Museum).

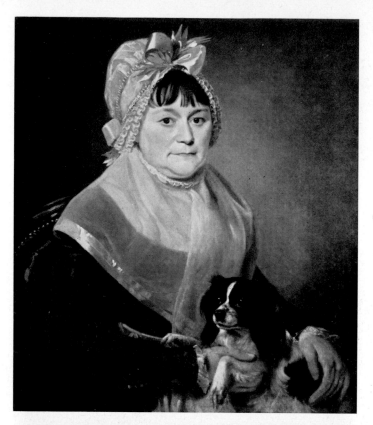

Ann Constable:
the artist's mother
(collection of Mrs
Eileen Constable)

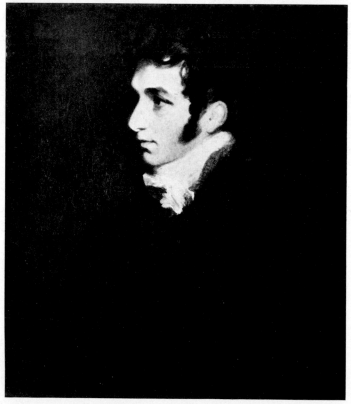

Abram Constable:
the artist's brother
(Christchurch
Museum, Ipswich)

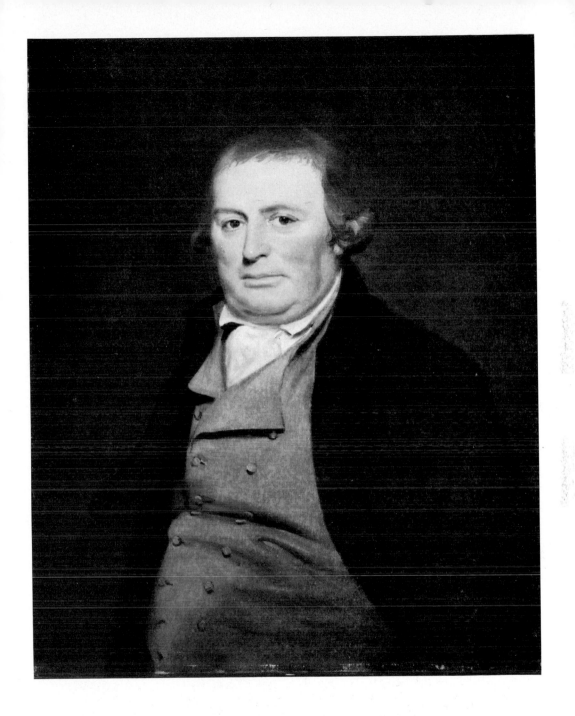

Golding Constable: the artist's father
(collection of Mrs Eileen Constable).

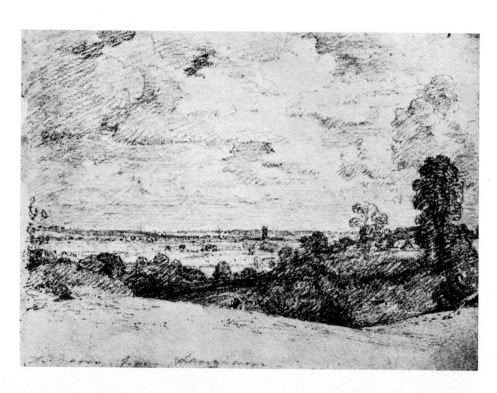

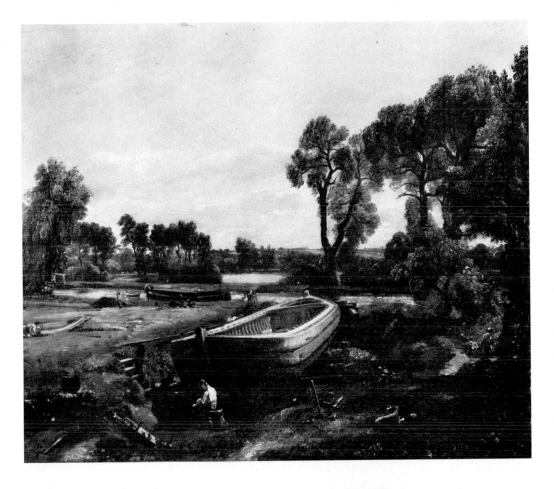

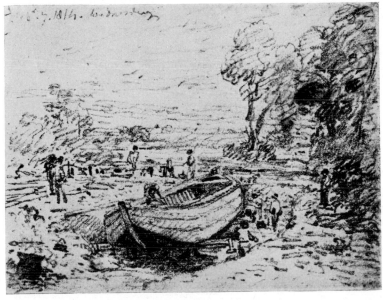

Boat-building near Flatford Mill: study and finished painting (Victoria and Albert Museum). 'I associate my "careless boyhood" to all that lies on the banks of the Stour.'

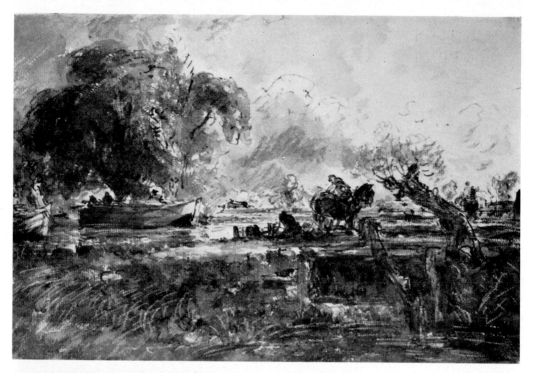

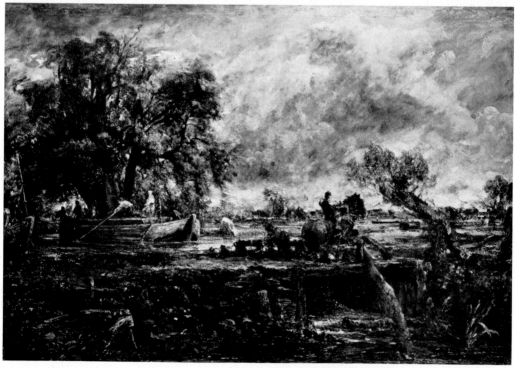

The Leaping Horse (Royal Academy). Drawing, sketch and (*right*) finished painting showing how the composition changed at different stages. 'It is a lovely subject, of the canal kind, lively – & soothing – calm and exhilarating, fresh – & blowing. . . .'

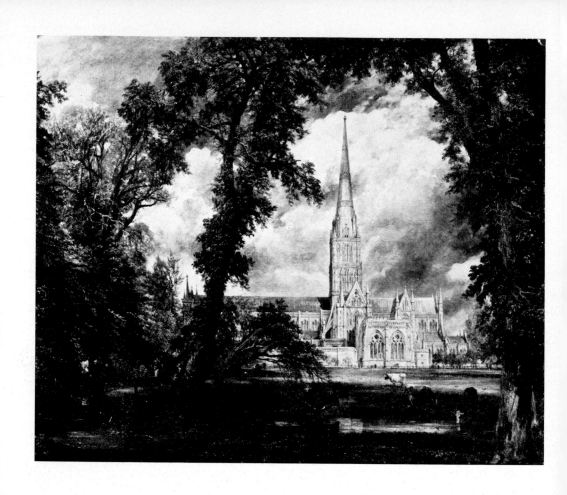

Salisbury Cathedral from the Bishop's Grounds (Victoria and Albert Museum). 'I have not flinched at the work, of the windows, buttresses, &c, &c, but I have as usual made my escape in the evanescence of the chiaroscuro.'

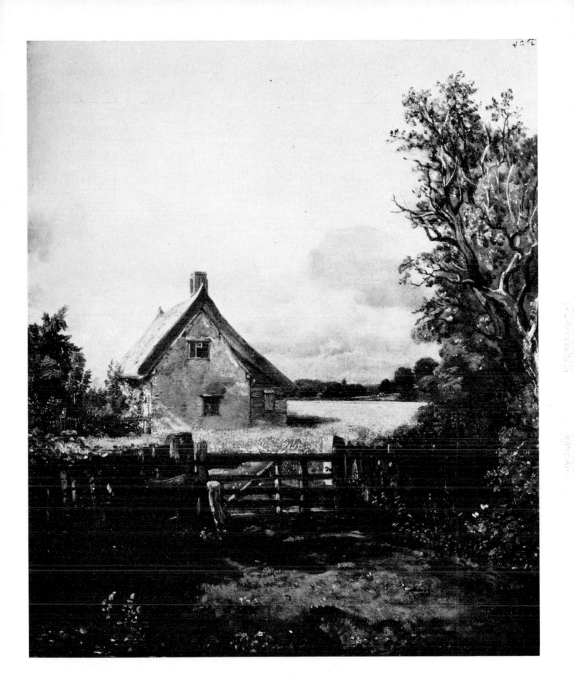

The Cottage in a Cornfield (Victoria and Albert Museum). 'I have licked up my cottage into a pretty look. . . .'

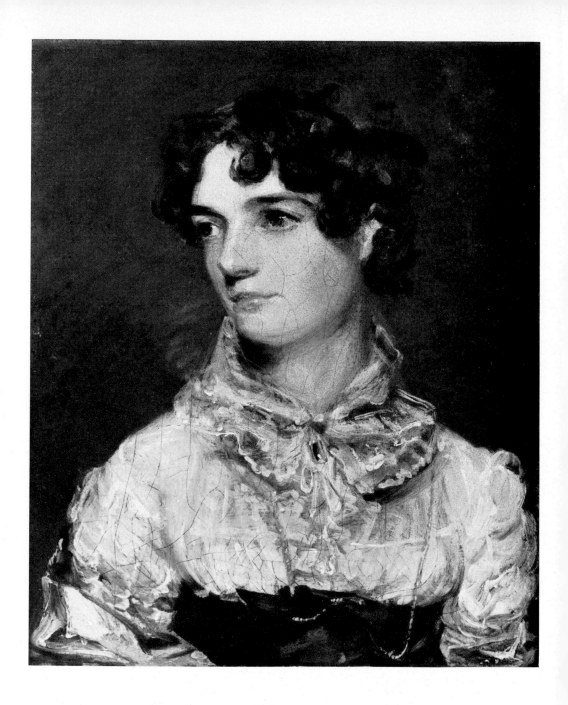

Maria Constable: the artist's wife (Tate Gallery)

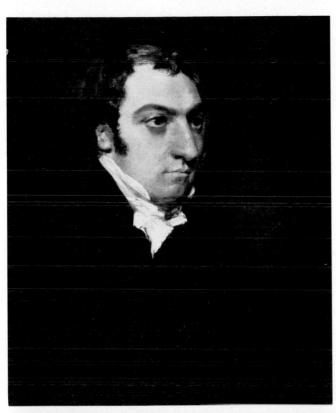

John Fisher (Fitzwilliam Museum, Cambridge). 'I should almost faint by the way when I am standing before my large canvasses was I not cheered and encouraged by your friendship and approbation.'

Charles Robert Leslie, R.A., by J. Partridge (National Portrait Gallery). 'You, my dear Leslie, what matters to me, are there.'

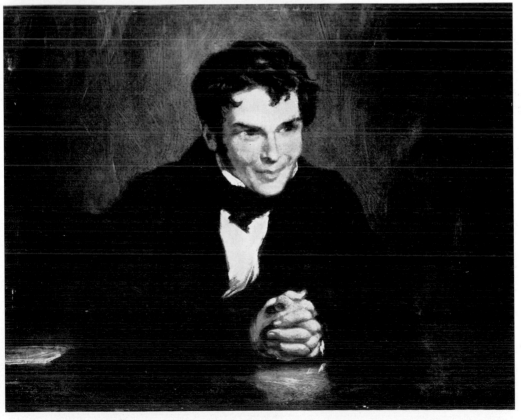

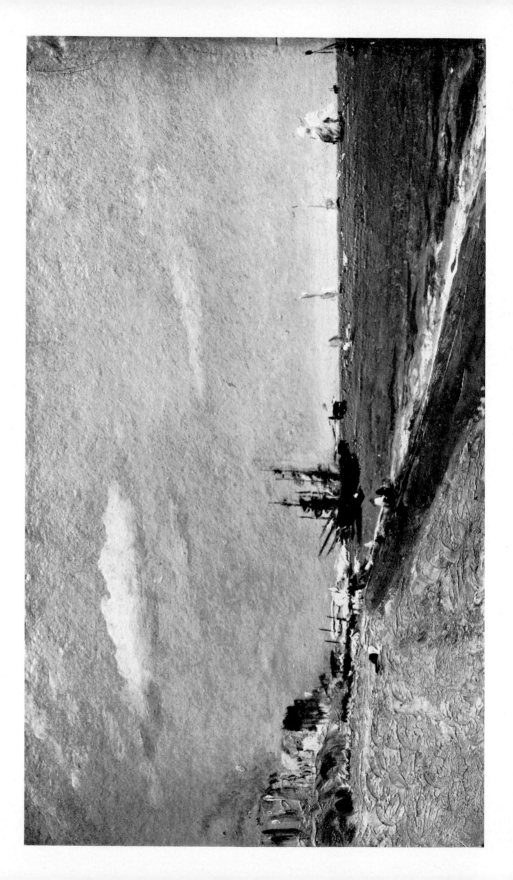

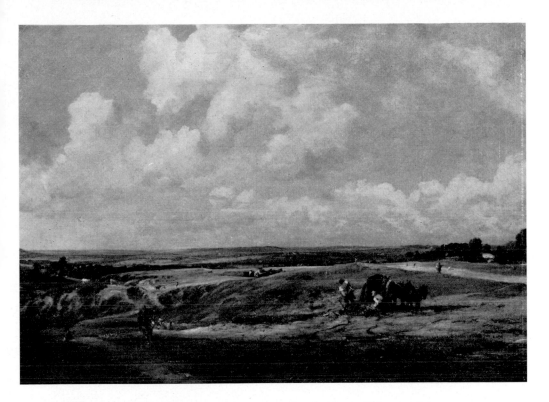

Hampstead Heath (Fitzwilliam Museum, Cambridge). 'I have often been advised to consider my Sky – as a "White Sheet drawn behind the objects." '

Brighton Beach, with colliers (Victoria and Albert Museum). 'There is nothing here for a painter but the breakers – & sky – which have been lovely indeed and always varying.'

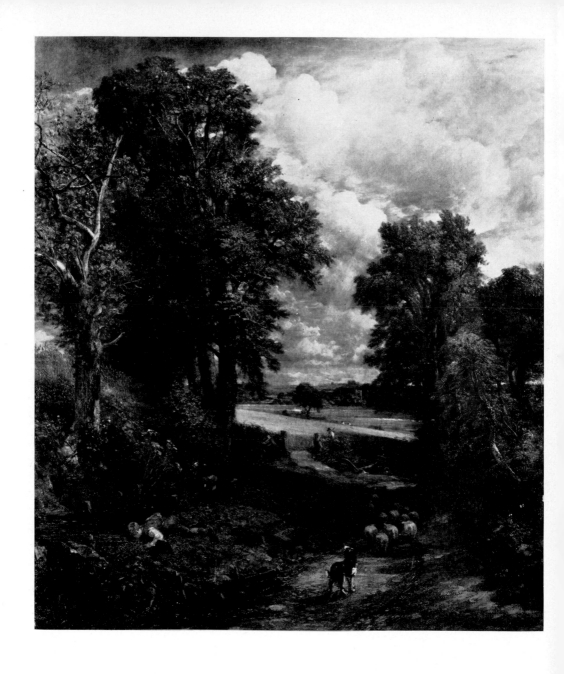

The Cornfield (National Gallery, London). 'The trees are more than usually studied and the extremities well defined – as well as their species – they are shaken by a pleasant and healthfull breeze – "at noon." '

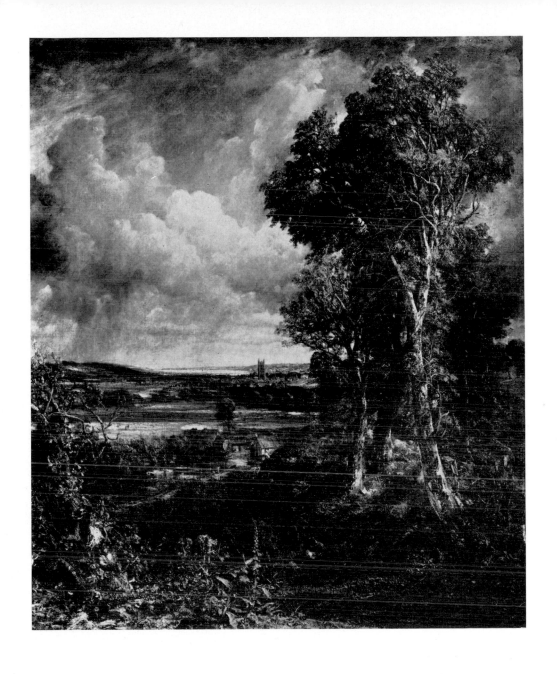

Dedham Vale (National Gallery of Scotland). 'A large canvas shows all your faults. . . .'

Constable as Visitor in the Life Academy by D. Maclise (National Portrait Gallery). 'I am become popular "in the life" (a thing not to be desired "in this life.")'

Maria Constable with their children John and Maria ('Minna') (collection of Mrs. Eileen Constable). 'I have a kingdom of my own both fertile & populous – my landscape and my children.'

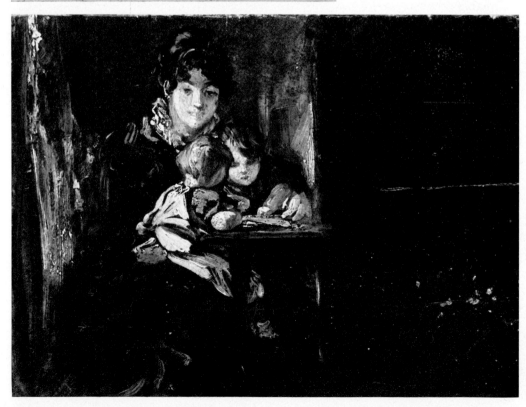

posterity and Constable could not readily conceive of these pictures, which contained so much of himself, being regarded as decoration in a gentleman's drawing room. It would not however be long before Tinney held out his hand again to Constable, only to see it shunned. Although Fisher would not have liked to have seen his friend spurned he appreciated Constable's difficulty in complying with Tinney's request:

> You see wealthy people regard artists as only a superior sort of work people to be employed at their caprice: & have no notion of the mind & intellect & independent character of a man entering into his compositions. They regard the art as they do needlework & estimate it by its neatness.[42]

'Nothing has gone well with me since I have been in this house', Constable confessed to Fisher on 21 February 1823. In the early days of January the children and two of the servants were struck down with what Constable described as a 'serious illness'. Constable nursed the family, giving his blood to help the recovery of John Charles until he himself became ill. He told Fisher that 'with anxiety – watching – nursing – and my own present indisposition I have not seen the face of my easel since X'mas'. He had also been unable to make any effort to further his chances of taking Farington's place in the Academy:

> I do not think my chance at the Academy so good as it was last year, when I was not elected. I am afraid they are not without their *sneaks*. I have nothing to help me but my stark naked merit, and although that (as I am told) exceeds all the other candidates – it is not heavy enough. I have no patron but yourself – and you are not the Duke of Devonshire – or any other great ass. You are only a gentleman & a scholar and a real lover of the art, whose only wish is to see it advance.[43]

His pessimism was justified because the successful candidate was Ramsay Richard Reinagle: 'Daniel(s)'s party got in Reinagle' was his laconic report to Fisher.

In spite of all these difficulties Constable began 'a large upright landscape' in the rather forlorn hope that he could finish it in time for that year's exhibition. He was still working on the Bishop's picture – *Salisbury Cathedral from the Bishop's grounds* – and in the few weeks that were left to him to prepare an Academy work it became clear that the Salisbury painting would have to go to Somerset House. It was far from being the kind of picture that Constable

would have wished to have entered for the Exhibition, but it was unthinkable that he should not appear at Somerset House. He could perhaps console himself with the thought that he was following Fisher's advice, echoed by some critics, that his work was becoming too monotonous: there would be no Flatford Mill, no Dedham Church, and no River Stour this year. Once the decision to submit the Salisbury picture had been taken he refused to let the Bishop see it, not only because it was an unfinished work, but because now that it was to go on public display he regarded it as his own. Constable however admitted to Fisher that he was 'at one time fearfull' that the Bishop might object to a '*dark cloud*' he had introduced, but by May he could report that it was much approved by the Academy and moreover in Seymour Street. The Bishop in his kindly way sent a note to Constable shortly after the opening of the Exhibition: 'As *applause* will not pay Bills – I enclose to you another Draft on account.'

It was the most difficult subject in landscape I ever had upon my easil. I have not flinched at the work, of the windows, buttresses, &c, &c, but I have as usual made my escape in the evanescence of the chiaroscuro. I think you will like it but you could have done me much good.[44]

Salisbury Cathedral from the Bishop's Grounds was also approved by several of his fellow professionals. 'Calcott admires my Cathedral' he told Fisher and reported a remark of Fuseli: ' "I *like* de *landscape* – of Constable – but he makes me call for my great coat" & particularly he says, I am always picturesque – "of a fine color – de lights always in their right places".'

This nonsense may amuse you when contemplating this busy, but distant scene. However though I am here in the midst of the world I am out of it – and am happy – and endeavour to keep myself unspoiled. I have a kingdom of my own both fertile & populous – my landscape and my children. I am envied by many, and much richer people.[45]

Fisher wanted Constable to visit him at his other home at Gillingham in Dorset. But he had little hope that Constable would come this year. 'Knowing how much you are tied down by your family, your portraits, & the necessity of carrying your dish between *fame & famine*, I almost despair of seeing you here.' To Maria's amusement Fisher mentioned as a bait that he had discovered 'three mills, old and picturesque'. 'But it is you I most want', Constable replied. Fisher's financial situation seems to have become sufficiently recovered by the middle of 1823 for him to order 'one of your coast windmills' and to reserve for himself a masterpiece:

I have a great desire to possess your 'wain'. But I cannot now reach what it is worth & what you *must have*. But I have this favour to ask that you would never part with it without letting me know. It will be of most value to your children, by continuing to hang where it is, till you join the society of Ruysdael Wilson & Claude. As praise & money will be of no value to you *then* personally the world will liberally bestow both.[46]

But Constable had already had a 'nibble' from Sir William Curtis, a former Lord Mayor of London – 'though a man of the world he is all heart, and really loves nature'. Although Constable felt bound by honour to hold the picture for Sir William he felt it belonged in Leydenhall: 'It was born a companion to your picture in sentiment. It must be yours.'

Constable's summer visit to Fisher was eventually arranged and on 19 August he took the coach to Salisbury to renew 'a friendship which is at once the pride – the honour – and grand stimulus of my life'. The two friends stayed briefly and rather reluctantly at Salisbury. The Bishop wanted to give his daughter Elizabeth a 'recollection of Salisbury' as she was 'about to change her situation, and try whether she cannot perform the duties of a wife as well as she has done those of a daughter'. He asked Constable to supply a version of his own picture, but with one predictable difference. 'I wish to have a more serene sky.' From the accommodating Tinney he received commissions for two landscapes at fifty guineas each. 'Nice employment for the winter', he remarked to Maria.

Constable felt at home in Fisher's vicarage at Gillingham which he had visited briefly in 1820. 'This is a very large house — close to the Church yard — & a mill at the bottom of the garden is now rattling away, and makes me think of old times at Flatford.' Fisher and his wife had created a family home which enchanted – 'all is kindness here – no beating, no crying &c'. He made an oil sketch of his godson William who was known as 'Belim' – probably his early attempt at pronouncing his name. 'The children are very amusing to me — & when I have got Belim on my knee I think it my darling Charley.' The vicarage was a 'world in itself' surrounded by country that reminded him of Hampstead – 'extreme distance & green fields'.

This is a melancholy place—but it is beautifull, full of little bridges, rivulets, mills, & cottages—and the most beautiful trees & verdure I ever saw. The poor people are dirty, and to approach one of the cottages is almost insufferable. Fisher has done a deal of good, especially in the medical way.[47]

Fisher, because of his medical knowledge – hitherto little more than a useful hobby – had become the unofficial doctor to the four thousand inhabitants of the village. This provided Fisher's main contact with his parishioners who, being mostly farmers and cattle dealers, looked upon him 'as a robber come for the milk, butter, &c, &c — but that is always the case'. It perturbed Constable, who could not walk about East Bergholt without greeting almost everyone he met, that 'there is not a single person in the village that the Fishers will visit . . .'.

Constable did not do as much sketching as he had hoped because of the rainy weather, but he did make pencil sketches of the bridge and Gillingham Mill; it was this building that had caught his eye during his first visit three years earlier. Fisher took Constable over to Sherborne on 1 September where he made a drawing of the church which he thought was 'finer than Salisbury Cathedral'. Probably the most enjoyable excursion was to Fonthill, the folly built by William Beckford. Constable was not particularly interested to see the extraordinary palace Beckford had erected, but he did enjoy having his suspicions about connoisseurs, picture dealers and now auctioneers confirmed. Beckford had sold the house and most of its contents in the previous year and the new owner, a gunpowder manufacturer named Farquhar, was selling the contents at auction. To Constable it was 'an auctioneer's job'. The catalogue of pictures said to be formerly owned by Beckford had increased by three hundred items since the house had been sold. Constable himself noticed a Wouvermans that he thought he had seen at Reinagle's house only about ten days before. Constable, for all his anger at blatant dishonesty, was glad to have seen Fonthill:

I wandered up to the top of the tower—Salisbury at 15 miles off darted up into the sky like a needle—& the magnificence of the woods & lakes, a wild region of the downs to the north, and distant Dorsetshire hills made me long much to be at dear old Osmington, the remembrance of which must always be dear to you & me.[48]

By the beginning of September Constable was 'heartily tired of being away from my love — I miss you at night and once I thought I had you in my arms, how provoking'. He returned to Hampstead in mid-September, eager to begin work and in particular to decide 'what I am to do for the world, next year, I must work for myself, and must have a large canvas. . . .'

In mid-October Constable suddenly decided that the world

could wait and accepted an invitation from Sir George Beaumont to stay with him at Coleorton Hall in Leicestershire. It was probably a standing invitation, otherwise Fisher would have known of his intention to accept it. Constable found the richness of his surroundings overwhelming. Almost every room at Coleorton contained a masterpiece. They were not merely pictures which Constable admired, but the very works on which he had attempted to base his own artistic practice:

> You would laugh to see my bed room, I have dragged so many things into it, books, portfolios, paints, canvases, pictures &c, and I have slept with one of the Claudes every night. You may well indeed be jealous, and wonder I do not come home – but not even Claude Lorraine can make me forget my darling dear Fish – I dream of her continually and wake cold and disappointed.[49]

By the beginning of November Constable had 'lost all that uncomfortable reserve and restraint that I first had' and he was now gaining great enjoyment from the visit: 'this whole scene is so very delightful to me that I am prolonging my stay I fear beyond prudence'. Apart from Sir George's many kindnesses to him, Constable was particularly impressed by the order of his host's home. Sir George and Lady Beaumont, being childless, were able to run a quiet, ordered house; nothing was permitted to upset the routine at Coleorton Hall. The visitor was so impressed by the domestic timetable that he wrote about it in some detail to a busy mother of four children:

> We breakfast at half past 8, but to day we began for the winter hour 9 – this habit is so delightful that if you please we will adopt it, but I must say you are very good.
> We do not quit the table immediately but chat a little about the pictures in the room, the breakfast room containing the Claudes. We then go to the painting room, and Sir George most manfully like a real artist sets to work on any thing he may fix upon – and me by his side. At two o'clock the horses are brought to the door and Lady Beaumont hunts us both out . . .
> We then return to dinner. Do not sit long – hear the news paper by Lady Beaumont (the Herald – let us take it in town) – and then to the drawing room to meet the tea – then comes a great treat. I am furnished with some beautiful portfolio, of his own drawings or otherwise, and Sir George reads a play, in a manner the most delightful – far beyond any pronounciation I ever heard – on Saturday evening it was 'As You Like It' and the Seven Ages I never heard so before.

Last evening (Sunday) he read a sermon and a good deal of Words-worth's Excursion, it is beautifull but has some sad melancholy stories, and as I think only serve to harrow you up without a purpose – it is bad taste – but some of the descriptions of landscape are beautifull. They strongly wish me to get it.

Then about 9 the servant comes in with a little fruit and decanter of cold water and at eleven we go to bed – where I find a nice fire in my bed room – and I make out about an hour longer, as I have everything here, writing desk &c. This makes me grudge a moment's sleep here.[50]

As the visit entered its third week Maria expressed resentment at being abandoned again, so soon after the visit to Salisbury. 'Had you not been so long at Mr. Fisher's which was quite *unnecessary* I should have thought nothing of this visit.' She was not enamoured by his excited reports about making copies of the Claudes. 'I begin to be heartily sick of your long absence. As to your Claude I would not advise you to show it to me for I shall follow Mr. Bigg's advice & throw them all out of the window.'

Sir George was also enjoying the company of a man who, accord-ing to Leslie, he regarded as a pupil. It was probably during this visit that Constable gave Sir George a practical and succinct lesson in the use of colour. In answer to his host's assertion that the colour of an old Cremona violin should be the dominant tone in a landscape he called for a violin and laid it on the grass in front of the house.* Such wide differences of opinion did not hinder the goodwill that existed between them. Constable was pressed to stay on for Christ-mas but wisely declined. In late November, a lonely and by now somewhat irritated Maria wrote: 'I shall expect you the *end of next week* certainly, it was complimentary in Sir George to ask you to remain the Xmas, but he forgot at the time that you had a wife.'

Constable returned to Charlotte Street at the end of November full of resolutions about his work and behaviour. Having witnessed the calm, methodical approach to art and to life practised daily by the baronet, Constable promised that he would 'never be cross to my poor Fish again'. He committed himself to expelling 'loungers' from his painting room – he was particularly subject to such people

* Constable was still being dismissed by the diehard traditionalists twelve years later. He expressed his anger and frustration in belligerent rhetoric: 'I ask – did Titian paint his pictures *with* 300 *years on their heads*—did Claude paint his pic-tures with 200 *years* on their heads—does nature use fitting colours—do the Water Color Society, dirty their paper before they use it? Do the house-painters mix up the new color to match the old rancid hues of the room or stairs, &c &c &c.' (JCC V. Letter to Charles Boner, dated 26 June 1835)

whom he allowed uncomplainingly to ruin his working days; in his absence Maria had had to suffer the intrusion of at least 'one great bore'.

So far as his art was concerned, Constable was convinced that this fortuitous refresher course would benefit him for the rest of his life. Immersing himself in the works of Claude had shown him again what was possible and had confirmed that he was right in pursuing his lonely course. 'I am sure my visit here will be ultimately of the greatest advantage to me and I could not be better employed to the advantage of all of us by its making me so much more of an artist.'

6

1824-1828

To me shadows
are realities

The new year brought the return of John Arrowsmith from Paris – 'my Frenchman' as Constable called him. Arrowsmith was primarily interested in securing *The Haywain*, but he was also prepared to buy *A View on the Stour* 'if he could get them at his own price'. Constable was mildly excited by Arrowsmith's new approach. He was flattered by his assertion that the painting enjoyed 'a great reputation in Paris', that it would be exhibited in the French Salon in the Louvre during August and that it was likely to become the property of the French nation. Constable considered that to let *The Haywain* go to Paris 'would be perhaps to my advantage — for a prophet is not known in his own country'. But in passing this information to Fisher he was asking his friend to release him from the option he had given him on *The Haywain* in the previous year.

Let your Hay Cart go to Paris by all means. I am too much pulled down by agricultural distress to hope to possess it. I would (I *think*) let it go at less than its price for the sake of the eclat it may give you. The stupid English public, which has no judgement of its own, will begin to think that there is something in you if the French make your works national property. You have long laid under a mistake. Men do not

purchase pictures because they admire them, but because others covet them.[1]

Arrowsmith improved on his paltry offer of the previous year and by April the price had been agreed. For *The Haywain, A View on the Stour*, and a small painting of Yarmouth jetty, Constable was to be paid £250. But the French were not to be trusted and he assured Fisher that 'I shall not let them go out of my hands till paid for.' Shortly before the pictures were surrendered to Arrowsmith's London agent Constable remarked that 'I think they cannot fail of melting the stony hearts of the French painters. Think of the lovely valleys mid the peacefull farm houses of Suffolk, forming a scene of exhibition to amuse the gay & frivolous Parisians.'

The early months of 1824 were spent in sustained work on *A boat passing a lock*, later known simply as *The Lock*. His reward came on the opening day of the Exhibition when the picture was bought by James Morrison of Basildon Park in Essex.* The price: one hundred and fifty guineas including the frame. Although he had now sold three of his six-foot canvases for a total of £400 Constable was not convinced that this signalled wider public acceptance of his aims. He unburdened himself to Fisher.

My execution annoys most of them and all the scholastic ones . . . perhaps the sacrifices I make for *lightness* and *brightness* is too much, but these things are the essence of landscape. Any extreem is better than white lead and oil and *dado* painting. . . .

I do hope that my exertions may at last turn towards popularity—'tis you that have too long held my head above water. Although I have a good deal of the devil in me I think I should have been broken hearted before this time but for you. Indeed it is worthwhile to have gone through all I have, to have had the hours and thoughts which we have had together and in common.[2]

There is much to indicate that Fisher had as great a need of Constable as Constable clearly did of him. 'When I write to you', Fisher wrote in 1826, 'I do it with all my heart.' Often he would urge Constable to take the coach to Salisbury – 'one night in the Mail & you are here' – and remind his friend that 'life is short: let us spend it as happily as possible.' Constable represented the metropolitan world of art and affairs: it was a life far removed from

* James Morrison, 1790–1857. One of the first English traders to rely upon low profit margins; amassed a considerable fortune which enabled him to collect pictures of the English school and to form a large library; MP for St Ives 1830, Ipswich in 1831. (DNB)

that of a country parson – as Constable occasionally reminded Fisher – but through their friendship Fisher could believe himself to be almost a participant. Although he had a thirst for London news Fisher was urbane enough not to be overawed by it. He was at pains to protect Constable from the delights of 'fame'. 'Do not be anxious about celebrity. It will find you out sooner sitting at your easel quietly than if you had made any stir.'

It often seems as if Fisher is the older man advising a junior on how best to conduct his life and his profession. 'Where *real* business is to be done', he began a letter thanking Constable for securing a picture for him in London, 'you are the most energetic and punctual of men: in smaller matters, such as putting on your breeches, you are apt to lose time in deciding which leg shall go in first'. Knowing of Constable's habit of skipping meals and eating an orange at his easel Fisher asked, 'How many dinners a week does your wife get you to eat at a regular hour & like a Christian?' But Constable was no slouch when it came to repartee. On one occasion Fisher inquired if Constable had enjoyed his sermon. 'Yes, Fisher', Constable replied, 'I always did like that sermon.'

Both men were uninhibited in exchanging information and opinions that at times verged on the scatalogical. 'Look at Rembrandt's descent from the cross', Fisher wrote in 1822:

The man on the ladder has a great rent in his breeks, & a large piece of his a—e apparent.—Is not this *gratuitous* vulgarity . . . I was told yesterday & the information came I *think* from Calcot(t), that he* gets his bread by painting pictures of another description. Representations of the manner in which that world is peopled.—It was the man's a—e that made me think of Guest & his doings.[3]

Anatomy remained one of their preoccupations. In 1826 Constable told Fisher about Leslie's Academy picture – 'a fearfull subject:'

Don Quixote in the mountains introduced to the donkeys (Dorothea), and as the picture is literal, he has made the Don without his breeches—he is in the act of stooping to raise the lady—and his back is towards the spectator.[4]

'Do the public object to the exposure of the Don's glutei muscles?' Fisher inquired. On another occasion Fisher urged Constable to 'run down to Windsor' for a few days; they had last been there together in 1818:

*Douglas Guest, a portrait painter.

Pray do; & let us walk over those delicious scenes again; scenes of natural & artificial magnificence, where parsons eat & stuff & dream of dirty preferment; where pedagogues flog little boys bottoms, talk burly, & think themselves great men in 3 cornered hats; where statesmen come, *not* to *flog* bottoms, but to kiss them; & where every body seems indifferent to the splendid scenes that surround them.[5]

In 1826 Fisher was thinking of using his obvious literary gifts to secure his own 'future fame'. The death of his uncle in whose shadow and under whose protection he had lived and worked for the first decade or so of his clerical career seems to have changed his admitted indolence into energetic activity. That Dr Fisher's successor, Bishop Burgess, approved of him for his abilities alone, gave Fisher self-confidence. The new Bishop urged his canon to show himself in print. Constable was delighted 'at seeing you at length properly appreciating yourself':

Take care that you launch your boat at the appointed time, and fearlessly appear before the world in a tangible shape—that they may clutch you. It is the only way to be cured of idle vapours—and useless fastidiousness. *Bury no longer* your natural manliness of character, and great acquirements in study—but let mankind be the wiser and better for them, especially in this age—of cant and folly on the one side and Catholick despotism on the other. You are admirably situated between both—to attain [ultimate] success.[6]

Constable was more than anxious to see his friend make his mark in the world because his old adversary in the Academy, William Collins, had expressed the opinion that Fisher was 'not thought much of' in his profession. 'I think that we shall both live to see ourselves', Constable wrote, 'where Collins will neither wish nor expect to see us.' Fisher had a detached, amused view of the profession which he wished to distinguish. In September 1827 he wrote to Constable 'sitting in commission upon a dispute between a clergyman and his parishioners, & compose while the parties argue':

There is a brother parson arguing his own case, with powder, a white, forehead & a very red face: like a copper vessel newly tinned. He is mixing up in a tremulous tone & with an eager blood-shot eye, accusations, apologies, statements, reservations, and appeals, till his voice sounds on my ear as I write, like a distant waterfall.[7]

Fisher was concerned that social changes in England would inevitably mean that the 'illiterate offspring of grocers and tallow

chandlers will fill the pulpits'. He was certain that the Church of England could no longer exist as a comfortable profession for literary men. But above all he wanted the Church to rid itself of pomposity and return to first principles:

What a mistake our Oxford and Cambridge Apostolic Missionaries fall into when they make Christianity a stern haughty thing. Think of St Paul with a full blown wig, deep shovel hat, apron, round belly, double chin, deep cough, stern eye, rough voice, & imperious manner, drinking port wine, & laying down the law, of the best way for escaping the operation of the Curates Residence Act.[8]

Constable was now nearly forty-nine years old. He had achieved success, but it had been in Napoleon's country; he continued to hold French approval of his work at arm's length. But he was seeking more than the plaudits of his contemporaries. He wanted to prove to Maria that his own firm confidence in himself had been justified. But it was in 1824 that Constable must have first suspected that his wife might be suffering from the complaint which had already carried off a number of her family. It is probable that consumption had claimed her mother and her brothers Durand and Samuel. After each birth the period of her recovery seemed to lengthen. A year after Isabel's birth in August 1822 Maria was still thin and neither the blandishments of her husband – 'I want you, to be fat & strong' – or her own attempts at treatment had any effect; an illness at the beginning of 1824 further delayed her recovery. The warm weather in early spring 'hurt her a good deal and we are told we must try the sea'. The despatch with which Constable arranged for Maria and the children to spend the summer by the sea indicates how seriously he viewed the state of her health.

Brighton was the chosen resort. Its fashionable atmosphere would have appealed to Maria who had visited the town before her marriage. Constable secured a house or apartments at the west end of the town; it was referred to by Maria as Western Place and by Constable as No. 9, Mrs Sober's Gardens. The situation of the house seemed perfect for a person with Maria's complaint: it was close to the beach and the Sussex countryside stretched away to the west. Constable found to his annoyance that one of Maria's neighbours would be a retired and wealthy portrait painter named John James Masquerier. Masquerier proved to be a persistent button-holer and Constable, who had little time for portrait painters,

was never able completely to shake off his attempts at friendship.

In May Constable took Maria and the children down to Sussex where they stayed throughout the summer and autumn. Brighton was not to Constable's taste:

Brighton is the receptacle of the fashion and offscouring of London. The magnificence of the sea, and its (to use your own beautifull expression) everlasting voice, is drowned in the din & lost in the tumult of stage coaches—gigs—'flys' &c. – and the beach is only Piccadilly (that part of it where we dined) by the sea-side. Ladies dressed & *undressed* – gentlemen in morning gowns & slippers on, or without them altogether about *knee deep* in the breakers—footmen—children—nursery maids, dogs, boys, fishermen – *preventive service men* (with hangers & pistols), rotten fish & those hideous amphibious animals the old bathing women, whose language both in oaths & voice resembles men – are all mixed up together in endless & indecent confusion. The genteeler part of the Marine parade, is still more unnatural—with its trimmed and neat appearance & the dandy jetty or chain pier, with its long & elegant strides into the sea a full $\frac{1}{4}$ of a mile. In short there is nothing here for a painter but the breakers —& the sky—which have been lovely indeed and always varying.[9]

After taking the sea breezes on the Sussex coast for two seasons Constable acknowledged that the resort appeared to have a measurable effect upon the vital forces:

This is certainly a wonderfull place for setting people up—making the well, better—& the ill, well, so so—and if I may judge by appearances, Old Neptune gets all the Ladies with child—for we can hardly lay it to the men which we see pulled & led about the beach here.[10]

The lengthy periods of separation which they could anticipate, in addition to the comparatively high cost of postage led Constable to suggest that he should compile a weekly journal of his activities in London which he would send down to Maria in Brighton. The journal is a prosaic account of how he spent his time. Hardly a day does not include a reference to his health or how he slept: in May his neighbour Manning, the apothecary, is prescribing purgatives and Constable is treating a cold by placing his feet in warm water before going to bed; subsequent ailments which he noted for the edification of Maria down in Brighton included heartburn, hot cheeks and stomach pains; sleep was adequate except on nights like Thursday 3 June 1824 when he would have had a very good night's sleep had a bug not 'annoyed my chin & ear & chest'. He reports that he 'got up & caught him — and drowned him'. The mode of

execution employed a fortnight or so later was less hygienic: 'I slept pretty well for so good a dinner — & was awakened by a flea at five o'clock. But I killed him, in the pleat of my night shirt.' He had dined that day at the Charterhouse in the company of Fisher where he consumed 'salmon, & a quarter of lamb, veal stewed — & some savory side dishes. 2nd course — large dish of green peas & 2 ducks — lovely puddings & tarts, beautifull desert, & I drank only claret.' This rich fare was in contrast to the monotonous diet he was provided with at home by the rather unsatisfactory under-maid Sarah; it often consisted of mutton in one form or another or toad-in-the-hole, with occasionally ham, bacon, veal or beef; gooseberry pudding was one of his favourite dishes.

With the house containing only himself and Sarah, Constable decided to import Johnny Dunthorne, the son of his old and banished friend, to live with him in Charlotte Street and to act as his studio assistant. Johnny Dunthorne was now twenty-six. He had inherited some of his father's artistic ability and it was his ambition to become a professional painter. He made himself valuable to Constable by squaring and transferring; one of his first jobs was to help pack up *The Haywain* and the *River Stour* for shipping to France. Dunthorne's regard for his employer was probably little short of hero-worship.

The continental connection was strengthened soon after Constable returned from Brighton after seeing Maria and the children into their summer lodgings. On Friday 21 May 1824 the Director of the Academy at Antwerp, a Monsieur van Bree, called at Charlotte Street, having admired *The Lock* at Somerset House. He saw the pictures which Arrowsmith had bought and remarked that he thought that 'they would succeed on the continent'. Soon afterwards, Arrowsmith also called, and returned the following day bringing with him another Paris dealer named Claude Schroth. Schroth's enthusiasm for Constable's work was immediate; of the three pictures he 'bespoke', two of them were to be views of Hampstead. Constable was able to report to Fisher that he was 'engaged to get seven pictures of a small size ready, for Paris, by August . . . making in all an amount of about £130'. The two French dealers between them helped to raise Constable's expected income for the year to about six hundred pounds. In June there was further confirmation of his success with the French. A Monsieur le Vicomte de Thulluson and his wife called one evening at Charlotte Street and asked to see ' "*de* gallery of Mr. Constable" '. The visitor – 'a genteel young man'

– ordered a small picture and wished to know if the painter 'would accept any commissions from Paris. I said, certainly. He said I was much known and esteemed at Paris, & if I would come I should be made much of — & he hoped I would call on him.' This view was supported by William Collins who had recently returned from a visit to France. 'He says that I am a great man in Paris, and that they speak only of 3 artists there – namely "Wilkie, Lawrence, & Constable" — this sounds very grand.'

Arrowsmith was an energetic entrepreneur and returned to Paris determined to catch the rising tide of interest in the Englishman's work. In the art circles of Paris the stage was being set for a faction fight which looked like reaching its culmination at the French Salon in August. Napoleon had imposed himself upon art as he had on other parts of French life. The result had been that the classicism represented by David had become paramount. The younger painters, led by Delacroix, prepared themselves for the attack on reaction. Into the arena wandered a not unwelcome ally. It is of course impossible to assess with any accuracy whether Constable significantly affected the outcome of the classic-romantic struggle, but what does seem incontrovertible is that Constable's works in Paris in 1824 opened up a fresh battle ground, a new front.

Arrowsmith, an amateur painter himself, was in touch with all shades of artistic opinion and it was apparent – and indeed had been for some time – that a state of open warfare now obtained between the two sides; it was this situation that Arrowsmith wished to exploit in advance of the Salon, by putting Constable's pictures on show at his own gallery.

Until June any reputation that Constable enjoyed in Paris must necessarily have been based upon the reports that visiting Frenchmen brought back with them after visiting London. Now that peace reigned between the two countries, English ideas were in vogue and intellectual relations were moving towards a state of mutual curiosity and respectful enmity. But not until June 1824, when Arrowsmith put *The Haywain* and *River Stour* on display in his gallery, did Frenchmen in large numbers stand before a painting by Constable. The result was acclaim such as Constable had never experienced before:

I can now Sir, assure you that no objects of art were ever more praised or gave more general satisfaction than your pictures and it is with great impatience that I wait for the Exhibition of the Louvre to insure you a most complete & deserved success; but you must yourself come over to

receive the congratulations of my countrymen. I shall then be happy to see you paid a just tribute for your admirable talent.[11]

Constable regarded 'the great stir' his pictures had made with singular insouciance. 'His letter is quite flattering but I hope not to go to Paris as long as I live', went the journal entry for 22 June. Fisher was amused at the incongruity of his friend being lionized in the French capital. 'It makes me smile to myself when I think of plain John Constable who does not know a word of their language being the talk & admiration of the French! That he should owe his popularity & his success to *Paris!*'[12]

Delacroix himself went to see *The Haywain* and *River Stour* while he was completing his *Massacre of Scio* for the Salon. The pictures had a profound effect on him and when he returned to his studio he set about amending parts of his own picture, in the light of what he had learned from Constable.

Some critics in the classical camp – 'angry at the French taste for admiring them' – condemned the English interloper and one absurdly attacked Constable's work as an undesirable influence on young French painters who would be seduced from the allegiance they owed to Poussin. 'They are very amusing and acute — but very shallow and feeble.' Having suffered for years at the hands of English critics – a gentler breed, it seems, than their Parisian counterparts – Constable stayed amused, but detached. 'The French criticks have begun with me', he wrote disdainfully to Fisher, 'and that in the *usual* way — by a comparison with *what has been done . . .*'. He was thankful that the English Channel separated him from those who wished to savage him as much as from the many who wanted to honour him.

Constable was represented at the Paris Salon of 1824 by *The Haywain, River Stour*, and a view of Hampstead Heath. *The Haywain* and Delacroix's *Massacre at Scio* were without doubt the most popular – and the most controversial – pictures in the exhibition. Together they ensured victory for the romantic school, but the battle continued to occupy the pages of the leading journals. The debate inevitably became political, with the liberals siding with the young romantic painters and the conservative element – themselves former revolutionaries – supporting the classical camp. At first Constable was probably not aware that his work was being used in the debate and that it was being produced by the romantic movement as evidence that right was on their side. He would have been

horrified to have known that his work was being used to support indirectly a political view which, had it been in England, he would have opposed.

Although Constable's pictures were given 'very respectable situations in the first instance' public interest caused the Director of the Louvre, Count Forbin, to remove them after a few weeks to the principal room where they were given 'a post of honor'. For his intelligence from Paris Constable relied on Arrowsmith's letters, articles in French journals translated by Maria and the reports of English visitors to the Louvre. William Brockedon, a painter, told Constable that he had overheard one visitor say to his companion: 'Look at these pictures by an Englishman — the very dew is upon the ground.'

They wonder where the *brightness* comes from. Only conceive what wretched students they must have been to be so surprized at these quali-ties – the fact is they study (& they are very laborious students) art only – and think so little of applying it to nature. They are what Northcote said of Sir J.R. – in his landscapes (at first) made wholly up from pictures – and know about as much of *nature* as a '*hackney coach horse does of a pasture*'. In fact they do worse. They make painfull studies of individual articles – leaves, rocks, stones, trees, &c, &c singly – so that they look cut out – without belonging to the whole and they neglect the look of nature altogether, under its various changes.[13]

Despite his mistrust of the French Constable was gratified with his success in Paris. His pictures had, as he might have said, begun an epoch. Works that in England had been largely ignored had in a foreign country made 'a decided stir, and have set all the students in landscape thinking — they say on going to begin a landscape, Oh! this shall be — à la Constable! ! !'

By the middle of July, Constable had had enough of his solitary life in London and departed for Brighton. 'I am come to seek some quiet with my chidren', he told Fisher before he left London. He found that Maria's health had recovered and she was now 'delight-fully well', but towards the end of summer Constable was concerned that she had become too stout.

For all his professed dislike of Brighton Constable did not delay long before being out and about with his sketchbook; his sketching forays – most of them within walking distance of Mrs Sober's gar-dens – began on 19 July and continued at irregular intervals prob-

K

ably until he returned to London in the middle of October. 'Pretty Minna's birthday' – 19 July – found him on the beach where he completed his first dated sketch at Brighton.

But these subjects are so hackneyed in the Exhibition, and are in fact so little capable of that beautifull sentiment that landscape is capable of or which rather belongs to landscape, that they have done a great deal of harm to the art—they form a class of art much easier than landscape & have in consequence almost supplanted it, and have drawn off many who would have encouraged the growth of a pastoral feel in their own minds—& paid others for pursuing it.[14]

Despite country jaunts and the cares of his family Constable could tell Fisher at the end of August 1824 that

I am however getting on with my French jobs. One of the largest is quite complete, and is my best, in freshness and sparkle – *with repose* – which is my struggle just now. A friend here wished Ld Egremont to see it. It was shown him. He recollected all my pictures of any note, but he recollected them only for their defects – so that my friends good intentions failed. But I will do his Lordship & myself justice. The truth is that landscape affords him no interest whatever.[15]

One of Constable's preoccupations during the summer was an exhibition which the British Institution proposed to mount in the following year. The 'Wise Men of the Institution', as Constable sarcastically dubbed the businessmen and connoisseurs who ran the Institution, usually played safe and held an exhibition of Old Masters, but in 1825 they proposed to display works of living artists in private collections. Constable's favourite exhibition picture in private hands was *Stratford Mill*, owned by the patient Salisbury lawyer, John Tinney. Constable begged Fisher to seek Tinney's permission for the painting to go to the exhibition adding that 'as it is already in my possession it is convenient — I trust neither you or Tinney will refuse me a request (unreasonable to be sure), but it will be of real service to me.' Tinney had reluctantly returned the picture to Constable for further work to be done on it, but he had made him promise that no material change would be made without his permission. Not surprisingly Tinney (or Mrs Tinney) was not at all enthusiastic about yet again denuding his drawing room of its most prominent and prized decoration. 'Tinney readily consents to your exhibiting your picture when the Gallery opens,' Fisher wrote, 'but he begs that he may have it till then.' *Stratford Mill* was returned

to its owner and the negotiations for the loan of the picture in 1825
lay dormant until November when Constable decided to approach
Tinney direct. It was not an easy letter to write. 'I have been knocked
up today owing to writing a long letter to Tinney yesterday, in
which I had to [make] the exertion of asking two favours of him
[and] to make if possible my motives for so doing not misunderstood.'
He asked if Tinney would send him *Stratford Mill* several weeks in
advance of the opening of the exhibition and he sought also to
escape the informal commission Tinney had given him to paint two
landscapes. He wanted to be 'free and independent' of such work
which Tinney generously wanted to put his way – 'these things only
harrass me. You known my disposition, is this — in my seeming
meakness, if I was bound with chains I would break them — and —
if I felt a single hair round me I should feel uncomfortable.' Tinney
replied that he would willingly let *Stratford Mill* come to London,
but only for the six weeks of the exhibition. Fisher had proposed to
lend Tinney *The White Horse*, but the lawyer could not agree that he
should 'unfurnish his withdrawing room to supply its place'. He
courteously waived the commission for the landscapes, but hoped
that it might be revived. Tinney found the refusal of his largesse
inexplicable, but Fisher accepted his need to escape the landscape
commissions – 'No man ever composed anything racy & genuine
with a shackle on his mind.'

With the year approaching its end Fisher knew that Constable
would be giving some thought to his next picture 'for the world'.
He repeated a criticism he had made before: the lack of originality
in his choice of subjects. 'I hope that you will a little diversify your
subject this year as to *time of day*. Thomson you know wrote not four
summers but *four Seasons*. People are tired of mutton on top mutton
at bottom mutton at the side dishes, though of the best flavour &
smallest size.'

I am planning a large picture—I regard all you say but I do not enter
into that notion of varying ones plans to keep the Publick in good humour
—subject and change of weather & effect will afford variety in landscape.
What if Van de Velde had quitted of his peices—or Ruisdael his water-
falls—or Hobbema his native woods—would not the world have lost so
many features in art? I know that you wish for no material alterations—
but I have to combat from high quarters, even Lawrence, the seeming
plausible arguments that subject makes the picture. Perhaps you think
an evening effect—or a warm picture—might do. Perhaps it might start
me some new admirers—but I should lose many old ones—[16]

The large picture which Constable was preparing was another scene of the River Stour: *The Leaping Horse*:

It is a canal and full of the bustle incident to such a scene where four or five boats are passing with dogs, horses, boys & men & women & children, and best of all old timber-props, water plants, willow stumps, sedges, old nets, &c &c &c.[17]

Unlike the previous Stour scenes, *The Leaping Horse* depicts action, one that was familiar to Constable from his childhood: barge-horses were trained to jump over the low fences erected along the towpath to prevent cattle from straying and Constable's picture shows a mounted horse at the start of its leap. Work on the painting – 'launched with all my usual anxieties' – was interrupted early in 1825 by a portrait commission in Surrey: 'You may suppose I left home most unwillingly to execute this job, but it is my wife's connection and I thought it prudent to put a good face on it.' Maria's friend, Jane Lambert, was looking after the three children of her brother who was in the Bengal Civil Service. The Lambert family home was at Shortts Place, Woodmansterne. Constable was required to produce a portrait of the children to be sent out to their parents in India. Miss Lambert had been privy to Maria's confidences during their troubled courtship and Constable told Maria that 'she does not wonder now that we are intimate that you was so determined on not relinquishing me.' To Fisher he confided: 'You cannot think how I regret being about this picture to the neglect of my large landscape, for every reason — besides I can make no part of art pay now so well as my own landscape.' Constable, his interest not fully engaged, was open to suggestions from the amiable Miss Lambert about how the portrait might best be composed:

Mary always sits so gracefully that it gave me the idea of the group which Mr C. seized, and it has [been] approved by all parties. It is sometimes difficult to form a group without stiffness. He has succeeded very happily, indeed he ought—such time and patience he bestowed upon it. He was extremely pleased with the darlings and has done them justice without flattery.[18]

It was while Constable was at Woodmansterne that the news reached him in a letter from Arrowsmith that he had been awarded a gold medal by King Charles X of France for his work at the Louvre. Three other English exhibitors had also been honoured, including the P.R.A. Sir Thomas Lawrence who was also made a Chevalier of the Legion d'Honneur; the other English painters

were Copley Fielding and Bonington. Arrowsmith was more than a little pleased that his judgement had not proved faulty; he hoped that 'the next exhibition will make you a *Knight of the Legion of Honor*.' Wryly, he concluded: 'You see that in our country merit is rewarded, come from where it will.' Maria, who had learned first of the French medal, decided that a brief note added to the Frenchman's letter – which she had opened in Constable's absence – was sufficient recognition of the signal honour that had been conferred on her husband. Her congratulation is over and done with in one sentence: 'This is the only letter & I thought you would like to receive it, the reward of merit must be agreeable.' Maria was however over six months pregnant with her fifth child and the same letter confessed to loneliness. She asked forlornly if she could come to Woodmansterne 'for a day or two, if you are obliged to come to town and return'. Constable gives no indication that he was disappointed at Maria's coolness about the French king's medal, but he wrote on the same day to Fisher who did not confine his congratulations to a mere seven, buttoned-up words.

Your medal could not have given you greater exultation than it did me. Indeed I always consider your fame as mine; & as you rise in slow but permanent estimation, pride myself that I have formed as permanent a friendship with a man of such talent. But these things are better felt than said.[10]

On his return to London Constable went joyfully to *The Leaping Horse*. Not particularly pressed by money problems, he was able to concentrate on it fully for several weeks; it was still occupying most of his time when Maria gave birth, prematurely, to her fifth child, Emily, on 29 March 1825. The birth took its toll of Maria, and Fisher was told that she 'is in a sad weak condition — and we are obliged to watch her carefully — and hope all will go well.' The family now consisted of five children: two sons, John Charles and Charles Golding and three daughters – Maria and Isabel and now Emily. Constable had predicted that both he and Maria would this year '*exhibit* at the same time', but Emily's birth occurred during the few days her father was completing his Academy picture. He sent it down to Somerset House with some misgivings:

I have worked very hard—and my large picture went last week to the Academy—but I must say that no one picture ever departed from my easil with more anxiety on my part with it. It is a lovely subject, of the canal kind, lively—& soothing—calm and exhilarating, fresh—&

blowing, but it should have been on my easil a few weeks longer. Never-theless, as my most numerous admirers are for my mind in these things—I thought I would send it.[20]

'*Why* was not your picture on your easil a few weeks longer?' Fisher inquired. Constable, as always, erred on the side of pessimism. He was concerned that with the preponderance of large pictures at the Academy *The Leaping Horse* might appear insignificant, but intelligence from 'the House' told him that 'it looks very bright'.

The Leaping Horse was well received, but it was the accompanying entries – two views of Hampstead Heath priced at seventy-five guineas each – which attracted a purchaser soon after the exhibition opened. A textile merchant named Henry Hebbert (or Hibbert) was enough taken with the views of Hampstead, similar to those which had so delighted Schroth, to want to own them. He put down a deposit of £40, but later found himself unable to complete the purchase and asked to be released from his contract. One would have expected the success in Paris to have been followed by acclaim in his own country, but here he was, left without a purchaser for replicas of the two pictures that were exciting the French. Constable's disappointment at the on-off sale was to be short-lived. A saviour appeared. Francis Darby, of Coalbrookdale in Shropshire, wrote during July to inquire about the prices of the exhibited pictures. Constable promptly told the inquirer that *The Leaping Horse* was 'disengaged' and that 'the price with frame and packing is 230 guineas'. He told Mr Darby that he had had inquiries about the Hampstead pictures 'but nothing being concluded I consider the pictures *not engaged* and are therefore the property of whoever first decides'. Mr Darby was only interested in buying the Hampstead pictures and sought a reduction in price. Constable remarked that he had been offered seventy guineas for one of them by a dealer, 'yet nevertheless so desirous I am that you should possess them that I will make a deduction of 20 gns, offering them to you at 130 gns, including as before the frames and packing'. Lest he should be misunderstood he diffidently added:

When I took the liberty of saying, I am desirous that you should possess them, I felt flattered that an application should be made to me from an entire stranger, without interest of affection or favor, but I am led to hope for the pictures' sake alone.[21]

His exultation at the appearance of a new patron – 'I don't catch

above one fish in seven years' – led him to confide in a man he had never met.

> I am obliged to you for your kind enquiries of my health. I always find business a cure for all *my* ills. I am not the worse but much the better for, my endeavours to attend to your wishes, and besides your letter afforded me the best excuse in the world for coming away from the apothecary.
>
> I ought not to trouble you, Sir, with myself, but the truth is, could I divest myself of anxiety of mind I should never ail any thing. My life is a struggle between my 'social affections' and my 'love of art'. I dayly feel the remark of Lord Bacon's that 'single men are the best servants of the publick'. I have a wife (daughter of Mr. Charles Bicknell of the Admiralty) in delicate health, and five infant children. I am not happy apart from them even for a few days, or hours, and the summer months separate us too much, and disturb my quiet habits at my easil.
>
> This disposition is no doubt to my disadvantage, as I have pressing invitations to push my success on the Continent by visiting Paris, &c, &c, but I cannot speak a word of the language, and above all I love England & my own home. I would rather be a poor man here than a rich man abroad. I am neither an ambitious man, nor a man of the world, but am sincerely gratefull to providence and my own exertions for being enabled to do that for myself which no human being could have done for me.
>
> I am certainly proud of my degree of reputation, for it has been honorably gained by my pencil alone—the height of my ambition has ever been to attain excellence, and to gain the publick for my patron. And I now repeat that the circumstance of your having purchased my pictures has been most highly gratifying on that account.[22]

Constable himself was not unaware that the intimate nature of this confessional letter might embarrass Mr Darby and concluded: 'I ought indeed, Sir, to beg pardon for this most unconscionable letter which I have now written to you.' Mr Hebbert whose business fortunes had apparently recovered was 'entirely shagrined' at having lost his pictures. It would not have occurred to Constable to have played one prospective purchaser off against the other. He wanted only that the pictures should 'speak for themselves or not as I have always done . . .'. Mr Hebbert refused to take back his deposit 'but made me promise him one of my best pictures for it'. Not wanting to be outdone in chivalry, Constable 'bought of him a nice warm plaid travelling cloack to come and see you at Brighton in the *"winter"*, 34 shillings'.

Earlier in the year Claude Schroth had reported that the two Hampstead pictures had been seen in his gallery in the Rue de la

Paix by many distinguished figures in the Paris art world; they had greeted them with the excitement which by now was customary for any works by John Constable. Arrowsmith provided Monsieur Firmin Didot, a printer and publisher, with a letter of introduction to Constable. His visit to Charlotte Street yielded a useful commission for three paintings, not particularly lucrative in themselves, but taken together with the work that was already in hand for the two dealers – three works for Schroth (ordered in January) and two for Arrowsmith – 'these all make income'.

Of the two dealers, Constable found Schroth the more sympathetic. Schroth was prepared to bide his time but Arrowsmith, while professing that time was immaterial, almost always includes in his letters a prod about completing his commissions. Of the two Frenchmen, Arrowsmith however was probably the more effective: it was Arrowsmith who had first recognized Constable's worth. He had been brave enough to stick out his entrepreneurial neck; and he had arranged the first displays of Constable's work in Paris. But Schroth, whose work on Constable's behalf was of a less flamboyant nature, became his friend, whereas Arrowsmith remained until the end of their association a business acquaintance.

After Schroth had forwarded Count Forbin's official notification of the royal medal Constable sent him a drawing which he had admired on his visit to Charlotte Street. Schroth's letter of thanks was brought to Charlotte Street by the painter who had first incorporated Constable's technique into his own work. 'Mr. Delacroix jeune artiste d'un talent très distingué porteur de cette lettre, que je prends la liberté de vous recommander comme digne d'admirer votre beau talent, vous dira tout le plaisir qu'ont fait les tableaux que vous m'avez fait;'.* It is known that on 27 May 1825, Delacroix was staying at 14, Charles Street, and that he had been in England for only a few days. He met other many leading English painters and it is unlikely that he would have left London without meeting Constable.

During the summer of 1825 the owners of *The White Horse* and *Stratford Mill* duly sent their pictures to Constable in London where they were entered for the British Institution exhibition. Tinney's

*Mr Delacroix, a young artist of outstanding talent and bearer of this letter, whom I take the liberty of commending to you as worthy of appreciating your fine talent, will convey to you the excitement created by the pictures you have done for me. (*Correspondance de Delacroix*, 1878, Vol. I, p. 153, given in JCC IV, p. 200)

picture was returned to him some time after the exhibition closed, but Constable continued to regard *The White Horse* as his own. Without seeking Fisher's permission he sent it to France. 'Your large picture ("Constable's *White Horse*") is now exhibiting at [the] Musee Royal in the city of *Lille in Flanders* — and that without your leave.'* Although Fisher was not at all put out by his presumption, Constable admitted that he was 'quite ashamed' of the deception. But when the picture returned from France 'with an increased reputation — and with a gold medal on its back' Constable wrote:

So far the Exhibition (in Lille) has extended my reputation—& I trust you will forgive me what I did and prize the picture the more. There are generally in the life of an artist, perhaps one, two or three pictures, on which hang more than usual interest—this is mine. *All* things considered, the gold medal should be yours.[43]

The satisfaction that Constable could feel at this new success was diminished by the illness of his eldest son John Charles. Fisher immediately offered to take the boy to Osmington where 'sea air, sea bathing & good food', he thought, would ensure his recovery.

Fisher was even more alive to the necessity of offering prompt help and comfort having recently nursed his wife and two of his children through serious illnesses. 'Whatever you do, Constable, get thee rid of anxiety. It hurts the stomach more than arsenic . . . You want a staff just at present. Lean upon me *hard*.' Maria and the children were at this time in a house in Hampstead to which Constable returned at the weekends. It was an unsatisfactory arrangement. 'Hampstead is a wretched place', he told Fisher, 'so expensive — and as it was so near I made my home at neither place. I was between two chairs — & could do nothing.' Despite Fisher's generous offer, Constable decided to send the family to Brighton on the grounds that 'it is cheaper than any other — it is near — and we have several friends there'. He took the family down on the last day of August 1825 and thankfully returned to Charlotte Street:

I am now thank God quietly at my easil again. I find it a cure for all ills besides its being the source 'of all my joy and all my woe'. My income is derived from it, and now that after 20 years hard uphill work—now

*The invitation to exhibit at Lille seems to have come from Auguste Hervieu, a French painter working in London. He was a member of the Society of Fine Arts in Lille and was acquainted with Constable at this time. It was Hervieu who told Constable that the Society had awarded him a gold medal. (JCC IV, p. 273)

that I have disappointed the hopes of many—and realized the hopes of a few (you best can apply this)—now that I have got the publick into my hands—and want not a patron—and now that my ambition is on fire—to be kept from my easil is death to me.[24]

He once again sent for Johnny Dunthorne to join him in London. 'He doats on me', he told Fisher. Constable decided to find him lodgings away from the house because 'he is too good for my maids'. As in the previous year Constable began a journal which he sent down to Brighton every week or so. It is a prosaic account of daily events, larded with the kind of domestic trivia that he knew Maria would enjoy:

September 16 (1825), Friday. A Grand Epoch
This morning was ushered in by a prodigious battle with the fowls in the garden—the black hen making a great to-do & cackling—the cock strutting and crowing—and Billy looking at them in great astonishment from the back kitchen window. When all was quiet I looked into the brew house & saw her on the nest which I had made, and at breakfast— Elizabeth brought me in a beautiful egg—probably the first hen's egg ever laid on the premises. . . .
Billy now plays with the kit—by pulling it out of its basket in the cupboard in the back kitchen. He tosses it up and holds it with his fore feet in a ridiculous manner—the old Lady Hampstead looking on all the while—rather smiling, than otherwise.[45]

By the end of September 1825 any serious cause for alarm on John's behalf had diminished, but the family stayed on in Brighton. Constable continued to go down to see them every few weeks but only for short periods. Although Constable seems to have had plenty of time to attend to his domestic duties he was far from being under-employed in his painting room. The entry for 1 October 1825 tells us that 'I am getting my dead horses off my hands, as fast as I can. I shall do as you say, not much mind my little jobs, but stick to my large pictures.' The 'dead horses' were pictures already paid for but which were incomplete. He was finishing new versions of the Bishop of Salisbury's picture of the Cathedral and of *The Lock* for his bookseller friend James Carpenter. He also had on hand a Hampstead picture for a Mr Ripley and three pictures for Arrowsmith. *The Leaping Horse* which had returned unsold from Somerset House was already being worked on to make it 'saleable'. Constable had taken out 'the old willow stump' to the right of the horse 'which has improved the picture much'. Johnny Dunthorne was busy

preparing an outline of the Waterloo picture, but Constable had yet to decide if it would go into the exhibition of 1826.

November saw the end of his relationship with Arrowsmith which, since neither he nor Schroth were in good financial health, in effect signalled the end of their championship of him in Paris. Early in the month Arrowsmith called at Charlotte Street and found that of his three commissions two were completed and the third was under way; he ordered more pictures to the value of about £200. It was, as Constable told Fisher, a 'most friendly meeting'. On his next visit to Charlotte Street on 15 November, Arrowsmith found Constable at work in his painting room. Johnny Dunthorne and his father were also present:

> At his last visit with a French friend—an amateur—he was so excessively impertinent and used such language as never was used to me at my easil before—that I startled them by my manner of showing that I felt the indignity. He apologized, but I said I could not receive it & he left my house telling Johnny that he would gladly have given 100£ rather &c—& I sent him a letter withdrawing all engagements with him—and enclosing him a draft for the balance (40£) on my banker.[26]

Constable's high dudgeon was probably because the Frenchman had sought a speedy completion of his pictures to help him out of his financial difficulties. This is the most likely conclusion that can be drawn from his shame-faced letter of admission to Fisher. 'When *your severe* comments are made on my impetuosity above — pray be so kind (for just, as well, you always are) to bear in mind that I have a high character to support in Paris'. Fisher was not curious about the substance of the dispute between his friend and the French dealer. He had Constable's own admission that Johnny Dunthorne – who although he confirmed that the Frenchmen were 'insolent and took liberties' – was 'grieved at his master having so much of the devil about him':

> We are all given to torment ourselves with imaginary evils—but no man had ever this disease in such alarming paroxysms as yourself. You imagine difficulties where none exist, displeasure where none is felt, contempt where none is shewn and neglect where none is meant. What passed between you & the Connoisseur I do not know; if he took liberties you acted quite right; & will probably raise yourself by vindicating (your) dignity.[27]

Constable accepted Arrowsmith's prompt apology. 'I have now written to him at Paris, to say, that as we were now on an

equal footing, I was most ready to forget all, & to resume our friendship, assuring him that resentment formed no part of my character, leaving it to himself, as to any further orders about pictures', he told Fisher; he added that 'Arrowsmith has a room in his house called Mr. Constable's room — I shall contribute no more to its furniture. He says my landscapes have made an epoch there.'[28] The reason for Constable's shortness of temper emerged later in the month:

I had that unfortunate morning received Tinny's—letter—it was laying with my brushes by me—and was such an one as I had thought he would not have written to me—or indeed to any one. It fell on poor Arrowsmith—& ultimately on myself—[29]

Tinney's letter refused Constable's request to allow *Stratford Mill*, which was still in his possession, to go to the opening exhibition in Edinburgh of the proposed Scottish Royal Academy. Tinney's letter 'has cut me deeply – but I deserved it'. Fisher thought so, too:

He recollected my simile I dare say & thought that getting his picture out of your hands was not unlike the gauze handkerchief in the bramble bush.—So he wrote to the institution. He says you are a develish odd fellow. For you get your bread by painting.—He orders two pictures leaves the subjects to yourself; offers ready money & you declare off for no intelligible reason. All this he says & thinks. But as for my wrath against you, or contempt for you, it is the shadow of a moon beam. Come hither before your wife and children arrive or I shall never see you. I hope the dose of bitters I have administered above will be of service.[30]

It was a gentle rebuke, but it produced from Constable a letter of extraordinary petulance:

It is easy for a bye stander like you to watch one struggling in the water and then say your difficulties are only imaginary. I have a great part to perform & you a much greater, but with only this difference. You are removed from the ills of life—you are almost placed beyond circumstances. My master the publick is hard, cruel & unrelenting, making no allowance for a backsliding. The publick is always more against than for us, in both our lots, but then there is this difference. Your own profession closes in and protects you, mine rejoices in the opportunity of ridding itself of a member who is sure to be in somebodys way or other.

I have related no imaginary ills to you—to one so deeply involved in active life as I am they are realities, and so you would find them. I live by shadows, to me shadows are realities.[31]

Constable began the new year in the buoyant hope that *Waterloo*

Bridge, which he intended to submit to the 1826 Exhibition, would satisfy Fisher and those critics who had remarked on his limited choice of subjects. It was to be a London picture: the opening in 1817 of Rennie's Waterloo Bridge by the Prince Regent. Dunthorne had prepared an outline some months previously. Although the work had been giving him sleepless nights, by January Constable was gathering himself for a period of concentrated work on the picture. But election time had come round again with the deaths of Henry Fuseli and William Owen. Constable could have felt confident that the acclaim he had received in France would now be converted into recognition by his professional colleagues. Although Lawrence was known to be unsympathetic towards landscape painting, Constable might reasonably have hoped that the President – his fellow-exhibitor at the Paris Salon and at Lille – would give him a helping hand. There was some indication that this might happen when in mid-January the carriage of the President of the Royal Academy drew up outside Constable's house in Charlotte Street:

I yesterday had a very pleasing visitor and all went off well—Sir Thomas Lawrence. He called to see what I was about—I showed him all—but he wanted (& I think he came on purpose) to see the large picture. I never saw him admire anything of mine so much—he said it was admirable especially to the left—not but the line of the bridge was grand—&c&c&c.[32]

After the confidence in the outcome of the election that Lawrence's unexpected visit must have aroused the poll in February was a cruel disappointment. Constable was not even narrowly defeated; his votes were derisory in the preliminary polls for both vacancies. He could have been in no doubt that the elegant thumbs of Sir Thomas had been turned down. His rejection yet again was even more painful because the successful candidates were painters not only younger by some years than himself, but who also practised the two branches of painting for which he had scant regard. Henry William Pickersgill, who replaced Fuseli, was a portrait painter. William Owen's place was taken by an historical painter, but, in this case, Constable could rejoice in the success of a friend, for it was Charles Robert Leslie. Constable's relationship with Leslie had been largely a professional association although a closer friendship began to develop from about 1823 when Leslie and his sister Ann, who was also a painter, took rooms in Charlotte Street. They began meeting in each other's homes for the occasional 'dish of tea'.

Leslie admired Constable's pictures and it was for this reason that he cultivated the older man's friendship. Leslie later recalled that he had known all the leading painters of his day, but he had found Constable the most interesting 'both as a man and as an artist'. He saw him as an artist who put his soul into his art, but also as a man of flesh and blood whose vulnerability manifested itself in an inordinate desire for 'fame'.

The impression his character made, and the impression his art made, and I may say the impression they did *not* make, were proofs to me of the truth of Roscoe's remark, that 'genius assimilates not with the character of the age'. No man more earnestly desired to stand well with the world; no artist was more solicitous of popularity. He had, as the phrenologists would say, *the love of approbation* very strongly developed. But he could not conceal his opinions of himself and of others; and what he said had too much point not to be repeated, and too much truth not to give offence. It is not, then, to be wondered at, that some of his competitors hated him, and most were afraid of him.

There was also that about him which led all who had not known him well and long to consider him an odd fellow, and a great egotist; and an egotist he was; but then, if the expression may be allowed, he was not a *selfish* egotist. 'By self he often meant', as Charles Lamb says of the poet Wither, 'a great deal more than self—his friends, his principles, his country, the human race'. Few, however, knew or studied him sufficiently to perceive this. He was opposed to all cant in art, to all that is merely specious and fashionable, and to all that is false in taste. He followed, and for his future fame he was right in following, his own feelings in the choice of subject and mode of treatment. With great appearance of docility, he was an uncontrollable man. He said of himself, 'If I were bound with chains I should break them, and with a single hair round me I should feel uncomfortable'. I felt inclined to say to him, 'Do all that is in thine heart to do'; and I was happy that to me he said all that was in his heart to say.[33]

Leslie left Charlotte Street in 1824 and went to live in a house in Lisson Grove, recently vacated by Benjamin Robert Haydon. Constable thought it a very fit house for an artist, but grumbled that Leslie had moved 'sadly out of the way — but it is quite the country'. In the following year the bonds between them were further strengthened when Leslie married. His bride was Harriet Stone, one of six daughters known as the 'Six Precious Stones'. She was a beautiful woman whom Constable much admired. Their first child, Robert Charles, was born only a few months after Leslie had become an Academician. Leslie's elevation did nothing to

undermine their relationship. Leslie was not a crusader, but he did what he could in an unobtrusive way to press Constable's claim to become an Academician. He frequently called at Charlotte Street at Constable's request to comment on work in progress and Constable often followed his advice. The advice was not only one-way. Leslie's own work, apart from portraits, consisted mainly of scenes inspired by the drama; mostly Shakespeare, but Don Quixote yielded a series of pictures over several years and the works of Scott (whose portrait he painted in 1824), Sheridan and Sterne also provided further material. Constable influenced Leslie's composition and his handling of colour; he even persuaded him to follow him down the chiaroscuro road, assuring him that the 'whitewash' would mellow with time. Leslie ingenuously acknowledged his debt in 1834: 'I am not aware that I have painted a picture since I have known you that has not been in some degree the better for your remarks, and I constantly feel that if I could please *you* with what I do, I should be sure to please myself.'

Possibly as a result of the unsuccessful election, Constable laid aside *Waterloo Bridge* and its place on his easel was taken by *The Cornfield*. For this work there was understandably only minimum preparation, nothing like so meticulous as that for *The Leaping Horse*. This new six-foot canvas became Constable's Academy work that year and occupied him wholly until April. On the face of it, this abandonment of a work which meant much to him can be seen as weakness, a retreat from anticipated criticism. But it was far from being that. It represented a tremendous effort of will to lay aside as late as February the intended Exhibition picture and turn to another canvas, another subject. It was a further indication of Constable's determination to succeed on his own terms, although he made some realistic concessions. To Fisher he wrote that *The Cornfield* 'has certainly got a little more eye-salve than I usually condescend to give to them'.* And it was not a canal scene. It was

*Constable could perhaps thank a friend from Brighton, Henry Phillips, for the variety and authenticity of the botanical elements in the picture. Phillips saw *The Cornfield* early in 1826 and told Constable what plants would be likely to be blooming in what he took to be 'July in your green lane'. He wrote on 1 March: 'At this season all the tall grasses are in flower, bogrush, bullrush, teasel. The white bindweed now hangs its flowers over the branches of the hedge; the wild carrot and hemlock flower in banks of hedges, cow parsley, water plantain, &C; the heath hills are purple at this season; the rose-coloured persicaria in wet ditches is now very pretty; the catchfly graces the hedge-row, as also the ragged robin; bramble is now in flower, poppy, mallow, thistle, hop, &c. . . .' (JCC V p. 80)

not surprising that having worked up a large carefully finished canvas Constable was so jauntily proud of his concentrated endeavour:

I have dispatched a large landscape to the Academy—upright, the size of my Lock—but a subject of a very different nature—inland— cornfields—a close lane, kind of thing—but it is not neglected in any part. The trees are more than usually studied and the extremities well defined—as well as their species—they are shaken by a pleasant and healthfull breeze—'at noon'—while now a fresher gale, *sweeping with shadowy gust the feilds of corn* &c, &c.

I am not without my anxieties—but they are not such as I have too often really deserved—I have not neglected my work or been sparing of my pains—they are not sins of omission. . . .

My picture occupied me wholly—I could think of and speak to no one, I was like a friend of mine in the battle of Waterloo—he said he dared not turn his head to the right or left—but always kept it straight forward—thinking of himself alone.[34]

Although Constable reported to Fisher that 'the voice in my favour is universal – 'tis my best picture' his work was still the butt of jokes from his fellow-artists. Francis Chantrey, the sculptor, even went so far as to attempt to repaint a detail of *The Cornfield*. On the evening before the Exhibition opened 'Chantrey came up and noticing the dark shadows under the tails of the sheep suddenly said "Why Constable all your sheep have got the rot, give me the pallet, I must cure them." His efforts made all worse when he threw the pallet at Constable and ran off.' At the close of the exhibition *The Cornfield* was returned unsold to Charlotte Street. It remained in Constable's possession for the rest of his life.

By the middle of the year Maria was several months pregnant. Because her health had now improved, Constable at first decided that there was little to be gained by removing to the coast for the summer. 'I trust we shall not need a country excursion, in which we leave this convenient house, and pay four guineas a week for the privilege of sleeping in a hen-coop for the sake of country air.' By August however a period in Hampstead was considered desirable, probably at the insistence of Maria who found London intolerable during the summer. Constable rented 1, or 2, Langham Place, Downshire Hill, Hampstead.

Maria was delivered of a premature baby, at the house in Langham Place on 14 November 1826. Maria nursed Alfred Abram herself – her husband expected it – but by Christmas she appeared

to be exhausted after bearing their sixth child in ten years. The friendship with Leslie had become sufficiently intimate for him to be given the kind of intelligence that before would only have been imparted to Fisher. 'My colony at Hampstead has not been going on so well of late. My wife is by no means strong and it trys her to be a nurse. She had almost given up her baby — but now they are both going on better — & it would be a pity, he is such a sweet lovely little fellow.' Constable was now the father of six children. To Fisher he confided his difficulty in providing for them out of an inadequate income that was no more certain now than it had been when he was a bachelor. 'It is an awfull concern — and the reflection of what may be the consequences both to them and myself makes no small inroad into that abstractedness, which has hitherto been devoted to painting only. But I am willing to consider them as blessings — only, that I am now satisfied and think my quiver full enough.' Maria's, however, had been full when there were only four children. Because of the arrival of Alfred Abram, Constable retained the house in Langham Place throughout the winter, but he found the expense and the disruption of maintaining two houses unsettling. He told Fisher of his intentions.

I am endeavouring to secure a permanent small house there [Hampstead], to prevent if possible the sad rambling life which my married life has been, flying from London to seek health in the country. I have put the upper part of this house into an upholsterer's hands to let, and have made my painting room, warm and comfortable, and become an inhabitant of my parlors. I am three miles from door to door—can have a message in an hour—& I can get always away from idle callers—and above all see nature—& unite a town & country life. All these good things I hope to add to a plan of economy, for I will not live under the depression of exceeding my income. Neither my principle nor my pride will bear it.[35]

Had Constable not been obliged because of Maria's health – and now because of the schooling of the two eldest boys – to make regular visits to Brighton, it is probable that the resort would have gone the way of the Lake District – an interesting area with which he had little affinity. But in 1827 Constable decided to develop some of the sketches he had made at Brighton into a large work. The six foot canvas *The Marine Parade and Chain Pier, Brighton*, now in the Tate Gallery, was the result. 'Fisher likes my coast', he remarked

L

to Dominic Colnaghi, 'or at least believes it to be a useful change
of subject.' Fisher passed a day in Hampstead early in April and
communicated his opinion of the picture to his wife in enthusiastic
terms: 'It is most beautifully executed & in a greater state of finish
and forwardness, than you can ever before recollect. Turner,
Calcott and Collins will not like it.' Whether this trio liked it or
not is unknown, but the picture was received largely with indiffer-
ence, except from *The Times* and the *New Monthly Magazine*. *The
Times* writer thought the picture one of Constable's best works:

He is unquestionably the first landscape painter of the day and yet
we are told his pictures do not sell. He accounts for this by stating that
he prefers studying nature as she presents herself to his eyes, rather than
as she is represented in old pictures, which is, as it seems the 'fashionable'
taste. That such a word should be heard of in matters of art![36]

The *New Monthly Magazine* found itself unable to congratulate
Mr Constable on his 'new style':

The present picture exhibits the artist's usual freshness of colouring
crispness and spirit of touch, but it does not exhibit them in connection
with the objects to which they are so appropriate as they are to green
trees, glittering rivulets and all the sparkling detail of morning scenes in
the country. Mr. Constable's style is rural and adapted to rural subjects
almost exclusively. We do not mean that he cannot change it, but change
he must, if he would meet with success in general subjects.[37]

The picture eventually returned to Charlotte Street to join
The Leaping Horse, *The Cornfield*, and other pictures in Constable's
salon des refusés.

Maria was still struggling to recover from the birth of Alfred
Abram when she found that she was pregnant again. It is unlikely
that Constable would have regarded the conception of their seventh
child as 'a blessing'. It can hardly have escaped him, when he
looked upon the weakened frame of his wife, that if there was one
eventuality that must be avoided it was a further pregnancy. There
must surely have been a feeling in the household that things were
getting out of hand. The head of this already large family was a
painter now in his fifty-second year; in a matter of a few months
he would be the father of seven children, not all of them in good
health; his wife had suffered intermittently over the past decade
from a general debility, the harbinger of the tuberculosis which had
claimed several members of her family. The 'blessing' was expected

at the end of the year; the imminence of its arrival dictated that more permanent quarters should be found without delay:

I am at length fixed in our comfortable little house in the 'Well Walk', Hampstead—& we are once more enjoying our own furniture and sleeping on our own beds. My plans in search of health for my family have been ruinous—but I hope now that my movable camp no longer exists—and that I am settled for life. So hateful is moving about to me, that I could gladly exclaim—'Here let me take my everlasting Rest'—no moss gathers 'on the rolling stone' . . . It is to my wife's heart's content—it is situate on the eminence at the back of the spot in which you saw us— and our little drawing room commands a view unequalled in Europe— from Westminster Abbey to Gravesend. The *dome* of *St Paul's* in the air, realizes Michael Angelo's idea on seeing that of the Pantheon—'I will build such a thing in the sky'. We see the woods & lofty ground of the land of the 'East Saxons' to the N. East.[38]

The substantial house in Well Walk, Hampstead, was taken not as a summer retreat but as an alternative home to Charlotte Street where Constable retained only a few rooms in which to lodge and work, having let the rest of the house to a dancing teacher.

Constable was conscious that the nature of his work and his shortage of money meant that the holidays and family visits which were normal for other families were being denied his own. In September 1827 he wrote to Abram suggesting that he bring the family down for a short holiday at Flatford Mill. Abram did not welcome the proposal believing that for children as young as his brother's 'a more dangerous place for children could not be found upon earth. It would be impossible to enjoy your company, as your mind would be absorb'd & engross'd with the children & their safety.' Abram was probably dismayed at the prospect of an invasion by half a dozen nephews and nieces. He conceded that his brother's alternative proposal – to bring two boys – was preferable as they could then be accommodated at Flatford Mill with their Aunt Mary. In the event, Minna and John were chosen to enjoy the delights and hazards of their father's boyhood home.

They travelled down to Suffolk at the beginning of October. They would almost certainly have listened to their father praising the beauties of his birthplace without fully understanding the significance that the countryside of Suffolk had for him; they would have been puzzled if they thought about it at all, at their father's obsession with the 'scenes of my boyish days'. Even the idea of Suffolk as a place was difficult to grasp, as Constable reported to

Maria. 'When we arrived at Stratford Bridge I told her (Minna) we were in Suffolk – she, O no, this is only fields . . . but she says Suffolk is very much like Hampstead, only that the blackberries are so much nicer.'

The holiday was a great success. The children were 'much admired' and 'all heads are out of doors & windows' as they passed through the village to make their calls. For the two London children Suffolk must have seemed like paradise – there was riding and fishing, jaunts to family friends in Aunt Mary's grand conveyance, skylarking in Uncle Abram's mill at Flatford; wherever they went they were the centre of attention. It is curious, in view of the importance that the idyllic days of his childhood had for him, that Constable was content to allow his children to be raised almost entirely in London; only once did he muse on the possibility of taking a house in Dedham but it came to nothing.

Fisher had been pressing for a visit to Osmington or Salisbury, but learning of the Suffolk holiday he must have realized that there was now little chance of persuading Constable to quit London again before the end of the year. Constable's financial difficulties were serious enough for him to apply to Fisher for a loan of £100. But the most that Fisher could manage was £30 which he brought up to London in December.

The last few months before the seventh child arrived must have been an unhappy period. It was becoming more and more apparent that Maria was weakening. A sensitive man like Constable could not have gazed upon his spreading wife without realizing that another child was more than she could, or should, bear. There were already hints of her delicate state of health. A walk from church in October necessitated spending the following day in bed. 'But I am willing to regard them as blessings . . .'.

Maria's seventh child and fourth son Lionel Bicknell was born at Well Walk on 2 January 1828. The father reported to Leslie that his wife 'goes on nursing famously . . . my fourth boy is a great beauty but "fair in the cradle, foul in the saddle". They seldom grow up fine looking'. So for the present, the 'comfortable little house in Well Walk' was suffused with the euphoria of birth.

Now that he was the father of seven children Constable set about attempting to secure his election to the Royal Academy with more than usual concentration. After 'running the gauntlet' of certain Academicians he found 'much feeling on my behalf and many decidedly avowing *for me* — such as Chalon — Pickersgill — Stod-

thard — Beechey — Chantry — but the last waits for information and is careful not to betray himself for me'. He had discovered that Shee and Phillips were 'cap a pie' for Etty – a campaign in which they were also supported by Sir Thomas Lawrence. Far more damaging to his chances of gaining election was the currency of a rumour reported to him by William Beechey that he had been 'pamphleteering for *myself* and *against others*'. It was a preposterous charge as his bland reaction indicated – 'is not this amusing — "surely the Devil reigneth".' Even his old student friend, John Jackson, was undecided. Turner – 'angry that I called on a Monday afternoon' – interviewed him on his doorstep and gave him no encouragement at all.

How sad it is to realize that Constable was obliged to doff his cap to inferior painters who are barely remembered today – men like Henry Bone and Richard Cook. The latter was an historical painter who had not exhibited since he had defeated Constable for election six years earlier. Bone was enamel painter to the King. 'I called on Bone. He would not see me . . . I called on Cooke. He would not see me — this may not be conclusive — though perhaps in the *Great Bone,* there may be a fracture.' Perhaps the most demeaning interview was with Chantrey. The sculptor informed Constable that 'his conduct would be governed by circumstances'. What this amounted to was that he would follow the majority because he did not wish to deprive 'the happy candidate of the honor & the eclat of a good majority'. Chantrey made no secret of his opinion that he rated Etty's art higher than Constable's – 'he was pleased to say that my *art* could not compete with Etty's "*for one moment*".' So the majority decided. William Etty took the vacancy caused by the death of Flaxman by eighteen votes to five.

In the following month, on 9 March, Maria's father died at his house in Spring Garden Terrace. He was nearly seventy-seven years of age and his death had been expected for some time. Constable's suspicion that his father-in-law was not rich and even in debt proved to be far from the truth. After payment of legacies his estate was estimated to amount to about £40000. This was to be divided between the two surviving children of his second marriage, namely Louisa Bicknell and Maria Constable. 'I shall stand before a 6 foot canvas with a mind at ease thank God', he told Fisher. Although the money had been left to Maria and not to them jointly the effect of the will was to vest the money in Constable; that this occurred in the will of a lawyer indicated that it was intentional and that any

residual mistrust of his son-in-law had long since evaporated. Constable announced to Fisher that he intended to settle it on Maria and the children 'that I may do justice to his good opinion of me'. Charles Bicknell's generosity was of particular interest to Abram who had admitted that he was becoming embarrassed by his brother's repeated appeals for money. He urged care in the administration of 'this good fortune of yours'. Fisher too offered sound advice.:

Your legacy gave me as much pleasure as it could have done to myself. You will now be releived from the carking fear of leaving a young family to privation & the world. You will feel that your fame and not your bread are dependent on your pencil. To work with success, we must work with ease. All the most delightfull productions of literature have been thrown off the mind, at an instant of leisure, and clear-headed tranquility.

Bicknell paid you a high moral compliment. My plan of provision, is to leave a home & bread to eat, round which the weak and unsuccessful of my family may rally. Every family should have a homestead: perhaps this should be your plan.[39]

Constable was at the time of his father-in-law's death preparing not a six-foot canvas, but certainly a large picture, for the forthcoming exhibition. In this painting he returned to a theme that had its origins in his young days as a painter – *Dedham Vale*. This work – 'perhaps my best' – is similar in design to the *Dedham Vale* of 1802. The death of Sir George Beaumont in the previous year may have prompted Constable to return to this theme which in its first manifestation had been inspired by Sir George's 'little Claude', *Hagar and the Angel*. Of the picture which accompanied it to Somerset House – *Hampstead Heath* – Constable remarked that although it was smaller than *Dedham Vale* it was 'better in quality'. Perversely, Francis Chantrey liked it, but dithered about buying it for so long that Constable sold it elsewhere.

One of Constable's fellow exhibitors this year was his own assistant Johnny Dunthorne. That he was competent enough to exhibit alongside his master indicated that he would not be content to continue indefinitely as Constable's assistant. A letter from Abram suggests that Dunthorne had expressed concern for his future in a way which had upset Constable. If, as seems likely, Dunthorne was chafing at the bit for reasons both financial and professional, Abram for one approved of his ambition; he even went so far as to hint that there were other reasons why Dunthorne might wish to

leave his brother's employ: 'your natural temperament & ardent mind must & does harrass any one constantly with you, this I believe you are aware of in part if not to the full extent'. Dunthorne was already being given independent commissions in Suffolk and later that year he finally left Charlotte Street and set up as a professional painter and picture restorer.

The month of May 1828 marked the beginning of Maria's decline. For a woman of delicate health the birth of a seventh child, in addition to the care of the other six, was already more than enough to bear. But the loss of her father for whom she had retained a strong affection stretched her already over-loaded reserves of strength and will-power to breaking point. This can be the only explanation for her apparently sudden collapse towards the end of May. Brighton was prescribed, but although Brighton might prolong life it could not save it.

When the idea of removal to Brighton was first mooted Constable thought that Maria was too ill to be moved. This was probably at the beginning of May because by the end of the month Maria was established on the Sussex coast; the children, all but Alfred, who was ailing, were left in London. 'My wife is sadly ill at Brighton — so is my dear Alfred: my letter today is however cheerfull. Hampstead — sweet Hampstead that cost me so much is deserted', he told Fisher on his birthday. Fisher tried gently to show Constable that it mattered little whether Maria was in London or at Brighton: 'Do you perceive that it is not *situation* that makes your wife ill?' Perhaps because of Fisher's advice Constable decided that Brighton, where the weather had been far from suitable for a tubercular patient, was not in any way hastening Maria's recovery. He took her back to Hampstead.

Fisher was right. The summer of 1828 passed with Maria appearing to recover a little during August, but the inevitable was already approaching. 'She is so sadly thin & Weak', read the bulletin at the end of August. A fortnight later Constable confided to Dominic Colnaghi that he was greatly unhappy at his wife's illness – 'her progress toward amendment is sadly slow, but they tell me she does mend; pray God that this may be the case'. Even as late as October Constable was still placing his hope in the restorative powers of Well Walk. 'My dear wife continues much the same – I do hope she is not worse, and home may yet do wonders.' In his unhappiness Constable turned in desperation to Fisher. He wanted him to drop everything and come to London to be with him. But Fisher 'much

hurried about at the present moment' could not come. 'I fear your friendship makes you over-value the use I can be of to you; but what I can give you shall have. Trial is the lot of life.' Nearer at hand was a source of comfort in Charles Leslie.

I was at Hampstead a few days before she breathed her last. She was then on a sofa in their cheerful parlour, and although Constable appeared in his usual spirits in her presence, yet before I left the house, he took me into another room, wrung my hand, and burst into tears without speaking.[40]

Maria died on 23 November 1828 at the age of forty.

Hourly do I feel the loss of my departed Angel. God only knows how my children will be brought up. Nothing can supply the loss of such a devoted, sensible, industrious religious mother, who was all affection. But I cannot trust myself on that subject. I shall never feel again as I have felt, the face of the World is totally changed to me . . .[41]

7

1829-1832

Who cares for landscape?

In the twelve years of his marriage, from 1816 until 1828, Constable painted most of the pictures on which his reputation rests. His marriage was his period of achievement. His domestic situation was serene, surrounded as he was by the woman for whose hand he had fought a protracted campaign and the children in whose birth and development he took so much joy. From that day in 1809 when he had first 'avowed' his love for Maria, no other woman seems to have existed for Constable. He chose Maria and he had remained loyal to his choice, applying to his marriage the same determination that it should in itself be a thing of beauty that he brought to the pictures he had created during their union.

Although he could not fly to his friend's side Fisher recommended that 'you should apply yourself rigidly to your profession'.

Some of the finest works of art, and most vigorous exertions of intellect, have been the result of periods of distress. Poor Wilson, painted all his finest landscapes under the pressure of sorrow. Set about something to shew the world what a man you are, & how little your powers can be depressed by outer circumstances.[1]

In Fisher's absence Constable turned to Leslie, but like Fisher

he was perplexed as to what help he could offer. He counselled reading. 'I should be delighted to read Tom Thumb', Constable replied, 'if it could amuse me.' Because Maria's illness had made her dependent on competent servants, life still continued to tick over at Well Walk. But it was a lonely man who sat down to celebrate Christmas with his seven children. Mrs Savage, who was 'all that her name does not imply' ruled the household, helped by Roberts, the children's nurse; she was a great favourite with her charges who nicknamed her 'Bob'.

Two months after Maria's death Constable wrote to Leslie that 'my greivous wound only slumbers'. Although he had been ill and John Charles was in 'a sad state' he hoped that his letter would 'prove to *you*, my dear Leslie, that I am in some degree at least "myself again" '.

I have been ill, but I have endeavoured to get to work again—and could I get afloat on a canvas of six feet, I might have a chance of being carried away from myself. I have just received a commission to paint a 'Mermaid'—for a '*sign*' on an inn in Warwickshire. This is encouraging—and affords no small solace to my previous labours at landscape for the last twenty years—however I shall not quarrel with the lady—now—she may help to educate my children.

I have some academical news to tell you but not much. I have little heart to face an ordeal (or rather should I not say, 'run a gauntlet') in which 'kicks' are kind treatment to those 'insults to the mind', which 'we candidates, *wretches* of necessity' are exposed to, annually, from some 'highminded' members who stickle for the 'elevated & noble' walks of art—i.e. preferring the *shaggy posteriors of a Satyr* to the *moral feeling of landscape*.[2]

On the night of 10 February 1829 the Council of the Royal Academy gathered in Somerset House to decide who should replace William Redmore Bigg. Constable's opponents were Francis Danby, George Clint, Henry Briggs, Charles Eastlake and Edwin Landseer. Constable might have expected that a clear vote in his favour in the first ballot – Constable: 12, Danby: 6 – would be converted into confident approval of his election in the final one. The first ballot eliminated, as it was intended to do, all but two candidates: Constable and Danby. Francis Danby's work was of a type which his opponent particularly abhorred – landscapes replete with historical or classical figures. In the final ballot Constable's comfortable majority was reduced to one curmudgeonly vote.

Turner, perhaps wishing to make amends for his churlish be-

haviour to a 'brother labourer' in the previous year, went from Somerset House with his friend George Jones and called on Constable in Charlotte Street. They remained talking until after midnight. On the day after his election, Fisher's congratulatory letter arrived. It was addressed to 'John Constable Esqr R.A.'

It is a double triumph. It is in the first place the triumph of real Art, over spurious Art; and in the second place, of patient moral integrity over bare chicanery, & misrepresented worth. Your rewards are beginning now to flow in upon you with full tide; although, as everything is ordained in a state of trial, the painful is mixed with the sweet. . . .

The event is important to me, since my judgement was embarked in the same boat with your success.[3]

Abram, loyal as ever, pleased and relieved at his brother's success, could find little to commend in the institution which bestowed it:

I am delighted to find that it has been obtained in a manner at once gratifying to your feelings as an Artist & as a Gentleman – that there should exist such a feeling as appears to exist, in any body of men, particularly of Painters whose sole aim ought to be the advancement of Art, is much to be regretted, and when it is so far predominant as to exclude real & superior merit, must I consider lessen & lower the honor of belonging, to such a Society. You may & I hope will, benefit by the attachment of R.A. to your name, but your Pictures will not need any other aid than their own intrinsic genuineness & worth, & the original manner in which you have endeavoured to represent your ideas & views of nature, and I think they will long be look'd at with pleasure by lovers of art and nature. . . .[4]

In terms of Academy politics, Constable's election by one vote was an insult, one that was compounded by Lawrence when the new Academician made his ritual call on the President. Lawrence was particularly insensitive at this meeting with the successful candidate who had at last been permitted to join the favoured forty. The President, according to Leslie, 'considered high art to be inseparable from historical art' and thought that Constable 'was as much surprised at the honour just conferred on him, as he was himself'. Constable 'felt the pain thus unconsciously inflicted' and 'his reply intimated that he looked upon his election as an act of justice rather than favour'. Apart from the rank unfairness of such a remark, Constable had a right to expect Lawrence to be aware that he was mourning his wife, that platitudes on both sides were the

order of the day, and that the President of the body artistic should not resort to jibes which he would have expected only from the more ill-natured paragraphers. Even as late as the beginning of April Constable could write: 'I am smarting under my election.'

But this was no time for self-pity. The Exhibition was only two months away and the most junior Academician would be expected to justify his advancement with a dazzling example of his work. Gathering himself after Maria's death had dominated his days; there had been no incentive to launch a six foot canvas; nor were his reserves of physical or emotional energy equal to the task. This was a time, as no other had been, for a formula work; no one could have objected had he taken the easy way out and turned in 'a Constable'. But he decided to return to the picture which in the previous autumn he had intended to be his Academy offering for 1829: *Hadleigh Castle*.* It is the work of a sad, disillusioned man: the desolate ruins of a castle standing high in a windswept landscape. He had first visited Hadleigh in 1803. Constable could have remarked about this picture, as later he did of *The Glebe Farm*, that 'I have added a "Ruin" . . . for *not* to have a symbol of myself . . . would be missing the opportunity.'

Hadleigh Castle continued the experiment in technique that he had only recently begun. Constable wanted to bring his work – even to such an ostensibly gloomy picture – 'a dewy freshness'. The palette knife provided the answer. He flecked the canvas with white paint in the belief that it would gradually undergo changes and impart to the work the effect of 'dewy freshness' that he was seeking. By April it was in a sufficiently finished state to be seen although 'I am in the height of agony about my crazy old walls of the Castle'. Constable was uncertain about whether 'I can or ought' to send it to the 'Pandemonium'. He sought Leslie's advice. 'I have little enough of either self-knowledge or prudence (as you know) and I

*In the Mellon Collection. The following lines from Thomson's *Summer* (*The Seasons*) accompanied the catalogue entry:

> The desert joys
> Wildly, through all his melancholy bounds,
> Rude ruins glitter; and the briny deep,
> Seen from some pointed promontory's top
> Far to the blue horizon's utmost verge,
> Restless, reflects a floating gleam.

(Leslie, p. 241)

am pretty willing to submit to what you shall decide – with others whom I value.'

During the varnishing period Francis Chantrey again offered advice and practical help. Leslie relates that Chantrey stood before the picture and gave his opinion that the foreground was too cold. He took Constable's palette and applied a glazing of asphaltum over it. Such an action would surely today give rise to a charge of malicious damage. Although Constable viewed Chantrey's amendment with some alarm his reaction was typically muted: 'There goes all my dew.' 'He held in great respect Chantrey's judgement in most matters', says Leslie, 'but this did not prevent his carefully taking from the picture all that the great sculptor had done for it.'

Constable's technique was not appreciated by his fellow painters. Turner commented that the picture had been splashed when Constable's ceiling was being white-washed. Because of the eminence of the originator the remark circulated and rapidly became part of the artistic folklore of the day. Several critics commended the painting although one remarked that it looked as if a 'huge quantity of chopped hay' had been scattered over the picture while it was still wet. Constable was untouched by such comments. 'I now trouble myself little with other men. I leave these things to speak for themselves.' Fisher thought it meet to administer another dose of bitters:

You choose February & March for composition; when the strongest men get irritable & uncomfortable . . . The season you select for composition is the chief reason of the unfinished *abandoned* state of your surface on the first of May. Your pictures look then like fine handsome women given up to recklessness & all abominations.[5]

Fisher with his customary persistence had been pressing his old friend to visit him, first at Windsor where he had been staying during May and later to come down to Wiltshire. After a visit to the Charterhouse in June to see his ailing mother, Fisher sent a note to Charlotte Street: 'I leave town for Salisbury tomorrow morning, where I shall be happy to see you, but shall not see you.' Perhaps Fisher suspected that the detachment which Constable was bringing to his professional life was also being applied to his friendships. What he does not seem fully to have grasped was that from November in the previous year Constable became a changed man; he was no longer the genial friend that he had been for the past twenty or so years. Fisher wanted him to drop everything in London and come down to chat about 'the art' in the Close or at Osmington. It

was Mrs Fisher who recognized Constable's difficulty. She wrote and invited him to come down to Salisbury with the children. With uncommon alacrity Constable accepted and left for Salisbury together with Minna and John at the beginning of July.

Constable spent most of July at Leydenhall completing a number of pencil and oil sketches from Fisher's library on the first floor of of the house which looked out over the water meadows towards Harnham. As usual he was content to confine himself to the Close; he made only one expedition and that was to Old Sarum where he sketched the ruins of the ancient city. At the end of the month Constable returned to London leaving the two children with Fisher, but this arrangement did not last long. Almost as soon as he had departed the Fishers were invaded by relations and asked for the two young visitors to be collected. John was taken back to London by 'Bob' Roberts who was 'come & gone like a flash of lightning', but Maria, who had formed a close affection for Emma Fisher, was allowed to stay on in the Close. Fisher found her an enchanting child. 'Minny is the nicest child in the house possible. Nobody would know of her existence if she were not seen. She improves in her French & otherwise – her ear is perfect; & she dances quadrilles with the chairs like a parched pea on a drum head.'

Constable made his last visit to Salisbury in November when he went down to bring back Maria. By now Fisher had had enough of summer visitors. 'Do not bring your boy with you at this time of year', he wrote, 'six children in the dining room at one time, is more than my nerves will stand.'

Now that Constable, as a result of the Bicknell inheritance, enjoyed financial security Fisher ceased his role as a patron and benefactor and turned supplicant. At the end of 1829 his need for money was so acute – 'total failure of rents at Gillingham' – that he asked if Constable would 'turn your two great pictures into money for me . . . I am much in want of money, being literally without any.' As an alternative, Fisher offered the two landscapes as security for a loan of £200. 'But the honestest and most satisfactory way will be for me to sell them.'

One of the 'two great pictures' was of course *The White Horse.* The other might well have been *Salisbury Cathedral from the Bishop's Grounds* which Fisher had probably inherited on the death of his uncle. By the end of December the sorry deal was done and the two pictures returned to Charlotte Street.

By the autumn of 1829 Constable was immersed in a venture that had been one of his preoccupations during the early part of the year: the preparation of a series of mezzotint engravings intended to illustrate what he called the 'chiar'oscuro of nature'. He also hoped to spread the gospel of what he had been about throughout his professional life. *English Landscape* 'originated in no mercenary views', he remarked in an introduction to the publication, 'but merely as a pleasing professional occupation'. The disclaimer was necessary because it was generally supposed that London print-sellers were making small fortunes by acting as publishers or selling agents for engravers and print-makers. Although he numbered among his friends Dominic Colnaghi and a number of other dealers, Constable regarded most London print-sellers as no better than 'sharks' feeding off the creative work of others whose rewards in no way matched those of the parasites. The most effective, certainly the most economic, method of selling engravings was through a print-seller who shared the costs of preparation and publication. They owned the outlets and often the means of production. But to Constable this smacked too much of 'engaging in trade' and he would have none of it. It was a naive view. For three years from 1829 until 1832 the preparation of the *English Landscape* caused Constable nothing but trouble and anxiety. The mezzotints which comprise the *English Landscape* became much more than 'a pleasing professional occupation'. He was now (in 1830) nearly fifty-four; he had been a professional artist for over thirty years, but his work was known and appreciated only by a handful of friends. The engraving project represented another attempt – ill-advised and bordering on the desperate – to make his mark with his contemporaries, as Turner had done with his *Liber Studiorum*.

That Constable's works should be engraved was not entirely new. There had been a proposal, which eventually came to nothing, that S. W. Reynolds, perhaps the best-known mezzotinter of the day, should prepare plates of the Paris pictures and of twelve of the Brighton sketches; Reynolds had earlier prepared a speculative plate of *The Lock*. And there had been other isolated essays into engraving, but they could not be said to have advanced his reputation or brought in much, if anything, by way of income. As a medium for Constable's work, Fisher was against mezzotint. 'There is in your pictures too much evanescent effect & general tone to be expressed by black and white. Your charm is colour & the cool

tint of English daylight. The burr of mezzotint will not touch that.'
It is perhaps significant that relations between Fisher and Constable
had at this time lapsed partly on account of Fisher's more immediate
local concerns. Had their friendship been as close as it had been in
the past it is tempting to believe that Fisher might have been
successful in holding Constable to his own belief, expressed in 1825,
that engravers 'cannot engrave my colour or evanescence, but they
can the chiaroscuro and the form, and with it most of my sentiment
. . . it is, as you say, quite impossible to engrave the real essence of
my landscape feeling'. If Constable believed this in 1825 nothing
had occurred in the intervening years which would have caused
him to change his mind. The decision to enter the dangerous waters
represented by engraving having been taken, there was only one
medium that could effectively achieve his purpose of showing the
effects of light and shade in landscape and that was mezzotint.
Mezzotint had the clear advantage over line engraving that any
shade from black to white could be reproduced. In the first stage
of making a mezzotint plate the engraver pits a copper plate all
over with a sharp instrument known as a rocker. The plate is then
ready for the translation to begin. The engraver (working in reverse)
then scrapes and indents the pitted plate in accordance with the
result he – or in this case the originator – wishes to achieve.

Having chosen the medium, the problem now was to find an
engraver. In March 1828 Constable had made an approach to the
engraver William Ward to ask how much he would charge to
prepare a plate of *Hampstead Heath*. *The thirty-five guineas
Ward asked for was thought to be excessive and he was not engaged.
Although he does not seem to have considered any other candidates,
Constable continued to cast around for an engraver until, early in
1829, he commissioned a young man of twenty-six named David
Lucas to prepare two small plates which were published that year.
They were taken from two water-colours of the Thames – *The
Approaching Storm* and *The Departing Storm, Sketch from Nature*. If
these two pictures, with their massed clouds, were chosen to test
the engraver's skill at capturing the quite different effects they
depicted, then Lucas satisfied Constable's stringent requirements.

*William James Ward had earlier engraved Constable's portrait of Dr
Wingfield, Headmaster of Westminster School. Constable wrote to Fisher on
26 August 1827: 'My Dr Wingfield has paid — but nothing more — no one will
buy a *schoolmaster*—nor is it likely. Who would buy the keeper of the treadmill,
or a turnkey of Newgate, who has been in either place?'

Here, at last, was a man worthy to be entrusted with the larger commission. It was one that would make his name but which would add little to the reputation of his employer.

David Lucas was, like Constable, a countryman, and there are several similarities in the pattern of their early lives. Lucas was the son of a farmer from Brigstock in Northamptonshire; in his youth he worked for his father as a labourer and in his spare time he made sketches of the country in which he lived until the age of eighteen. Then by chance the young Lucas came to meet S. W. Reynolds. Reynolds, while travelling in Northamptonshire in 1820, happened to call for refreshment at the Lucas farmhouse and there he saw some of the son's sketches. Immediately impressed by their quality, Reynolds persuaded a reluctant and somewhat suspicious Farmer Lucas to allow his son David to become his apprentice; so certain was he that Lucas had a considerable talent that he waived the usual indenture fee of £300, assuring the father that he believed that his son would become 'an engraver of much respectability'.

Constable met Lucas at some time during the latter's seven years' apprenticeship. It seems likely that this would have been in 1824 or 1825 when Reynolds was at work on his speculative engraving of *The Lock*. Constable was disappointed by *The Lock*. When a proof arrived at Charlotte Street it was so dark that Minna thought it was a night scene. From time to time during his association with Lucas, Constable would invoke what he called Reynolds' 'soot-bag' or 'black fog' when criticizing a particularly black print. In David Lucas Constable had found the ideal man with whom to form a creative alliance. Only a man of Lucas's patient, long-suffering temperament could have withstood the manifold wrong turnings, about-turns, false starts, vacillation, disorganization, and unreasonable temper which his employer was to display during their working association. Lucas, because he was not yet an established engraver, was also malleable; his feeling for the scenes which he was required to translate stemmed also from his earliest memories. All these elements combined to make Lucas indispensable to the project as time went on. And, he was willing to work for fifteen guineas a plate.

The preparation of the *English Landscape* shows just how little of the commercial good sense possessed by his father and his brother Constable had inherited. He engaged Lucas, certainly at an advantageous fee, but before he had decided which plates he wished to publish, in what order they should appear, or how many plates

M

should comprise each issue. For all this apparent disorder, Constable did have in the deep recesses of his mind a clear enough aim: that of showing what he meant by light and shade in nature, the chiaroscuro.

By the late summer of 1829 Lucas began work on the first plate. Typically, this was a small engraving of *Hampstead Heath* which was published as the last plate of the fifth and last number in 1832. The tone of the relationship between Constable and Lucas is set by one of the first notes, dated 15 September 1829, carried by Constable's odd-job man, Holland, to Lucas's home in Harrow Road, Paddington:

A total *change* has again taken place. Leslie dined with me yesterday – we have agreed on a long landscape (Evening with a flight of rookes) as a companion to the 'Spring' and the 'Whitehall Stairs', in place of the Castle. Prithee come and see me at six, this evening—& take the things away, lest I *change* again.[6]

He would have to wait only a few weeks before a new plan would issue from Charlotte Street. Lucas accepted Constable's idiosyncrasies with stoicism. Constable did not regard the engravings simply as straightforward, accurate translations of his paintings: he saw each plate as a new picture, one that could be subject to 'touching up' and even second thoughts about composition. In *Stoke by Nayland* he even caused the composition of the picture to be changed so that it no longer accorded with the topography of the area. 'I long to see the Church (Stoke by Nayland) now that it is removed to a better spot — two feilds off. Take care to avoid rottenness, it is the worst quality of all.' On matters of detail Constable was characteristically meticulous. To help him with *Spring* he provided Lucas with working diagrams of a windmill so that 'I might correctly understand the mechanical construction of the vanes in order to avoid a common fault to be found in the windmills of uninformed artists in making sails, as they are erroneously called, that no amount of wind would be able to turn round.' Possibly because of the continual demands Constable made to see proofs, Lucas decided to install his own press. He probably regretted it. While it hastened the process of reaching the proof stage it also provided Constable with another aspect of Lucas's work for him to interfere with. Constable had no patience with the machine and only played with it once. In March 1830 he urged Lucas 'to take your time – I will be very good and patient in future'.

Work on the first number of the *English Landscape* was so far advanced by March 1830 that Lucas found the time to prepare a large speculative plate of *Hadleigh Castle*. A smaller version was included in the fifth number of the *English Landscape*. Constable was a little put out by this exercise of initiative on the part of a man whom he regarded as 'his' engraver. Although the large *Hadleigh Castle* was Lucas's idea, there was no possibility that a work after one of his own paintings could be released for public sale without Constable himself 'touching' the proof.

I have not the wish to become the owner of the large plate of the Castle, but I am anxious that it should be fine, & will take all pains with it. It will not fail of being so, if I may now judge . . .

Bring me another large Castle or two or three, for it is mighty fine—though it looks as if all the chimney sweepers in Christendom had been at work on it, & thrown their soot bags up in the air. Yet every body likes it—but I should recollect that none but the elect see my things—I have no doubt the world despises them.[7]

Another candidate for inclusion in the first number of the *English Landscape* was *Summerland*, but it did not pass muster, as the son of the mill-owner informed the farmer's son:

I have taken much pains, with the last proof of 'Summerland', but I fear I shall be obliged to reject it—it has never recovered from its first trip up, and the sky with the new ground is and ever will be as rotten as cow dung.[8]

Summerland was, however, included in the fourth number. It was not until the end of May that Constable finally decided on the plates to be used for the first number of the *English Landscape*: *A Dell, Weymouth Bay, A Mill,* and *Spring.* A considerable print order – nearly 1500, on various papers – was sent over to Lucas. They were priced at two guineas for India paper proofs, one and a half guineas for other proofs, and one guinea for prints. It seems clear that Constable stood to make a substantial profit on his outlay of about £250 if he were to sell all that he had printed.

By the middle of June 1830 the first number of the *English Landscape* was ready to be released to the public. The publisher sent a copy for review down to the offices of the *Athenaeum*, the 'Journal of Literature, Science and Fine Arts' and a most enthusiastic 'puff' appeared in the issue of 26 June 1830:

The subjects are more varied than we could have expected to find

in a work taken wholly from the productions of Mr. Constable; who appears to have fed his genius, like a tethered horse within a small circle in the homestead. The village river with its lock – the water-mill, with its rude deep shades and solitary wheel – the old decaying trees, and country lanes stealing down by the upland corn: these have been within eye and heart-reach of Mr. Constable's home; and these were to him 'riches fineless' . . . to the admirer – but that is a cold word – to the lover of nature, these, which are faithful miniatures of his mistress, will be treasures indeed.

The reviewer, although anonymous to readers of the *Athenaeum*, was S. W. Reynolds.[9]

Presentation copies were sent out to friends and fellow-painters including Peter de Wint who lived not far away in Gower Street and John Britton, the compiler and illustrator of *The Beauties of England and Wales*. De Wint wished him success with his 'work of great taste'. Britton, however, criticized the darkness of Lucas's work, an opinion with which Constable professed to agree. Writing soon afterwards to Lucas, Constable dismissed Britton's carping in a sentence: 'Britton just wrote to me saying we are too black — he is too white.'

Immediately after publication of the first number the publisher believed that it was to his advantage to produce a second. He also had an incentive for lying in Lucas's workroom were at least four plates which had been rejected for the first number, but which were by no means unusable. However, of the plates available only *Stoke by Nayland* and *Old Sarum* found their way into the second number. To these were added a Brighton beach scene – *A Seabeach* – and a Hampstead picture – *Noon*. According to Lucas, *Noon* was the only proof which Constable himself produced.

The second number appeared at the end of 1830. Although the first number had not sold well Constable further expanded his intentions for the venture. 'The whole work will amount to six, of four prints in each – which with a title and vignette will make *26 prints*.' Needless to say, this scheme underwent several changes in the twelve months it took for the third number to be produced. The list of titles for the next four numbers does show that Constable was anxious to make of the *English Landscape* a strongly built vehicle to support his ideas about the chiaroscuro: he wanted to show the world that it did not matter whether the picture was pastoral, architectural, marine, or historic for it to be improved by the application of his theory of the chiaroscuro. He warned Lucas – 'I

fear if we do not mind we shall not have enough of the "Pastoral".'

Though I want variety I don't want a 'hotchpotch'—we must not have any one 'uncongenial' subject. If we have, it cannot fail of tinging the whole book—& imparting a discordant feeling.[10]

An illness – 'I cough all night, which leaves me sadly weak all day' – contributed to his depression although he was habitually gloomy in the first few months of the year and invariably ill with a bad cold. Probably what had tipped him into melancholy was that the *English Landscape* was not selling as fast as he had hoped; indeed, there is no evidence that it was being sold at all. The reviews had mostly been unhelpful. He was his own publisher and he could tell better than anyone from the barely dimished stacks of the first and second numbers piled up at Charlotte Street.

Constable seems to have realized at last that to reach 'the multitude' with a publication like the *English Landscape* it was unfortunately necessary to leave the selling of it to people whose daily business if was – the print-sellers. In February and March he had been putting out feelers amongst the more reputable dealers he knew to see if any of them would like to take on part of the risk. He needed more than the helping hand his old friend Dominic Colnaghi was giving him by selling the numbers in his shop in Pall Mall. He approached Mr White of Brownlow Street, the dealer who had partly financed and then sold Turner's book. It was a humiliating experience. He recounted the details in a letter to Lucas in March which has something of a valedictory tone to it:

My indisposition sadly worries me and makes me think (perhaps too darkly) on almost every subject – nevertheless my 'seven infants', my *time of life*, and state of health, and other serious matters, make me desirous of lightening my mind as much as possible of unnecessary oppression – as I fear it is already overweighted.

I have thought much on my book and all my reflections on the subject to go oppress me—*its duration, its expence, its hopelessness of remuneration*, all are unfavorable—added to which I now discover that the printsellers 'are watching it as their lawfull prey', and they alone could help me: for 'I cannot dig, & to beg I am ashamed'. I can only dispose of it by giving it away. My plan is to make the whole number of plates now in hand only to form the book, for which I see we have about twenty. The three present numbers make 12—others begun are about eight or ten more, some of which may not be resumed—& we must begin the frontispiece.

I am led to conclude of this definition of our book – finding that it greivously harrasses my days, and disturbs my rest of nights. The expence

is too enormous for a work that has nothing but your beautifull feeling and execution to recommend it—the painter himself is totally unpopular and ever will be, on this side of the grave certainly—the subjects nothing, but '*The Arts*', and 'buyers' are totally ignorant of that. I am harrassed by the lengthened prospect of its duration—which seems quite undefined. Therefore I am come to my first plan, of *twenty*, including frontis peice & vignette—& we can now see our way out of the wood. I can bear this perhaps—because I then know the worst. I can bear the irritation of delay (from which I have suffered so much that I attribute my present illness to it in part) no longer. Consider, not a real fortnight's work has been done towards the whole in the last four months—years upon years must roll to produce the 26 prints—& all this time I shall not sell a copy, but must stand ready to part with every *fifty* or *hundred* pounds of my ready moncy—till it comes to £1000.

Remember dear Lucas that I mean not to think one reflection on you—every *thing* with the *plan* is my own—and I want to releive my mind of that which now harrasses it like a disease—& looking forward as I now do I think of it with delight as an occupation, though utterly hopeless in its result. Do not for a moment think I blame you—or that I do not sympathize with you in those lamentable causes of hindrance which have afflicted your house. Nobody will do me any good—even that man who thinks he is sure of going to heaven by dipping his arse under water*—I mean Mr. White of Brownlow Street—offers to propagate & guarantee the money for Turner and his liber stupidorum for *15 per cent*, & will not do the same for me under *35 per cent*. Therefore let us protect ourselves, by drawing the circle a little closer—& compleat & that as rapidly as possible whatever is began, be these what they are. We have no really bad subjects amongst them, at least one is as good as another of them, & let us get them out of hand—the sooner the better.[11]

Only twelve days after telling Lucas that he intended to confine the 'book' to twenty prints including the frontispiece and the vignette he backtracked again. 'I have formed a serious resolution to make the work consist of 3 numbers *only*, adding a title and a vignette. The work worries me greatly. It was indeed thought of "in cvil hour".' But by the middle of May the warmer weather and the partial recovery of his health led Constable to revive the plan for five numbers. *Summer Evening, Summer Morning, Mill Stream*, and *A Heath* were eventually chosen for the third number which was published early in September 1831. Because of the large number of unpublished plates available and ready for printing, bar a little

*Constable would felt have doubly insulted at being so hardly treated by a Dissenter, as Mr White seems to have been.

touching, the fourth number followed soon afterwards in November
1831; it was made up of *A Summerland, Summer Afternoon, A Lock on
the Stour* and *The River Stour*. By now the end of the blighted experi-
ence was in sight. It was now Lucas's turn to ruin a proof by excessive
touching up. The victim was *The Glebe Farm*. Constable was dis-
traught:

How could you dear Lucas think of touching it after bringing *me such
a proof* & without consulting me—had I dreamt of such a thing I should
not have slept—besides I wanted as [at] least a *dozen* of it in that state.

I know very well it can be *blotched up*, with *dry point burr*, regrounding,
&c, &c, but that is hatefull.

But I will say no more on so painfull a subject, for I wish you not to
be vexed. It will retard the work—but we must not mind.

I am now writing with the two proofs before me and I frankly tell
you I could burst into tears—never was there such *a wreck*. Do not touch
the plate again on any account—it is not worthwhile.

But lose no time in grounding another, for I will not lose so interesting
a subject. It would have saved the 5th number, & was it *now* in its first
state, I would rejoice to publish it *just* so. . . .

I could cry for my poor wretched wreck of the Glebe Farm—a name
that once cheered me in progress—now become painfull to the last
degree.

As the subject of the Glebe Farm is now lost, I have thoughts of sub-
stituting two new ones—the *Old House & Ford with a Waggon*, & the
Hadleigh Castle—but that we will arrange on Tuesday.

I could cry at this sad change—& that too with the *bird* once in my
hand. I know very well what you will say—that it can soon be brought
about. I know better—our 'blasted Heath' proves what can be done
only, in that way.

My opinion cannot change—my experience is now too great. If we
keep the G.F. in the book, *ground a new plate instanter*. This is my dear
boy's birthday—this day 14 years ago gave me my *first child*—we have
had a party, & a feast—but my joy is utterly alloyed by the wreck of
my poor Glebe Farm—which has not quitted my sight all day, though
stretched and locked up in a drawer.[12]

Later the same day Constable sent Pitt, who had replaced Holland,
over to Paddington with another pained message.

God knows how I shall now proceed—& when will my work end.
Besides it returns me nothing & takes away all my ready money—&
these terrible failures take away all the profit, that even can come. But
like all travellers in an unknown land we have proceeded too far to
return—& we must proceed at all events. 'Tis true we ought to calculate

on failures—this I know—but the last failure is with the cup at the lip—the bird I calculated was already netted.

But be assured, dear Lucas, the plate of the G.F. is utterly aborted. It is & must ever be of that nature (do what you will), that is *all*—*all*—that I have wished to avoid in the whole nature of the work. The book is made by me to avoid all that is to be found there—a total absence of breadth, richness, tone, chiaoscuro—& substituting soot, black fog, smoke, crackle, prickly rubble, scratches, edginess, want of keeping, & an intolerable & restless irritation.[13]

Constable was far from well at this time. Shortly before Christmas 1831 he succumbed to rheumatism which had left him, for a week or so, unable to stand; he remained at Well Walk without making his usual trips down to Charlotte Street. The attack was bad enough to leave one hand temporarily unusable, and he had to ask John to act as his amanuensis. The time his illness gave him to brood over the fifth number led to inevitable second thoughts. The final shape of the fifth number was settled in March after Constable recognized that an engraving of Waterloo Bridge had no place in a book of landscape pictures and replaced it with *Hadleigh Castle*. This plate together with a new version of *The Glebe Farm, Autumnal Sunset*, and *Yarmouth* made up the fifth number which was published in June 1832.

Now that the aim of twenty prints with two 'given in' had been achieved Constable must have anticipated washing his hands for ever of the murky world of print-making and selling. But he had not quite done with it. The prints were there for all to see – and to buy if they would – but there was something missing. The *English Landscape* appeared to be incomplete. What the book needed, Constable decided, was a word or two of explanation. He had been misunderstood before: to lose money, as he was certain to do, *and* to be misunderstood would be intolerable. His first thought was to ask his old friend from Brighton, Henry Phillips, to write an introductory letter. Constable rejected Phillips' rather stiff essay and sat down to compose his own. It went through several drafts and by May 1832 Constable felt that he had explained his aim in producing the *English Landscape*. The final version was a polite plea for understanding.

The present collection of Prints of English Landscape after much pains and considerable expence bestowed upon it, is at length completed, and is offered to the notice of the Public; not without anxiety as to the kind of reception it may meet with. The very favourable opinion, however,

passed upon it while in progress, by professional and other intelligent friends, at the same time that it has encouraged its publication, has also served to lessen that anxiety in no small degree.

The subjects of all the plates are from real scenes, the effects of light and shadow are merely transcripts of what happened at the time they were taken.

The object in view in their production has been to display the Phaenomena of the CHIAR'OSCURO of nature, to mark some of its endless beauties, to point out its vast influence upon Landscape, and to show its use and power as a medium of expression.

In Art as in Literature, there are two modes by which men aim at distinction; in the one the Artist by careful application to what others have accomplished, imitates their works, or selects and combines their various beauties; in the other he seeks excellence at its primitive source NATURE. The one forms a style upon the study of pictures, and produces either imitative or eclectic art, as it has been termed; the other by a close observation of nature discovers qualities existing in her, which have never been pourtrayed before, and thus forms a style which is original. The results of the one mode, as they repeat that with which the eye is already familiar, are soon recognised and estimated; the advances of the Artist in a new path must necessarily be slow, for few are able to judge of that which deviates from the usual course or qualified to appreciate original studies.[14]

There was a last-minute hitch in the publication of the fifth number due to Mr Sparrow the printer of Newman Street. He had chosen this inopportune moment to fall in love and get married. This event had incapacitated him to such an extent that he had taken to writing poetry and was unable to complete for some weeks the letterpress printing for the latest production of Mr Constable and Mr Lucas. Constable had little patience with such unprofessional behaviour. June was the happy Sparrow's month.

Poor infatuated printer Sparrow, has done nothing for me for 3 weeks—not a single India copy, or one plain one can I get. But he has just sent me a large peice of wedding cake—and this too, just as he has been begging assistance to buy bread and butter. The devil undoubtedly finds much fun in this town, or we never could hear of such acts of exceeding folly.[15]

With the appearance of the fifth number the purpose for which the alliance between Constable and Lucas had been formed was complete. Lucas, having given his time almost exclusively to Constable's work for over three years, understandably wanted to

display his talents to a wider audience. But Constable saw himself as the younger man's guardian. He did not welcome 'his engraver' working on plates other than his own. Lucas perhaps not very tactfully had engraved a view of Hampstead Heath after an artist called Marshall. When it appeared in 1832 one paper described it at a 'wretched attempt at a strong contrast of light and shade, through a joint error of the artist and the engraver'. Constable who saw himself as having exclusive rights in chiaroscuro and in Lucas as a means of expressing it was incensed. 'It is a pity you would not let me see this wretched business before you sent it hence, but this is like going to a woman of the town — it would not be known but for the "result".' Constable wanted Lucas to be employed only by those painters of whom he could approve and at various times urged both Wilkie and Chantrey to patronize him. Later he also sought unsuccessfully to have Lucas elected A.R.A.

Constable, beset by guilt that this ill-advised venture might have dissipated the inheritance of his children, decided in 1833 to prepare what amounted to a second edition of the *English Landscape*. To see plates rusting away in Lucas's work-room was an affront to his notions of financial prudence and he could not condone such extravagance any more than Abram would have allowed his milling machinery to fall into disrepair. This new editon, with an expanded introduction, was published towards the middle of 1833. It was well-received by the leading journals – the *Literary Gazette, Library of Fine Arts*, and the *Athenaeum* – and although it was, unlike the first book, on sale at several print-sellers at considerably reduced prices its sales were insignificant.

Constable suspected that one reason why 'the book' was not selling was inadequate presentation. 'Many can read print & cannot read mezzotint', he remarked to Leslie. This was easily mended. During the autumn of 1833 Constable began to compose short essays to accompany the prints in the *English Landscape*: six only were completed. These essays reiterated the creed which he had observed in his practice of landscape painting, but despite this considerable effort – literary composition did not come easily to him – the piles of prints at Charlotte Street showed no signs of diminishing.

If Constable needed yet another indication of the inadvisability of indulging in print-selling it came in the summer of 1834. Lucas interested a firm of print-sellers in his speculative large engravings of *The Lock* and *The Cornfield*. Dedicated by the publisher to the

President and Members of the Royal Academy 'the pair' as Constable called them, enjoyed an immediate success. It led indirectly to a foolish quarrel between Lucas and Constable the blame for which attached to only one of the parties.

Encouraged by this probably unexpected success Lucas sought to engrave *Stratford Mill*. This picture was in the possession of Mrs Tinney, the Salisbury lawyer's widow. She agreed to surrender it to Constable, adding a rider – which her husband might have written from the grave – that he 'neither retain it longer than is requisite or send for it before it is wanted'. The picture was duly sent up from Salisbury and on to Lucas who by now had moved from Paddington to Chelsea – 'in some street in Chelsea but the devil knows where' as Constable addressed one letter.

In December Constable learned that Moon, Lucas's publisher and print-seller, wanted to offer the new large engraving of *Stratford Mill* as a companion to a landscape by another artist in the hope no doubt of repeating the success that had been enjoyed by 'the pair'. Constable would appear as a companion to no one. With the engraving incomplete he peremptorily demanded Lucas to return the painting. Lucas did so promptly on the day that he was asked. With the picture he sent a note:

I have just received your letter—as you desire it I do not delay in sending back the picture and do allow me to say I most fervently wish you that peace which you say I have helped to disturb.[16]

It was a hasty move and Constable knew it, but he was in the height of anger when he told Leslie about the latest fracas with Lucas:

Now Lucas turns round upon me, and sells me with him, to the low publishers, allows himself (I fear with reason) to engrave balderdash for money—in my style, & in companion to my things. I know your calm and upright mind will say, 'Let him'—but I lose the gratification of seeing my own creations, multiplied by this beautiful art of his, which I helped to foster & cultivate.

The two beautiful prints by Lucas are in the windows, but every gleam of sunshine is blighted to me in the art at least. Can it therefore be wondered that I paint continual storms?[17]

Almost as soon as he made his unreasonable demand Constable realized that he was in the wrong and that his action would involve Lucas in some financial loss. He wrote one of his rambling letters disclaiming any intention of injuring the engraver and reminding

him that 'there is a consideration due to those *who help to adjust the foot to the "first step".'* He concluded with a sermon:

We have all our foibles and our failings. A love of money has seemed always to me to be yours—take care lest it lead you to abandon that independency of spirit, those habits of pains taking, to which I once so much delighted to administer all the encouragement in my power, in all ways—this made you an artist, and from this source emanated your two most beautifull prints.

I now offer this (perhaps) my last advice—that you study to preserve the moral feeling in art—it can have no better name. *I could tell you much more*—but you are not in that state of mind in which it would be either relished or understood—if I am not greatly in error. What return, may I ask, *could* I look for in you, more than that which is reciprocal? You had no other way to return the great and irretrievable loss I have sustained than in supporting my art—and this you could but do by supporting your own self and independence in art.[18]

The temptation to cut loose from Constable must have been a strong one, but Lucas had weathered his employer's storms before. He maintained a dignified stance, denying the accusation that he was a money-grubber, thanking him for his 'friendly hints' and claiming that his only intention was 'the pleasure of trying to make a beautiful [engraving]' of *Stratford Mill.*

I own dear Lucas that my sad impetuosity has in this instance (as well as in all others) led me to such conclusions as *I now fully beleive I was unwarranted in coming to.* I was driven by it to anticipate evils that (I really at the time thought) might come rather than what, did really exist—but you have set me at rest, and as far as *yourself* is concerned my mind is releived.

I never neither wished or expected you not to engage in any work you pleased, but I left it to your honour and leave it so whether for both our sakes you should engage to make 'centres', *'imitations'*, *'companions'*, of any works approaching to my style in landscape—thus by your excellent art to enhance common place for the good of publishers, to our disgrace and ruin. This courtesie I expect from you and no other—and I know as long as you keep *your independence* it will not be otherwise. At present I know you have nobly refused all requests—so *unfair—so ungenerous—so perfideous.* I was alarmed—and my behaviour & conduct was wholly directed by that alarm, taken in a moment of surprize as I was. 'Tis my style, and your admirable mode of rendering that style, of which I am so watchfull & jealous. Of this perhaps I have now said enough.

Of your regard for me, dear Lucas, I shall never have a doubt, even under any circumstances—and of the sincerity of your love for my things

in landscape, there can be no greater proofs than the manner in which you have rendered them, and the disinterestedness in which you have undertaken such considerable works, at your own risk, and that of your family and reputation. And, dear Lucas, as to obligations they are mutual —reciprocal – and fairly balanced on both sides.

My man Joseph is waiting in the hall with the picture, and I hasten to conclude this note—and I do so in that Christian spirit, which I desire to possess but which is in you better rooted than in me. Let what has passed rather *add* to our friendship than *shake* it—for we have a bond of friendship, even here, that all do not possess—*a unison of feeling in art* and a mutual regard for the talents of each of which we have sufficient proofs, in the lovely amalgamation of our works.[19]

Although the relationship with Lucas continued until the end of Constable's life it was never again so close as it had been during the making of the *English Landscape*.*

After occupying the Presidency for some ten years Sir Thomas Lawrence died suddenly on 7 January 1830. Gossip around Somerset House had for some time favoured Wilkie as the heir-apparent, although the uncommunicative Scotsman had his opponents. The contest was between Wilkie and the Irish portrait painter Martin Archer Shee. Shee had narrowly missed succeeding West and his claims to the highest office in the Academy were no less strong now than they had been in 1820. Surprisingly the Academy did not frown on a man who dissipated his talent by dabbling, as Shee did, in other forms of art. He was a versifier, having produced his *Rhymes on Art* in 1805. Shee's essay into the theatre was of more recent memory. In 1824 he had written a play *Alasco: a Tragedy* which had to be withdrawn following objections by the deputy licenser of plays. In 1829 Shee had tried his hand at a novel. Such evidence of frivolity would surely have damned the chances of advancement for a candidate with a less acceptable background than Shee.

Shee was a gentleman; his family had connections with the formidable Connaughts. A courteous man with the perhaps unartistic

*Lucas never escaped from Constable, even after the painter's death. That we have such a full record of their association is largely because Lucas kept almost every note or letter Constable ever wrote to him. For nearly twenty years after Constable's death hardly a year passed without Lucas having one or more engravings after Constable 'on the stone'. This dependence did not serve him well: Lucas died a pauper – and probably an alcoholic – in the Fulham workhouse in 1881, aged 79. (JCC IV, p. 442)

trait of having a sound head for business, Martin Archer Shee would be an admirable figure-head, one who could be relied upon to bring to the Presidency the unquestioned acceptability of a patrician. In the election on 25 January 1830 only two votes were cast for Shee's opponent David Wilkie. Leslie admitted to one of them, and it is possible that Constable, who had earlier declared that he would never vote for a portrait painter as President, also supported his old friend. Once Shee was elected, however, Constable remarked that much was expected from his chivalrous sense of honour. Shee was not overjoyed at his success which had come to him unsought and he feared that his finances might not be able to stand the strain.

David Lucas relates that when John Jackson called on the new President to congratulate him on his knighthood the new President of the Royal Academy showed him an account for a hundred pounds which he had received from the Lord Chamberlain's office and said: 'You see I am rather to be pitied in my position, for I fear this is only the beginning of sorrow.'

For the first time for many years Constable did not contribute to the British Institution exhibition in 1830. He went to see what was on display, but came away unimpressed. He told Leslie: 'I recollect nothing in the Gallery but some women's bums by Etty R.A.'* For some time William Etty had been the butt of his fellow-painters because of his predilection for nude painting. Long after he had ceased to need instruction in the art of figure painting Etty continued to attend the life class at the Academy. Such diligence was not ascribed to the painter's modesty.

Largely because of the *English Landscape* Constable did not have on his easel any large work for this year's Academy Exhibition. However, a commission from James Carpenter the bookseller fell through and it was this painting of *Helmingham Dell* which became one of his exhibits. 'My picture has and is plaguing me exceedingly', he told Leslie in April, 'for it is always impossible to know what they really want "till it comes to the last" — however, it shall go.' It was as he was finishing *Helmingham Dell* that, as Leslie relates, Constable was 'beset with a great many suggestions from a very

*Constable had a keen eye for what might be called the painter's *double-entendre*. Reporting to Leslie after seeing Alfred Chalon's painting of Samson and Delilah he wrote: 'Alfred has chosen a fine moment — the lady is lovely, in her supplicating posture, & justly [ruffled] finery. She extends her hand to take hold of his — which he refuses, but I think her in danger of taking hold of something else that equally belongs to him.' (JCC III, letter dated 7 January 1833)

shallow source'. Constable adopted some of the suggested amendments, but the 'shallow source' eventually came up against his more acerbic side. 'Very true', Constable replied to one suggestion, 'but don't you see that I might go on and make this picture so good that it would be good for nothing?' Constable's report to Fisher suggests that some of the newspaper comments on his affectation and mannered method might have hit home:

My Wood (*Helmingham Dell*) is liked but I suffer for want of that little completion which you always feel the regret of—and you are quite right. I have filled my head with certain notions of *freshness—sparkle—brightness*—till it has influenced my practice in no small degree, & is in fact taking the place of truth so invidious is manner, in all things—it is a species of self-worship—which should always be combated—& we have nature (another word for moral feeling) always in our reach to do it with—if we will have the resolution to look at her.[20]

With *Helmingham Dell*, Constable sent to Somerset House *A Heath*, another landscape, and *Water-meadows near Salisbury*. This year Constable served on both the selecting Council of the Academy and on the Committee of Arrangement, or Hanging Committee. It was when *Water-meadows near Salisbury* came before the Council that Constable suffered another of the humiliations which seemed to dog his life. Owing to an error in the preliminary sorting of the contributions *Water-meadows near Salisbury* which, being the work of an Academician, should have been approved and hung without examination, was brought in and placed before the selecting Council:

The first judge said, 'That's a poor thing'; the next muttered 'It's very green'; in short, the picture had to stand the fire of animadversion from everybody but Constable, the last remark being 'It's devilish bad – cross it'. Constable rose, took a couple of steps in front, turned round, and faced the Council.

'That picture,' said he, 'was painted by me. I had a notion that some of you didn't like my work, and this is a pretty convincing proof. I am very much obliged to you,' making a low bow.

'Dear, dear!' said the President [Shee] to the head-carpenter, 'how came that picture amongst the outsiders? Bring it back; it must be admitted, of course.'

'No! it must not!' said Constable; 'out it goes!' and, in spite of apology and entreaty, out it went.[21]

Serving on the Hanging Committee was not an enjoyable experience: 'My duty as "Hangman" has not been the most enviable — it

may account for some of the scurrilities of the newspapers, the mouths of which who can escape who has others to please?' Leslie relates that Constable dealt summarily with one amateur painter who had complained at the position given to his exhibit. After accusing several Academicians of jealousy the disappointed painter said: 'I cannot but feel as I do, for painting is a passion with me.' 'Yes', said Constable, 'and a bad passion.' Another source of irritation was the excessive size of some of the frames. One exhibitor claimed that his frames were exact copies of those used by Sir Thomas Lawrence. This gentleman was put down by a liberal dose of Constable acid. 'It is very easy to imitate Lawrence in his *frames*.'*

Of the 'Hangman's' own work, the *Morning Post* approved of *Helmingham Dell*, but the critic of the *Morning Chronicle*, apparently the same writer who had last year heaped lavish praise on *Hadleigh Castle*, took against both the work and the man who had produced it:

> This artist manages by a fantastic and coarse style of painting, for his colours appear to be lain on with a knife rather than with a brush, to produce powerful effects and sometimes a remarkable degree of natural truth; but he has not improved in art as he has in fortune, to which latter he certainly owes the obsequiousness of the Academy and the long struggled for R.A. Though not without great merits, much impaired by silly affectation and various clumsy efforts at singularity, he, as a painter falls far short of Callcott and Lee in their respective excellencies . . . Effect, *quocuque modo*, is the idol of Constable, both in his painting and himself, and both would be more respected with less coarseness.[22]

This was the first salvo in a vendetta which the *Morning Chronicle*, then one of the most influential London newspapers, waged against Constable until 1834; in the following year the same writer continued his vituperative excesses in *The Observer* until he was dismissed. The reason for the attacks and the identity of the writer are unknown.

Constable's life, outside his professional concerns, was confined to the well-being of his seven children. He had indulged them during Maria's lifetime and, if anything, he continued to indulge them even more. Constable enjoyed their company; his disappointment at missing a party was almost as great as theirs. In January the

* In his *Memoir of Richard Redgrave*, F. M. Redgrave wrote (p. 56): 'Leslie has just completed his life of Constable, and the world will know Constable only through Leslie's agreeable life of him. There he appears all amiability and goodness, and one cannot recognise the bland, yet intense, sarcasm of his nature: soft and amiable in speech, he yet uttered sarcasms which cut you to the bone.' He was, however, writing of Constable in middle age.

Leslies who were now living at 41, Portman Place off Edgware Road had failed to visit Charlotte Street as expected:

> It was a grievous disappointment to all of us not seeing you and Mrs. Leslie. It had been so much reckoned upon—my dear little girls were all in 'apple pie' order to be seen—my dear Maria had been practising her 'steps' & music all day that she might appear to every advantage—all my boys were in their best and had allowed a total clearance of the drawing room of all their numerous 'ships'—& 'castles'—books—bricks—drawings—&c &c &c.
> My pretty Maria had ready a little present for my goddaughter—and to prove to you & Mrs. Leslie that though our disappointment was severe, we are not angry—she begs to send it this after noon.[43]

He once took John and Charles to John Beauchamp's 'British Plate' factory in Holborn. They were entranced – so, possibly, was their father: 'forges — smelting potts — metals — turning lathes — straps & bellows — coals, ashes, dust — dirt & cinders — and everything else that is agreable to boys. They want me to build them just such a place, under my painting room: and had I not better do so — and give up landscape painting'. With his children Constable displayed extraordinary patience and understanding. For a Constable child – probably any child – to deserve even chastisement, the misdemeanour had to be of a very serious order; there is no record anywhere of a child being punished or even 'in disgrace'. To Constable a child should be respected; his behaviour should be indulged, understood and forgiven. Julian Young, son of the actor Charles Mayne Young, recounts a visit to Constable by his uncle Edward Young:

> He called on Constable one day and was received by him in his front room. After half an hour's chat the artist proposed to repair to another room to show him a large picture on which he had been engaged. On walking up to his easel, he found that in his absence one of his little boys had dashed the handle of the hearth-broom through the canvas, and made so large a rent as to render its restoration impossible. He called the child up to him and asked gently if he had done it. When the boy admitted that he had, he rebuked him in these unmeasured terms: 'Oh! my dear pet! See what we have done! Dear, dear. What shall we do to mend it? I can't think – can you?'[24]

Leslie's son Robert witnessed another remarkable display of tolerance in the face of extreme provocation. In later life, he recalled an occasion when he was playing in the courtyard at Charlotte

N

Street which Constable had had glazed over to make a playground for his children:

Among many other interesting toys they had a complete working model of a fire engine; and one of the elder boys, after cutting holes in a large box to represent a house with windows, filled it with shavings and set fire to them. Another boy then rang a small bell and the fire engine appeared, but had scarcely begun to play upon the burning box when Constable, to whose studio the dense smoke had made its way, came among us, and saying, 'I won't have any more of this,' looked for a can of water to put out the fire, while the author of the mischief cooly turned the hose of the little engine on the back of his father's head, who, instead of being furious with the boy, as I expected, appeared to think it rather a good joke, and after extinguishing the fire went quietly back to his painting room.[25]

A later incident involving saltpetre resulted in an injury to Constable's hand. John hoped that his father would not suffer another explosion and added precise instructions for home-made fireworks: 'Take peter and lay it on a warm shovel, it first begins to blacken and then explodes with a loud report, yes Sir.'

The education of his elder sons, John and Charles, remained a problem, partly caused by his own procrastination. They could not, however much Constable might wish it, remain for ever protected from exposure to 'accumulative evil — the real word for schools'. His view of the education of his girls – Maria in particular, who was now twelve – was at the opposite pole. 'I believe it to be for her good', he told Leslie at the end of the year, 'isolated as I am that she is so much away from me — but her education is better than under any circumstances it could be under this roof.' The three girls, – Minna, Isabel, and Emily — were now all attending a school in Hampstead called Elizabeth House where the proprietor, Miss Sophia Noble, aimed to foster gentle accomplishments and the reticent charm that was considered becoming in the daughters of the well-to-do. 'As to all my boys,' Constable remarked in 1834, 'I wish I could turn them into girls.'

Constable concluded that for as long as he could manage it, financially and practically, he would have his boys educated at home. He therefore let it be known among his relatives that he wanted to engage a private tutor. His cousin Jane South recommended a 'Mr. Boner, he would come to them every day from nine to eleven for a guinea a week the two. He is very *gentle* & very *clever* – I am sure the dear children would like him – I think the hours

very good as it will not interfere with any day arrangements.' Jane South was enough aware of her cousin's requirements to recommend a candidate who was 'gentle'.

Charles Boner was engaged for a stipend of £20 per quarter. In temperament he was an ideal person to join the painter's family. A gentle, studious youth not yet sixteen years of age, he was of German origin and had grown up in the West Country. An injury in childhood had left him time to follow a long course of self-education in addition to his formal schooling. He soon acquired the nickname of 'old Bo' although he was less than two years older than John Charles. Constable could feel satisfied that he had made the correct decision; his boys would not be corrupted through association with the sensitive Mr Boner.

In January 1831 Constable renewed his association with a discipline he had not practised since his student days when he acted as Visitor to the Life Academy. The Visitor was required to set the pose of the model and instruct the students in figure drawing. One of his students was a future Royal Academician, Daniel Maclise, who sketched the Visitor to the Life Academy and wrote an account of his teaching methods. Constable was an enthusiastic teacher; he had plenty to say about 'execution' and was continually commenting, no doubt with the directness that offended some of his contemporaries, on the work in progress. 'I am become popular "in the life" (a thing not to be desired "in this life")' he told Leslie. The students liked him because he was no dry-as-dust instructor; he wanted them to see the figure and its background and surroundings as he did. He considered that the young painters could best learn to see and appreciate the relationship by posing the model in an attitude which recreated a well-known masterpiece. Raphael's *Eve* was the first tableau. She was provided with a background of evergreens; oranges were attached to the branches to suggest the Tree of Knowledge. 'In my *address* to the students I said that probably they expected a landscape background from me.' Constable's men bringing the greenery down from Hampstead were arrested, suspected of theft, by zealous officers of Sir Robert Peel's two-year old London police force. The Visitor himself had to attend the police court before they could be released with their 'green boughs'. Models were difficult to recruit because it was considered immoral to pose in the nude; those who did present themselves often disappeared, one session being enough in the draughty rooms of the Royal Academy Schools. Eve, for one, 'shivered sadly, and became

like a "goose" all over. I got her warm & told her not to be such a goose as to tell her "Aunt" who was very loath to let her come to the Academy.' Eve was succeeded by two men who impersonated Michaelangelo's *Last Judgement*. Finally, came a figure 'liked better than all' whom Constable called 'my Amazon'. Etty, who remarked of another model that she was 'remarkably fine in front', was so delighted that he invited Constable to a social breakfast.

At the end of the month Constable returned to a picture which he considered his greatest. *Salisbury Cathedral from the Meadows* is a direct descendant of the sketches he had done during his summer visit to Fisher in 1829. The ageing Academician Sir William Beechey called at Charlotte Street during March when Constable was completing his picture for Somerset House: 'Why *damn* it Constable, what a *damned* fine picture you are making, but you look *damned* ill – and you have got a *damned* bad cold.' Charley was impressed too, and he wrote to Minna on 28 March that 'Papa is painting a beautiful Picture of Salisbury Cathedral'.

The top half of *Salisbury Cathedral from the Meadows* belongs to Wiltshire while the lower half with its 'slimy posts' and the horses pulling a tumbril through the shallow waters of the River Avon could be taken for a scene on the Stour. To combine the two parts of England that he loved best in a stormy landscape scene with a rainbow soaring triumphantly over the cathedral must have seemed a most appealing idea. His only other exhibit this year was a small oil of *Yarmouth Pier*.

To the critics, *Salisbury Cathedral from the Meadows* was a sitting duck. *The Times* chose to develop the jibes that *Hadleigh Castle* had attracted. The writer conceded that it was a vigorous and masterly landscape, but went on to remark that 'someone spoiled it since it was painted, by putting in such clouds as no human being ever saw, and by spotting the foreground all over with whitewash. It is quite impossible that this offence can have been committed with the consent of the artist.' The antagonistic gentleman who wrote for the *Morning Chronicle* dismissed it as a 'coarse vulgar imitation of Turner's freaks and follies'.

We have found out Mr. Constable's secret, he is a Cornelius Ketel; see Harding's excellent catalogue of portraits, No. 153: 'Cornelius Ketel took it into his head to lay aside his brushes and to paint with his fingers only; and at length, finding those tools too easy, undertook to paint with his toes'. We rather suspect that Turner is sometimes a little inclined to this failing, but never so perfectly *in toto* as Mr. Constable this year.[26]

Visits to and from the Leslies became one of Constable's 'chief delights'. He took a keen interest in the births of the Leslie children for, as he told Leslie after the arrival of his second son, Bradford, in August 1831, 'they were happy days with me when I had infants . . .'. But a child at the breast also brought back other memories:

I rejoice at the good account of dear Mrs. Leslie & your infant—but I would insist on the little rascal's taking something more than 'his natural food'—they are terrible little leeches—& the effects of their exhaustion are not felt at the time but grievously afterwards. I am no bad nurse, as fatal experience has made me.[27]

With the onset of summer the Suffolk relatives offered holidays. Constable gladly took up Patty Whalley's invitation for the girls to spend a month with her at Dedham. Accommodation was limited, but 'perhaps variety would compensate them for the great comforts & indulgence left at home'. The invitation did not include the elder boys both of whom had been suffering from the 'nasty beggarly school complaint', ringworm. While Minna, Emily and Isabel enjoyed their pony van rides and their visits around Bergholt and Dedham, the two afflicted boys spent their time fishing and, in John's case, attending to the mineral collection which he had been building up since the age of about twelve. 'Bob' Roberts attended to the simpler needs of 'Lion' and 'Alfie'.

Throughout his life Constable was largely indifferent to politics unless it seemed that the status quo was likely to be upset. This eventuality seemed possible in the autumn of 1831 when agitation for reform of the House of Commons and the fever engendered by Lord John Russell's Reform Bill was at its height. That the House of Commons appeared to be presiding over its own demise appalled Constable. He convinced himself that if the government was given 'into the hands of the rabble and dregs of the people, and the devil's agents on earth — the agitators' his children's inheritance would be more than halved in value. Constable's pessimism coincided with the onset of an undefined illness which was to culminate in a serious breakdown of his health at the beginning of 1832. Leslie tried to calm his fears by pointing out, as Fisher would have done, the dangers to his health of burdening the mind 'with useless apprehensions of the future'. Constable had recovered his equilibrium by the beginning of November and typically informed Leslie that 'the

"Reform bill" now gives me not the least concern — I care nothing about it — & have no curiosity to know if it be *dead* or *alive* — or whether it will rise from its ashes'. Constable had an uncomplicated view of the way in which Englishmen lived their lives, governed themselves, and conducted their relationships. He believed in order, in fairness, in a defined class structure and in the responsibilities that accrued to the more fortunate to care for those whom he would have regarded as inferiors.

Constable found a number of outlets for his paternalism. In London he gave his time and energy to the affairs of the Artists' General Benevolent Institution. The Institution was founded in 1814 to provide for the widows of artists; in the following year it was decided that living artists 'whose works have been generally known and esteemed by the public, as well as their Widows and Orphans' could also benefit. Constable first attended a meeting of the Institution in May 1818 and in December of that year he was elected to the Council. Between 1818 and 1837 Constable acted variously as a director, steward, or vice-president of the Institution. Among his fellow-directors and officers were Turner, Chantrey, Wilkie, Beechey, Jackson, and Dominic Colnaghi. Deserving cases were brought to the notice of members who pleaded their worth at meetings of the Council. Constable's name appears regularly in the records of the Institution as a sponsor of applications for funds.[28]

Constable regarded the provision of assistance to the needy as a moral duty and even at a time when he was short of money he still dipped into his pocket to distribute what charity he could afford. In 1820 he learned of a poor Swiss organist named Fontaine who had seven children. He was unable to support his family even by begging because he was taken for an Italian; the war had only been over for five years. For several years Constable helped to support Fontaine and his family with the aid of Fisher and Lady Dysart and no doubt others to whom he applied for contributions to Fontaine's pension. From about 1830 the poorer people of East Bergholt often received a gift of blankets from Constable at Christmas.

Almost as an adjunct to his charitable interests, Constable could always be relied upon to help those whom he considered were being treated unfairly. November 1831 found him fighting openly in the Council of the Royal Academy for equity. The matter concerned an architect named Joseph Gandy who had yet to become an Academician after twenty-eight years as an Associate. Gandy, who was sixty, was in the habit of writing letters to the Council to

press his claims for recognition. His latest letter, considered by the Council on 25 November, described his condition in vivid terms:

He mentioned his having dreadful symptoms of a discharge of blood from his mouth—sometimes in quantities and always a constant spitting of it . . . I however declared before the Council that I was shocked that such a man should never have been elected an Academician—& that I could not myself vote for any other architect while he still breathed.[29]

It is not surprising that Gandy's case excited Constable's sympathy. They had both experienced the petty arrogance of the Royal Academy and Gandy was very much his own man, as Constable learned from the sculptor, Richard Westmacott:

I walked away with Westmacott—and I then asked him, if he knew of any positive reason or cause which had ever been urged to his exclusion— no answer that was intelligible. He said he was a 'bad-mannered' man—& was *rude* to any *gentleman* or *nobleman*, who *found fault* with his designs— & 'that he would not alter his drawings,' &c. This has much enhanced Gandy *with me ! !*[30]

Constable suspected that Gandy – and probably himself – had been excluded through some chicanery on the part of Henry Thomson, R.A., Keeper of the Academy until 1827. He seems to have engineered diplomas for his favourites and was described by Lawrence in unusually strong terms: 'for *envious hatred*, and low, toiling, *crafty* mischief, there has existed in the Academy no Iago like that man'.

Constable's special pleading on Gandy's behalf was unsuccessful. It was particularly galling for Gandy that his younger brother John, also an architect, had begun his own campaign to secure election to the Academy. John Gandy, on receiving an inheritance, had changed his name to Deering and was attempting to buy his way into favour by entertaining 'batches' of Academicians. Constable was invited to a party by the 'huge lusty builder', as he described him, but refused. Joseph Gandy died an A.R.A.; his brother John Peter Gandy Deering became an R.A. in 1838.

Constable intended to pass 'a quiet and domestic winter' making 'Hampstead my *home* — Charlotte Street my *office*', but the illness to which he had been subject throughout the year emerged in December – at about the time he was beside himself with disappointment at the botched *Glebe Farm* plate – as a severe attack of rheumatism. It left him for a time with only the use of his right hand. 'Thank God this right hand is left to me — entire' he wrote to

Leslie, '— reminding me, if I could ever forget it, of your dear child's surprize (on seeing a picture of a hand) at "the poor gentleman who was all gone but his hand". . .'. He ascribed the illness in part to 'fretting — pining for my children — of whom I saw little or nothing, only night and morning'. Illness never diminished the joy he derived from his children:

How heavenly it is to wake up as I do now after a good night—and see all these dear infants about my bed all *up early* to know how papa passed the night—even little Lionel puts out his little face to be kissed and smacking his lips like a fish, says, 'Are you well-better to day.'[31]

Constable passed his fourth Christmas as a widower at Well Walk with all the children bar Minna whom he had reluctantly allowed to spend a week with her Aunt Louisa at Putney. Before she left 'my pretty Mini dressed up my mantlepeice with X'mas [boughs] & likewise set out a little table that I might look pretty in the dining room in her absence, which I scrupulously avoid being disturbed'.

I miss her exceedingly. She is so orderly in all her plans—& so full of method—so ladylike by nature—& so firm & yet so gentle that you cannot beleive the influence of this heavenly little monitor on this whole house—*but most of all on me*, who look, and watch, on all her dear ways with mingled smiles and tears. . . .

Should I live and this dear image of her mother be spared to me—what a blessing and comfort to my old age. I have much indeed to be thankfull for & though I pass little of my time on my knees, I live a life of eternal gratitude.[32]

The first month of a new year, 1832, had again arrived and with it the pressing necessity to decide upon a contribution to Somerset House. Constable took a bold decision: he chose to make another attempt at the picture he nearly always referred to as 'the Bridge' — *The Opening of Waterloo Bridge*. It was a work that could be said to be in its fifteenth year of composition; at least the idea dated from the opening of the new Waterloo Bridge in 1817. That year had produced a 'promising sketch'. There were further sketches in 1819 and then in 1820 Constable attempted a big canvas. He worked on this, despite Farington's early disapproval, not 'a touch a day for five years' as Fisher had recommended, in addition to several other sketches and studies; in 1827 he retired temporarily from 'putting

my River Thames on a large canvas'. In 1824 he had produced a 'little Waterloo, a small balloon to let off as a forerunner of the large one'.[33]

It was indeed a large canvas; measuring four feet ten inches by seven feet ten inches, it was probably his largest. 'A large canvas shows all your faults . . .'. It also took much more strength and endurance than Constable could call upon. His illness was real enough. He was suffering from a particularly disabling form of rheumatism. It was so severe that, as he told Leslie, he 'could not walk to the top of my own street'. He was unable to hold a pen for the first three weeks of January 1832. Yet a little over a month later he could report, to Lucas, that he was 'dashing away at the great London — and why not. I may as well produce this abortion as another — for who cares for landscape?'* It is moving to imagine the lonely, ageing, artist struggling away in his painting room in Charlotte Street while some of his seven children would be elsewhere in the house, occasionally coming in to see their father playing with his pretty colours. 'Alfa does all he can to help me — at least he never quits my easil and sometimes he does me incredible mischief . . . to my great delight.' Constable worked on his huge canvas – a 'Harlequin's jacket' of a picture – seven days a week between late February and April, but he did not neglect his responsibilities to the children. On one occasion during this period he told Mrs Leslie that after dining at Charlotte Street with Charley and Alfa he was going up to Well Walk to spend some time with his three little girls and that he would 'return to my vomit (my picture) at night'.

But labour as he might there was not enough time to finish a canvas of this magnitude. Leslie was encouraging, but old Thomas Stothard, who came round to Charlotte Street during April when the picture was about to be sent down to Somerset House, demolished 'the Bridge': 'Very unfinished Sir — much to do — figures not made out Sir.' Constable was himself uneasy about the painting; he feared its reception because 'it has not my redeeming voice ("the rural")'. *Waterloo Bridge* was a metropolitan picture; it was not a river scene with boats.

*Beckett suggests that the following note, found among Constable's papers, was written towards the end of his life; it may refer to *Waterloo Bridge*. 'That I am not liked I can eassly beleive — as it flatters none by "imitation" and courts none by "smoothness", and "tickles" none by "petiteness", and is without either "fal lal" or fiddle deedee".

'How then can I expect to be popular?' (JCC IV, p. 6)

There was still a chance that the picture could be tidied up and improved during the varnishing days and this, combined with a good position in the Exhibition, might save it from being dismissed as yet another of Mr Constable's attempts to appear singular. But neither of these last-chance cards was to be dealt to him:

They have put it where it can only be seen to the greatest disadvantage, in the traffic between the doors in the new room—the light of the worst kind for my unfortunate 'manner' & also, coming across mine, had you seen it, I am sure you would not have let me have sent it out of my house in so bad a condition—there I deserve my punishment.[34]

The amount of time allowed for varnishing was the cause of much dissension among exhibitors; it was an unfair privilege which was granted only to Associates and Academicians. Five days had been allowed for many years; for some painters this time was invaluable, enabling them to bring their pictures up to exhibition standard. But this year President Shee decreed that varnishing would take place on only one day. He could view the consternation his edict produced with a certain detachment since his work left his studio already varnished. So there could be no last-minute work to save 'my scrambling affair'. Turner was hardest hit. He habitually submitted his pictures in an unfinished state; often they were devoid of colour and detail. Although Turner regarded varnishing days as a social occasion this did not stop him from working from early morning to darkness – to 'make' his pictures. In 1832 he exhibited *Helvoetsluys* which Leslie described as 'a grey picture, beautiful and true, but with no positive colour in any part of it'.

Constable's 'Waterloo' seemed as if painted with liquid gold and silver, and Turner came several times into the room while he was heightening with vermilion and lake the decorations and flags of the city barges. Turner stood behind him, looking from the 'Waterloo' to his own picture, and at last brought his palette from the great room where he was touching another picture, and putting a round daub of red lead, somewhat bigger than a shilling, on his grey sea, went away without saying a word.
The intensity of the red lead, made more vivid by the coolness of his picture, caused even the vermilion and lake of Constable to look weak. I came into the room just as Turner left it. 'He has been here', said Constable, 'and fired a gun.' On the opposite wall was a picture, by Jones, of Shadrach, Meshach, Abednego in the furnace. 'A coal', said Cooper, 'has bounced across the room from Jones's picture, and set fire to Turner's Sea.' The great man did not come into the room for a day and a half; and then, in the last moments that were allowed for painting,

he glazed the scarlet seal he had put on his picture, and shaped it into a buoy.[35]

Reaction in the public prints was mixed as usual. *The Times* and the *Morning Post* were troubled by the 'white spots' and the 'flakes of white', but they in common with the *Literary Gazette* found much to admire in the picture. The *Morning Post* pompously saluted the work as 'one of the proudest productions of the English pencil'. The *Morning Chronicle* notice began aggressively: 'What a piece of plaster it is!'[36]

In 1832 Constable sent to the Academy more works than he had ever submitted before. There were eight in all: in addition to the main picture there were three oils – *Sir Richard Steele's Cottage, Hampstead, A Romantic House at Hampstead* and *Moonlight* – and four drawings which included a large water-colour of *Jaques and the Wounded Stag*.

The remainder of the year proved to be a testing time. Towards the end of June, Minna was suddenly taken ill with scarlet fever. Dr Evans and the Hampstead apothecary were called in to treat her, but she was not allowed to leave school, and her illness also kept captive her two younger sisters:

It is so cruel I cannot see her—it is hard on the other little girls, that they cannot come home—but they are getting reconciled, & little Emily told Miss Noble 'that it was not near so disagreeable & *nasty* to stay the holidays as she expected'—poor little souls—& if my boys should get it it will be very bad, & will go hard with them.[37]

Minna pulled through and after recuperating at Brighton with the Leslies who were on holiday there, she was sent down to Suffolk in the hope that country air would complete her recovery. Constable left her with Patty Whalley at Dedham and went on to Flatford to stay with Abram. While there he would certainly have passed on to his old friend John Dunthorne the latest bulletin about his ailing son. Constable's former assistant, young Johnny Dunthorne, who was only twenty-six had been ill with a heart complaint for much of the year and recently his condition had worsened:

Poor dear John Dunthorne is very much worse—his legs are now so large he can hardly walk. He had several doctors with him yesterday who have releived him a little, but this scene of things cannot last long. It makes me sadly melancholy—I shall lose a sincere friend, whose attachment to me has been like a sons from his infancy. He is without fault & so much the fitter for heaven. I woke in the night about him.[38]

In 1829, the younger Dunthorne, with Constable's help, had established himself as a picture restorer in Grafton Street. He had already been employed on the collections of Lord Westminster and Lord Westmorland. 'He is lamenting that just as he is succeeding in the world he is taken away from it.' Dunthorne was not to see out the year and died in Suffolk in November.

Dunthorne was the second of Constable's close friends to die in 1832. He had only just had the great relief of seeing Minna totally restored to health when he learned that Fisher had died suddenly in France. It had been hoped that his ill-health would respond to a change of climate. The cause of death was apparently cholera although this unpleasant fact was kept from Mary Fisher. He was nearly forty-six.

I cannot say but this very sudden and awfull event has strongly affected me. The closest intimacy had subsisted for many years between us—we loved each other and confided in each other entirely—and his loss makes me a sad gap in my life & worldly prospects—He would have helped my children, for he was a good adviser though impetuous—and a truly religious man.

God bless him till we meet again—I cannot tell how singularly his death has affected me.[39]

8

1833-1837

Painting should be understood

With Fisher gone the association with Leslie, already close, became more intense. It fell to Leslie to maintain, as Fisher had done, an unflagging interest in Constable's work. This was no chore for Leslie whose regard for Constable and his work and ideas was enthusiastic. Constable had never flinched from acknowledging his debt to Fisher; neither did he with his successor:

> It is time at '56' to begin at least to know 'one's self'—and I do know what *I am not*, and your regard for me has at least awakened me to believe in the possibility that I may yet make some impression with my 'light'— my 'dews'—my 'breezes'—my *bloom* and my *freshness*—no one of which qualities has yet been perfected on the canvas of any painter in this world.[1]

All these qualities Constable wanted to bring to another picture that was already half-finished. This was a view of Englefield House in Surrey, the seat of an immensely wealthy man named Richard Benyon-De Beauvoir. Constable had been recommended to Mr De Beauvoir by Samuel Lane as long ago as 1824, but it was not until August 1832 that he made his first exploratory visit to Surrey. He was looking for the landscape possibilities in such a run of the mill 'job', of the kind that had made satisfying work of *Wivenhoe*

Park and *Malvern Hall*. 'A gentleman's park is my aversion', he wrote. 'It is not beauty because it is not nature.' One of the preliminary sketches suggests that Constable saw the commission as a landscape with the house as an ingredient rather than the reverse. When Leslie saw the picture in December 1832 he thought that Constable had gone too far in relegating the pastoral elements to insignificant details.

> Your note of Wednesday reached me at tea time that day—and before bed time, I had made all the cows in the foreground of the house picture, bigger, and put in another bigger than all the rest put together. This has had all the effect you anticipated and sent the house back and also much enhanced & helped to realize my foreground, which indeed this blank canvas wants to aid it. But I must try at one of the elements—namely air—& if that include light, I ought not to despair.[2]

After the exhausting task of painting the endless 'windows & window frames & chimneys and chimney pots' Constable finished the picture by the end of March 1833. One person who saw the picture at about this time was the Countess of Morley. 'On seeing the "House" she exclaimed — *how fresh* — *how dewy* — *how exhilarating.* I asked her if she was aware of what she was saying — half of it, if true, was worth all the cant & talk of pictures in the world.'

Constable sent the 'House that Jack Built' down to Somerset House where it was first examined by the Hanging Committee. Mr Reinagle, Mr Briggs and Mr Westall were puzzled. The Committee decided that Constable had painted a picture of a house in the country and after hanging it in a position Constable approved, they took it down again 'and put it where it is quite destroyed'. President Shee's view would have been decisive in ensuring that the picture remained in the unsatisfactory position it had been allotted. 'Shee told me it was "only a *picture of a house,* and ought to have been put into the Architectural Room. I told him that it was "a picture of a summer morning, *including a house*".' No one on the Council would support him in his fight to have the painting restored to its first more favourable position. 'None of the men who have the handling of it', he wrote to Boner, 'have the least feeling for the art itself — or any of the qualities of nature that perhaps exist on that canvas.' Shee and Howard, the Academy's secretary, were beyond conversion because they are 'so strictly academical that they deny the painter the power of making a picture out of nothing, or out of a subject not to their liking — though they do not deny it to the poet'.

What of the critics? The *Morning Chronicle* predictably dismissed it; if the word had existed the writer would have called it photographic. The *Morning Post* liked it, but could not resist a gentle jab:

We have seen nothing to compare with this from the hand of Mr. Constable for a long time. There is so much freshness and truth and such a mass of bright but sober colour, that it is quite a gem in its way. Mr. Constable has evidently forgotten to put on his last layer of whitewash, with which he generally complements his finished pictures. We hope he has lost the brush.[3]

The painting did mark a new direction or, rather, a return to an old one in that Constable had at about this time discarded his palette knife, but not until 'I had cut my throat with it'. He was amused that John Chalon had spread a report about his current practice 'that he actually saw four small sable pencils in my hand & that I was bona fide using them — in the art of painting'.

Constable must have felt that the winter had been well-spent: for a 'job' to have earned such praise had not happened before. His patron would surely be pleased. Far from being pleased, Mr Benyon-De Beauvoir was so dissatisfied with the painting that he did not wish it to be sent to him. Lane, acting as intermediary, passed on his principal's complaints to the artist. He thought that the side of the house 'appeared to be tumbling down'. He particularly objected to the 'specky or spotty appearance of your touch, and the quantity of sheep, oxen, &c which are in the foreground, and which he said looked as if he had his farm yard before his Drawing Room windows'.

Mr De Beauvoir also thought that at £100 Constable was asking too much for the picture, but 'he had learnt since from other friends *since* you began the picture that your prices were very high'.*[4] Constable did his best to placate his employer. He painted out the cows and further 'finished' the picture. He even prepared a fresh canvas. All to no avail. Letters from Constable to Mr De Beauvoir went unanswered and Lane's efforts to intercede came to nothing. In his letter of 23 March 1834 proposing a new picture Constable acknowledged that the 'perplexity' Mr De Beauvoir felt on seeing the picture 'arose from the desire to unite tastefully the elegant

*The picture had been commissioned in 1824, two years before Constable printed a price-list which indicates that he expected 120 guineas for a canvas of 'half-length size, namely: 4ft. 2in. by 3ft. 4 in.' As the painting was completed by a Royal Academician, Mr Benyon–De Beauvoir could have had little cause to complain about the price.

architecture of the house . . . with the adjoining scenery'. Not until
the middle of 1834, when Constable demanded and was paid the
money owing to him, did this unhappy episode come to an end.

Before the Academy Exhibition closed the *Morning Chronicle* found
another stick with which to beat him. It concerned a version of
Helmingham Dell which Constable had painted for Mr Pulham of
Woodbridge in 1826. On Pulham's death Constable bought back
the picture and then passed it to his friend Robert Ludgate who
gave him some old pictures in exchange. At his request the picture
was shown at the British Institution in 1833, but Ludgate died
before the exhibition closed. Mrs Ludgate was advised to regard
the picture as forming part of her husband's estate. She asked
Constable to return the picture, and then without his knowledge
sent it for auction to Christie's. It arrived too late to be included
in the sale catalogue with the result that dealers and collectors,
doubting its authenticity, refused to bid. Mrs Ludgate apparently
did not appreciate '*how my pictures not being known to be by me could
do me any harm!*' The *Morning Chronicle*, however, informed its readers
that 'a good-sized *Dell Scene* by Mr. Constable R.A., in his usual
style, and we should say preferable to anything he has in the present
exhibition at the Academy, was knocked down at fifty shillings.'
The writer hoped that this experience would 'teach a little modesty
to the Royal Academicians in their demands'. Constable did not
reply publicly to this damaging libel. Commended by Shee and
Mulready and the collectors, Sheepshanks and Allnutt, for his
forbearance, Constable communicated his deep anger and resent-
ment to Boner:

Let such wretches feel that I consider name and character beyond
the reach of such attacks.
But I have little doubt that such villainy will be unkenneled in time.
What can such a man be but an assassin, to destroy character, livelihood
& everything else, & to let himself out to hire to write against everything
good, for pay? It is quite impossible that I should compound with an
assassin.[4]

In the early months of 1833 Constable received several visits which
clearly indicate the patronizing humiliation which he still had to
suffer from 'connoisseurs'. During January William Seguier, the
Keeper of the National Gallery, called at 35, Charlotte Street:

I have had a friendly visit from a much greater man than the King—
the Duke of Bedford—Lord Westminster—Lord Egremont or the Presi-

dent of the Royal Academy—'MR. SEGUIER'. He was much delighted to all appearance, and rather astonished to find so good—or rather beyond his expectations. He bestowed much extempore praise, such as—Did you do this! really—who made that, drawing—you, really, very good indeed! ! !⁵

Constable followed Seguier's advice and sent *Salisbury Cathedral from the Meadows* to the British Institution exhibition that year. March brought another visitor, William Wells of Redleaf in Kent. Mr Wells – subsequently a patron of Leslie's – liked to have a promising young painter under his wing; he disparaged both Constable and Turner and was particularly eager to discover a painter who might be able to topple the mighty Turner from his perch. In 1833 his protégé was an ex-soldier turned artist named Frederick Richard Lee whose landscapes had gained great popularity; Constable's arch-enemy amongst the journals and also the *Morning Post* placed Lee's vapid scenes higher in achievement. In March Wells called at Charlotte Street:

He saw hundreds of my things—I sincerely beleive nothing amongst them made any impression upon him or did they come into his rules, or whims, of the art. I told him, that I had perhaps other notions of the art than picture admirers in general—I looked on *pictures* as things to be *avoided*. Connoisseurs looked on them as things to be *imitated*, & this too with a deference and humbleness of submission amounting to a total prostration of mind, & original feeling, that must obliterate all future attempts—and serve only to fill the world with abortions.

But he was very agreable, and I endured the visit without I trust the usual courtesies of life being violated. My house however has not yet recovered its tone, though all the windows have been open ever since.

Good God—what a sad thing it is that this lovely art—is so wrested to its own destruction—only used to blind our eyes and senses from seeing the sun shine, the feilds bloom, the trees blossom, & to hear the foliage rustle—and old black rubbed-out dirty bits of canvas, to take the place of God's own works.⁶

After he had cast an eye over Lee's latest productions Wells conceived the notion that Constable's ideas coupled with his protégé's execution might be a capital arrangement. He returned to Charlotte Street a month later:

Mr. Wells saw nothing in my house to approve—but much to disparage. I had 'lost my way'—Turner was 'quite gone'—lost and possessed by a yellow which he could not see himself, therefore could not avoid. Mr. Wells looked not at any of my pictures—only by glances of contempt

o

—but on seeing some of my *studies*, he kept saying, *this* would be of use to 'Lee'—& *this*—& *this* 'might' be of service to *Lee*—& so on.

He has sent Lee since to know what I would take for my studies, as he would buy my studies to *give to Lee*. I told Lee to wait 'till my sale.

Poor dear landscape—how they use you. During poor Mr. Well's visit I said nothing of *myself* or *others* which I wish to recall. He was here TWO *hours*. More 'over bearing meekness,' I never met with before, in any *one* man. More *self satisfaction* in his own opinions of the 'art' of which he knows nothing, I never saw. *Turner* was quite lost & gone—some good still *remained* with *me*, which his *MONEY was to transfer* to '*Lee*'. . . .

All this wicked conduct, comes of the vanity of connoisseurship & love of patronage for the advancement of a *protege*. All who have fairly won the feild must be swept out. I must be pulled down & my *studies* bought to *build up Lee*.[7]

To be sent round by his patron to the studio of a fellow-painter to ascertain whether and for how much he would sell his studies that he might learn something from them was an embarrassing mission. Constable understandably was not disposed to spare the younger man's feelings:

Lee called on me yesterday morning to ask what price I would out on my studies—if I would sell them at all—as he was desired to ask both questions. I asked Lee, if he was situated as I was, whether he would sell his best studies. He looked abashed (I will do him the justice to say) and said—well, perhaps not. I told him he had better with his friends wait till my sale, when they would get them by the dozen—for nothing. I might over value them at present.[8]

Lee, who became an Academician in 1838, recounted as an old man a meeting he had with Constable:

'I hear you sell all your pictures', said Constable, to the younger landscape painter.

'Why, yes', said Lee, 'I'm pretty fortunate — don't you sell yours?'

'No,' said Constable, 'I don't sell any of my pictures, and I'll tell you why. When I paint a *bad* picture, I don't like to part with it, and when I paint a *good* one, I like to keep it.'[9]

The melancholy induced by the loss of Fisher was in part allayed by the beginning of a new friendship. It began in a way that immediately endeared the new friend, George Constable, a brewer from Arundel in Sussex, to his namesake. Writing from 58, Charlotte

Street, where presumably he was staying with friends or relatives, George Constable appeared at first in the guise of a 'nibble' —. George Constable had been charmed by the *English Landscape* – 'the perfectly natural yet masterly manner with which you have treated the light & shade is to me quite astonishing. I must say that it is the most perfect and interesting work on landscape I have ever seen.' He wanted to buy a copy of the complete issue. Constable wasted no time in hauling in the line. As with Francis Darby, who had approached him as a stranger in 1825, Constable responded to George Constable's compliments in terms of unrestrained emotion reserved only for those who indicated an interest in, or admiration for, his work:

I should feel happy in the beleif that my book should ever remunerate itself, for I am gratifying my vanity at the expence of my children, and I could have wished that they might have lived on me, not the reverse. My only consolation is that my fortune has not sheltered me in idleness, as my large canvasses, the dreams of a happy but unpropitious life, will prove. Pray forgive the unreserved tone of this hasty scrawl.[10]

It seems most likely that Constable met George Constable to complete the transaction before he returned to Arundel taking with him a copy of the *English Landscape*. The two Constables remained in touch and in April 1833 the painter approached his Sussex patron to inquire if he would help him in a charitable venture in aid of the widow and family of an old friend of his named Slade. Constable wanted him to buy three drawings – by Varley and his pupil Ziegler – which would bring the widow Slade £10. George Constable did not however want the drawings himself, but generously arranged for a friend to buy them. By this time the brewer had shown himself to be more than superficially interested in the world of London artists; enough for Constable to send him Somerset House gossip.

I hear the Exhibition will be excellent—the quantity sent exceeds all precedent. Wilkie and Leslie are strong, Phillips and the President are strong, Landseer is strong, and so on. But perhaps you wish me to speak of myself—Constable is weak this year.[11]

The friendship continued to develop during the year. Constable offered the brewer 'something to look at' during his recovery from a broken arm; he in turn asked Constable's opinion of a Cuyp which he sent up to London and said that he wanted to possess

Salisbury Cathedral from the Bishop's Grounds which he had seen during one of his calls at Charlotte Street. Constable was invited down to Arundel during December and at Christmas George Constable sent John Charles some fossils for his collection.

The welfare of his seven children remained Constable's most important preoccupation. There is every reason to believe that, outside periods of intense work such as the painting of *Waterloo Bridge* involved, their well-being and development were of more concern than the fulfilment of his own ambitions. He had no worries now that he would be unable to provide for them. Constable was not the kind of father to have left the upbringing of his children in the hands of others, however loving. By this time they had all reached an age when they needed rather more than the competent though no doubt limited care that 'Bob' could provide: John was now sixteen; Minna aged fourteen, gave her father pain and joy as she became more and more like her mother; Charles, at twelve, was the most boisterous; eleven-year-old Isabel and eight-year-old Emily were developing under the firm guidance of Miss Noble; Alfred was now seven and Lionel, at five, was the baby of the family.

Towards the end of 1832 Constable had begun to have doubts about the wisdom, or perhaps the practicality, of keeping three energetic boys at home for the whole of their education. His first plan was to dismiss Boner and to have John tutored by his nephew Daniel Whalley, who, having graduated from Cambridge, was about to enter the Church. Charles would go to a small school in East Bergholt. For some reason Abram disliked Boner and would have liked to have seen his nephews placed in a regular school. 'I think Boner would be a great riddance & your home more comfortable — I like the plan . . .'. Abram would perhaps have been unaware of the help that Boner was rendering his brother in other ways, notably in secretarial and editorial help in connection with the *English Landscape*. Constable came to the conclusion that he would have to entrust his beloved boys to a carefully chosen school for the completion of their formal education. But having made the decision he remained cautious and at first only allowed Charles to be 'transported'. The Reverend Thomas Pierce's school at Folkestone in Kent was chosen probably because Constable had heard good reports of it from his cousin Jane South whose son Burton was already a pupil there. Fearing that the Folkestone school was little better than the 'petty starveling preparatories' he had so far managed to avoid, Constable arranged for Boner to accompany Charles

down to Kent in February taking with him a letter to the proprietor.

I am very desirous that Mr. Boner should have a little conversation with you not only as to what he has been doing—but also respecting the (perhaps) peculiar disposition and habits of this dear child, whose natural temperament partakes I fear of that of genius. A more open and noble disposition there cannot be—or a more affectionate heart. I know no one thing amiss of him, but a natural ardor and activity of mind and habit, with no great power of volition, may perhaps cause his character not to be immediately understood.

He has never been treated with severity. I have experience enough to know it would ill accord with him—if I am right in my contemplation respecting his constitution, both of body and mind. I must now beg to apologize for having said so much—though I can easily imagine to myself your kind indulgence—and shall only refer you to my friend who has so long had this dear boy and his brother under his care, domesticated with them, and whose conduct to them has been of the most mild and amiable kind.

My very old and much esteemed friend, Mr. Drew, who has always been the medical attendant of my family, has kindly given me a letter which he begs may be shown to your medical friend as it may be of the greatest service to the health of my child.[12]

John's education remained in Boner's hands, but having announced his intention of becoming a doctor he had begun attending lectures in anatomy. Constable no doubt considered that his health was not robust enough to be plunged into the rough and tumble of a conventional school.

Not surprisingly perhaps, Charles did not find it easy to settle down at the Reverend Mr Pierce's school after the affection and indulgence he had been used to at home. Encouragement and inspiring homilies reached him from his father, brother John, Boner, and 'Bob' Roberts. 'Bob' supposed that John was '*Like all young Gentlemen* [who] soon forget their nurse.' She reminded her former charge that 'now Dear Charles Is the time to make your Self an accomplished Gentleman in Education & Polite manners'. John warned his brother that as a result of his dilatory efforts at letter-writing 'Papa is geting figity lest you should not be well as he has not heard from you at all, you have written to me but not to Papa!' He found it necessary in May to rebuke his absent brother's reckless stewardship of his 'monney'. 'I cannot think what you have done with your Guinea for you promist me you would not follow Burty's example and spend your monney in eatables and other such like foolings.'

To augment his finances Charley was soon exploiting his inherited artistic ability, and not long after he had arrived at Folkestone he 'sold his first picture — a drawing (God knows what it is) is bought by the *curate* of Folkestone for one shilling — ready money I dare say'. By August Constable had decided that the Reverend Mr Pierce could be trusted with the education and care of his eldest son but 'to part with my dear John is breaking my heart — but I am told it is for his good'.

'Remember I play the part of Punch on Monday at eight, at the Assembly Rooms, Hampstead – to wit – ! ! !' Constable reminded Leslie in June 1833. Hampstead was at this time already recognized as a congenial area for men and women with artistic and intellectual interests. Among the residents were writers, painters, scientists, actors and art-collectors. As a result the village was acquiring a number of associations which enabled these minds to meet and exchange ideas. Constable was an early supporter of the Hampstead Public Library which opened in March 1833; he subscribed five guineas in November which, it was later decided, entitled him and other subscribers to life membership.[13] There was also a Literary and Scientific Society and it was this association which invited him to give an address. The evening of 17 June 1833 saw Constable's first essay into the field of public speaking when he rose in the elegant Hollybush Assembly Rooms to address members of the Society on 'An Outline History of Landscape Painting'.

The main theme of Constable's address was that landscape art, having begun as an adjunct to history painting, had only with difficulty been extricated from its confines, and had lost its way during the seventeenth century. But Wilson, Gainsborough, Cozens, and Girtin had led landscape in new directions in the eighteenth century. These painters had not 'lost sight of nature' unlike most of their contemporaries who, by imitating the 'landscape' of earlier masters, had corrupted the taste of connoisseurs. He singled out for particular praise his own models, Poussin, Claude and Rubens. In Claude's pictures he had found qualities which he had endeavoured to impart to his own, namely 'the union of splendour with repose, warmth with freshness, and darkness with light'. The remarks he made about Rubens could also have been applied to his own work:

In no other branch of the art is Rubens greater than in landscape;

the freshness and dewy light, the joyous and animated character which he has imparted to it, impressing on the level monotonous scenery of Flanders all the richness which belongs to its noblest features . . . Rubens delighted in phenomena—rainbows upon a stormy sky—bursts of sunshine—moonlight—meteors—and impetuous torrents mingling their sound with wind and wave.[14]

Constable was particularly keen that Leslie should attend his maiden speech because it seemed unlikely that there would be another opportunity to witness him telling the world that 'there is such a thing as Landscape existing with Art'. Leslie had decided to return to America where his brother had obtained for him the post of teacher of drawing at the Military Academy at West Point. Constable spent a melancholy summer as the time of Leslie's departure approached:

The thoughts that I am to be deprived of society, at least of the happy hours of your and Mrs Leslies several interviews, of our communications on art, and on many things else—weigh very heavily on my heart—so much so as to depress my mind, and prevent the enjoyment of even the little that remains of your countenance to me. This is not right on my part I know.[15]

Leslie sailed for America in September 1833 taking with him a water-colour drawing of a windmill at Colchester inscribed 'a trifling farewell to my dear Leslie'.

Constable was also deprived of the company of his eldest son who went to join Charles at Folkestone. Soon after arriving John fell ill following a fall in his sleep. The injury developed into erysipelas and the boy was confined to bed for a month. Constable went down to Folkestone in October to see him, and finding his illness more serious than he had supposed he stayed in the town for over a fortnight. The illness left John in poor health for the remainder of the year. When he and his brother arrived home for the Christmas holidays they found their father in the early stages of rheumatic fever.

By February Constable was seriously ill. The affairs of the family were left in the capable hands of Boner who more and more was proving his value to Constable. He had ceased to be only a tutor to the eldest boys and was now more a secretary to his employer, but he continued to act as tutor to the younger boys. In the early months of 1834 he added to these duties those of nurse and night attendant. 'My dear Boner had, last night, a terrible night with me. It was a grievous one for both of us', Constable wrote on 20 February. Years

later Charles Constable recalled Boner's devotion to his father:
'I have never forgotten how Boner was up night after night attending
him.' Boner, then, was responsible for keeping the life of the family
ticking over while its head struggled to recover from his incapacita-
ting illness. For most of February and March Constable was in
great pain. According to the family physician, Mr Evans, Constable
was 'never so well after this severe illness; its effects were felt by
him, and showed themselves in his looks ever afterwards'. The
illness played havoc with his work and he was able to send only three
previously exhibited works to the British Institution exhibition.
There was no time to prepare a picture 'for the world' and he was
represented at the Academy only by a number of drawings in water
colour and pencil.*

With Leslie absent there was no one on whom he could rely for
an honest and sympathetic appraisal of his work.

I find it hard to touch a pencil now that you are not here to see—even
when you did not like what I was about. It was delight to have your
[voice] addressed to my canvas—I am now alone—still the trees and the
clouds all seem to ask me to do something like them—and that is no
small reward for a life of labor.[16]

But it would not be long before Leslie would be back in London.
The post at West Point had not turned out as he had expected.
Hoping to be able to have enough time to paint without the need
to sell his work to keep his family, Leslie found that his teaching
duties were far more onerous than he had been led to expect. He
was provided with only an attic in which to live with his wife and
family. He decided to resign and returned to London in time to
see the Exhibition of 1834.

Constable was delighted. A house in Pine Apple Place off Edgware
Road became Leslie's new home. It was further away from both
Constable's houses than either Lisson Grove or Portman Place,
but 'you, my dear Leslie, what matters to me, are there'. Although
he grumbled that 'the last additional mile has played old gooseberry
with your friendship — or I should have said with your acquain-
tances' it was not long before the convalescent took a walk across
the fields to visit his old friend. Robert Leslie recalled what must
have been a familiar experience of his boyhood:

The house had then an open stretch of sweet-smelling hayfields in

* Two of the drawings were for an illustrated edition of Gray's *Elegy*, published
in 1834.

front of it, extending to Harrow on the Hill, and I can see Constable now as he used to sit on a summer evening in the front room, sipping what he called a 'dish of tea', and admiring a sunset beyond a row of fine oaks and elms. After which he and my father spent the rest of the evening in the painting-room.[17]

In July, prompted by the fossil-collector, who wanted to explore Sussex, Constable accepted George Constable's invitation to stay with him at Arundel. Constable and his son stayed in Arundel for about ten days. 'John is enjoying himself exceedingly. The chalk cliffs afford him many fragments of oyster shells and other matters that fell from the table of Adam in all probability . . .'. Constable's visits to the country were becoming rarer and at the age of fifty-eight he was becoming less inclined to tramp the fields in search of subjects for his pencil; a visit he had paid to East Bergholt in the previous August was given over to his eldest son's hobby in which he was taking a great interest, but he had produced a few sketches during his enforced stay in Folkestone in October. Constable found Arundel and the surrounding country very much to his liking:

The Castle is the cheif ornament of this place—but all here sinks to insignificance with the woods, and hills. The woods hang from excessive steeps, and precipices, and the trees are beyond everything beautifull: I never saw such beauty in *natural landscape* before. I wish it may influence what I may do in future, for I have too much preferred the picturesque to the beautifull – which will I hope account for the *broken ruggedness of my style*.[18]

His host was concerned to make the visit of value to his guest and took him to a number of places on the Sussex Downs where Constable sketched: Houghton, Fittleworth, Bognor and Petworth all produced drawings. Constable was driven over to Petworth on 14 July where he met Lord Egremont. 'He wanted me to stay all day — nay more he wished me to pass a few days in the house.' Constable declined the invitation saying that he would prefer to come when Leslie was also there. Lord Egremont, who was familiar with Constable's work, was a generous patron of English artists and continued to encourage and support men like Turner and Wilkie long after they needed personal patronage from a nobleman. He was a great admirer of Leslie's works and since 1826 hardly a year had passed without Leslie and his family staying for a month or so at Petworth.

Leslie went down to Petworth on his annual visit in August and

encouraged Constable to accept Lord Egremont's invitation. The suggestion put Constable in a quandary: 'Dear Leslie, tell me if I can, really without impropriety, write to Lord Egremont — I do not know how. It will be so much like a *self* invitation.' Leslie assured Constable that Lord Egremont expected no more than his arrival. But Constable continued to dither about protocol – 'you see how awkward I am with the great folks'. After wondering whether or not to tell Lord Egremont that he was coming, he pleaded with Leslie 'to say all you can to make me comfortable, for I feel I am running into danger, & may do amiss'.

Constable eventually joined Leslie at Petworth at the beginning of September. Thomas Phillips, R.A., was also a guest with his wife The new visitor was soon given an example of the hospitality of which he had heard so much from Leslie. Lord Egremont ordered that a carriage be at his disposal every day so that he could see as much as possible of the surrounding country. 'He passed a day in company with Mr and Mrs Phillips and myself, among the beautiful ruins of Cowdray Castle, of which he made several very fine sketches; but he was most delighted with the borders of the Arun, and the picturesque old mills, barns and farmhouses that abound in the west of Sussex.' Constable's visit to Petworth enabled Leslie to observe his habits:

He rose early, and had often made some beautiful sketch in the park before breakfast. On going into his room one morning, not aware that he had yet been out of it, I found him setting some of these sketches with isinglass. His dressing-table was covered with flowers, feathers of birds, and pieces of bark with lichens and mosses adhering to them, which he had brought home for the sake of their beautiful tints.[19]

For most of the year Constable had been engaged in a running battle with Alaric Watts, who owned and edited the *Literary Souvenir*, a journal combining the work of the leading painters and writers of the day. Something of a rebel himself, and perhaps wishing to give Constable an opportunity to express his singular ideas about the art of landscape painting Watts sought an article from Constable. Constable was somewhat dilatory in beginning his article and despite several reminders, did not complete it until the autumn. Being unused to writing for the Press, Constable was touchy about un-invited sub-editing:

How could you so act under a mistake as to alter one line of what I originally sent you? I sat up days and nights to do it—to my great and

serious loss, and which I shall feel at the next exhibition. May I beg again that my once perfect essay, be not printed at this time. I promise most faithfully that my work shall not appear 'till it is in yours of the next year, 1836. I am truly unhappy—& I can never show my face if this my poor mangled work is printed, now, at all. If however it must, I must beg, very more, that my name be not printed as being in any way the author, of it.[20]

Watts attempted to mend the breach in their relations but warned his contributor that 'you promised me the paper and by not re-deeming your promise you have made me look somewhat foolish: I have instanced it as the excuse for asking other aid from your brother R.A.'s'. After a period of reflection, Constable wrote Watts a rambling, incoherent letter:

You are certain that it was at least my wish to do something that should have been worth your having—and so sincere was I in that intention that I have devoted almost the 1st month exclusively to it. I [?own] I was rigid—precise—& anxious—but remember *my whole—my all*—rested on the throw. I was drawing the jealous attention of my brethren, upon me, and in a new form—& one in which I [?own] I was ill prepared for—as a writer—but it was my ideas, that would have been handled, I was not a free agent – therefore I would not yield, but my views were of the best kind—& I was not to climb downward, to the general mind. I am confidant that my effort would have answered the purpose of, yourself and me—and I regret excessively our abortive labors for both our sakes.

My dear Boner is sadly and sorely greived, for he bore his share of fag, which was by far the greatest, in great patience as from his great attachment to me, he was looking to the result with exultation—for he is far more anxious of my reputation that I am myself.

If you have the opportunity of explaining to Howard or Shee, the reason of my exclusion, do so—for I have been boasting to them, of the honor which awaited me—little dreaming of the fate of my poor ideas—but do not doubt they deserved it.[21]

Watts continued to deal with his recalcitrant contributor gently but firmly:

Where I love the man and admire his art I am not likely to quarrel with a friend (tho' some people aver that I am quarrelsome) upon slight and frivolous occasions. . . .

I have thought you the best, almost the only genuine landscape painter of the day and I have said so on all occasions and shall say so till I find a better. I am not likely to see either Howard or Shee and if I do am not obliged to give them any explanation.[22]

Constable had been hoping to set to work on a new canal scene during the winter of 1834–35. But he was now a tired, disillusioned man and, in his own words, he had become indolent. The *English Landscape* had proved to be a total loss; it had neither advanced his ideas nor improved his finances; it had not even paid for itself. (The price for 'the book' in 1832 had been ten guineas; by 1835 it was three guineas.) Now approaching sixty he was having to face the dismal truth that for all his single-minded application he had failed to raise the art of landscape painting to new heights. Even the great 'stir' in Paris more than ten years ago must have seemed like a flash in the pan; his pictures were no longer in demand in France. The six large Stour pictures had not bought him the 'fame' that he had hoped for; three of them were still in his possession, unsold. Despondent and exhausted by nearly forty years of unremitting endeavour, Constable made a further strenuous effort towards the end of 1834 to summon enough energy to begin another Stour picture. 'I have almost determined to attack another canal for my large frame', he told Leslie in September. What resulted was *The Valley Farm*.

The Valley Farm engaged most of Constable's attention during the first three months of 1835. His preparation for this work had been careful and thorough: several sketches, in oils and water colours, can be related to the final picture. But the painting of it caused him much worry, borne largely of indecision. After inquiring about Leslie's Academy picture Constable told him that 'I am making a rich plumb pudding of mine, but it keeps me in a "death sweat" — I am in the divil of a funk about it — and yet I like it and am confident.' His confidence was not misplaced. Before the exhibition opened, the great patron Robert Vernon joined the small band of strangers who had bought his pictures because they liked them. Since 1820 Vernon, who had made a considerable fortune out of horse-dealing during the Napoleonic wars, had been building up a collection of pictures by British painters. When Vernon called at Charlotte Street in March Constable was still working on *The Valley Farm*. Vernon, whose purchases were dictated by his own taste and not by dealers and connoisseurs, took an immediate liking to the picture and asked if it was being painted for any particular person. 'Yes, sir, it is painted for a very particular person', was Constable's ironic reply, 'the person for whom I have all my life painted.' The picture

having been sent down to Somerset House, the painter wrote to George Constable:

I have got my picture into a very beautifull state. I have kept my brightness without my spottiness, and I have preserved God Almighty's daylight, which is enjoyed by all mankind, excepting only the lovers of old dirty canvas, perished pictures, at a thousand guineas each, cart grease, tar and snuff of candles. Mr Wells, an admirer of common place, called to see my picture, and did not like it at all, so I am sure there is something good in it.[23]

The Valley Farm was Constable's only picture in this year's exhibition; it had 'the rare luck, when exhibited of pleasing even some of the newspaper critics'. The critic of the *Morning Chronicle* had been dismissed in the previous year, but the vacancy for a venomous critic of Constable's work was more than amply filled by the Reverend John Eagles who, as 'The Sketcher', wrote on art for *Blackwood's Magazine*. 'The Sketcher' did not like *The Valley Farm*:

No. 145. *The Valley Farm*. John Constable, R.A. There is nothing here to designate a valley or a farm, but something like a cow standing in some ditch-water. It is the poorest in composition, beggarly in parts, miserably painted, and without the least truth of colour—and so odd that it would appear to have been powdered over with the dredging box, or to have been under an accidental shower of white lead—which I find on enquiry is meant to represent the sparkling of dew. The sparkling of dew! Did ever Mr Constable see anything like this in nature? If he has, he has seen what no one else ever pretended to have seen. Such conceited imbecility is distressing, and being so large, it is but magnified folly.[24]

Constable was no eager litigant even when vilified, but some objection was raised to the paragraph and Eagles was obliged to apologize for his remarks in the journal's next issue.*

Constable had been invited to give another lecture before the Hampstead Literary and Scientific Society in June and, as with his Academy paintings, it was still being prepared in the week before it was to be delivered. He begged and borrowed and annexed paintings and prints to illustrate his talk; James Carpenter the Bond Street bookseller supplied some of the books that Constable did not have in his considerable library. On this occasion Constable did

*John Eagles, 1783–1855, was a frustrated painter; after rejection by the Water Colour Society in 1809 he seems to have sought refuge in the Church and was ordained. His interest in painting emerged again in 1831 when he began writing for *Blackwood's Magazine*.

not summarize his lecture after he had given it, but Leslie claimed that much of the material was included in the series of lectures he gave a year later at the Royal Institution. Leslie of course strolled over from Pine Apple Place to hear his friend's latest discourse.

I remember that the sky was magnified on the day on which it was delivered; and as I walked across the West End fields to Hampstead towards evening, I stopped repeatedly to admire its splendid combinations and their effects over the landscape, and Constable did not omit in his lecture to speak of the appearance of the day.[25]

As with his first lecture, Constable aimed at a conversational style. He spoke for an hour and a half 'only occasionally referring to my notes'. The Society's committee found Mr Constable's address 'novel, *instructive* and entertaining' and one of the speaker's friends complimented him on his ability to command an audience. Leslie was of the opinion that the success of Constable's second essay in public speaking was due in part to 'the charm of a most agreeable voice (though pitched somewhat too low), the beautiful manner in which he read the quotations, whether of prose or poetry' and 'his very expressive countenance'.

By the end of June, John and his father were 'panting for a little fresh air' and a visit to Arundel was arranged for the following month; Maria was to join the party on this occasion. Constable and his son and daughter were in Sussex for much of July. It was during this visit that George Constable offered to take John to visit the scene of his father's great triumph of more than ten years earlier. Constable's eldest child, at the age of seventeen, seems to have inherited his father's chauvinism, though not his artistic bent:

John was amused with France, but with the food he was annoyed, as he said they put vinegar into every thing they ate & drank. He saw the Louvre, *but does not remember any of the pictures*, excepting the Watteau, 'where ever so many cupids & people were flying about the sky & climbing up the mast of a boat.' As to Ruisdael, Claude, Poussin & Titian, he knows little and cares less.[26]

Constable was now preparing to part with the son whom he had hoped would follow him into his own profession. But Charley, despite his abilities as a draughtsman, had from an early age wanted to go to sea. During the summer of 1835 Constable gloomily prepared to consign one of his beloved children to the 'hateful tyranny' of the navy. The three hundred pounds that Robert Vernon had

paid for *The Valley Farm* was no doubt being used to provide the young sailor with his sea-going outfit:

What would Diogenes or an old sow (much the same thing) say to all this display of trousers, jackets, &c by the dozens—blue & white shirts by scores—and a supply of ratlin for the hammock, as he expects to be often *cut down*.

Poor dear boy—I try to joke, but my heart is broken, He is mistaken by all, but you & me—he is full of sentiment & poetry & determination & integrity, & no vice that I know of.[27]

It had been intended that Charley should join the Royal Navy as a midshipman, but Constable having learned from a friend at the Admiralty that 'they had 1200 midshipmen they did not know what to do with' decided that he should join a merchantman. Charley, who was only fourteen, was enlisted in the East India Company and placed on the *Buckinghamshire* – 'a noble ship, the size of a 74'. A saddened father, 'Bob' and 'Alfie' went down to Portsmouth to see the young sailor off on his first voyage. It was a melancholy occasion. At the moment of parting 'poor Charles hung about me when we left him . . . He asked if I could keep with the ship 'till next day, but I knew I must then part — so I shook hands — & saw him no more.'

As Charley sailed for the East Indies, Constable reluctantly prepared for further appearances as a lecturer, this time in Worcester where his pictures had 'played first fiddle' at a recent exhibition. His audience was to be the city's newly-formed Literary and Scientific Institute. 'Who would ever have thought of my turning Methodist preacher,' he wrote to Lucas, 'that is, a preacher on "Meth'd" — but I shall do good to that Art for which I live.'

The lectures, augmented versions of the Hampstead addresses, were to be given at midday on 6, 8 and 9 October. As with the other lectures Constable took considerable pains to ensure that his points would be understood. He made several charts which displayed the names of those painters most responsible for the advancement of landscape painting. Again, the lectures delivered to 'a highly respectable auditory' were well received. A 'mangled' report of 'my sermons' appeared in the *Worcester Guardian*, but the reporter of the *Worcester Herald* was able to convey that 'the very beautiful and feeling illustrations of the parentage and birth of the art, and its complete isolation from the great mass of historic art with which it had hitherto been involved, called forth repeated remarks of

satisfaction and delight'. The following year Constable repeated his lectures, in a slightly enlarged form, to the Royal Institution in London.

Constable was now in his sixtieth year and as his children began to leave home his thoughts turned towards Suffolk. East Bergholt still exerted a considerable pull on his affections; he had never felt at home in London and now, as his energy to continue the struggle in which he had been engaged since the beginning of the century diminished, it must have seemed an attractive idea to return to the 'scenes that made me a painter'. All his brothers and sisters lived in and around the village; his interest in 'all things upon the anvil' in Bergholt had never waned. The possibility that he should buy a house there was discussed with Abram earlier in the year – 'it would be very comfortable to have such a house with a little land attach'd, to retreat into when you grow tired of the smoke & dirt of London'.

Mary Constable acted as agent for her brother and by 1836 negotiations had begun for the purchase – jointly with Mary – of Old House Farm and a parcel of land known as 'Fisher's'. The price was £4000. By May the parties had closed and Abram supervised the completion of the transaction. The terms of the arrangement between Mary and her brother were that she would be 'tenant of the whole & pay you a rent for your part' – presumably until Constable decided to live in the farmhouse himself.

While the negotiations were in progress Constable was at work on a view of _Arundel Mill and Castle_. But after starting this new canvas he decided to return to a painting he had begun two years earlier. As this was to be the last Exhibition held in Somerset House – the Royal Academy was soon to move to quarters in the east wing of the new National Gallery building in Trafalgar Square – he wanted to pay a personal tribute to Sir Joshua Reynolds. For this he returned to a sketch he had made at Coleorton in 1823 of the cenotaph Sir George Beaumont had erected to his old friend, the first President of the Royal Academy. In _The Cenotaph_ Constable overcame his aversion to the season of decay. 'I never did admire the autumnal tints in nature, so little of a painter am I in the eye of commonplace connoisseurship', Constable told Leslie. 'I love the exhilarating freshness of spring.' But in this picture 'gone are the swelling curves of summer. For the first time Constable has painted the gothic

architecture of winter.'[28] The entry of this 'tolerably good' painting in the catalogue was accompanied by the lines which Wordsworth had written at Sir George's request.* A watercolour drawing of Stonehenge was also hung.

The Cenotaph was liked by *The Observer* whose critic conceded that there was some truth in Constable's statement that his 'chopped hay' or 'whitewash' would mellow in time. 'We have seen pictures of his after they had been done some time, and were surprised how much superior they appeared to what they were when they were first painted.'[29]

Constable's interest in science – attested by his sound knowledge of the mutability of pigments – was deepening now that John had become a student of chemistry at the Royal Institution where his tutor was Michael Faraday.

As each month passed Constable was becoming lonelier. Charley had returned from the East Indies only to depart soon afterwards for China. John – his 'whole and sole companion' – was shortly to go up to Cambridge to become 'either a clergyman or a physician'. The other children – 'the girls get almost women' – were at Hampstead. Forlorn as he was, Constable replaced *Arundel Mill and Castle* on his easel. The move to Trafalgar Square was likely, as Constable might have expressed it, to begin a new epoch in the life of the Royal Academy and he would have felt that he could best show his belief in its value to British art by exhibiting a carefully finished canvas; he could pay the Academy no higher compliment. Although he

*Ye lime trees ranged before this hallow'd urn,
Shoot forth with lively power at spring's return;
And be not slow a stately growth to rear
Of pillars branching off from year to year,
Till they have learn'd to frame a darksome aisle,
That may recall to mind that awful pile
Where Reynolds, 'mid our country's noblest dead,
In the last sanctity of fame is laid.
There, though by right the excelling painter sleep
Where death and glory a joint Sabbath keep,
Yet not the less his spirit would hold dear
Self-hidden praise and friendship's private tear;
Hence in my patrimonial grounds have I
Raised this frail tribute to his memory;
From youth a zealous follower of the art
That he profess'd, attach'd to him in heart;
Admiring, loving, and with grief and pride
Feeling what England lost when Reynolds died.
(Leslie, p. 342)

P

grumbled about its shortcomings Constable 'at bottom' revered the institution and was proud of his rank within it; he served the Academy loyally, particularly during the last decade of his life.

The Academy had been under attack as the result of a Parliamentary Select Committee which had been inquiring into grievances expressed by a number of artists including George Clint, John Martin and Benjamin Robert Haydon. The most serious charge was that the Academy was exclusive and undemocratic; it was an accusation which Constable might have supported in his middle years. But now, as a Royal Academician, his dismissal of the proceedings was characteristically blunt: 'They have mustered all the off scouring of our profession, all the blackguards — down to Haydon & Bob Stothard — & have collected volumes of falsehood, & slander, & ignorance . . .' The accusations were so mischievous and ill-expressed that Sir Martin Archer Shee had little difficulty in rebutting them. The strictures of the Committee were largely ignored by the Academy and its move to the National Gallery building, which had been attacked during the Committee's hearings, was duly accomplished at the beginning of 1837.

For a few months the Life Academy continued to occupy rooms in 'the old house' and it was there that Constable carried out his last official duty as an Academician when he relieved Turner as Visitor. In his lectures Constable had invoked Titian's *St Peter Martyr* as marking a watershed in the history of art and it was this picture that he decided to recreate in his month 'in the life'. From Monday until Saturday during a bitter March Constable attended to his teaching duties in Somerset House from five until nine o'clock in the evening. He enjoyed instructing the young painters and they responded to his 'jokes and jibes' and the 'vein of satire he was ever so fond of'. At the end of his last session on Saturday 25 March the Visitor gave a farewell address to the young artists.[30]

Somerset House, he said, had been almost 'the cradle of British art' and he hoped that the students' achievements would honour not only the Academy but also their native land. He warned them not to look only to European masterpieces for their instruction and remarked that 'the best school of art will always exist in that country where there are the best living artists, and not merely where there are the greatest number of works of the old masters'. He concluded by thanking the students for their constant application during the month's work and they acknowledged his popularity by giving him a standing ovation.[31]

There was still work to be done at Charlotte Street on the Arundel picture and this occupied him during the following week. On Thursday 30 March, after attending the general assembly of the Royal Academy in the new building, Constable and Leslie walked home part of the way together. Leslie recalled that it was a very cold but fine night. As they walked along Oxford Street they heard a child crying. Constable crossed to the other side of the street to comfort a little girl who had hurt her knee. 'He gave her a shilling and some kind words, which, by stopping her crying, showed that her hurt was not very serious, and we continued our walk. . . . We parted at the west end of Oxford Street, laughing.'

On the following day, the last day of March, Constable was hard at work on his Academy picture which was almost finished. A mission on behalf of the Artists' General Benevolent Institution took him out of the house during the evening, but he returned at about nine o'clock and ate 'a hearty supper'. Soon afterwards he retired to his bed which, contrary to his usual habit, he had asked to be warmed. He read himself to sleep with Southey's *Life of Cowper* in his small attic bedroom; the walls were covered with engravings. Shortly afterwards a servant came up as usual to remove his candle.

John Charles, who had been to the theatre, returned home between eleven o'clock and midnight and as he was preparing to go to bed in the adjoining room his father called to him that he was in pain. He took rhubarb and magnesia and warm water which caused sickness. When the pain increased a neighbouring physician, Mr Michele, was summoned and he prescribed brandy. But as a servant ran downstairs to fetch it Constable died.

In Mr Michele's opinion it was 'barely possible that the prompt application of a stimulant might have sustained the vital principle, and induced reactions in the functions necessary to the maintenance of life'. A post mortem examination failed to establish the cause of death; the extreme pain could only be ascribed to indigestion.

In the morning John sent Pitt to Pine Apple Place telling Leslie the sad news. Leslie and his wife went immediately to Charlotte Street. 'I went up into his bedroom where he lay, looking as in a tranquil sleep; his watch, which his hand had so lately wound up, ticking on a table by his side, on which also lay a book he had been reading scarcely an hour before his death.'[32]

John was so overcome by the death of his father that he could not attend the funeral at Hampstead Church. The service was conducted by an old friend, the Rev. Thomas Judkin who had been for many

years a fervent admirer of Constable's paintings.* He found it impossible to restrain his emotions and 'tears fell fast on the book as he stood by the tomb'. The vault which Constable had built for Maria nearly nine years earlier was opened and he was laid beside her. It bore the inscription:

> *Eheu! quam tenui e filo pendet*
> *Quidquid in vita maxime arridet*†

Not long afterwards Leslie, who was arranging Constable's affairs, called a hackney carriage from the rank in Charlotte Street. When it reached Pine Apple Place the driver said, 'I knew Mr Constable; and when I heard he was dead, I was as sorry as if he had been my own father — he was as nice a man as that, sir.'

*The Rev. Thomas Judkin of Southgate was an amateur painter – 'He is a sensible man . . . but he will paint' – who idolized Constable to such an extent that in 1826 he composed what he called a sonnet in the style of Milton in praise of him. Fisher thought the sonnet resembled 'Miltons in shape but in nothing else. . . . The sonnet is however gratifying to you to shew how persons think of you.' (JCC VI, pp. 224–5)

†Alas! From how slender a thread hangs
 Whatever in life most favours us

Notes and Sources

Abbreviations

Except where stated, all quotations, including shorter extracts for which sources are not indicated, derive from the six volumes of *John Constable's Correspondence*, edited and annotated by the late R. B. Beckett, published by the Suffolk Records Society, 1962–1968. These, and other frequently cited works, are identified as follows:

JCC I The Family at East Bergholt, 1807–1837.
JCC II Early Friends and Maria Bicknell (Mrs Constable).
JCC III The Correspondence with C. R. Leslie, R.A.
JCC IV Patrons, Dealers and Fellow Artists.
JCC V Various Friends, with Charles Boner and the Artist's Children.
JCC VI The Fishers.

FARINGTON *The Farington Diary*. The diary of Joseph Farington, R.A. Edited by James Greig in eight volumes. Hutchinson, London, 1922–1928.
LESLIE C. R. Leslie, R.A. *Memoirs of the Life of John Constable, R.A.* Edited by the Hon. Andrew Shirley, Medici Society, London, 1937.
WHITLEY I W. T. Whitley. *Art in England, 1800–1820*. Cambridge, 1928.
WHITLEY II W. T. Whitley. *Art in England, 1821–1837*. Cambridge, 1930.

Chapter One (*pages 15 to 27*)

1 JCC I, pp. 3–8.
2 JCC I. Letter dated 9 July 1816. See also 'Golding Constable's Gardens' by M. Rosenthal, *The Connoisseur*, October 1974.
3 Leslie, p. 1.
4 JCC I, p. 9. David Lucas, the engraver of Constable's *English*

Landscape, thus annotated his copy of Leslie's *Memoirs* (Fitzwilliam Museum, Cambridge).

5 Leslie, p. 3.
6 JCC VI. Letter dated 23 October 1821.
7 JCC I. Letter dated 7 March 1815.
8 JCC II, pp. 21–2.
9 Lucas annotation given in JCC II, p. 22. See also 'John Dunthorne's "Flatford Lock" ' by Ian Fleming-Williams, *The Connoisseur*, December 1973.
10 JCC IV, pp. 1–10.
11 JCC I. Letter dated 11 August 1796.
12 Unpublished letter in the Constable family collection.
13 JCC II. Letter dated 29 May 1802.
14 See 'Constable's first landscape' by Professor A. Cecil Alport, *Country Life*, 10 October 1952.
15 Leslie, p. 7.
16 JCC II. Letter dated 2 October 1797.

Chapter Two (pages 28 to 47)

1 Farington, 25 February 1799.
2 Farington, 26 February 1799.
3 Hutchison, *History of the Royal Academy*. See also 'The Schools of the Royal Academy' by Dr H. C. Morgan, *British Journal of Educational Studies*, Vol. XXI, No. 1, February 1973.
4 G. D. Leslie. *The Inner Life of the Royal Academy*.
5 JCC II. Undated, p. 26.
6 JCC II. Undated, p. 24.
7 JCC II. Letter dated 25 July 1800.
8 JCC II. Undated, p. 25.
9 JCC II. Undated, p. 26.
10 JCC II. Letter dated 8 January 1802.
11 Unpublished MS diary in the Constable family collection.
12 JCC II. Undated, p. 29.
13 Leslie, pp. 19–20.
14 JCC II. Letter dated 29 May 1802.
15 JCC II. Letter dated 23 May 1803.
16 JCC III. Letter dated 23 May 1803.
17 *Gentleman's Magazine*, 1816, pp. 182–4.
18 JCC V, p. 4.
19 Farington, 12 December 1807. See also 'Wordsworth and Constable' by J. R. Watson, *Review of English Studies*, N.S. Vol. XIII, November 1962, pp. 361–367.

20 Whitley I, pp. 121–2.
21 Farington, 19 June 1809.
22 Farington, 21 April 1806.
23 Farington, 18 April 1808.
24 Farington, 20 April 1809.
25 Farington, 24 May 1809.
26 Leslie, p. 367.

Chapter Three (*pages 48 to 72*)

1 JCC II. Letter dated 22 June 1812.
2 JCC II. Letter dated 15 March 1810.
3 JCC II. Letter dated 19 February 1814.
4 JCC II. Letter dated 17 July 1810.
5 JCC IV. Letter dated 24 November 1810.
6 JCC II. Letter dated 28 April 1811.
7 JCC I. Letter dated 17 July 1810.
8 JCC I. Letter dated 26 July 1810.
9 JCC I. Letter dated 16 February 1812.
10 JCC I. Letter dated 6 March 1811
11 JCC I. Letter dated 6 March 1811.
12 JCC II. Letter dated 16 March 1811.
13 JCC IV, pp. 26 7.
14 JCC IV, pp. 28–9.
15 JCC II. Letter dated 12 November 1811
16 JCC IV. Letter dated 28 September 1811.
17 JCC II. Letter dated 23 October 1811.
18 JCC II. Letter dated 26 October 1811.
19 JCC II. Letter dated 29 October 1811.
20 JCC I. Letter dated 3 November 1811.
21 JCC II. Letter dated 2 November 1811.
22 JCC II. Letter dated 4 November 1811.
23 JCC II. Letter dated 12 December 1811.
24 JCC II. Letter dated 17 December 1811.
25 JCC II. Letter dated 24 December 1811.
26 JCC I. Letter dated 19 January 1812.
27 JCC I. Letter dated 31 December 1811.
28 JCC II. Undated, p. 59.
29 JCC II. Letter dated 21 March 1812.
30 JCC II. Letter dated 24 April 1812.
31 JCC VI. Letter dated 13 November 1812.
32 JCC VI. Letter dated 8 May 1812.
33 JCC II. Letter dated 27 May 1812.
34 JCC I. Letter dated 12 April 1812.

35 JCC II. Letter dated 22 July 1812.
36 JCC II. Letter dated 22 July 1812.
37 JCC II. Letter dated 22 September 1812.
38 JCC II. Letter dated 28 October 1812.
39 JCC II. Letter dated 28 October 1812.
40 JCC II. Letter dated 6 November 1812.
41 JCC II. Letter dated 17 November 1812.
42 JCC II. Letter dated 12 December 1812.

Chapter Four (pages 73 to 98)

1 JCC I. Letter dated 31 January 1813.
2 JCC IV. Letter dated 13 July 1813.
3 JCC I. Letter dated 10 June 1813.
4 JCC II. Letter dated 23 January 1813.
5 JCC II. Letter dated 3 May 1813.
6 JCC VI. Letter dated 14 June 1813.
7 JCC II. Letter dated 25 August 1813.
8 JCC IV, p. 47.
9 JCC II. Letter dated 24 November 1813.
10 JCC II. Letter dated 23 December 1813.
11 JCC I. Letter dated 24 February 1814.
12 JCC II. Letter dated 19 February 1814.
13 Leslie, p. 71.
14 JCC II. Letter dated 11 May 1814.
15 JCC II. Letter dated 18 May 1814.
16 Farington, 23 July 1814.
17 Leslie, p. 75.
18 JCC II. Letter dated 2 October 1814.
19 JCC II. Letter dated 15 November 1814.
20 JCC I. Letter dated 7 March 1815.
21 Leslie, p. 92.
22 JCC I. Letter dated 29 January 1815.
23 JCC I. Letter dated 12 March 1815.
24 JCC II. Letter dated 15 November 1815.
25 JCC II. Letter dated 28 December 1815.
26 JCC II. Letter dated 25 January 1816.
27 JCC II. Letter dated 2 February 1816.
28 JCC II. Letter dated 7 February 1816.
29 JCC II. Letter dated 13 February 1816.
30 JCC II. Letter dated 18 February 1816.
31 JCC II. Letter dated 19 May 1816.
32 JCC II. Letter dated 1 August 1816.
33 Farington, 3 July 1816.

34 JCC II. Letter dated 17 July 1816.
35 JCC II. Letter dated 16 August 1816.
36 JCC II. Letter dated 30 August 1816.
37 JCC II. Letter dated 30 August 1816.
38 JCC VI. Letter dated 27 August 1816.
39 JCC II. Letter dated 15 September 1816.
40 JCC II. Letter dated 19 September 1816.
41 JCC II. Letter dated 26 September 1816.

Chapter Five (pages 99 to 135)

1 See 'Constable's Honeymoon' by R. B. Beckett, *The Connoisseur*, March 1952.
2 JCC I. Letter dated 25 December 1816.
3 Farington, 12 June 1817.
4 C. R. Leslie, R.A. *Autobiographical Recollections*, Vol. I, 1860, p. 64.
5 Farington, 6 April 1818.
6 JCC II. Letter dated 21 October 1918.
7 JCC I. Letter dated 8 November 1818.
8 JCC II. Date uncertain, p. 248.
9 Whitley I, p. 301.
10 JCC VI. Letter dated 2 July 1819.
11 JCC VI. Letter dated 11 August 1819.
12 Farington, 1 November 1819.
13 JCC VI. Letter dated 4 November 1819.
14 Farington, 1 April 1820.
15 Whitley I, p. 317.
16 JCC VI. Letter dated 27 April 1820.
17 JCC VI. Letter dated 12 November 1822.
18 JCC VI. Undated, p. 63.
19 JCC VI. Letter dated 1 April 1821.
20 Whitley II, p. 8.
21 JCC I. Letter dated 17 June 1821.
22 JCC VI. Letter dated 1 April 1821.
23 JCC VI, p. 64.
24 JCC VI. Letter dated 1 April 1821.
25 JCC VI. Letter dated 6 August 1821.
26 Leslie, p. 117.
27 JCC VI. Letter dated 4 August 1821.
28 JCC VI. Letter dated 20 September 1821.
29 See also Badt and '*John Constable's Writings on Art*' by Louis Hawes, Jr. Unpublished thesis, University of Princeton, copy held by Victoria & Albert Museum Library.
30 JCC VI. Letter dated 23 October 1821.

31 JCC VI. Letter dated 20 September 1821.
32 JCC VI. Letter dated 1 February 1823.
33 JCC VI. Letter dated 7 February 1823.
34 JCC VI. Letter dated 16 October 1823.
35 JCC VI. Letter dated 23 October 1821.
36 JCC II. Letter dated 15 November 1821.
37 JCC VI. Letter dated February 1822.
38 JCC VI. Letter dated 16 February 1822.
39 JCC VI. Letter dated 17 April 1822.
40 JCC VI. Letter dated 17 April 1822.
41 JCC VI. Letter dated April 1822.
42 JCC VI. Letter dated 12 November 1822.
43 JCC VI. Letter dated 6 December 1822.
44 JCC VI. Letter dated 9 May 1823.
45 JCC VI. Letter dated 9 May 1823.
46 JCC VI. Letter dated 5 July 1823.
47 JCC II. Letter dated 5 September 1823.
48 JCC II. Letter dated 29 August 1823.
49 JCC II. Letter dated 5 November 1823.
50 JCC II. Letter dated 27 October 1823.

Chapter Six (pages 136 to 168)

1 JCC VI. Letter dated 18 January 1824.
2 JCC VI. Letter dated 8 May 1824.
3 JCC VI. Letter dated 30 November 1822.
4 JCC VI. Letter dated 8 April 1826.
5 JCC VI. Letter dated 27 April 1829.
6 JCC VI. Letter dated 28 November 1826.
7 JCC VI. Letter dated 27 September 1826.
8 JCC VI. Letter dated 3 September 1829.
9 JCC VI. Undated, p. 171.
10 JCC II. Letter dated 1 September 1826.
11 JCC IV. Letter dated 19 June 1824. See also 'Constable in France'
 by R. B. Beckett, *The Connoisseur*, May 1956.
12 JCC VI. Letter dated 31 May 1824.
13 JCC VI. Letter dated 17 December 1824.
14 JCC VI. Undated, p. 171.
15 JCC VI. Undated, p. 171.
16 JCC VI. Letter dated 17 November 1824.
17 JCC VI. Letter dated 23 January 1825.
18 JCC II, pp. 372–3.
19 JCC VI. Letter dated 27 January 1825.
20 JCC VI, pp. 197–8.

21 JCC VI. Letter dated 6 August 1825.
22 JCC IV. Letter dated 24 August 1825.
23 JCC VI. Letter dated 14 January 1826.
24 JCC VI. Letter dated 10 September 1825.
25 JCC II. p. 394.
26 JCC VI. Letter dated 19 November 1825.
27 JCC VI. Letter dated 21 November 1825.
28 JCC VI. Letter dated 19 November 1825.
29 JCC VI. Letter dated 14 January 1826.
30 JCC VI. Letter dated 21 November 1825.
31 JCC VI. Letter dated 26 November 1825.
32 JCC II. Journal, p. 424.
33 Leslie, *Autobiographical Recollections*, I, pp. 115–16.
34 JCC VI. Letter dated 8 April 1826.
35 JCC VI. Letter dated 28 November 1826.
36 Whitley II, p. 132.
37 Whitley II, p. 133.
38 JCC VI. Letter dated 26 August 1827.
39 JCC VI. Letter dated 19 June 1828.
40 Leslie, p. 232.
41 Leslie, p. 234.

Chapter Seven (pages 169 to 204)

1 JCC VI. Letter dated 29 November 1828.
2 JCC III. Letter dated 21 January 1829.
3 JCC VI. Letter dated 11 February 1829.
4 JCC I. Letter dated 13 February 1829.
5 JCC VI. Letter dated 3 September 1829.
6 JCC IV. Letter dated 15 September 1829.
7 JCC IV. Letter dated 26 February 1830.
8 JCC IV. Letter dated 26 February 1830.
9 JCC IV, p. 329.
10 JCC IV, p. 354.
11 JCC IV. Letter dated 12 March 1831.
12 JCC IV. Letter dated 4 December 1831.
13 JCC IV, p. 362.
14 Shirley, *The Published Mezzotints of David Lucas after John Constable R.A.*
15 JCC IV, p. 379.
16 JCC IV. Letter dated 11 December 1834.
17 JCC IV. Undated, p. 414.
18 JCC IV. Undated, p. 414.
19 JCC IV. Letter dated 16 December 1834.

20 JCC VI. Letter dated 24 May 1830.
21 W. P. Frith, R.A. *My Autobiography and Reminiscences*, Vol. I, 1887, pp. 237–8.
22 Whitley II, p. 195.
23 JCC III. Letter dated 31 January 1830.
24 Whitley II, p. 329.
25 Whitley II, p. 328.
26 Whitley II, p. 212.
27 JCC III. Undated, p. 44.
28 Minute books of the A.G.B.I.
29 JCC III, p. 51.
30 JCC III, p. 51.
31 JCC III. Letter dated 17 January 1832.
32 JCC III. Letter dated 28 December 1831.
33 Leslie, p. 162. See also 'Constable's "Whitehall Stairs" or "The Opening of Waterloo Bridge"' by Denys Sutton. *The Connoisseur*, December 1955.
34 JCC III. Letter dated 24 April 1832.
35 Leslie, *Autobiographical Recollections*, I, pp. 202–3.
36 Whitley II, pp. 236–7.
37 JCC III. Undated, p. 71.
38 JCC III. Letter dated 6 July 1832.
39 JCC III. Letter dated 4 September 1832.

Chapter Eight (pages 205 to 228)

1 JCC III, p. 96.
2 JCC III. Letter dated 17 December 1832.
3 Whitley II, p. 252.
4 JCC V. Letter dated 27 July 1833. Whitley II, pp. 255–6.
5 JCC III. Letter dated 11 January 1833.
6 JCC III. Letter dated 2 March 1833.
7 JCC III. Letter dated 3 April 1833.
8 P. Leslie. *Letters of John Constable, R.A. to C. R. Leslie, R.A.* (1826–1837), London, 1931, pp. 111–112.
9 Redgrave, *Memoir*, p. 284.
10 JCC V. Letter dated 14 December 1832.
11 JCC V. Letter dated 17 April 1833.
12 JCC V. Undated, p. 143
13 Information kindly supplied by Swiss Cottage Library.
14 *John Constable's Discourses*. Compiled and annotated by R. B. Beckett. Suffolk Records Society, 1970, p. 61.
15 JCC II. Letter dated 16 August 1833.
16 JCC III. Letter dated 20 January 1834.

17 JCC III, p. 110.
18 JCC III. Letter dated 16 July 1834.
19 Leslie, p. 319.
20 JCC V. Undated, pp. 98–9.
21 JCC V. Letter dated 3 December 1834.
22 JCC V. Letter dated 4 December 1834.
23 JCC V. Letter dated 8 April 1835.
24 Whitley, II, pp. 300–301
25 Leslie, p. 328.
26 JCC III. Letter dated 14 September 1835.
27 JCC III. Undated, p. 129.
28 Clark, *Romantic Rebellion*, p. 280.
29 Whitley II, p. 317.
30 Redgrave, *Memoir*, p. 58.
31 Whitley, II, pp. 326–7.
32 Leslie, *Autobiographical Recollections*, I, pp. 158–160.

Select Bibliography

Badt, K., *John Constable's Clouds* (Routledge, 1950).

Boase, T. S. R., *Oxford History of English Art (1800–1870)* (Oxford University Press, 1959).

Boner, C., *Memoirs and Letters of Charles Boner.* 2 volumes (London, 1871).

Clark, K., *Landscape into Art* (John Murray, 1949).

Clark, K., *The Romantic Rebellion* (John Murray/Sotheby Parke Bernet, 1973).

Constable, W. G., *The Painter's Workshop* (Oxford University Press, 1954).

Dale, A., *Fashionable Brighton, 1820–60* (London, 1947).

Davies, M., *The British School* (London, National Gallery, MCMLIX).

Edwards, E., *Anecdotes of Painters* (Cornmarket Press).

Evans, G., *Benjamin West and the taste of his times.* (S. Illinois University Press, MCMLIX).

Finberg, A. J., *The Life of J. M. W. Turner, R.A.* (Oxford University Press, 1939. 2nd Edition, 1961).

Frith, W. P., *My Autobiography and Reminiscences.* 2 volumes (1887–8).

Fry, Roger, *Reflections on British Painting* (Faber, 1934).

Greaves, M., *Regency Patron: Sir George Beaumont* (Methuen, 1966).

Hodgson, J. E. & Eaton F. A., *The Royal Academy and its members* (John Murray, 1905).

Hutchison, S. C., *History of the Royal Academy, 1768–1968* (Chapman and Hall, 1968).

Key, S. J., *John Constable, his life and work* (Phoenix 1948).

Leslie, C. R., *Memoirs of the Life of John Constable, R.A.* Revised and enlarged by the Hon. Andrew Shirley (Medici Society, 1937).

Leslie, C. R., *Autobiographical Recollections.* 2 volumes (John Murray, 1860).

Leslie, G. D., *The Inner Life of the Royal Academy* (John Murray, 1914).

Leslie, P., *Letters from John Constable, R.A. to C. R. Leslie, R.A.* (London, 1932).

Lindsay, J., *J. M. W. Turner* (Adams & Dart, 1966).

Lister, R., *British Romantic Art* (Bell, 1973).

Martin, E. W., *The Secret People* (Phoenix, 1954).

Mason, E. C., *The Mind of Henry Fuseli* (Routledge, 1951).

Paterson, Rev. T. F., *East Bergholt in Suffolk* (Privately printed, 1923).

Peacock, Carlos, *John Constable, the man and his work* (Baker, 1965).

Pye, John, *Patronage of British Art* (Facsimile reprint, 1970).

Redgrave, F. M., *Richard Redgrave, A Memoir* (London, 1891).

Redgrave, R. & S., *A century of British Painters* (Phaidon edition, 1947).

Reynolds, G., Catalogue of the Constable Collection in the Victoria & Albert Museum (HMSO, 1960; 2nd edition 1972).

Reynolds, G., *Constable: The Natural Painter* (Evelyn, Adams & Mackay, 1965).

Rothenstein, John, *Nineteenth century Painting, A study in conflict* (John Lane, The Bodley Head, 1932).

Ruskin, John, *The Lamp of Beauty*. Selected and edited by Joan Evans (Phaidon, 1959).

Sandby, W., *The History of the Royal Academy of Arts*. 2 volumes (London, 1862).

Shields, C. & Parris, L., *John Constable 1776–1837* (London, Tate Gallery, 1969).

Shirley, A., *The Published Mezzotints of David Lucas after John Constable, R.A.* (Oxford University Press, 1930).

Shirley, A., *The Rainbow, a portrait of John Constable* (Michael Joseph, 1949).

Smith, J. T., *A Book for a Rainy Day* (Methuen, 1905).

Smith, T., *Recollections of the British Institution* (London, MDCCCLX).

Sturge Henderson, M., *Constable* (Duckworth, 1905).

Taylor, B., *Constable, Paintings, Drawings and Watercolours* (Phaidon, 1973).

Thirsk, J. (and J. Imray), *Suffolk Farming in the Nineteenth Century* (Suffolk Records Society, 1958).

Trevor-Roper, P., *The World through blunted sight* (Thames & Hudson, 1970).

Turner, J., *Rivers of East Anglia* (Cassell, 1954).

Waller, A. J. R., *The Suffolk Stour* (Ipswich, 1957).

Whitley, W. T., *Artists and their friends in England, 1700–1799*. 2 volumes (Medici Society, 1928).

Whitley, W. T., *Art in England, 1800–1820* (Cambridge University Press, 1928).

Whitley, W. T., *Art in England 1821–1837* (Cambridge University Press, 1930).

Whittingham, S., *Constable and Turner at Salisbury* (Friends of Salisbury Cathedral, 1972).

Wilenski, R. H., *English Painting* (Faber, 1946).

Windsor, (Lord), *John Constable, R.A.* (London, 1903).

Young, A., *General View of the Agriculture of the County of Suffolk* (London, 1804).

Index